Also by Lenny Lipton:
Independent Filmmaking

THE
SUPER 8
BOOK

by Lenny Lipton

edited by Chet Roaman

designed and illustrated by Christopher Swan

A FIRESIDE BOOK
Published by SIMON AND SCHUSTER

Library of Congress Catalog Card
Number 75-9430
ISBN: 0-671-22082-9
Printed in the United States of America

1 2 3 4 5 6 7 8 9 10

for Chloe

And further, by these my son be admonished:
Of making making many books there is no end;
And much study is a weariness of the flesh.

Ecclesiastes 22.12

CONTENTS

SOUND

PROCESSING AND STRIPING 168

EDITING

FORMAT

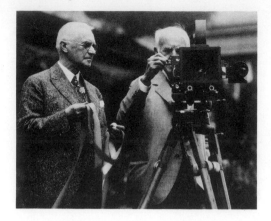

Motion picture pioneers George Eastman, holding film, and Thomas Edison, behind the camera, in this 1928 photograph. (Eastman Kodak)

When Edison and his associate William Kennedy Dickson set out to invent motion pictures, they had nearly everything they needed—except film. The substance we call film did not exist; people used glass plates for photography. But Edison knew that glass as a medium for movies was hopeless.

He knew he needed something flexible and ribbon-like, but cellulose nitrate base was still a few years in the future when he and Dickson undertook their first design efforts with thick acetate sheets glued together for adequate length. By 1888 Edison had determined that when suitable film was invented it would be of a specific design using film 35 millimeters wide.

So Edison invented the concept of movie film in general, the 35mm film format specifically, before there was any film! When Eastman came along with film in 1889, Edison was ready to use the 35mm format, retained to this day for theatrical motion pictures.

The design of every motion picture format rests on three basic points: the width of the format; the location and size of the perforations; and the area devoted to its frame and sound track. To be called super 8, a film must conform to specific dimensions for width, perforations, image and sound track.

But we are not concerned so much with dimensional standards as we are with the actual super 8 format design, which is based on that of its precursor, the standard, or double, 8mm format. Aside from cartridge loading, super 8's most basic improvement over standard 8mm is that its frame is larger than that of the earlier format. And since all picture information is contained within the rectangle of the frame, a bigger frame yields better quality images. While the super 8 frame has 50 percent more image than the standard 8mm frame it replaced, it has less than a third of the image area of the next larger format, 16mm. All three formats have the same aspect ratio (page 6).

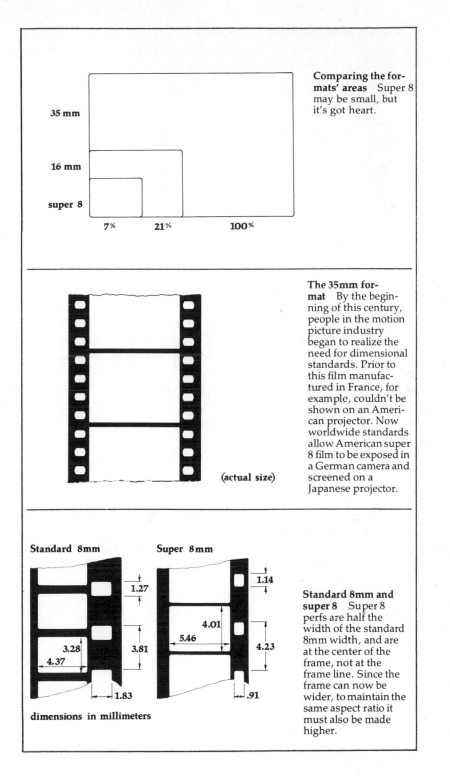

35 mm

16 mm

super 8

7% 21% 100%

Comparing the formats' areas Super 8 may be small, but it's got heart.

The 35mm format By the beginning of this century, people in the motion picture industry began to realize the need for dimensional standards. Prior to this film manufactured in France, for example, couldn't be shown on an American projector. Now worldwide standards allow American super 8 film to be exposed in a German camera and screened on a Japanese projector.

(actual size)

Standard 8mm

Super 8mm

1.27

1.14

4.01

5.46

3.28
4.37

3.81

4.23

1.83

.91

dimensions in millimeters

Standard 8mm and super 8 Super 8 perfs are half the width of the standard 8mm width, and are at the center of the frame, not at the frame line. Since the frame can now be wider, to maintain the same aspect ratio it must also be made higher.

3

Super 8 film is a ribbon-like material, made up of a succession of frames; on the edge of the film, on the side away from the perforations, is the area devoted to sound information, the sound track.

Each perforation (perf) must be in the same position with respect to each frame. The super 8 perf is at the middle of the frame and not at the frameline as is the case for standard 8mm and the other formats. These have frameline perforations because they are spool loaded and not packaged in cartridges. If there are any light leaks when loading or unloading spool film—and there almost always are near the head and tail of a roll—the light tends to bleed most through the perfs, fogging the immediately adjacent film. So the perfs were placed in the corner of the frame to make this spurious exposure less noticeable. Because super 8 is cartridge loaded, and therefore not subject to light leaks, the perfs can be in a more advantageous position, alongside the middle of the frame, and not between frames. In this way the super 8 format makes splicing easier, since you don't have perfs which can be broken in the area of the splice, at the frame line.

In all super 8 cartridge-loading cameras, and for many projectors, the only place the mechanism touches the perfs is at the optical

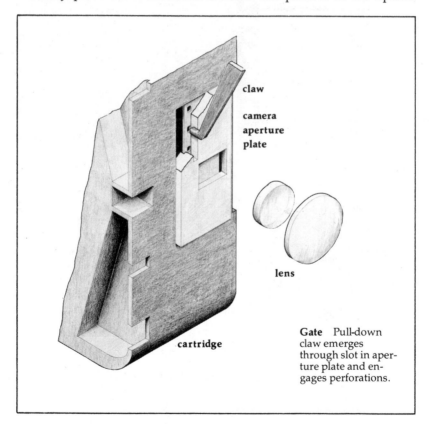

claw

camera aperture plate

lens

Gate Pull-down claw emerges through slot in aperture plate and engages perforations.

cartridge

interface, or gate area, where the frame is exposed or projected. A shuttle, or claw, engages the perf to position each frame properly: the claw pulls each frame down the height of one perf and momentarily holds it at rest while the film is either being exposed or projected.

Other formats and some super 8 projectors use sprocket wheels to help advance the film as well. There's an opportunity for wear anytime anything touches the film; so one of super 8's advantages is that much of its equipment doesn't have sprocket wheels.

The prime function of the super 8 perf is to advance or position the film one frame—and exactly the height of one frame—at a time in the camera and projector optical interfaces. In other words the perforations serve to give the position of each frame in the hardwares' optical path. This is called indexing.

For what's been described so far, some mechanical means of indexing, a projector or camera shuttle, has been used. But the indexing function of the perf can be carried out without the shuttle's intermittent action. This has been demonstrated in the Eastman videoplayer which can hook up to any TV set and display a super 8 film over an open channel (page 285). The film is transported continuously within the videoplayer, with photoelectric scanning of the perforations providing the frame indexing.

Film must have an intermittent, or pulsed, motion for image recording or display in the traditional camera and projector apparatus, even if this pulsed motion is not compatible with the requirements of sound track recording and reproduction. Both sound recording and reproducing devices require smooth and continuous motion past a soundhead or playback device; but each frame must be intermittently positioned for image photography or projection: start, stop, start, stop. Since this jerking motion of the film is not compatible with the continuous action needed by the track, the sound information of a particular frame has to be carried a small distance away from it. This separation allows the film to be

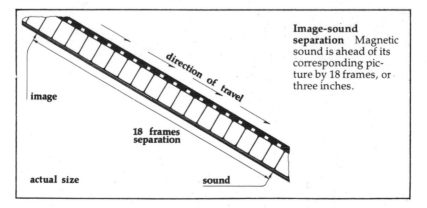

image

direction of travel

18 frames separation

Image-sound separation Magnetic sound is ahead of its corresponding picture by 18 frames, or three inches.

actual size sound

pulsed, while some distance ahead of it—simultaneously—the track is smoothly flowing past a soundhead.

The super 8 sound track may be either optical or magnetic. An optical sound track is a photographic record of changes in sound intensity. A magnetic sound track is a magnetic record of changes in sound intensity. For a magnetic track, the sound is advanced 18 frames; 22 frames for an optical track.

Dimensions for movie sound tracks are traditionally given in mils, or thousandths of an inch (nothing to do with millimeters). The super 8 track has been standardized at about 30 mils wide (0.76 millimeters).

You'll notice on the perforation edge of the format that there's room for a narrower track, the balance stripe. Because magnetic stripe coated on the film is raised about 0.4 mils above the base, the higher track side would cause the film to wind unevenly on reels—piling up on one edge, sagging on the other. The balance stripe's original function was to prevent this by being the same height above the base as the record stripe.

But the balance stripe can also be used to record sound or other information since it's made of the same iron oxide material as the record track. Standards for the balance stripe are very relaxed: anything from 8 to 16 mils will pass muster. While these standards accomplish the balancing function, they're inadequate for sound recording. Presently, Kodak's prestriped Ektasound balance stripe is 13 to 14 mils, and its quality and surface smoothness have been greatly improved to aid sound recording. However, the maximum permissible dimension should become standard, hopefully a full 16 mils, for the stripe to be of best possible sound quality.

Aspect ratio You probably realize that each frame has a precise rectangular shape. This shape is called the aspect ratio—a term used in many branches of engineering to describe exactly the proportions of a rectangle. A square has an aspect ratio of one to one, written 1:1. A rectangle twice as long as it is high has an aspect ratio of 2:1.

The super 8 frame has an aspect ratio of 1.33:1. Judging from the numbers or by looking at the frame itself, the super 8 rectangle is really a mild departure from the square. The aspect ratio of 1.33:1 is the one originally chosen by Edison for his 35mm format. His variation on the square leads to a somewhat more dynamic shape, more suitable for most subjects. Until the early '50s, the theatrical aspect ratio of 1.33:1 persisted for 35mm projection. Then the CinemaScope standard, 2.33:1, was introduced, with special anamorphic lenses much like funhouse mirrors, spreading the image across a broad screen. To suggest this effect and to get the most mileage out of films already shot in the 1.33:1 ratio—or to

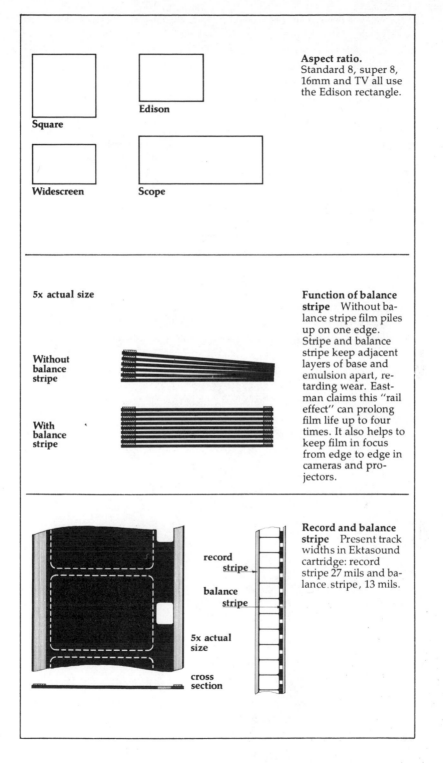

Square

Edison

Widescreen

Scope

Aspect ratio.
Standard 8, super 8,
16mm and TV all use
the Edison rectangle.

5x actual size

**Without
balance
stripe**

**With
balance
stripe**

**Function of balance
stripe** Without ba-
lance stripe film piles
up on one edge.
Stripe and balance
stripe keep adjacent
layers of base and
emulsion apart, re-
tarding wear. East-
man claims this "rail
effect" can prolong
film life up to four
times. It also helps to
keep film in focus
from edge to edge in
cameras and pro-
jectors.

record
stripe

balance
stripe

5x actual
size

cross
section

**Record and balance
stripe** Present track
widths in Ektasound
cartridge: record
stripe 27 mils and ba-
lance stripe, 13 mils.

Kodak Model A 16mm camera. Harris B. Tuttle behind the camera in 1923. (Eastman Kodak)

avoid paying royalties to 20th-Century Fox, CinemaScope's patent holder—the 35mm frame was often cropped top and bottom to project the wide screen ratios of 1.85:1 for North America, and 1.65:1 for Europe. Films shot wide screen can be shown on TV by simply projecting the entire uncropped frame, since the TV rectangle is also 1.33:1. However, films shot in CinemaScope (or the modern variation Panavision) must be optically scanned with relatively elaborate printing machines, and are not as easily converted to the TV aspect ratio, or for viewing in 16mm or super 8 which also use the Edison ratio.

So for the most part the aspect ratio of the super 8 frame is essentially compatible with all other film formats, and television as well; this means that larger format films can be duplicated in super 8, or super 8 film blown up to a large format. If the need should arise, and without any trouble at all, super 8 films may be shown on your own TV screen, or even on broadcast TV.

History of the Format We've come a long way, in a short period of time, from Edison and Eastman's joint invention of 35mm motion picture film to present-day super 8. The 35mm format created by these geniuses has been of prime interest to the commercial world, but efforts to bring motion picture systems to the amateur began before the turn of the century with the Biokam 17.5mm camera, in 1899. In 1912 Pathé offered a 28mm system, and there have been other efforts to attract the home moviemaker with smaller, less costly formats. Things didn't exactly click until 1923 when Eastman Kodak introduced the 16mm system. One of the most important aspects of the system was perfected by scientist John G. Capstaff. The product was black and white reversal film which bypassed the negative-positive system's need for making a print. The very film which passed through the camera was processed to have normal tonality so that it was projectable. To this day all films intended for home movie use are reversal materials.

The 35mm stock of the day was issued on flammable nitrate base, and this continued to be the case for theatrical films well into the '50s. Nitrate base would never do for an amateur system, so cellulose acetate base—safety film—was introduced as part of the 16mm package. Film was made 16 millimeters wide to discourage slitting or cutting down flammable 35mm stock, as could be done with the 17.5mm Biokam system. And Eastman didn't go it alone, since both Bell & Howell and Victor offered 16mm equipment of their own.

In 1928 Eastman introduced their Kodacolor film, a lenticular system, not unlike today's color television. A three-band color filter was fitted over camera and projector lenses, and the film was exposed through a corduroy-ribbed layer of cylindrical lenses over-

coating the emulsion. Although the process is now obsolete, 20th-Century Fox continued to experiment with it until the early '50s.

In 1932 Eastman introduced their double 8mm format because 16mm had proven to be too costly for the amateur. This new format was given double the number of perforations a running foot, and pulled down half the height of a 16mm frame in the new 8mm cameras. Once half the film was exposed on the first pass, the film was run through the camera for a second one, getting not merely double, but quadruple the time out of a comparable length of 16mm film, because the frame size was reduced by one quarter. This 16mm deviant had the advantages of being low in cost and compatible with existing 16mm processing equipment. After processing the lab slit the film in half and mounted the 8mm film on reels.

Kodachrome, a total departure from the early Kodacolor, was introduced in 1935 for 16mm, and in 1936 for double 8mm. It was faster, or more sensitive to light, than Kodacolor, and it screened much brighter images without the need for a light-robbing triple-band filter over the projector lens. Moreover, copies, or prints, could be easily made, a Kodacolor weak point.

Early in the game Kodak recognized that loading the camera was

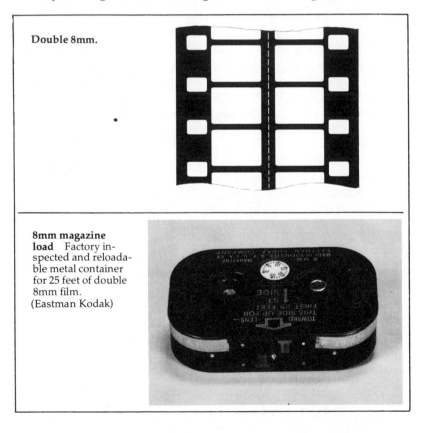

Double 8mm.

8mm magazine load Factory inspected and reloadable metal container for 25 feet of double 8mm film. (Eastman Kodak)

one place where the amateur was likely to screw up, so efforts were made to perfect a magazine-loading system. A 16mm device holding 50 feet of film was introduced in 1936, and a similar magazine holding 25 feet of double 8mm (50 feet slit) appeared in 1940. After returning to the processing station, these factory-loaded metal monstrosities had to be inspected for defects and reloaded with fresh film. Inspection is a costly process, and these cartridges were notorious for jamming. However, you can still buy them.

The late '30s and '40s saw the rise of 16mm optical sound. After the Second World War, 16mm took on more of the aspects of a professional medium and double 8mm became the sole province of the amateur.

The next landmark was Eastman's once again, a basic improvement of the 25-year-old Kodachrome with the 1961 introduction of Kodachrome II, which was two and a half times faster, and had greatly improved color, sharpness and grain, as well as lower contrast.

The first words about super 8 appeared in print in Eastman research papers stressing the audio-visual applications of a redesigned standard 8mm format. The new format was to have increased image area and good sound quality with magnetic stripping. But insiders and people in the industry knew that part of the super 8 scheme called for cartridge loading of film. With advanced plans the industry tooled up for super 8 equipment. In May 1965, super 8 in its stubby, coaxial plastic cartridge arrived loaded with Type A indoor balanced Kodachrome II, billed as a universal film. All super 8 cameras were to have built-in daylight conversion filters. Bell & Howell and other major equipment suppliers simultaneously showed their wares, and Fuji introduced super 8 format film in their own single 8 cartridge.

May 1965 was a bullish month in the history of our small format. In addition to the introduction of super 8, Fairchild offered their 900 model sound-on-film standard 8mm camera. It featured designer Hans Napfel's servo drive, the basic ingredient in the later Ektasound system. Also of passing interest, that month the German giant Agfa patented its version of a sound-on-film movie cartridge, similar in many ways to the 1973 Ektasound device.

The next stroke for super 8 was a total systems approach by Eastman to the challenge of filming movies in low level light doing away with hot and bright movie lights. The XL (existing light) concept was introduced in 1972: this included the new fast Ektachrome 160 film and cameras with fast lenses and broad shutter angles for making the most of dim light.

Fifty years after they introduced the 16mm system, Eastman in 1973 introduced the Ektasound cartridge, based on the silent super 8 cartridge design, loaded with magnetic-sound striped film. Cameras accepting the cartridge were introduced, and in the next few years many major manufacturers joined Eastman with sound cameras and new sound projectors. Beaulieu, for example, introduced the 5008.S sound-on-film camera in 1974.

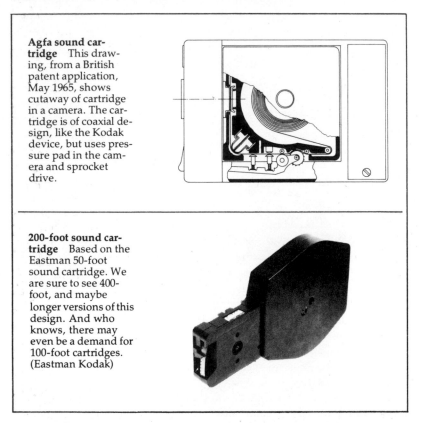

Agfa sound cartridge This drawing, from a British patent application, May 1965, shows cutaway of cartridge in a camera. The cartridge is of coaxial design, like the Kodak device, but uses pressure pad in the camera and sprocket drive.

200-foot sound cartridge Based on the Eastman 50-foot sound cartridge. We are sure to see 400-foot, and maybe longer versions of this design. And who knows, there may even be a demand for 100-foot cartridges. (Eastman Kodak)

In '74 and '75 Eastman made available the 200-foot super 8 sound and silent cartridges and a camera, the Supermatic 200, to accept these cartridges, and the videoplayer, a low cost film-chain for displaying super 8 on home TV, or broadcast TV. The $13,000 Supermatic Ektachrome processor was also introduced; this can process a 50-foot cartridge in 13½ minutes, bringing us one step closer to "instant" movies.

Film Basics Motion picture film is composed of a layer of light-sensitive stuff called emulsion, on a support material called base. The emulsion, which on the average, is about 0.0005 inch thick, is made up mostly of gelatin, very much like the dessert; throughout it are dispersed salts of silver, called silver halides. Those specifically used are silver iodide and bromide. In addition various other chemicals are added to enhance the properties of the emulsion. In the case of color film, there are several layers coated on the base. There will be three picture-forming layers, as well as additional filter layers. Nevertheless, the thickness is still held to that of a black and white emulsion. Black and white film is often made up of more than one layer too, in order to combine the best qualities of specific emulsion combinations.

The base, which is about 0.0055 inch thick, is usually made of cellulose acetate, although in recent years manufacturers have begun to use polyester base. Fuji and 3M use polyester in their single 8 and super 8 cartridges, respectively, and some manufacturers offer it for print material. Polyester's major advantage is its strength, so it can be made thinner than acetate, while serving the same purpose. Its major disadvantage is that it is a petroleum product, subject to ecological pressure and rising oil prices. Cellulose acetate, on the other hand, is made from good old renewable cotton.

Motion picture film base must be transparent, flexible, strong, and it should maintain these properties for many, many years to be really useful. Modern base material does just that.

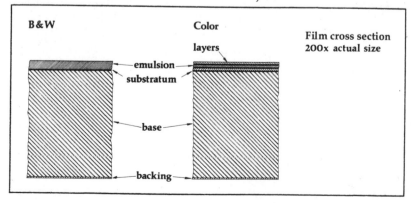

B & W Color layers Film cross section 200x actual size
emulsion — substratum — base — backing

Super 8 movies are shot on reversal film, which is like the slide film used in still cameras—Nikons or 110 Pocket Instamatics. The film is processed to deliver an image with normal tonality and color. When prints are made from reversal original camera film, they are made on reversal print film. I bring the concept of printmaking into this discussion only to clarify a point: the approach used for much still photography and motion picture work is the negative-positive system, in which the camera original film—a negative material— must be printed on positive stock to yield projectable or viewable images. Reversal images can be projected and appreciated without the need to make a print, which is what makes the reversal system so attractive to the super 8 filmmaker. In point of fact, you can't buy negative super 8 camera film.

Color dominates super 8. There's just a little bit of super 8 black and white film being shot, compared with color. It's a continuation of a trend that started with the introduction of Kodachrome movie film in the '30s.

Color film is made up of a sandwich of emulsions. These layers are essentially black and white emulsions that have been replaced by appropriate dyes in processing. The black and white image is made up of silver metal particles, called grains, dispersed through-out gelatin. Where there are more grains of silver, there's more density, and that part of the image is black. Black areas are heavily loaded with silver metal, and white or clear areas have very little silver on them.

Instead of clumps of silver metal, color film has grains of dye. Processed color film has three dye layers, which, descending to-ward the base are yellow, magenta (a pinkish red) and cyan (a bright blue). The dyes' replacing of the silver metal in each layer is proportional to the metal's density. Each layer is sensitive to only one third of the visible spectrum, and each dye replacing it also represents one third of the visible spectrum of light. When screened, light is projected through the dye layers; by passing through each layer the light is filtered by it, producing the appro-priate color. For example, if yellow and cyan are present but not magenta, we'll see green.

Projected color movie film, which is made up of a succession of still images, has a continually changing granular pattern. This cor-responds quite closely with the actual background noise of human vision, resulting from residual neural activity of the retina and optic nerve; this appears as a scintillating pattern you may be able to see in the dark or when you apply pressure to the closed eyelid or in solid masses of tonality like the sky. The Beatles sang of "Lucy in the Sky With Diamonds," and their diamond-textured sky has also been commemorated by Huxley in *The Doors of Perception* and others who have been under the influence of drugs like LSD or mescaline.

And some people can see the granular texture of the universe without drugs because they are so high, or so old.

And as one gets older, the eye's background noise increases and visual activity decreases. When this goes far enough, the message (vision) is swamped in granularity and there is blindness.

The swirling granular texture of movie film comes very close to reproducing this characteristic of vision, unlike the ordinary television image which is rear projected onto a fixed line or dot pattern.

Films with a tight granular pattern are called fine-grained films. This is the hallmark of a material with good pictorial quality; as a rule of thumb, film which is less sensitive to light has the finest granularity.

It's pretty clear what we mean by sharpness. A needlessly out-of-focus image will drive most people who are into photography up the wall. The usual axiom is that the faster the film, the less sharp. While this is true in some cases, fast or very sensitive modern movie films can still be very sharp, even if they are rather grainy. Don't believe me? Take a look at some projected Plus-X, a slow film, and 4-X, a fast film. I think you will agree that sharpness for both these black and white films is roughly equal, even though 4-X is much grainier than Plus-X *and* eight times as sensitive to light.

This brings us to the subject of film speed, which for many filmmakers, for much of their shooting, is the most important single technicality of film they consider. Faster films will allow the filmmaker to shoot in lower intensity light than slower films. In this country and much of the world, movie film is rated in terms of exposure index (EI). If you use a lightmeter, the EI values correspond to the ASA numbers printed on the meter's scale. If you use a typical super 8 camera, you don't have to know the EI of the film since the cartridge keys the camera for film speed. The lens is then set by the automatic iris diaphragm mechanism.

Super 8 film is available in three ranges of speeds, 40-25 EI, 160-100 EI and 400-250 EI. The first number of each pair, the higher

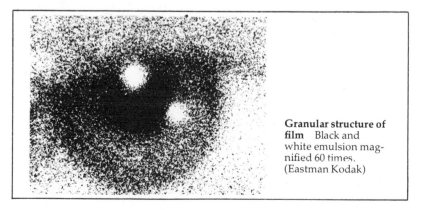

Granular structure of film Black and white emulsion magnified 60 times. (Eastman Kodak)

one, represents the film speed for shooting without using the built-in filter. Most super 8 cameras have built-in type A or daylight filters (also known as a number 85 filter). These orange filters alter daylight passing through the camera lens so that it is suitable for properly exposing indoor-balanced color film. Most super 8 color films are balanced for tungsten-filamented electric lights, so when shooting in this illumination, the filter must be swung out of the optical path. Many super 8 cameras will do this automatically when a movie light is attached to the top of the camera. The first number then, 40 EI, is for example the speed for Kodachrome 40 when shot in tungsten lights without the filter in place. The 25 EI is for Kodachrome 40 when the filter is in place for shooting daylight illuminated subjects.

According to industry standards, with the filter in, film speeds from 10 to 400 EI are possible, and, with the filter out, the range is 16 to 640 EI. The film speed is set in the camera by a feeler which enters the cartridge (page 30). The deeper the notch, the faster the film. Practically speaking, only the three discrete sets of speeds—40-25, 160-100 and 400-250—are employed, because many camera mechanisms are set to activate these values only. The least expen-

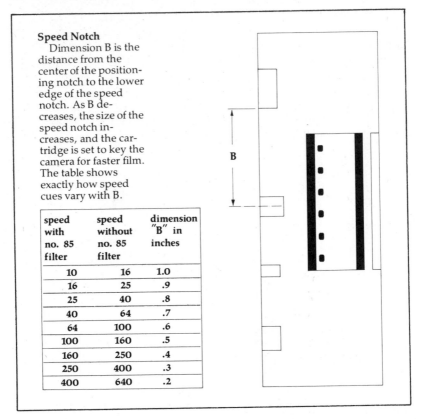

Speed Notch
Dimension B is the distance from the center of the positioning notch to the lower edge of the speed notch. As B decreases, the size of the speed notch increases, and the cartridge is set to key the camera for faster film. The table shows exactly how speed cues vary with B.

speed with no. 85 filter	speed without no. 85 filter	dimension "B" in inches
10	16	1.0
16	25	.9
25	40	.8
40	64	.7
64	100	.6
100	160	.5
160	250	.4
250	400	.3
400	640	.2

sive cameras will key for only the 40-25 speed. Many of the more expensive machines will also key for the 160-100 speed, but still too many will not key the fastest 400-250 range. Too bad. This means only a few super 8 cameras are capable of accepting really fast film. To find out what your camera will do, check the instruction book.

Manufacturers like to call their 40-25 EI products medium speed. I think this is a bit of semantic double talk. In most super 8 cameras with reflex finders and large ratio zoom lenses using up most of the image-forming light, film of this speed is capable of making movies only in the brightest conditions. Very often I have been unable to get acceptable exposures in shade with these cameras and this low EI film. So it makes sense to me to call the 40-25 EI range slow film. The next step up the ladder, the 160-100 EI range, represents a real jump in speed and will allow you, with any given camera, to take pictures in one quarter the light levels of 40-25 EI film. That represents a real increase of two f stops (page 62), making possible shooting under formerly impossible conditions. I call film in the 160-100 EI category, fast film. The next step up, the 400-250 EI level, is a little more than a doubling in film sensitivity, helping you take pictures in very dim light. With an XL camera (page 78) and this very fast film, shooting is extended to its limits. You should be able to get acceptable exposures with an XL camera and this very fast film in a small room with just a single 25-watt electric light. At present, only black and white film is generally available in this speed range.

In this rap I touched on the subject of color balance: most super 8 color film is balanced for tungsten light and so must be used with the built-in daylight filter outdoors. If you use indoor color film with the filter mistakenly in place under tungsten lights, you'll get orangish or very warm images. If you omit the filter when shooting outdoors, you'll get bluish or cool images. Sometimes if you are shooting a mixture of daylight and tungsten, it's hard to know whether to leave the filter in or out. If you are not sure, leave the

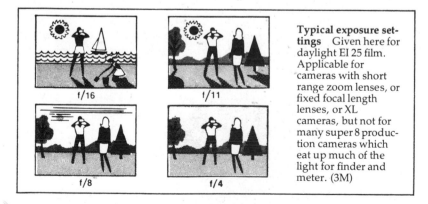

f/16

f/11

f/8

f/4

Typical exposure settings Given here for daylight EI 25 film. Applicable for cameras with short range zoom lenses, or fixed focal length lenses, or XL cameras, but not for many super 8 production cameras which eat up much of the light for finder and meter. (3M)

filter in. Warmer images are usually more pleasing than colder images. It's also better to leave the filter in when shooting under fluorescent lights, usually.

Another fancier term for color balance is sensitization, which specifically refers to the adjustment of the relative speed and color response of each emulsion layer of the color film sandwich. The subject of sensitization of color emulsions has been called into question by recent developments by Eastman. Let me explain.

Most super 8 film is balanced to give pleasing colors when exposed to photofloods, or movie lights. Kodachrome 40, 3M Color Movie Film and GAF Color Movie Film are all such type A sensitized film. Only Fuji offers a daylight balanced color film, sometimes called type D, for their single 8 cameras. It can be exposed to daylight without the need for a correcting type A filter.

Type B film, like type A film, has been marketed for years. It is meant to be used with slightly warmer floods, and exposed to daylight through the slightly deeper type B filter. Ektachrome 7242, which will be discussed shortly, is a type B film, but experience shows that it may be used entirely successfully with the usual photofloods or type A filter.

In 1972 Eastman introduced two new Ektachromes—160 and 40; both were designated type A films. Although they can be used just like type A films with regard to movie lights and filters, Eastman changed the red layer's sensitivity. Essentially the red layer is unable to distinguish among different shades of red. Eastman researcher Don Gorman discovered that sensitizing a film this way produced pleasing colors under most types of illumination, including fluorescent lights. (Perhaps these films should be known as type A').

Although E/160 and E/40 are less accurate reporters of color than Kodachrome 40, for example, in many situations people will be more pleased with their view of the world.

Gorman went a step further, and fudged the blue sensitivity to produce Ektachrome G, the world's first G type film (G, I suppose, for general). The idea was to have a film that would never need a filter, and could always produce reasonably pleasing colors under any kind of illumination from daylight, to tungsten, to fluorescent.

Another important color film concept is called saturation. If you've ever fooled around with the control knobs of a color TV, you undoubtedly have seen that you can alter the color saturation of the image from black and white to supersaturated colors. Some kinds of color film are more saturated, or have richer, brighter colors than others. Exposure also affects saturation. Underexposed, darker images have more deeply saturated colors than pale, washed-out overexposed images.

The last important film basic is exposure latitude which has been described as a film's ability to withstand departures from correct exposure. Actually, there is no such thing as a perfectly correct exposure, and it is possible that several different exposures of the same scene may give acceptable images. A film's exposure range, or latitude, is usually expressed in terms of camera *f* stops (page 62). It's not unusual for modern reversal film to have an exposure latitude of plus or minus one stop; some films have more, some less. Less contrasty films (and subjects) have more latitude.

The color films of different manufacturers have different looks. For one thing they use different dyes in their films. For another the sensitization of the emulsion layers may differ. That is, the films may actually see the world quite differently. Eastman, in fact, offers more than one family of films, each of which has its own look.

Ultimately what counts is what you see with your eyes when you screen your movies. With practice, it should be easy for you to be able to tell a fine grain from a coarse grain image, or a sharp film from one not so sharp, or one which has well-saturated colors from one which is only so-so in this respect.

All of this will become clear to you with experience. Experience means shooting film and looking at it, and believing what your eyes see, rather than what it says in the ads or in the film magazines.

How Film is Made Very briefly, here's how film is made: cotton, wood shavings, sawdust and bones can be transformed into cellulose acetate; this is done by being washed and dried and then treated, mostly with acetic acid which turns it into a gooey liquid called dope, not unlike the product used by model airplane builders. It's then filtered to make it homogeneous, and spread evenly on polished silver- or stainless steel-plated drums.

When the dope dries, what's left is cellulose acetate film base, which is heat cured for toughness, stripped off the drums and then treated with substratum. The thin sublayer is made of a combination of base and emulsion components so its physical properties will be intermediate between base and emulsion. In this way it keeps the two together.

The base is now ready for the emulsion to be applied. Gelatin is prepared from cooked hides and hoofs. The emulsion is made in large silver kettles where potassium bromide and iodide are added to the gelatin. This mixture is heated and stirred before silver nitrate is added, forming the light-sensitive salts of silver. Additional heating and stirring and cooling and cleaning take place, several times in sequence, and then dyes are added to the emulsion to extend the ability of the film to "see" the full visible spectrum. Without these dyes film would be sensitive to just blue-violet light.

The emulsion is coated on the base; hoppers are used for even spreading—can't have any lumps or foreign particles, and the coating must not vary in thickness. When color film is made, three emulsion coatings are piled up, one on top of another. In addition to sensitive coatings, there are also filter coatings and a protective overcoating to be applied.

Many color films are also base-side coated with a black carbon mixture (called a rem jet coating by Kodak) which serves as protection against abrasion and as an antihalation layer; this backing absorbs light which would have been reflected back to the emulsion causing flaired or halo-like images.

Film is made in batches several miles long, usually about four or five feet wide. The film is slit and perforated and packaged in the super 8 cartridge by automatic machinery. These operations have to be carried out with super and constant accuracy too, or film won't be transported properly through your camera and projector.

Samples of the film are tested during manufacture and changes can be made before an emulsion batch is ruined. Checks are made for thickness of coating, and samples of film are exposed and processed to check on color balance, granularity and so on.

Magnetic recording tape is made in very much the same way. As a matter of fact, a factory making film can convert to making tape in a very short time. Both processes involve accurate coating of thin films on acetate or polyester base. For movie film, the thin film is a light-sensitive emulsion. For tape, it's a magnetizable iron oxide mixture.

Various Films What follows is an overview of the most widely available super 8 materials. It's cursory because projecting a few feet of film is worth ten thousand words, and you may learn more from five feet of your own shooting than anything I have to say. It's very easy to do comparative testing of super 8 films because the super 8 cartridge pops in and out of the camera in a flash, and you can switch from one film to another to run a series of tests. Or you can just plain fool around with film, and learn in a happenstance fashion. One way isn't better than another; it's more a reflection of temperament than anything else.

There is a great variety of materials available to the super 8 worker. In addition to the raps that follow I've included a handy-dandy film guide listing some of the vital statistics of most of the films you can buy (page 25). Such a list is likely to be out-of-date as soon as the ink on this page is dry, so keeping it up to date yourself is the only way it can continue to be useful.

The good thing about the variety of super 8 film stock to choose from is that each film has its own way of looking at the world. Each has its own color rendition, contrast and so on. By matching film

with subject, you can vastly expand the range of possible effects. Most people will probably settle on one or two emulsions to take care of most of their needs. But there are times when you may need something different.

Slow Film Kodachrome 40 is fine-grained with well-saturated but not super-saturated colors; it has moderate contrast, and it is sharp but not as sharp as black and white film of comparable speed like Plus-X. It also has good exposure latitude. Kodachrome has an open, pellucid quality. There is a great deal of professional prejudice against this film. I have heard some of the pros complain about Kodachrome's being too bright or too gaudy. So help me it isn't. It will record the bright day bright, and the overcast day like it is. People tend to forget how magnificently colorful a bright day can be. Kodachrome always remembers. Like all other slow super 8 color films, it is tungsten, or indoor, balanced and most super 8 cameras will automatically key the filter in place for outdoor shooting.

In the Kodachrome class is Fujichrome, found only in the single 8—that is, 8mm—cartridge. The thin polyester base film is warmer and more contrasty than Kodachrome, so you may like it for these reasons. It's also a little grainier. Unlike super 8 film, it is available in two versions, a daylight type at 25 EI and a tungsten at 50 EI. If you shoot with the tungsten material, you can filter it for daylight.

Agfachrome was another 40 EI fine-grain, sharp color film that was offered in this country until 1974, when Honeywell took over distribution of Agfa-Gevaert's consumer products. An entirely new Agfachrome for super 8 has been introduced in Europe, but I haven't seen what this new film can do.

3M offers its 3M Color Movie Film, which like Fujichrome is coated on polyester base. It's the only super 8 film so available. 3M won't put more film in the super 8 cartridge, despite the fact that its thinner base would allow this. The reason they give is a good one—super 8 camera film counters won't work past 50 feet, so the 66 to 75 feet that might be loaded into the cartridge would be a confusion. 3M Color Movie Film started life as Dynachrome, manufactured by the Rochester-based Dynachrome Corporation, which became part of 3M in their never-ending battle to nibble away at Eastman's control of the amateur software market. The film has gone through many changes in two decades. Originally it was a copy of Kodachrome, manufactured with secrets carried off by former Eastman employees. Now it is a totally different material made by Ferrania in Italy. It is not as fine-grained as Kodachrome, and it's relatively contrasty. Dynachrome has good skin tones, bluish shadows, and it will turn some kinds of deep bluejeans blazing blue.

Ektachrome 40 sees colors very much like its companion material, Ektachrome 160 (below). It is also in the same sharpness and grain league as Kodachrome, with the choice between them lying in the different ways they reproduce color and the fact that E/40 makes better prints. In some ways it is more delicate than Kodachrome 40, with skin tones tending toward the pleasantly peachy. This beautiful material tends to be overlooked, even though it has been greatly improved since its 1972 debut.

Then we have a curious film, GAF Color Movie Film, a first-rate performer in every way except granularity. It has the graininess of a fast film, but sharpness nearly the equal of Kodachrome. It is moderately contrasty, with very good colors. The very pleasing skin colors seem to be accurate but somewhat subdued. This is a very nice film, and GAF would do well to improve its granularity. Until they do, this graininess may well be your reason for choosing it. If you recall my discussion of granularity on page 14, you'll see that I am a grain fan. If you love photography, you have to love grain.

The only generally available slow black and white film is Eastman's Plus-X with an EI of 50. You'll find it at larger photographic retailers. It is a superb material. It is one of the finest-grained super-sharp films in the world, and it has a beautiful scale of tonality, or what's usually termed good gradation. It has strong, strong blacks and good middle tones.

Plus-X exposure advice: leave the filter out! If your camera has a filter control on the body, put in the tungsten, or electric light bulb symbol, position. If your camera keys for the filter with a slot in the top for a movie light, use the key your camera came with and swing the filter out of the way. Lost your little key, as we all do? Well, use some masking tape to cover the cartridge film type notch.

Most super 8 cameras, with their built-in meters keyed by the cartridge, will expose this 50 EI film at 40 EI. You'll probably never see the difference. If you use a Beaulieu cartridge-loading or Canon DS 8 or Pathé DS 8 spool-loading camera, you can set the speed as you like it, with the EI selector on the camera body.

I wish that Eastman would omit the filter notch for Plus-X cartridges. Right now they are keyed just like Kodachrome, I suppose in the spirit of consistency. This is a misguided effort since the type A filter is never needed.

Fast Film　These are the color and black and white 160-100 EI rated materials generally available through many consumer outlets.

Most widely used is Ektachrome 160, which was introduced in 1972 as part of the XL system. It is a fast tungsten-balanced film which Eastman says is a type A material.

There is also similar Ektachrome 7242 which is actually rated at

125-80 EI. In terms of sharpness and granularity and contrast, Ektachrome 160 and Ektachrome 7242 are very similar. They are decidedly grainier, quite a bit less sharp, and I think a little more contrasty than Kodachrome 40. Despite the fact that Ektachrome 7242 is rated at 125-80 EI, it is notched for the 160-100 EI rating, and I think you will find it does very well exposed this way. Although it should be exposed through the slightly more deeply colored, or warmer, 85B, it looks good in daylight with the usual 85 filter.

TV news has used 7242 film for many years. It has undergone steady improvement so that it has become a better film. (The recently introduced 16mm 7240 is even better and will probably replace 7242). Why then introduce a new film—Ektachrome 160? Two reasons: Ektachrome 160 processes differently from 7242, and it is sensitized differently (page 18).

What is different about Ektachrome 160? It has had its red sensitivity fudged. Although this film is far from being an accurate color reporter, as Kodachrome is for example, in many situations it can produce more pleasing colors. This is especially true when shooting under fluorescent illumination. 7242 and just about every other indoor film looks lousy under most fluorescent tubes, but Ektachrome 160 (and E/40 as well) produces acceptable color. No greenish or yellowish or bluish overall tint.

These new Ektachromes also shine in situations of mixed illumination. Say you've got daylight through the windows and fluorescent overhead; shot with E/40 or E/160; it usually looks just fine. For best results under fluorescent lights, use the daylight filter in place.

The Ektachrome 160 and 40 processing differs from the ME-4 process used for Ektachrome 7242. It is a far simpler process, making it easier for the bungling photofinisher to do good work with your film. Photofinishers are mostly in the snapshot business, and they may run their Ektachrome machine only part of the time. The ME-4 process is suited to professional labs that handle 7242 and other similar Ektachromes all day long.

There's no problem matching footage shot in dim light with Ektachrome 160 and film shot under bright daylight with Ektachrome 40, since they both use the same dyes. Since its introduction in 1972, E/160 has greatly improved in terms of finer grain and more pleasing colors. E/40 and E/160 are a good filmmaking combination.

Most of my experience is with 160, and under some conditions it can take on a muddy look, especially when there are large solid masses or shadowy areas, or dark walls. Just a little underexposure (darkening) will tend to make this film look grainier, muddier and generally less sharp. The film has less exposure latitude than Kodachrome. Watch out for bright indoor walls. These will fool the meter into stopping the lens down too much, causing underexposure of skin and other important tones.

23

Now we come to Eastman's 1974 innovation, Ektachrome G. It is similar to Ektachrome 160 in overall quality, and it uses the same process. It's the world's first G type film. It was designed specifically for dumbbells who cannot remember to set the camera filter selector, or it is especially useful under fluorescent lights. Eastman found that failures were experienced by people unable to select the appropriate filter setting, or just plain forgetful about setting it. Type A color film shot outdoors without the filter looks very bluish. (Actually, Ektachrome 160, with its altered red sensitivity doesn't look half as bad as unfiltered Kodachrome 40 shot in daylight.)

So Eastman went a step further with their Ektachrome G film and altered the blue of the film's sensitivity so that it could give acceptable results under daylight without a filter, or fluorescent without a filter, or tungsten without a filter. Eastman markets an XL camera, the XL320 which is the only super 8 cartridge camera not to have a built-in filter. It is intended for use solely with Ektachrome G.

At first I didn't think too much of Ektachrome G. Unfiltered results outdoors are usually too bluish for my taste. G looks much better outdoors shot through the usual 85 filter, although it's rather warm if you do this. Under tungsten the film can be too warm, with annoying skin tones, while Ektachrome 160 often produces a yellowish skin cast under such conditions. I was told by my man at Kodak to expect great things with this film under fluorescence, so I compared it with Ektachrome 160 and found that some of the time it looked better and some of the time it looked worse. It all depends upon the kind of fluorescent lights. There are a dozen or more varieties, with different colors in general use. Curiously, it often looked quite a bit less grainy than E/160.

The film gave its best results under mixtures of daylight and artificial light. Then it was outstanding. The more I used it, the better I liked it. It usually did give good results with fluorescents, and you can make the best of its 160 speed, since it doesn't ever have to be filtered. This is perfect for the many super 8 production cameras that make inefficient use of light.

The only generally available fast (I didn't say very fast—that comes later) black and white film is Tri-X Reversal, another Eastman effort. It is rated at 200 EI, and you should always use it with the filter out, unless you find that it is impossible to shoot outdoors with this fast film and you need to hold back some of the light entering the camera. In which case the 85 filter will serve nicely as a neutral density filter (page 104). Although it is a drop faster than the 160 EI your camera will be keyed for, I doubt that this will make a noticeable difference in exposure.

Tri-X is a sensationally good film, a beautiful material. It is extremely sharp with moderate granularity. It is more contrasty than Plus-X, but it still has a good scale of tonality.

CARTRIDGE FILM

SLOW FILM	EI	TYPE	50 FEET SOUND	50 FEET SILENT	200 FEET SOUND	200 FEET SILENT
Fujichrome R25	25	D		X		
Durachrome (Eso-S)	40/25	A		X		
Ektachrome 40	40/25	A'		X		
Focalfilm (K-mart)	40/25	A		X		
Fotomat	40/25	A		X		
GAF Color	40/25	A		X		
Kodachrome 40	40/25	A	X	X		
Sears Color	40/25	A		X		
Technicolor	40/25	A		X		
3M Color	40/25	A		X		
Ward's Color	40/25	A		X		
Fujichrome RT50	50/32	A		X		
Deluxe Sepia (Eso-S)	40/25	B&W		X		
Plus-X	50/40	B&W		X		
Superior 3M CR-64	64/50	B&W		X		

FAST FILM	EI	TYPE	50 FEET SOUND	50 FEET SILENT	200 FEET SOUND	200 FEET SILENT
Anscochrome T-100 (Superior)	100/64	B		X		
Pioneer Color (Eso-S)	100/64	B		X		
Ektachrome EF	125/80	B	X	X	X	X
Ektachrome 160	160/100	A'	X	X		
Ektachrome SM	160/100	B	X	X	X	X
Ektachrome G	160	G		X		
Hi-speed Color (Eso-S)	160/100	B		X		
Superior 3-M CR-160	160/125	B&W		X		
Hi-speed Sepia (Eso-S)	200	B&W		X		
Tri-X	200/160	B&W		X		
Miracle Hi-speed (Eso-S)	250/200	B&W		X		
Superior 3M CR-250	250	B&W		X		

VERY FAST FILM	EI	TYPE	50 FEET SOUND	50 FEET SILENT	200 FEET SOUND	200 FEET SILENT
4-X	400/320	B&W		X		
GAF 500	500	B&W		X		
Superspeed (Western Cine)	500	B&W		X		
Supreme X 4-S (Eso-S)	800	B&W		X		

NOTE: This chart does not pretend to be complete. Addresses of suppliers on page 290. Types A, A' B and G are color materials.

FORMAT

Very Fast Film There are but two very fast films available through the usual photographic retail outlets, and they are both black and white materials: Eastman 4-X Reversal and GAF 500 Black and White Movie Film. The Eastman film is rated at 400 EI, and the GAF film at 500.

The overall look of 4-X is well-matched to Tri-X, and it has the same good scale of tonality and appears as sharp and as contrasty. It is grainier, but it isn't at all unpleasant. GAF 500 is grainer than 4-X, but it is plenty sharp and has a good tonal scale too. It can be successfully intercut with the Eastman family of black and white films.

I had an interesting, enlightening experience with GAF 500. I was shooting near the farm of some friends who lived surrounded by the rain forest on the west coast of Vancouver Island. The only way I could shoot in the forest, even at high noon, was with very fast film, so despite the fact that I was filming in color, I switched to GAF 500. At home, when I screened this black and white forest footage intercut with the color stuff, many people didn't perceive the change. They thought that the black and white film's rendition of the dark forest was appropriately colored. It looked just like a dark forest to them. I knew it was black and white film, so I wasn't "fooled," but I think the swirling grain had as much to do with it as anything else.

The Author Dreams Company literature says that it's the Kodachrome dyes that are not well-matched with print stock for duplicating purposes. This is probably more to the point than the usual explanation that it's the Kodachrome contrast that makes good prints difficult. Kodachrome isn't all that contrasty any more. Long ago it was a contrasty material.

Eastman offers an Ektachrome material, Ektachrome Commercial, usually called ECO, or by its code number 7252 for the 16mm worker. It is not available in super 8 cartridges, but it is offered in 100-foot double super 8 loads.

This film produces very pleasing 16mm prints, but I suspect that for the super 8 worker it would leave a great deal to be desired. For one thing this type A film is slow 25 EI tungsten and 16 EI daylight. For another, I think it is too grainy for super 8, even though some people will probably not agree with me. I'd rather see Eastman figure out a way to make fine prints from Kodachrome 40 than for the super 8 filmmaker to have to use the present ECO.

What I ought to clarify now about the foregoing comments is that the quality of various camera films means exclusively how they look upon projection. Prints shift color and increase contrast and so will look different from camera original film. Even though the information about printmaking starts on page 231, for now let me emphasize that I think going the 16mm route—a special camera film for

prints—would be a misplaced effort. There are so many interesting super 8 camera films at present, I would regret not being able to make good prints from any and all of them.

I think we'd be better off with print stock improved to complement our already first-rate projection-quality camera film. My capsule recommendations for those of you who will be making prints is to shoot on Ektachrome (40, 160, G, EF or SM) and print on Gevachrome 9.02. The soon-to-be-introduced Gevachrome 9.03 might even make better prints.

Cartridges Super 8 film is packaged in a number of ways. Most people most of the time buy it in the familiar 50-foot super 8 silent cartridge. There is also a 200-foot silent cartridge, based on the 50-foot design, but at the moment, no camera is made especially for it. However, it can be used in cameras accepting a 200-foot sound cartridge.

There are 50- and 200-foot sound cartridges. Silent cartridges may be used in sound cameras, and 50-foot cartridges may be used in cameras accepting 200-foot cartridges. Sound cartridges will not fit into silent cameras, and neither will 200-foot cartridges fit in 50-foot cameras. Clear?

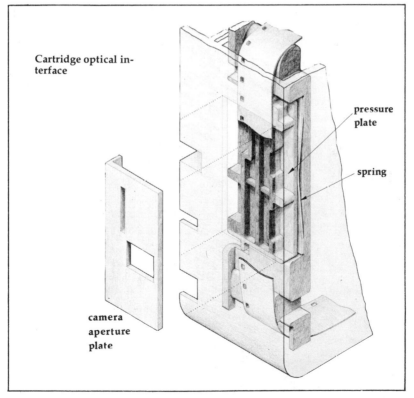

Cartridge optical interface

pressure plate

spring

camera aperture plate

I'll return to the sound and 200-foot cartridges in the sound section (page 115). For now, I'm going to discuss the basic super 8 cartridge, the 50-foot silent device. Every super 8 camera accepts it. Well, almost every. There are super 8 cameras that use spool-loaded double super 8 film.

Then we have the Fuji single 8 cartridge. Fuji cartridges cannot be used in super 8 cartridge cameras, and vice versa. However, since Fuji film has the same design as the super 8 format (technically film in both cartridges is 8mm format type S), film shot in Fuji cameras in the single 8 cartridge may be projected in super 8 projectors. Similarly, super 8 films may be projected on Fuji single 8 projectors.

The silent 50-foot super 8 cartridge—the prototype of all other super 8 cartridges (sound and 200-foot versions)—is one of the neatest precision designs I've seen for a mass-produced consumer item. The cartridge is factory-loaded with film; and this is removed at the processing station usually by cutting or chopping open the container. You never have to touch film when loading or unloading super 8. (And you shouldn't, or you can cause the film to jam in the camera.) The cartridge positions in the camera in a moment or two, and removes as easily.

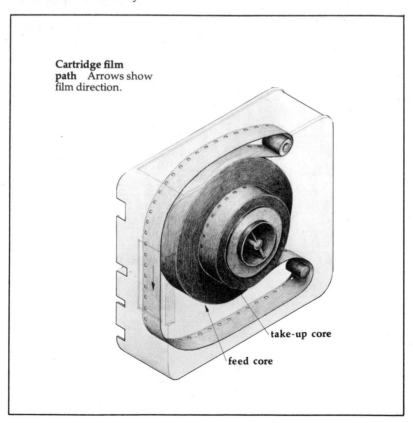

Cartridge film path Arrows show film direction.

take-up core

feed core

The black plastic cartridge—2¾ by 3 by almost 1 inch—contains two side-by-side compartments: a feed and a take-up chamber. The film is wound on a plastic core in the feed chamber; as it travels from feed to take-up core, the film forms a curved path to the optical interface where it is exposed. Then it passes into the adjacent take-up chamber where it winds onto another plastic core. Because both side-by-side cores center on the same axis, the device is sometimes called a coaxial cartridge.

You can see the film through an opening about 1⅛ inch long in the front of the cartridge. Directly behind the film is a contraption called a pressure pad, or pressure plate. This is positioned within the camera by three facing projections which are part of the camera's aperture plate, or pad. The word aperture means hole, and the aperture pad provides the hole that delineates the frame's rectangle. The aperture and pressure pad make up what's called the gate area of the camera.

Each frame must be exposed at the same distance from the lens, and it is the job of the pressure pad to position each successive frame properly. The plastic pressure pad is spring-loaded, or tensioned (the spring is the only metal cartridge part), to push against

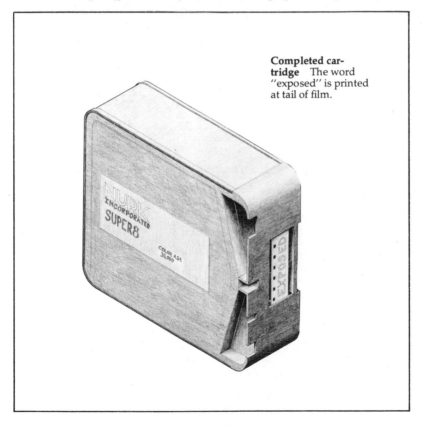

Completed cartridge The word "exposed" is printed at tail of film.

the film; but how much it pushes is determined by the aperture pad's three projections. Remember, it takes three points to determine a plane. This design ensures greater precision than you have a right to expect from an injection-molded plastic device.

The last internal part of the silent cartridge to be considered is a thin plastic ratchet attached to the feed core. Its stepped wedges prevent film from unraveling so that enough back tension is maintained at the pressure pad. This antiback-up device, and the fact that the feed core has no external spindle to turn it, guarantees that film in the super 8 cartridge flows in one direction only—from feed to take-up core. This could mean no backwinding and therefore the loss of being able to do fades and dissolves or other tricks in the camera. However, there are quite a few super 8 cameras that get by this difficulty to some extent by being able to stuff about fifty frames, or eight inches, of film back into the feed chamber in order to achieve dissolves or brief double exposures.

The kind of film used within the cartridge is printed on one side of it, so you can read the information through a window in the side of your camera.

The front left edge of the cartridge (pressure pad facing you and film type printed on the left) has a series of notches. The top notch automatically signals the camera about the film's speed, or sensitivity to light. The longer the notch, the deeper the camera's feeler thrusts, and the greater the film speed (see page 16).

Next there's a locating notch. This helps position the cartridge properly within the camera.

The third notch is for the processing station. It aids them in sorting cartridges.

The bottom notch tells the camera whether to employ its built-in type A filter. Most super 8 color movie film is balanced for warm indoor illumination. With the built-in 85, or type A, conversion filter, indoor film can be used outdoors. Super 8 cameras have an accessory key or body control that allows the filter to be swung in or out of the lens' optical path.

If you've taken the trouble to examine a super 8 cartridge while reading this, you'll see that there's a round mechanism on the take-up side of the cartridge, the side opposite the film reminder. Take-up is accomplished by a slotted spindle about 5/8 inch in diameter that connects to the take-up core; as the camera's motor-driven dog rotates, it engages fins within the spindle to turn and wind film on the take-up core.

For those of you interested in reloading your own cartridges, and I wouldn't advise it, the photofinishing division of Eastman can provide ten cartridges for $10 as catalogue number 147-9641. Out of the box, they are not suited for camera use and must be modified by

adding the supply side roller bearing and a take-up core. Both can be obtained from used cartridges. You will also have to notch the cartridge for proper speed.

The cartridges are difficult to load, and although the sides snap-lock together, tape has to be used to ensure an effective light seal. The notched side also has a 3/16 inch hole which must be taped shut.

The Russians have shown a reloadable super 8 cartridge, featuring a metal pressure pad which some people think is dimensionally more stable than the plastic kind. As far as I know, these are not yet being imported here.

Super 8 on Rolls Super 8 is also available in two roll varieties: a 200-foot sound-striped form eight millimeters wide, spooled on a roll which must be darkroom loaded; and a 100-foot form, which can be loaded in moderate illumination, similar to double 8mm, that's slit after processing. The 200-foot loads are meant for Wilcam sound-on-film cameras used by TV stations for news gathering; there are about fifty of these cameras in the world, and only the fast newsfilm standard Ektachrome 7242 is available.

AVAILABLE DOUBLE SUPER 8

film		100 feet on spool	200 feet on spool	400 feet on core	1200 feet on core
			special order		
Kodachrome 25	color	X			
Kodachrome 40	color	X			
ECO 7252	color	X	X	X	
Ektachrome EFB 7242	color	X	X	X	
Plus-X 7276	B&W	X	X	X	X
Tri-X 7278	B&W	X	X	X	X
4-X 7277	B&W	X	X	X	X

NOTE: Double super 8 is also available from Eso-S and Superior (see address section).

More relevant to readers of this book is the 100-foot double super 8 form, usually not sound striped, sixteen millimeters wide, giving two hundred feet of eight millimeter wide film after processing and slitting. Like standard or double 8mm, this film is run through the camera twice to expose both halves. Eastman makes a wide variety of films for this variation of the super 8 format, including Ektachrome Commercial, a favorite of the 16mm filmmaker seeking hi-fidelity prints.

There are only two cameras presently in production that can take advantage of the double super 8 format: the Canon DS 8, and the Pathé DS 8, both expensive cameras with electric motors, reflex finders, backwinding facility and so on. It will be interesting to see how they fare competing against the 200-foot cartridge cameras. As it now stands, double super 8 is the least expensive way you can purchase super 8 film stock, at least as far as list prices go.

Fuji Single 8 Cartridge The term single 8 is used for the Fuji movie system, based on their film cartridge. Before I describe the cartridge in any detail, let me make this clear: film within the Fuji cartridge is super 8 format. It can be shown on any super 8 projector. I stress this because there is a terrible lack of information about this point even in camera shops.

The single 8 cartridge is 4 by 2½ by ½ inch thick. Its shape is different from the squat coaxial Eastman cartridge. The Fuji device is thin and flat. The supply core is immediately above the take-up core, and the film runs through the cartridge in a straightforward top-to-bottom fashion. This design allows unlimited backwinding for double exposures and dissolves of any length.

While the difference between the layout of the Fuji and Eastman supply and take-up reels is the most striking design difference— and determines the overall shape of cameras using the devices— there is another important variation. The Eastman pressure pad is an integral cartridge part, while the Fuji pressure pad is part of the camera body.

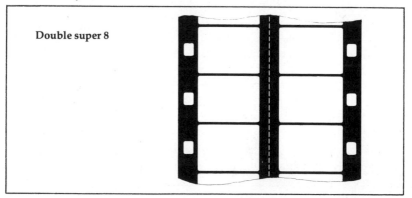

Double super 8

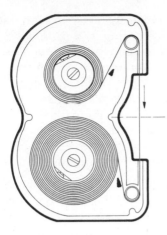

Fuji single 8 cartridge Arrows indicate film direction. (Fuji Photo Film)

In the Eastman cartridge, the film is entirely enclosed at the gate area, or optical interface. The single 8 device, however, must have an opening behind the film in the gate area so that the camera pressure pad may be inserted into place. When the loading door of the single 8 camera is closed, the pressure pad is brought fully into position.

Fuji film is about 25 percent thinner than the standard acetate base film usually found in super 8 cartridges (except for 3M Color Movie Film which also employs polyester). In order to package fifty feet of film in their relatively small chamber, Fuji uses this thinner but stronger polyester base film. One minor drawback of this material is that it cannot be cement spliced, although very fine tape splices can be made with this or any other film. And Fuji supplies one of the best, least expensive tape splicers (see page 189).

About 1¾ inch of film is outside of the Fuji cartridge proper, so it's somewhat less protected than the Eastman design; but rarely does anything go wrong. However, the cartridge can be misloaded, as Fuji shows in their instruction books, by placing the film behind, instead of in front of, the pressure pad. I've succeeded in misloading the Fuji cartridge, but I've also successfully misloaded a Kodak cartridge. The Fuji apparatus was easily unloaded for proper reloading, but I had to pry the wedged-in Eastman cartridge out of the camera with a knife. Admittedly both were fluke accidents.

Like the Eastman super 8 cartridges, the type of film is printed on the Fuji cartridge so it can be read through a window on the camera body; but unlike the Eastman cartridge, you can see a white dot turning through the window on the feed hub, making certain that film is being advanced (you don't know for sure, though, if it's being taken up). The Fuji cartridge is keyed for film speed, but not for type (daylight or tungsten), and Fuji cameras require an external conversion filter.

Fuji offers a sound cartridge system, but only in Japan at this time; it is based on optical sound recording, not compatible with magnetic sound which is standard in the world of home movies. Moreover, manual threading over a complex path is needed after drawing a sufficient length of film from the cartridge. The future of the Fuji system may depend on whether they introduce a mag stripe single system sound camera.

Fuji is the only manufacturer offering cameras and film for their system, so no matter how good their products—and they are good—your choice is necessarily limited compared with super 8.

Packaging As I am about to head out for a day of shooting, I unpack my super 8 cartridges from their cardboard boxes and throw away the boxes and enclosed instruction sheets. The cardboard boxes supplied by Eastman and others take up more room in my gadget bag than the film cartridge packed in its vapor-seal envelope. This eliminates valuable seconds at the time of shooting, tearing open these cursed cartons and trying to dispose of them and the instruction sheet in the field.

The instruction sheet? Who looks at it? A first time user may have questions, but remember, the cartridge keys for film type and speed, and loading is goof-proof.

The vapor-seal, or humidity-seal, or air-tight envelope that encloses the film, is made up of a layer of metal foil and a layer of polyethylene material. They're a tough and effective barrier against the environment. They keep the contents at a stable humidity, necessary for preservation of film properties. Moreover, super 8 film in the cartridge is self-packaging. So why do we have to have a cardboard box? Functionally, it is entirely useless. It must be a marketing ploy, but so help me I don't believe that customers give a hoot.

I don't want you to think this is entirely an Eastman problem. Everybody who makes super 8 film packages it the same way, in a cardboard box, with an instruction sheet and a vapor seal envelope.

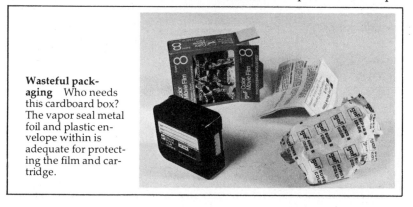

Wasteful packaging Who needs this cardboard box? The vapor seal metal foil and plastic envelope within is adequate for protecting the film and cartridge.

I figure that the industry rapes at least a score of forest acres a year, and probably much more, to supply pulp for these useless cardboard boxes and instruction sheets.

What I propose is this: get rid of the dumb cardboard box and print the instructions on the inside or outside of the vapor-seal envelope. (For now at least, please print the name of the film on the humidity-proof envelope!) And since you'd be cutting costs, photographic industry, you could also lower the list price of the film.

Roll on, Kodak Kodak's key to their super 8 dominance is Kodachrome, that product invented in the bathtub of musicians Mannes and Godowsky, and perfected these past forty years in the labs at Kodak Park. Kodachrome is one of those super products, like DC 3 airplanes or Rolls Royce automobiles, that have no peer.

Kodak has lots of competition, but most of it isn't in terms of quality, only price. I'm talking specifically about super 8 movie film; other branches of photography have their own trips. Any super 8 film you pick up of the same speed as Kodachrome is likely to be grainier than Kodachrome. In terms of traditional standards, of what constitutes a good quality image, Kodachrome is almost without competition.

As far as speed is concerned, all you'll be able to find marketed in most retail outlets are Ektachrome 160 or Ektachrome G. You can buy them at the corner drugstore or at the photographic department store downtown. Here in terms of supply, Kodak is without rival.

"You push the button, we do the rest." George Eastman had a word for it: Kodak. Who knows where it came from? It sounds like the Alaskan bear, but now it means photography to just about everybody.

What is it that makes Eastman Kodak Company such hot stuff? After all, look who they're up against: Agfa-Gevaert, the enormous German-Belgium combine; and Ilford-Ciba, a pooling of British and

Kodak Park, Rochester N.Y., U.S.A.

Swiss know-how; and 3M-Ferrania adding together Minnesota Mining and Manufacturing with the Italian manufacturer; or General Analine and Film, formerly Ansco by way of Agfa; or the Japanese giant, Fuji Photo Film.

All of these concerns can, I believe, make film as good as Eastman. Agfa-Gevaert and Fuji are capable of this, and the others could if they tried, I am sure. Maybe the key to it is: why try? Eastman already has the market. They've got every drugstore in this country; they spend millions celebrating the virtues of their film on national television; they rent cinemascope-shaped billboards hither and yon; they have the cleanest-cut, best-trained representatives ready to help amateur and professional alike; even Paul Simon sings about beautiful Kodachrome.

Before the turn of the century, George Eastman pioneered the total systems approach to photography with his early Kodak snapshot cameras. Customers bought a camera loaded with film and after shooting sent the whole shebang off to Rochester. They got back their snapshots and a camera loaded with fresh film.

Eastman, the creator of film base, was one of the great inventor-businessmen of the middle industrial revolution. His inventive skill was surpassed by Edison, but his business genius was second to none. He was a businessman in the same league with Henry Ford.

Eastman built the world's greatest photographic empire through acquisition as well as invention. He purchased manufacturing capability as well as technology. Before the turn of the century, key purchases were the Wratten and Wainwright filter works, and the Hawkeye Camera factory, a pattern which has kept up to the present day with the acquisition of the Spin Physics company for their advanced tape recorder head technology. Very helpful when you are about to launch the Ektasound system.

And the company he founded did not forget Eastman's lesson. The total systems approach to photography is still the only viable method of marketing. To do it you have to have the muscle to introduce cameras, film supply and processing for tens of millions of customers, all in one stroke. One portion can't go waiting while another is available.

If you introduce super 8 cameras, you have to have super 8 film in super 8 cartridges and you have to make available super 8 processing and super 8 projectors. With the recent major exception of Fuji, and single 8, which is largely compatible with super 8, the other photographic giants don't try to introduce movie systems anymore. They just wait on Kodak, and fill in the gaps.

Kodak grosses more than a billion dollars annually, and 80 percent of their business is in photography. The rest is in related Eastman chemicals, and Kodel fabrics, spinoffs of organic chemical

George Eastman, 1884 The original carries the writing, "Made on paper with a soluble substratum developed after transferring Feb 18/84" (Eastman Kodak)

research done in the name of photography. It's a tight company, and it knows what it's about, unlike other modern corporations so diversified that they resemble holding companies more than anything else. Kodak is into photography as its number one thing.

Kodak does not feel like other companies I know about or have dealt with. Nearly all of the people at Kodak with whom I have had any dealings love photography. How can you stop a company of photography nuts? Does American Gypsum have employees who love wallboard?

The Price You Pay Eastman Kodak charges more for their super 8 film than anybody else, at least according to list prices. Eastman film is also the only generally available product sold without processing included. That's a result of the twenty-year-old agreement between the bright yellow box and Uncle Sam. The Justice Department acted to spread around the processing of Kodachrome to the rest of the photofinishing industry.

So what do you pay for a cartridge of silent Kodachrome? At this moment list is $3.40. I have been able to buy fresh Kodachrome cartridges for as little as $2.44 (on sale) at Long's Drugs in El Cerrito, California. I have had to pay as much as $3.60 a cartridge at Hoss's Corner in Long Lake, New York. (Eastman list for processing is $3.15, but you can find this service discounted at 10 to 20 percent.)

But Kodak still lists prices higher than anybody else's for film and processing. You might say, why not? Nobody makes better camera film. You might also say that other manufacturers are clearly attempting to compete in terms of price, and not quality. All well and good, but we're still paying too much for Kodachrome and Ektachrome super 8 film, too much in terms of the internal logic of the Eastman pricing structure.

Let's concentrate on just the price of film now (we'll talk about processing costs on page 169). Compare the price of Kodachrome 40 available in the cartridge with Kodachrome 40 available as double 8mm on spools. A 50-foot super 8 cartridge costs 8 or 9 percent more than a 25-foot roll of double 8mm. Remember, double 8mm is slit after processing and spliced together to make one 50-foot roll. Now you might say to me: 9 percent more isn't so much more to pay when you consider that you are enjoying the virtue of rapid-loading cartridges. Unlike double 8mm, super 8 offers foolproof loading, and you won't get any more fogged or light-struck film in the process.

An interesting point this, and it leads us to the nub of my disagreement with Kodak's list prices. A 25-foot double 8mm spool, to allow for sufficient head and tail leader to prevent fogging of film, is actually 33 feet in length. That works out to 66 running feet of 8mm film when you buy a roll of double 8mm. But super 8 needs very little leader, just enough to anchor the film to the feed and take-up cores, maybe four or five feet. That means that you are buying a dozen feet less of film in a super 8 cartridge. Shouldn't we be paying less for super 8?

Now the people at Eastman might say that either way we're actually buying 50 feet of usable 8mm film; leader notwithstanding, it's the usable length of film that records image. They would probably also say that it cost a lot of bucks to research and develop that super 8 cartridge, and that it costs more to package film in the cartridge than on spools.

I quarrel with all of this. If we are buying 15 percent less film, we should pay 15 percent less. Although it may have cost a small fortune to R and D the super 8 cartridge, Eastman's motive was to sell more film, and that's exactly what cartridge loading encourages. It's hard to believe that the millions of super 8 cartridges sold by Eastman—and by others using the cartridge who must pay Eastman a royalty—have not already more than offset any R and D costs. And I dispute the claim that the cartridge package costs more than the spool and metal can package. Why should it? The packaging operation is entirely automated.

And it costs 10 percent more to shoot super 8 than standard 8mm, because the super 8 frame is 10 percent taller than the standard 8mm frame. So it works out that it costs about 20 percent more to shoot super 8 than standard 8mm. Were Eastman to charge the same price for both, super 8 would only cost 10 percent more, which means that Eastman would still be selling us 10 percent more film for the same running time.

In addition, I want to know why Ektachrome 160 costs 24 percent more than Kodachrome 40. I suppose the reasoning is you pay more

for speed. It's like automobile horsepower. Maybe I am just beating my head against a wall when I try to figure out reasons for any of this, beyond that they charge what they think they can get. Yet, I consider myself a logical man, at least part of the time. I want to know why it makes any more sense to pay a premium for sensitivity to light than it does to pay a premium for fine grain, sharpness or beautiful color? The Kodachrome image, in plain English, looks better than the fast Ektachrome image. So why pay more for Ektachrome? Why not pay the same lower price for both?

There's more. We haven't discussed sound shooting yet, but let me say this for now: the company cost for prestriped super 8 stock, which is what we buy in the Ektasound cartridges, is 3/10 of a cent per foot, based on catalogue prices for Eastmancolor release print material. Why then is Eastman charging 3.8 cents per foot more for striped Ektasound film? I think somebody in Rochester may have shafted us by shifting the decimal point. The increase in cost of an Ektasound cartridge based on a pricing policy that would be consistent with corporate policy, as I see it, would be less than $.20 more per cartridge, not the horrendous $1.90.

Super 8 has turned filmmaking into a medium which is not unlike writing. Everybody is doing it. Filmmaking is fast becoming a viable means of personal communication. I put it to you that it is a fundamental right of human beings to be able to communicate freely with each other. That doesn't mean that Eastman should give away film, although that's not such a terrible idea. It does mean that they have some kind of obligation to price their products fairly.

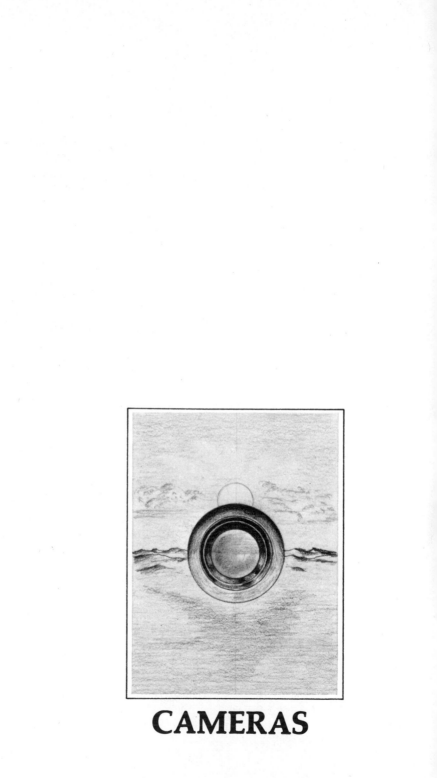

CAMERAS

Harris B. Tuttle
shooting the first in-
dustrial film in 1922
with a Kodak model
A 16mm camera.
(Eastman Kodak)

A movie camera is a machine for exposing a series of still photo-
graphs, at least 18 each second.

Except for the lens' image of the outside world projected on the
film, the inside of the camera is light tight. Super 8 cameras have a
light-tight chamber which accepts the cartridge. The cartridge is
divided into twin chambers, one supplying film, the other taking it
up.

A super 8 camera has an electric motor to drive the film through
the camera, and it may also have another electric motor to work the
power zoom, if the camera has such a feature. Some cameras even
use a third motor to operate the electric-eye system for setting the
lens at the proper exposure.

To power these motors, and other functions as well, super 8
cameras use power cells or batteries. The most commonly used are
penlight AA cells, nominally rated at 1.5 volts. Alkaline cells are
usually called for, but I prefer rechargeable NiCads (page 105).

You can eliminate a lot of frills like power zoom and electric-eye
exposure meters, but a movie camera has to have a lens and film
drive and a light-tight box.

The film-drive motor turns a dog, or pronged finger, which
hooks up to the cartridge take-up hub. In this way the take-up core
is rotated so that film will be wound on it. The drive motor also
operates the shutter and pull-down claw, both part of the intermit-
tent mechanism. Each frame, after it has been pulled, or actually
pushed into position, must be exposed while at rest. The claw,
which looks like a little finger, enters the perforation and pushes the
film one perforation, or the height of one frame. The claw holds the
film at rest while the exposure is made. The exposure is made when
the shutter is out of the optical path. The shutter is a whirling metal
disk which part of the time is interposed between lens and film. If

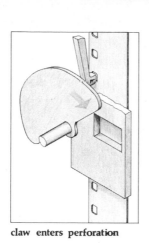

claw enters perforation

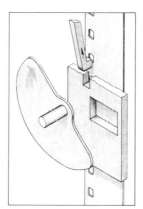

pushes down one frame

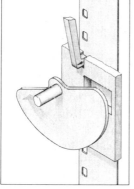

retracts

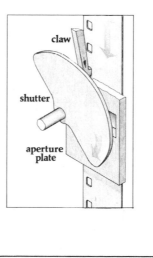

returns

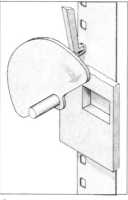

claw enters perforation

claw

shutter

aperture plate

there were no shutter, the exposure would continue while the frame was being pushed into place by the claw, and a blurred or ghost image would be exposed. The purpose of the shutter is to prevent this blurred moving image.

The action of the claw, and the shutter synchronized to the movement of the claw, is called the intermittent cycle. This is the basic mechanical system of every successful movie camera.

In most super 8 cameras, the claw takes half the intermittent cycle to advance the frame, therefore leaving only half the cycle to expose the frame. The shutter whirls at a constant rate, and for the cycle described here, the shutter is exactly half a disk. When the film is in transport, the opaque metal disk prevents exposure; when the film is at rest it gets exposed. When shooting at 18 fps, the standard super 8 running speed, the film will spend 1/36th second in transport, and 1/36th second being exposed. (At 24 fps the exposure would be 1/48th second; at 56, 1/112th second and so on.)

A shutter that exposes the film half the time is called a 180 degree shutter, since that measures half a circle and corresponds to the shutter opening. Many super 8 shutters depart a little from this, so you will find that your camera instruction book may tell you that at 18 fps your exposure is 1/40th or 1/45th of a second, indicating that you have something like a 170 degree shutter. In this case instead of the intermittent cycle being equally divided between pull-down and exposure, more time is spent in pull-down, decreasing exposure time.

To recap the intermittent cycle: the claw entering the super 8 perf pushes the film down the height of one frame. While this is happening, the shutter interrupts the light between lens and film. When the claw brings the frame to rest, the shutter has rotated out of the optical path, and the claw holds the film steady for an exposure. Then the claw withdraws from the perf, as the shutter moves between lens and film. The claw enters a new perf to repeat the cycle again.

Each frame must be registered in the same relative position as the last frame. Assuming that the perforations have been accurately cut, and that the intermittent mechanism can position each perf in the same place, each frame will be perfectly registered. If not, the projected image will jiggle up and down, or it will weave from side to side.

The aperture plate has spring-loaded side guides which press snugly against the edges of the film. These serve to eliminate side weave, while most of the job of vertical registration is accomplished by the claw itself.

If you understand how the intermittent cycle works, and the relationship between the cartridge pressure pad and camera aper-

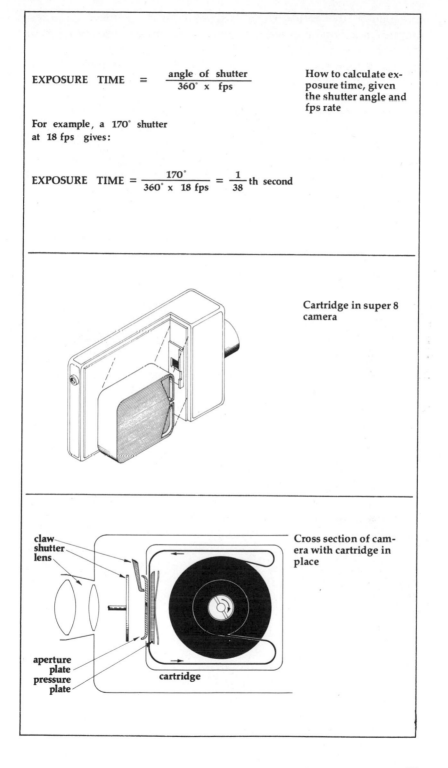

$$\text{EXPOSURE TIME} = \frac{\text{angle of shutter}}{360° \times \text{fps}}$$

How to calculate exposure time, given the shutter angle and fps rate

For example, a 170° shutter at 18 fps gives:

$$\text{EXPOSURE TIME} = \frac{170°}{360° \times 18 \text{ fps}} = \frac{1}{38}\text{th second}$$

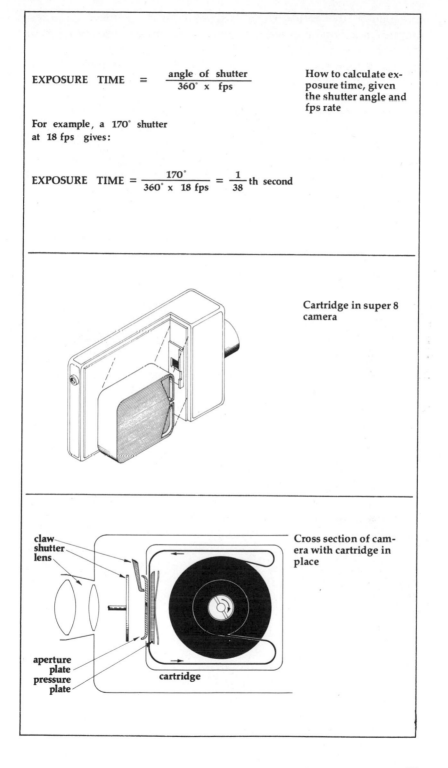

Cartridge in super 8 camera

claw
shutter
lens

Cross section of camera with cartridge in place

aperture
plate
pressure
plate

cartridge

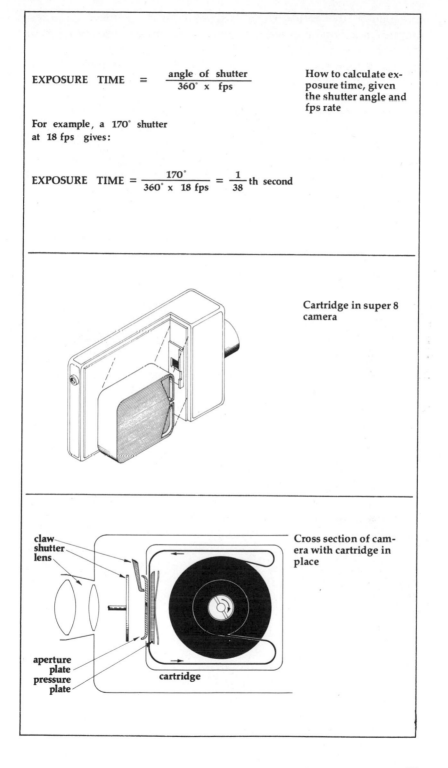

ture pad at the gate (in the past cameras have used a hinged pressure pad which resembled a gate), you understand the heart of the matter. You may want to fresh your memory by reading page 29 where the gate is discussed in the context of the cartridge.

A super 8 camera is a combination of interrelated optical, mechanical, electrical and electronic systems. Optics is used to form the image, and part of that image-forming light is also taken by the viewfinder and exposure systems. The basic mechanical system is the intermittent mechanism, shutter and take-up dog driven by the electric motor. Electronics function in camera control systems, the exposure control and fps control. The number of frames exposed each second is accurately controlled by an electronic governor in many cameras. Mechanical systems were used in the past, primarily inspired by James Watt's steam engine governor. Power must be supplied for the electric and electronic systems. In modern super 8 cameras, one set of batteries does the trick. In the past separate cells had to be used for drive system and exposure control.

Since super 8 production cameras (a versatile camera with reflex viewing and a wide range of creative controls) were introduced in 1965, their differing features, functions and various controls have undergone a kind of parallel evolution. By now the similarities among production cameras are stronger than their differences.

Kinds of Cameras There are a few general types of super 8 cameras you can buy. Before I list them, let me say that in practice one type is often combined with another.

There are simple box-type cameras. Some don't have automatic exposure control. Most don't let you focus the lens but are set up for a compromise distance to get the most in focus.

Then there are the production cameras that offer the widest choice, since there are more models in this category than any other. They offer reflex viewing, a choice of fps rates, zoom lenses and so on. For example the Beaulieu and the Nizo cameras are production super 8 cameras.

Another type of increasingly popular super 8 camera is the compact camera. Some, like the Eumig Mini 5, includes production camera features as well. While a compact camera may not have the versatility of a production camera, its small size encourages you to take it along, increasing opportunities for filming. Usually box cameras also qualify as compact cameras.

The XL camera, with its ability to take pictures in very little light, is one of the hottest selling items in the super 8 marketplace. The XL concept has pervaded other areas of camera design, so we have XL production, XL compact and XL box-type cameras.

While XL cameras can take pictures in low light, most production cameras require bright light, so I sometimes call them BL machines.

Design Trends The short history of super 8 design actually shows a continuing momentum carried over from the days of standard or double 8. By the time super 8 was introduced in 1965, the movement had progressed from spring to electric drive, from interchangeable lenses—often in the form of turret-mounted optics—to zoom lenses and from lightmeters more or less attached to the camera body to automatic through-the-lens meters controlling the lens opening. For many years also, through-the-lens viewfinders had been replacing direct finders, and I've almost forgotten the time, ten or more years ago, when people could actually hold onto their camera's body, instead of a pistol grip.

When super 8 cameras appeared, zoom lenses started at about 9 to 11 millimeters. Today zoom lenses starting in the 6 to 9 millimeter range are the norm. Clearly there is a trend to shorter focal lengths, as well as high speed optics in conjunction with the XL system. The illumination you use for eating and working and reading and talking has now become adequate for filmmaking. XL moviemaking is a powerful advance, more useful than power zoom or high powered zoom lenses, or the automatic dissolve. And there's no reason why we can't be offered highly creative production cameras that are also XL.

Sankyo, Nizo and Bauer think this is the case, and others are likely to join in, especially if they're interested in selling more cameras. Whatever the case, there's little doubt that the automatic dissolve feature or super long focal lengths are useless if there isn't enough light to shoot.

I have decided that the best way to go about this subject is to present to you a typical super 8 camera of my own invention, the Typica. After a look at the Typica, specific cameras.

Typica This is not an instruction book. There's an instruction book that comes with your camera. Read it several times. Read it while practicing working your camera. Read it no matter how badly written it is: most instruction books are really stinko. They are second-rate translations of second-rate writing from the German or Japanese. But amidst the archaic whilsts, and sprinklings of foreign phrases, you may be able to glean a word or two that can help.

Like just about every other super 8 camera, the Typica's controls are on the left side of the body, lens facing away from you. For the majority of us who are right-handed, this makes the camera easy to hold and operate. A simple half twist of your right wrist towards your body allows you to use the controls simply and easily. Most people who are right-handed are also right-eyed. The Typica is also right-eyed. You can use the Typica with your left eye, but the rear of the camera will push into your nose.

However, things aren't that bleak if you are left-eyed and left-

handed. It just isn't that difficult to adapt to right-handed, right-eyed designs. This I know to be a fact, since I am right-handed and right-eyed, and for years I have used left-handed, left-eyed standard 8mm and 16mm cameras.

Try to master the valuable skill of leaving both eyes open, as some people do at a microscope, while you shoot; this will enable you to view the controls with your left eye while using the right for the finder. You'd also see enough of the control side of the camera to operate many of the functions without having to take the camera from your eye. Further advantages: you'll be able to spot objects about to enter your lens' field of view and, possibly, keep yourself out of harm's way.

The Typica has a fairly broad fps rate, from 9 to 54 fps, in these increments: 9, 18 (super 8 normal), 24 and 54 for slow motion.

The Typica has an on-off switch, and it's a good idea to leave it off, except when shooting, since the power cells will continue supplying juice to the automatic diaphragm.

The Typica marketing and design people decided to offer many versions of the camera based on a single basic body. That's the same approach used by American car manufacturers, for example. Lenses and features go and come, but the body abides. They like to make changes from time to time, and a new model number will also have a new and higher price tag. It's a way that the Typica manufacturer has of keeping pace with (actually, helping to create) inflation. The new Typica may have a do-dad here and there the old model lacked, but it may not be a better machine.

Some models of the Typica offer a built-in intervalometer for time-motion work, usually directed toward industrial uses or time-lapse work. You've seen shots like the unfolding of a blooming flower or the passage of a day in a few seconds of screen time. The Typica's intervalometer control allows for the running of a few frames a second down to a frame a minute. This is a money-saving feature, since an intervalometer can cost a thousand dollars.

Time-lapse flower blooming

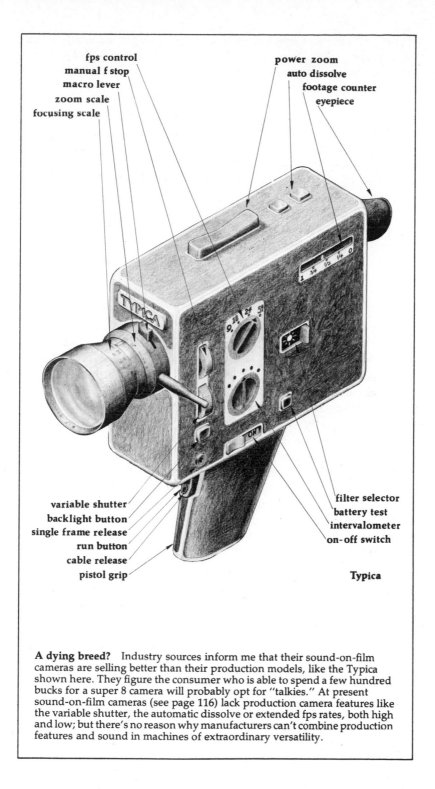

fps control
manual f stop
macro lever
zoom scale
focusing scale

power zoom
auto dissolve
footage counter
eyepiece

TYPICA

variable shutter
backlight button
single frame release
run button
cable release
pistol grip

filter selector
battery test
intervalometer
on-off switch

Typica

A dying breed? Industry sources inform me that their sound-on-film cameras are selling better than their production models, like the Typica shown here. They figure the consumer who is able to spend a few hundred bucks for a super 8 camera will probably opt for "talkies." At present sound-on-film cameras (see page 116) lack production camera features like the variable shutter, the automatic dissolve or extended fps rates, both high and low; but there's no reason why manufacturers can't combine production features and sound in machines of extraordinary versatility.

The Typica also allows you to do animation through a single frame control, actually a cable release socket in the side of the body. A cable release is a sheathed wire, one end an operating plunger, the other screwed into the camera body. Some use an air bulb for longer cable lengths as well as foot operation, an added convenience for animation. For continuous run, the cable release will also fit into the Typica's run button, located beneath the lens on the front of the body. You don't have to touch the camera to run it if you're after smooth shooting when it's tripod mounted. Just screw the cable release into the appropriate input, and press the plunger for filming either one frame at a time or continuous run.

On the control side of the camera, you'll find a footage counter in unspecified but easily identifiable increments: half, a quarter and so on. The Typica designers opted to leave off meter or footage calibrations, since the camera is marketed internationally. If you swing the side-loading door open to change cartridges in mid-roll, the counter resets to zero; when you reinsert the half-exposed cartridge, the counter will be inaccurate. It's too bad the Typica designers couldn't overcome this problem: changing midcartridge from fast to slow film, or black and white to color, is one of super 8's distinct advantages. In this process you fog only seven frames in a silent cartridge, a small loss indeed for such an advantage.

The Typica's four size AA penlight batteries power the camera's drive motor, zoom motor and the autodiaphragm; that's a lot to ask of the run-of-the-mill batteries, so use alkaline cells (or even better, rechargeable NiCads, page 105). In chilly or cold weather, chemical activity slows down and batteries lose power. So the Typica offers an accessory battery pack which may be plugged into the camera body. The Typica will run about fifteen 50-foot cartridges on each fresh set of four alkaline batteries at normal room temperature.

Here's how the batteries can be tested: push the battery button on the control side of the body for a second or two, and the f stop indicator, seen through the viewfinder, will swing to $f/8$ if the

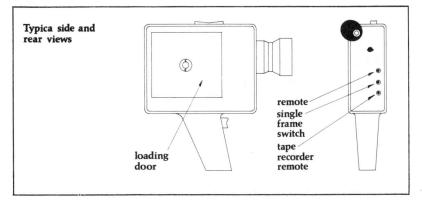

Typica side and rear views

loading door

remote
single
frame
switch

tape
recorder
remote

batteries are up to par. Any reading below that, and it's time to change the batteries housed in the pistol grip.

Although the Typica's fully automatic through-the-lens diaphragm control usually produces accurate exposures, some of the time you'll want to overrule the meter's decision. There's a manual control for setting the *f* stop as you please or holding the one the electric eye has selected. The Typica also provides a backlight control to open the diaphragm one stop, doubling the exposure so that you can get more detail from faces strongly lit from behind, say, by the sun.

The Typica has a variable shutter that can be closed or opened for fade-ins or fade-outs; it has an autodissolve feature which employs the variable shutter in a controlled program; a fade-out, then backwinding sixty frames of film into the cartridge's feed chamber so that when you're ready with the next shot, the shutter gradually opens. This effect of a fade-out over a fade-in, one shot blending into another, is a dissolve, and it's handled automatically. If the Typica didn't do all of this, you'd have to shoot on a tripod, and you'd need a frame counter to get back to the exact start of your fade-out. (A frame counter would be a nice feature to have especially if you do animation, but unfortunately the Typica doesn't have one.) The dissolves are a joy to behold and turn out to be one of the loveliest features of the Typica.

The Typica has a two-speed power zoom control located on the top of the camera. Push down a touch and you get a slow zoom, more pressure for the faster one.

There's a filter selector on the control side of the body. Flipped in the sunburst position, the built-in 85, or type A, filter is in place. The light bulb shows that the filter is out of the optical path.

Some cameras use a filter selection key that enters a slot usually meant for a movie light. The idea is that once the movie light is inserted into the top of the camera, its keying device will swing the filter out of the way so the tungsten balanced film will match the

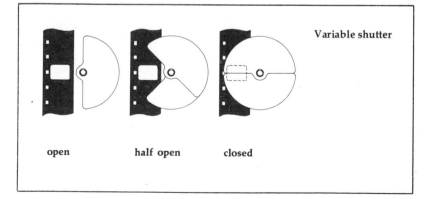

open half open closed

Variable shutter

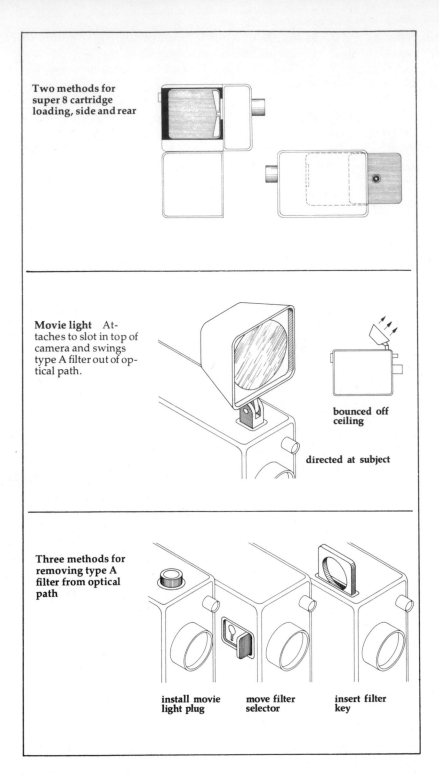

Two methods for super 8 cartridge loading, side and rear

Movie light Attaches to slot in top of camera and swings type A filter out of optical path.

bounced off ceiling

directed at subject

Three methods for removing type A filter from optical path

install movie light plug

move filter selector

insert filter key

light source. With the selection key in place, sans movie light, the filter is swung out of the way so you can shoot in available light indoors, let us say, without the harsh, unpleasant movie light. Trouble is, the key is small, the size of a quarter, and terribly easy to lose.

Swing open the loading door on the side opposite the controls and insert a fresh cartridge for three minutes and twenty seconds of shooting at the standard 18 fps; like all other super 8 cameras, it's a snap. Side loading's advantage over rear loading (the other super 8 possibility) is that it's easier to get to the gate area to clean the aperture pad. I clean my aperture plate with a brush and a puff of breath, but a blower or syringe might be better. My brush is periodically cleaned with soap and water.

Now to the back panel where the viewfinder eyepiece is located. Here we see three electric mini plug female sockets. One is for remote control, to start and stop the camera from distances of a hundred feet or more. This is useful, for example, in nature photography with the camera set up in a blind ready to film what turns up. With the appropriate equipment, the camera can also be started and stopped by radio.

Another socket supplies two functions: it can fire an electronic flash in conjunction with the time-lapse function; but far more important, it is used for lip sync recordings with a special cassette or reel-to-reel recorder or super 8 mag film recorder (more about this on page 133).

The third socket is for remote starting and stopping of a tape recorder. Very useful for sync sound.

Turning attention to the viewfinder itself: it is shrouded with a removable rubber cup that may be folded back on itself if you want to use eyeglasses. You can get out from under those glasses to see the entire finder area with a +5 to −5 diopter correction (from far- to nearsighted), adjusted by turning a knurled wheel. The ridged wheel can be locked with a set screw. To adjust the finder, Typica

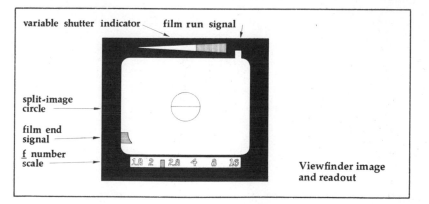

variable shutter indicator film run signal

split-image circle

film end signal

f number scale

Viewfinder image and readout

instructs you to focus to infinity and maximum telephoto position of the lens, then to sight a suitable distance target—houses or hills. Focus the finder until the image is sharpest and lock the adjusting knob. That's the Typica's way. The camera you're using may have different advice for focusing its finder.

In the center of the finder field, there's a split-image rangefinder. When the two circular halves of the image in the finder are aligned, you're in focus. Unfortunately the finder works best for vertical lines, which often are not present in your most promising subjects—people. Too bad. The Typica's designers have goofed. This split-image finder is hard to use even at its most accurate position, telephoto.

Other camera designs in super 8 set a ground glass or textured circular screen in the center of the finder image. Usually these are so coarse that they're hard to focus, as well as being dimmer in low light than the rest of the finder.

Nevertheless the Typica's finder is large enough to see the entire frame with bright clarity. As well, you see just what the lens sees, or what the film is recording. The finder (and exposure meter sensor) takes its light directly from the lens. A beamsplitter, two prisms cemented together and coated at the join with a semireflecting mirror, subtracts the light needed for this purpose. Then the light for the finder follows its own path where it is formed into an image suitable for direct viewing by the eye. What happens next, is this: part of the light is directed by the beamsplitter to the viewfinder optics, while most of the light passes on to form the image which is recorded by the film. It's the perfect finder for choosing any of the many possible focal lengths, for zooming and for closeups. Basically, it represents an accurate simulation of how that projected image will appear on a screen in a darkened room.

However, you should not have blind faith in your finder's accuracy. If one of its reflective prisms is slightly out of alignment, you will be seeing an image up, down, right or left of the actual field of

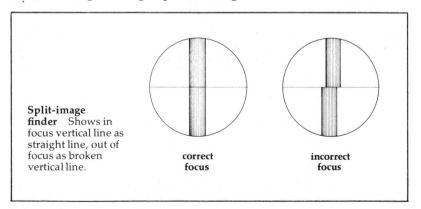

Split-image finder Shows in focus vertical line as straight line, out of focus as broken vertical line.

correct focus

incorrect focus

view of the lens and film. This is not uncommon, and for most work slight errors are of no consequence. But when shooting titles or other tightly composed shots, you may discover that your otherwise accurate finder leaves a lot to be desired. You can check this out by shooting a rectangular test target in advance. Then, depending upon the size of the error, you yourself can compensate when shooting, or send the camera to the repair shop.

I have found that this is one of the most difficult camera adjustments; don't be surprised if repair efforts prove unsatisfactory. Also be aware that your finder may show slightly less than the full field recorded by the film. It may well be that it is set up for the projector aperture, which is slightly smaller than the camera aperture.

An f stop scale is located at the bottom of the image area, as well as a film-run indicator that flickers as long as film is being advanced. At the end of a cartridge, or in the event of a jam, goodbye flicker. The cartridge indicator lights up when you've got less than ten seconds of shooting left. Really convenient since your eye can take in the picture information and the readout of f stops and film run all at the same time.

Before we get to the lens itself, a few gripes about the Typica's pistol grip. Super 8 designers do not seem able to work out a better solution to camera holding than a built-in pistol grip. It does provide the necessary handhold afterall, while housing the batteries that run the camera.

But the Typica grip is always in place: it cannot be removed or swung out of the way. This makes tripod mounting awkward, since the tripod socket, or thread screwhole, is on the bottom of the grip. The designers probably felt that you'll handhold the camera most of the time. Well, with this design you will.

As you can tell when you pick it up, the Typica has a solid metal body with a nice finish and black inlaid leatherette completing the camera's good feel, even though this last is an anachronistic touch. I would prefer fur, but it's not as practical as leather, and it gets smelly when it's wet.

Typicon The Typica has a 7 to 56mm, $f/1.8$ zoom lens. For the economy minded, there's a model with an 8 to 40mm zoom, while another has an 8 to 80mm zoom range for showoffs or people who are fated to shoot football games from the grandstands. The $f/1.8$ lens focuses to 4.5 feet, and there is a close focusing range, too, brought into place by moving a lever. Your 7 to 56mm, $f/1.8$ Typicon lens can shoot a postage stamp, if that's what you're stuck on.

The trouble with the closeup, or macro setting, is that it is a distinct focusing range. With the normal part of the focusing range you can get to 4.5 feet, but the macro range is good for only a few inches from the lens. With the Typicon you are doomed to miss

whatever possibilities lie between the two ranges, unless of course you use a closeup lens. Closeup lenses, or positive diopter lenses, are offered by Typica as well as specialists in lens accessories like Tiffen or Spiratone. Typical useful strengths are rated at +1, 2 or 3 diopters, although people have been known to use even stronger lenses, up to +10 diopter power. The virtue of the diopter lens is that you can do closeups and zoom with it in place. In the Typicon macro closeup mode, you cannot zoom. Working the zoom control will focus the lens instead.

So you can look upon the Typicon macro mode as a bonus, which is useful alright, but you may still have to use an accessory closeup lens for some effects. If I had my way, the Typicon designers would forget about the macro mode and give me a lens that focused continuously to two feet. I find that zoom lenses that stop focusing at four or five feet are a great big pain.

The finder and the meter grab much of the light that would have gone to the film. And the lens itself loses some light because of its many lens elements, consequently, air-to-glass surfaces. In fact, there are nineteen lens elements, cemented into several groups, totaling twenty-four air-to-glass surfaces. Even with coating (page

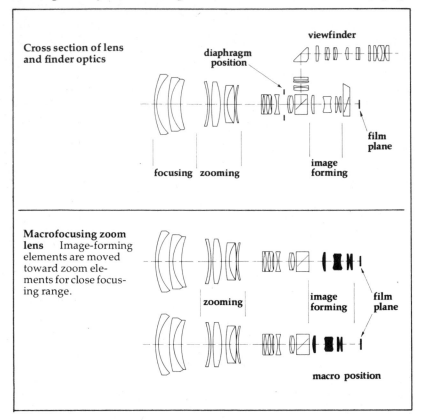

Cross section of lens and finder optics

viewfinder

diaphragm position

film plane

focusing zooming

image forming

Macrofocusing zoom lens Image-forming elements are moved toward zoom elements for close focusing range.

zooming

image forming

film plane

macro position

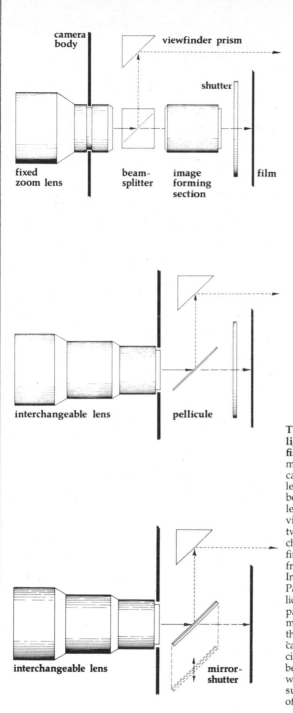

camera body

viewfinder prism

shutter

fixed zoom lens

beam-splitter

image forming section

film

interchangeable lens

pellicule

interchangeable lens

mirror-shutter

Three ways to take light for the finder The vast majority of super 8 cameras with built-in lenses use a beamsplitter to take lens light for the viewfinder. The next two types use inter-changeable lenses, so finder must get light from behind the lens. In the case of the Pathé camera, a pel-licule, or very thin partially reflecting mirror, is used behind the lens. The Beaulieu cameras employ a re-ciprocating mirror behind the lens, whose action suggests the motion of a guillotine.

57

DIOPTER POWER
& SUBJECT DISTANCE

Diopter	Distance on lens scale (feet)	Distance from film plane (inches)
+1/2	∞	79.
	25	69.5
	15	64.8
	10	59.3
	6	51.
	4	43.3
+1	∞	39.5
	25	34.8
	15	33.4
	10	29.6
	6	25.5
	4	21.6
+2	∞	19.5
	25	18.5
	15	17.8
	10	16.9
	6	15.5
	4	14.
+3	∞	13.
	25	12.5
	15	12.3
	10	11.9
	6	11.1
	4	10.4

CLOSEUP LENS & FOCAL LENGTH

Camera lens	Lens setting (feet)	2+ CLOSEUP LENS		3+ CLOSEUP LENS	
		Closeup lens-to-subject distance (inches)	Approx. field size (inches)	Closeup lens-to-subject distance (inches)	Approx. field size (inches)
9.5mm	∞	19.5	8.5 x 11.8	13	5.6 x 7.6
	25	18.5	8 x 11	12.5	5.4 x 7.4
	10	16.9	7.4 x 10	11.9	5.1 x 7
	6	15.5	6.8 x 9.1	11.1	4.8 x 6.5
12mm	∞	19.5	6.6 x 9.1	13	4.4 x 6
	25	18.5	6.4 x 8.6	12.5	4.3 x 5.8
	10	16.9	5.8 x 7.6	11.9	4 x 5.5
	6	15.5	5.3 x 7.3	11.1	3.8 x 5.1
13mm	∞	19.5	6.1 x 8.3	13	4.1 x 5.5
	25	18.5	5.8 x 7.8	12.5	4 x 5.4
	10	16.9	5.4 x 7.1	11.9	3.9 x 5
	6	15.5	4.9 x 6.5	11.1	3.5 x 4.8
28mm	∞	19.5	2.8 x 3.6	13	1.9 x 2.5
	25	18.5	2.6 x 3.5	12.5	1.8 x 2.4
	10	16.9	2.4 x 3.1	11.9	1.6 x 2.3
	6	15.5	2.1 x 2.9	11.1	1.6 x 2.1
36mm	∞	19.5	2.1 x 2.9	13	1.4 x 1.9
	25	18.5	2 x 2.8	12.5	1.3 x 1.8
	10	16.9	1.9 x 2.5	11.9	1.3 x 1.6
	6	15.5	1.6 x 2.3	11.1	1.1 x 1.5
45mm	∞	19.5	1.6 x 2.3	13	1 x 1.5
	25	18.5	1.5 x 2.1	12.5	1 x 1.4
	10	16.9	1.4 x 1.9	11.9	1 x 1.3
	6	15.5	1.3 x 1.8	11.1	.9 x 1.3

NOTES: Left: a +2 lens used in front of a camera lens (no matter what focal length) focused at 15 feet will produce a sharp image 17.8 inches from subject to film plane (front of cartridge). Some cameras are marked with a φ symbol to indicate the film plane. Right: set at 36mm and focused at 25 feet, your camera lens will cover a 2 x 2.8 inch field size when using a +2 lens.

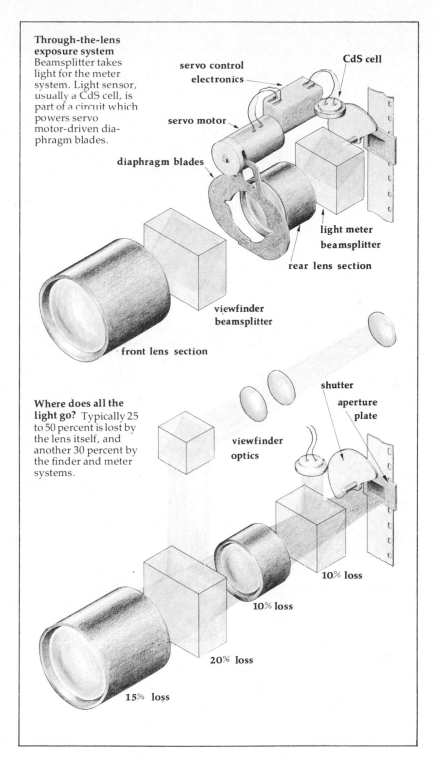

Through-the-lens exposure system Beamsplitter takes light for the meter system. Light sensor, usually a CdS cell, is part of a circuit which powers servo motor-driven diaphragm blades.

servo control electronics

CdS cell

servo motor

diaphragm blades

light meter beamsplitter

rear lens section

viewfinder beamsplitter

front lens section

Where does all the light go? Typically 25 to 50 percent is lost by the lens itself, and another 30 percent by the finder and meter systems.

shutter

aperture plate

viewfinder optics

10% loss

10% loss

20% loss

15% loss

59

65). the Typicon loses nearly a full f stop, while the light taken by the finder and meter adds up to at least another half stop. Too bad, because this steals some 60 percent of the light needed for exposure. This means that some of the time when you ought to be able to shoot with an $f/1.8$ lens, you just can't take movies with the Typica. Actually the effective f stop, what's called a T stop (page 64), is more like $T/2.8$. So a $25 box-type super 8 camera with an $f/2.8$ triplet (three-lens element) is as fast as the Typicon. (And as sharp!)

The Typicon designers were willing to sacrifice light for zoom versatility, finder viewing and through-the-lens meter sensing. With XL cameras (page 78) capturing the market, you can bet that updated Typicas will make more efficient advantage of usable light.

The Typica and Typicon represent some of the common design features, good points and flaws you're going to encounter in real super 8 production models. Besides comparing these points with those of your camera, you should be able to appreciate how complicated the design problems are and how much creative, inventive work still needs to be done.

Lenses Some people become frightened by the subject of lenses because there are so many numbers floating around. Don't worry. It's easier to operate a lens than to balance your checkbook, easier by a country mile. Here are the lens basics that you need to know.

The important quantities involved are focusing distance, focal length and f stops. Focusing distance is pretty simple: your lens must be set for the proper distance, subject to camera, to get the sharpest possible image. Focal lengths are related to the size of the image you are photographing. Longer focal lengths give a more magnified image than shorter focal lengths. The f stops are an arbitrary scale used to indicate the amount of light passing through your lens. The film's exposure is controlled by the f stop you set.

So the adjustments of your lens are: focus, focal length and f stop. The first adjustment is more or less obvious, and discussed in sections dealing with depth of field and close focusing.

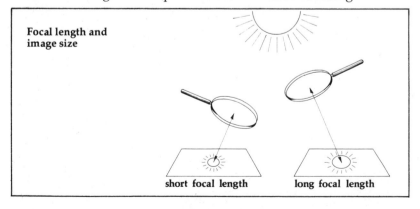

Focal length and image size

short focal length long focal length

Focal Length You know you can set fire to a leaf or a piece of paper with a magnifying glass and the sun. Lower the glass to the leaf, and after the sun is in focus, the leaf will soon start to smolder. The image is in focus—and most concentrated for burning—when the size of the disk of the sun is smallest. Lowering the glass beyond this point will unfocus the light, making the diameter of the sun's image larger. The distance from the magnifying glass to the leaf when the image of the sun is in focus is called its focal length. A lens with double the focal length will have to be held twice as far from the leaf for a focused image of the sun, but naturally enough the image of the sun will be twice the diameter.

What to remember about focal length, then, is that it determines the size of the object you are filming. As you move your lens to long focal lengths (say 20 to 70mm), the area covered becomes less, and the subject becomes larger. Zoom to shorter focal lengths, or numerically lower focal lengths (6 to 9mm), and the subject is smaller, but you include more of it.

All of which leads us to what used to be the concept of "normal" focal length. For super 8 this principle does not really exist, since super 8 cameras are usually fitted with zoom lenses, not prime, or fixed, focal length lenses. But even enlightened super 8 lens designers have been heavily influenced by the larger formats, and super 8 zoom lenses tend to be rather long in focal length. The normal lens from 35mm theatrical filmmaking heydays, when everything was shot in the studio and sets were constructed to order, was 50mm—about twice the diagonal of the 35mm Edison format's frame (page 3). It's a long focal length, selected because it is flattering for portraits. And, with sets designed with their missing walls, cameras could be properly positioned some distance from the action.

For five decades, half the 35mm theatrical format's normal focal length was accepted as the 16mm normal, or standard, lens. Until the days of the zoom lens, the 25mm, or one inch lens, at one time or

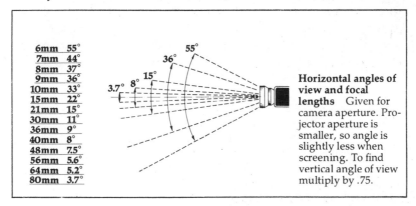

6mm	55°
7mm	44°
8mm	37°
9mm	36°
10mm	33°
15mm	22°
21mm	15°
30mm	11°
36mm	9°
40mm	8°
48mm	7.5°
56mm	5.6°
64mm	5.2°
80mm	3.7°

Horizontal angles of view and focal lengths Given for camera aperture. Projector aperture is smaller, so angle is slightly less when screening. To find vertical angle of view multiply by .75.

61

another has graced just about every 16mm camera body. Normal 8mm standardized on a focal length half that of the 16mm format, about 12 or 13mm. Since the super 8 frame is a little bigger, the first fixed focal length super 8 camera had focal lengths a millimeter or two longer than their standard 8mm counterparts. In other words lens focal lengths have been scaled down from the 35mm standard to match each smaller frame.

But these days super 8 cameras with fixed focal length lenses are measuring in at about 9mm, a much better choice for people who aren't shooting sets and shouldn't have to rip out the walls of their homes to position their cameras properly. My experience with super 8 indicates that a normal focal length of about 7mm is just fine. It will cover a good angle or view, about 45 degrees, so you can be close to your subject and still cover enough of it. And 7mm turns out to be a little more than the diagonal of the super 8 frame.

If you go to your camera shop and take a look at what's available, you'll be hard pressed to find super 8 cameras with focal lengths less than 7mm. Most super 8 zoom focal lengths start at 7 to 9mm and extend to anywhere between 40 and 70mm. Therefore, these lenses can zoom from short focal lengths, which are, at best, normal or slightly long to super powerful telephotos that serve mainly to prevent wild animal cinematographers from being devoured.

If you take a look at the chart correlating horizontal angle of view and focal lengths, you'll see that a change of a millimeter at the short end is more significant than a change of many millimeters at the long end. For example, you get 11 degrees more coverage at 6mm than 7mm, but only 4.3 degrees more coverage at 40mm compared with 80mm. So don't be fooled by super long focal lengths. Adding (or subtracting) millimeters to the long end means less than at the short end. What counts is the angle of view of coverage. Manufacturers love to add to the long end because it's easier to design well-corrected long zoom optics than well-corrected optics for the more useful shorter focal lengths.

It's a combination of design difficulties and plain ignorance on the part of designers and consumers alike that keeps us from having the valuable shorter focal lengths for wide angle filmmaking. In most cases the super 8 filmmaker would be much freer with a 5 to 25mm zoom lens than the common 8 to 64mm one.

f **stop** Let's return to the magnifying glass and its image of the sun on the leaf. If we increase the size of the magnifying glass, its diameter, and keep the same focal length, then the image of the sun will be brighter. That's sensible, since we can expect a larger diameter lens to pass more light through it. The image of the sun on the leaf will not be larger, for that is controlled by the focal length, but simply more intense, better able to start a fire on the leaf.

If we call the focal length of the lens F, and the diameter of the lens d, then we can make this arbitrary but useful definition which we call the f stop:

$$\frac{F}{d} \;=\; f \,stop$$

If the distance of the focused sun image to the magnifying glass is two inches, and the diameter of the lens is one inch, the lens has an f stop of 2, written $f/2$. We could slow down the lens from its maximum ability to project light, with a filter or, as is more common, with an iris diaphragm not unlike your eye's pupil. As the blades or sections of the diaphragm are closed, or stopped, down, the area of the lens is effectively decreased, and less light is transmitted. In this way the speed of the lens, as it is called, is decreased.

Lenses are usually calibrated with the following scale of f stops:

1, 1.4, 2, 2.8, 4, 5.6, 8, 11, 16, 22, 32.

Your typical super 8 lens has a speed of $f/1.8$, or midway between $f/1.4$ and $f/2$. People often work with half stops and third stops, but rarely to any finer gradation. As we progress from right to left, from $f/64$ to $f/1$, we are moving from slower to faster stops, or stops of lower to higher light transmission. In particular, closing the lens down from one stop to the next, say from $f/2$ to $f/2.8$, halves the amount of light passing through the lens or, going the other way, from $f/2.8$ to $f/2$ doubles the light passing through the lens.

In general your lens gives sharpest results lowered (or stopped down) a stop or three from maximum opening. Typically, your $f/1.8$ lens may reach its maximum quality, especially at the edge of the frame, at about $f/4$. If you are shooting subjects composed toward the center of the frame—a usual situation—you may not be able to tell the quality of image of $f/1.8$ from $f/4$. However, if you are shooting titles or subjects that require sharpness across the entire frame, stopping down your lens is a good idea.

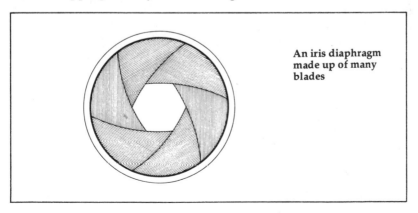

An iris diaphragm
made up of many
blades

In the same way, zoom lenses usually perform better for one range of settings than others. Whether yours does its best at wide angle or telephoto is a matter of individual lens design.

T **stop** The *T* stop scale is calibrated in the same numerical intervals as the *f* stop scale; however, *T* stops measure the actual light transmission of a lens, while *f* stops are a potential, or a calculation based purely on geometry and not the physics of the situation. For the magnifying glass example I have been using, *T* stops and *f* stops are essentially interchangeable.

Complex designs, like those of super 8 zoom lenses, require a number of carefully shaped lens components, either spaced individually or cemented together in groups. Each individual lens is called an element. And it is the purpose of each element to bend the light passing through it properly. Depending upon the type and curvature of the glass, light is bent differently, or refracted, by each element. Working together each group of elements contributes toward what none of them can do alone, namely producing the sharpest, best-corrected image on the film.

But all of the light that enters the lens is not bent or refracted by the elements. Some of it is reflected within the lens itself, and lost for image-forming purposes. This occurs at air-to-glass surfaces. At these interfaces about 4 percent of the light is lost because the optical properties of air and glass are quantitatively very different and reflections occur. No light is lost between glass-to-cement-to-glass surfaces because of their optically similar properties.

T stops are rarely printed on the lens or read out through the finders of any super 8 cameras; *f* stops are the language of the medium. The only reason for bothering with *T* stops is to simplify the following discussions and to make sure your understanding is complete: a lens that *f* stops at *f*/2.0, and loses half its image light from air-to-glass surfaces, *T* stops at *T*/2.8. I use the expression image-forming light rather than simply light to emphasize that it

Light loss Exposure chart for GAF 500 black and white movie film. Light loss is expressed in terms of shutter speed so users can obtain the proper *f* stop by using an in-the-hand meter. Cameras with broad range zoom lenses lose about two stops (l/150th compared with l/40th second). (GAF)

Type of camera lens	Using the 18 frames-per-second standard camera speed, set lens at f/stop indicated on exposure meter dial for the following shutter speed
Fixed focal length (not zoom)	1/40 sec.
Zoom lens with 2-1 or 3-1 zoom range	1/60 sec.
Zoom lens with 4-1, 5-1, or 6-1 zoom range (includes GAF ST/101E Super 8 Movie Camera)	1/80 sec.
Zoom lens with 7-1, 8-1, or greater zoom range (includes GAF ST/111E Super 8 Movie Camera)	1/150 sec.

reaches the film in the form of overall background noise, or fog, rather than image. This effect lowers the image contrast and apparent sharpness. But it is possible to increase the effective speed and decrease the lens' background fog by coating the lens.

Coating and Multicoating For more than three decades, lenses have been coated with an antireflection layer at each air-to-glass boundary. Typically, in an evacuated chamber called a boat, a very thin film of magnesium fluoride is deposited on the lens surface. This gives the lens its characteristic purplish color when you look directly into it. Coating will decrease the light lost to reflection from 4 to 1 percent. In a typical super 8 zoom lens, this 1 percent loss is significant because of the many air-to-glass surfaces. The cumulative effect becomes considerable because we are dealing with successive reductions of the light passing through each air-to-glass interface.

Even with coating, as you can see from the chart that GAF supplies with their 500 EI black and white film, super 8 zoom lenses with longer zoom ratios lose much more light than those with short ratios. By contrast, prime or fixed focal length lenses T stop and f stop at very nearly the same value; but a 10 to 1 zoom lens that f stops at $f/1.8$ may actually T stop at $T/2.5$. I should point out also that a great deal of light is also used by the viewfinder and light meter systems.

Multicoating is a technique that marginally improves traditional coating by adding several layers, three or four or maybe a dozen. Single-layer coating can be maximally effective for only one color of light; green, in the middle of the spectrum, is usually selected. Multicoating can be adjusted for a number of colors.

But multicoating all the air-to-glass surfaces of a particular lens may not result in any improvement. Multicoating is effective only for lens elements of certain optical characteristics. Specifically, only elements with the proper curvature and index of refraction (a mea-

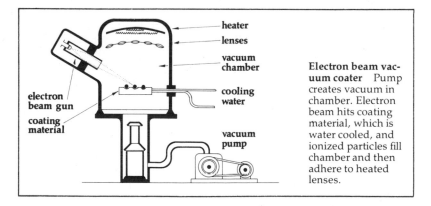

Electron beam vacuum coater Pump creates vacuum in chamber. Electron beam hits coating material, which is water cooled, and ionized particles fill chamber and then adhere to heated lenses.

sure of glass's ability to bend light) will gain from multicoating. At this time only Canon and Fuji boast of multicoating, but it is pretty well known that many manufacturers have been multicoating appropriate surfaces for some years.

Multicoating is far from the last word in coating. One idea presently being experimented with is a coating that would form an air-to-glass boundary layer with a varying refractive index. Super multicoating would work for all photographed light.

If you try to use a lightmeter, like a Seconic Studio Deluxe or a Weston V, you will find that their readings will not correspond with your camera's f stop indicator: your meter is reading actual f stops, while the automatic lightmeter circuitry is balanced for T stops. If you set your camera diaphragm to the f stops the independent meter reads, the actual transmission of the lens will be less than indicated, and you'll underexpose your shot. But it's possible to use your meter so that it gives readings which correspond to your camera's automatic internal meter. This can be done by making exposure tests and then mentally converting the readings when you shoot. For this reason, and the generally good accuracy of internal or through-the-lens camera meters, super 8 filmmakers rarely use or feel the need for accessory meters.

However, hand meters are often useful for selecting film of the appropriate speed for the level of existing illumination. You can't get such a reading with most super 8 cameras until a film cartridge is in place in the machine.

Depth of field　The lens produces an image in focus in front of and behind the distance for which it is set. The range of this is called depth of field. For example, if you focus at ten feet, everything from about eight and a half to twelve feet might be in focus, so you have a depth of field of from eight and a half to twelve feet. Sometimes you need to know more or less precisely how much will be in focus. For this you must consult appropriate depth of field tables, like the one printed here. Or, much, much better and more accurate, use a camera like the Beaulieu whose textured screen permits you to judge depth of field precisely. Usually though, all you need is a feel for depth of field, so that you can gauge how critically you need to focus to get the sharpest possible image.

There are three factors that contribute to depth of field: the subject distance, the focal length and the f stop.

—The closer the subject, the less the depth of field.

—The longer the focal length (more telephoto), the less the depth of field.

—The faster the f stop (numerically lower), the less the depth of field.

And conversely for all these cases.

66

DEPTH OF FIELD TABLE

FOCAL LENGTH	FEET	1.8	5.6	11	22
6mm	∞	3'11 - ∞	1'05 - ∞	0'11 - ∞	0'07 - ∞
	10	3'00 - ∞	1'04 - ∞	0'10 - ∞	0'07 - ∞
	5	2'05 - ∞	1'03 - ∞	0'10 - ∞	0'07 - ∞
8mm	∞	6'01 - ∞	2'01 - ∞	1'02 - ∞	0'09 - ∞
	10	4'00 - ∞	1'10 - ∞	1'02 - ∞	0'09 - ∞
	5	2'11 - 19'09	1'08 - ∞	1'01 - ∞	0'08 - ∞
10mm	∞	9'04 - ∞	3'02 - ∞	1'08 - ∞	0'11 - ∞
	10	5'00 - ∞	2'06 - ∞	1'06 - ∞	0'11 - ∞
	5	3'05 - 9'06	2'01 - ∞	1'05 - ∞	0'10 - ∞
12mm	∞	13'03 - ∞	4'04 - ∞	2'04 - ∞	1'03 - ∞
	10	5'11 - 35'00	3'02 - ∞	2'00 - ∞	1'02 - ∞
	5	3'09 - 7'06	2'06 - ∞	1'09 - ∞	1'01 - ∞
17mm	∞	26'05 - ∞	8'06 - ∞	4'04 - ∞	2'02 - ∞
	10	7'04 - 15'07	4'09 - ∞	3'02 - ∞	1'11 - ∞
	5	4'03 - 6'00	3'03 - 10'05	2'06 - ∞	1'08 - ∞
24mm	∞	52'05 - ∞	16'09 - ∞	8'06 - ∞	4'02 - ∞
	10	8'05 - 12'03	6'04 - 22'10	4'08 - ∞	3'00 - ∞
	5	4'07 - 5'06	3'11 - 6'10	3'03 - 10'06	2'04 - ∞
34mm	∞	105' - ∞	33'07 - ∞	16'11 - ∞	8'04 - ∞
	10	9'02 - 11'00	7'09 - 14'00	6'04 - 22'06	4'07 - ∞
	5	4'09 - 5'03	4'04 - 5'10	3'11 - 6'11	3'02 - 10'09
40mm	∞	153' - ∞	48'10 - ∞	24'08 - ∞	12'01 - ∞
	10	9'05 - 10'08	8'04 - 12'06	7'02 - 16'04	5'06 - 41'09
	5	4'10 - 5'02	4'06 - 5'07	4'02 - 6'03	3'06 - 8'01
48mm	∞	209' - ∞	66'11 - ∞	33'10 - ∞	16'08 - ∞
	10	9'06 - 10'06	8'08 - 11'09	7'08 - 14'00	6'03 - 23'00
	5	4'11 - 5'02	4'08 - 5'05	4'04 - 5'10	3'09 - 7'01
60mm	∞	327' - ∞	105' - ∞	52'11 - ∞	26'01 - ∞
	10	9'08 - 10'04	9'01 - 11'01	8'04 - 12'04	7'02 - 15'11
	5	4'11 - 5'01	4'09 - 5'03	4'06 - 5'07	4'01 - 6'03
66mm	∞	372' - ∞	119' - ∞	60'03 - ∞	29'08 - ∞
		9'09 - 10'03	9'02 - 10'11	8'06 - 12'00	7'05 - 14'11
	5	4'11 - 5'01	4'09 - 5'03	4'07 - 5'06	4'02 - 6'01

NOTE: This is a bright light depth of field table. How to use: If you are focused for 10 feet at f/1.8, at a focal length of 12mm, everything from 5'11 to 35'00 will be in focus. Intermediate values of distance, f number and focal length can be used for making depth of field estimates. When in doubt, or for greater sharpness, choose a numerically higher f than you intend using. (Schneider)

Super 8 cameras allow the most depth of field of any generally employed still or moving image, silver or electronic photographic system. That's because super 8 has a small frame, and the focal lengths of its lenses are comparatively short. Shorter focal lengths give more depth of field.

I take all the advantage I can of super 8's depth of field by often shooting at the shortest focal length available on my zoom lens. If I'm using an 8 to 40mm lens, approximately 90 percent of my shots are at 8mm. This is not only to maximize the depth of field, but because I like the point of view and perspective of shooting with a short lens as well as the heightened intimacy it achieves with my subjects. I prefer walking to zooming.

Here then are the things you can do to get more depth of field: you can choose a fast film that will require a numerically greater (smaller) f stop for a given level of illumination. Stopping down your lens to a numerically higher value of f extends your depth of field. So you could also undercrank (lower frames per second than the normal 18 fps) to increase f stop and depth of field.

You can zoom to your widest focal length: most depth of field is achieved with short focal length settings.

Step back and put more distance between you and your subject. The farther away you are, the more depth of field.

And finally, if you are lighting your subject, use brighter lights. You'll need less exposure then, and a smaller f stop will gain more depth of field.

Camera Lines While there are about one hundred and thirty individual super 8 models, there are probably less than fifty basic bodies. These bodies, fitted with various lenses, or features, comprise a manufacturer's line of machines that may be marketed under several brandnames. Even if I were able to become familiar with the basic bodies, it would be all but meaningless to comment on them classified in this way, since so much variation on a particular theme is possible.

In the discussion of the Typica, my average super 8 camera, I lumped features of many machines into one. In this way, I hoped to acquaint you with the fundamentals of modern camera design, what features are offered, the layout of controls, how the camera handles and how the basic optical systems work.

Now it's appropriate to turn our attention to cameras and manufacturers' lines of cameras illustrating the state of the art of super 8 picture-taking machines. I chose specific cameras to discuss at greater length than others because I like them and because they are important for specific reasons. This is not to say that the other models omitted or given brief attention are for the birds. Far from it. Many of them are creditable performers.

XL DEPTH OF FIELD

(Eastman Kodak)

FOCUS	f/1.2		f/2	
feet	9mm	21mm	9mm	21mm
∞	13'2 - ∞	71'0 - ∞	8'10 - ∞	47'5 - ∞
50	10'5 - ∞	29'1 - ∞	7'6 - ∞	24'1 - ∞
25	8'8 - ∞	18'5 - 38'3	6'7 - ∞	16'4 - 52'4
15	7'1 - ∞	12'5 - 19'0	5'8 - ∞	11'5 - 21'11
12	6'4 - ∞	10'3 - 14'5	5'2 - ∞	9'7 - 16'1
10	5'9 - 39'11	8'9 - 11'8	4'9 - ∞	8'3 - 12'8
8	5'1 - 19'9	7'2 - 9'0	4'3 - 77'11	6'10 - 9'7
7	4'8 - 14'5	6'5 - 7'9	4'0 - 31'8	6'1 - 8'2
6	4'2 - 10'8	5'6 - 6'7	3'8 - 17'10	5'4 - 6'10

FOCUS	f/4		f8	
feet	9mm	21mm	9mm	21mm
∞	5'1 - ∞	26'9 - ∞	3'8 - ∞	19'1 - ∞
50	4'7 - ∞	17'3 - ∞	3'5 - ∞	13'8 - ∞
25	4'3 - ∞	12'10 - ∞	3'2 - ∞	10'9 - ∞
15	3'10 - ∞	9'7 - 34'3	3'0 - ∞	8'5 - 71'5
12	3'7 - ∞	8'3 - 21'9	2'10 - ∞	7'4 - 32'6
10	3'5 - ∞	7'3 - 15'11	2'9 - ∞	6'7 - 21'1
8	3'2 - ∞	6'2 - 11'5	2'7 - ∞	5'8 - 13'9
7	3'0 - ∞	5'7 - 9'6	2'6 - ∞	5'1 - 11'1
6	2'10 - ∞	4'11 - 7'9	2'4 - ∞	4'7 - 8'9

f 2

f 16

4 feet

12 feet

25 feet

long

medium

short

Depth of field
These drawings give a feeling for how depth of field varies with lens opening (top), subject distance (middle) and focal length (bottom).

The cameras I chose to test for in-depth reports are the Nizo S-560 because it is an exemplary production camera; the Beaulieu 4008ZM II, also a fine production machine, but with the bonus of lens interchangeability; the Fujica Z800 because it is top of the line of the sister single 8 format cameras; the Eumig Mini 5 because it is a compact camera with an XL-type shutter approaching production camera sophistication and features; and the Supermatic 24 which serves to illustrate the essential XL concept.

My findings are not objective, but in fact highly subjective. A camera is made for an individual who must finally, in effect, live with it. It must fit comfortably in the hand, which is the first and single most important part of any camera evaluation. Pick up the camera and see how it feels. Do you like it? Fine. Is it comfortable? Try holding it for a minute or two. Use it for a longer time. Is your hand tired? How about your shoulders and arms? Only you can tell how a particular camera is matched to your body, how it satisfies you.

Here then is my listing of super 8 cameras in alphabetical order by manufacturer's name. As I have said, five cameras were chosen for testing; other reports are based on word of mouth from friends, students and associates, what I learned from salesmen at camera shops, the international filmmaking press and the manufacturer's literature. And some of the cameras given briefer write-ups I have used, but not very much.

Bauer Bauer of West Germany offers a rounded line of super 8 production machines which, I believe, are of highest quality. Weirdly, many of their cameras have controls on the right side of the camera body as you're holding the camera in shooting position. Out of keeping with other super 8 cartridge-loading machines, but this should be of interest to left-handed moviemakers. Camera prices range from a list of $135 for the Star XL, one of the niftiest compact XL super 8 cameras going, to the C Royal 10E listing at $750. The C Royal 10E contains features similar to the Nizo S-560; it has a 7 to 70mm zoom lens, compared to the S-560's 7 to 56mm zoom range. The Bauer factory also makes Rollei cameras, but there are more Bauer than Rollei models produced and, I believe, every Rollei corresponds to a Bauer version.

The most interesting Bauer camera, I feel, is the C5XL ($450) with its 230-degree shutter and 8 to 40mm, $f/1.2$ Neovaron zoom lens. Its broad range zoom lens and reflex finder extend the XL concept by allowing for a vast selection of focal lengths and accurate composition. The camera will not key for fast films like 4-X or GAF 500 black and white—or any faster color films that are sure to come along. This omission is in keeping with the practice of most super 8 camera designs. Too bad. The C5XL looks like it would be a fine basis for

development into a sound-on-film camera accepting the Ektasound cartridge, and as a matter of fact, Bauer has shown a sound-on-film camera.

Beaulieu 4008ZM II This camera has aimed higher (list, about $1100) than any other super 8 cartridge-loading machine; and I believe that for the most part it has found its mark. It's the only super 8 cartridge camera usable with super 8 and 16mm standard interchangeable C mount lenses. That means it can take just about any 16mm interchangeable lens—many of which already use C-type screw-in mounts—or other mounts that easily adapt to a C mount or any of the 35mm still camera lenses which are also easily converted to C mount. There must be thousands of lenses that can be used with this camera. Granted, most of them would be rather long by super 8 standards. For example, a 35mm still camera has a normal lens of about 50mm, which is telephoto for super 8, over seven times the normal 7mm focal lengths, as I figure it.

The camera comes equipped with a 6 to 66mm Schneider Optivaron $f/1.8$ zoom lens that features a separate focusing range for extreme closeups, down to matchbook-size subjects. The Optivaron focuses to about five feet for its normal range, which for my taste is inadequate. However, focused at five feet at 6mm, you can move to two feet even at $f/1.8$ (see depth of field table, page 67).

The lens was superb even at extreme focal lengths and when wide opened ($f/1.8$). I was impressed with its performance at $f/1.8$ and 6mm, settings I used a great deal indoors with Ektachrome 160 and 4-X reversal film. Outdoors with Kodachrome, I shot the sharpest super 8 footage I have ever seen. Well, without taking that back, there are other lenses as good; but a lens this good, with its enormous 11:1 zoom range: what an accomplishment!

I like the 6mm end of the zoom range. It does qualify as a wide angle setting, but just barely for my taste. I really prefer shorter focal lengths and feel stymied by designers concentrating on big

Beaulieu 4008ZM II 4008's are available with the 6 to 80mm, $f/1.2$ Angenieux and 6 to 70mm, $f/1.2$ Schneider. (Hervic)

zoom ratios and long focal lengths. But this lens doesn't deserve these complaints, since it is one of the few to make it to 6mm.

Unlike other cartridge-loading super 8 machines, the EI is user set. It is not cartridge keyed. This allows calibrating the EI for each kind of film used. The manufacturer's EI rating is only a suggestion, a starting point for determining good exposures. Most super 8 cameras, since they are cartridge keyed in their auto mode, will work at only that given EI. You might decide that you get better exposures at 16 EI, or maybe 32 EI instead of 25 EI with Kodachrome 40 outdoors. The Beaulieu lets you set it as you like it. Most other super 8 cameras have to be sent to the repair center for meter adjustment.

The EI dial is interlocked with the fps control. When you change the fps rate, variable continuously from 2 to 70 fps, the meter system will compensate for this change of exposure time, even while you are shooting. In effect, this gives the Beaulieu user the instant slow motion feature found in many cameras, but in a much more flexible system.

The interchangeable ZM II lens, you will note, has two cylindrical housings above and below it. These are part of the lens itself; one is a servo motor for driving the iris diaphragm, the other a variable rate power zoom motor. The image-forming light passes through the lens and is reflected by the viewfinder mirror partly to your eye for viewing, and partly to an exposure sensor, a CdS cell. The cell modulates a current, and this output is sent to the servo motor by way of the levels set by the EI and fps controls. The servo motor learns how to set the diaphragm directly from the camera body through contacts next to the lens mount. In this way the Beaulieu achieves automatic diaphragm control and full lens interchangeability.

The auto-exposure meter worked well, but it was fooled—like all of them—by backlighting and other difficult situations. Using the

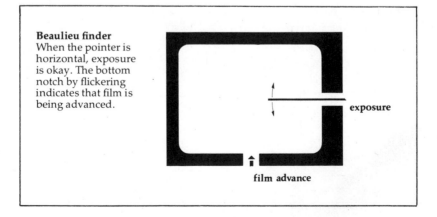

Beaulieu finder
When the pointer is horizontal, exposure is okay. The bottom notch by flickering indicates that film is being advanced.

exposure

film advance

camera almost entirely in the manual mode, I viewed the meter needle through the lens, setting the diaphragm by making the needle point horizontally. Then, to suit my subject and lighting situation, I adjusted the exposure up or down. I obtained nearly 100 percent perfect exposures this way, doing far better with my eye-brain than with the autodiaphragm. This method of setting the exposure would be used with any nonautomatic lens mounted on the body. It would be nice if the exposure needle were shorter and so intrude less into the finder image.

Atop the camera there's a variable shutter control, useful for fades or exposure control.

There's a sync pulse connection for an expensive generator ($275) yielding a 60 Hz signal for 24 fps, compatible with large format double system sync recording, or with the Erlson cable ($114) with a digital output for the super 8 standard system. The Erlson cable, or switch, is the more desirable of the two, since it is less expensive and will work for either 18 or 24 fps with Super8 Sound or Inner Space equipment (pages 142 and 148). Add to this tape recorder start outputs and a remote control input, located on the rear panel near the finder.

The NiCad battery, which can be recharged overnight, screws into the body; unlike some other users, I found its supply to be adequate, probably because I so infrequently use the power-draining auto-iris control, or power zoom.

Weirdly, the built-in filter is slot keyed. Why not a simple control on the camera body like those on Nizos or the XL cameras, especially when these keys are usually meant to work in slots originally designed for hot movie lights, and Beaulieu offers none? The key is so losable, and it is simply inconsistent with the manual setting of film speed.

The grip, the ungrabable grip: was it designed for an infant or a digit-missing accident victim? This has to be the world's worst pistol hold. (In all fairness, some Beaulieu users interviewed liked the grip.)

Clearly this camera cries out from its profoundest depths for a removable grip so that the nice flat bottom could be tripod mounted. And this is one super 8 camera that may well be tripod mounted, more than most, for example, when using very long focal length lenses. Right now the camera attaches to a tripod in the most awkward way: to the bottom of the sloped grip. Moreover, there is simply no nice way to set the camera down, say for loading or routine cleaning.

The same screw-in opening that accepts the sync pulse attachments also accepts a backwinding knob ($40) for up to 100-frame double exposures or manual dissolves. All of these attachments get in the way of the main switch (manual, auto or battery test).

About registration: through most of the range and especially at 18 or 24 fps, the steadiness is very, very good. At the extreme slow motion end, 70 fps, which I suppose could be called ultra slow motion for a super 8 cartridge-loading camera, things aren't so good. Nobody else has dared to go beyond 54 fps, I think, because of the convoluted path the film travels through the cartridge. The extra drag on the film, designers must have reasoned, would cause too much back tension and unsteadiness.

At 70 fps I suspect this is exactly what is happening in the Beaulieu. It isn't very steady. You will probably find that the registration is acceptable for many slow motion subjects. None of the people who looked at my footage thought it was unsteady, but I did.

The camera side loads and has an easy gate to clean. The finish of the camera is of the highest possible order. It is physically beautiful, I think one of the world's most finely manufactured cameras.

The viewfinder is the sharpest, clearest, biggest and possibly brightest super 8 finder. It is a magnificient optical device, magnifying some 27 times; that's a couple of times the usual magnification employed. With the rotation of a knob, you can choose viewing on a brilliant, clear finder screen or on an almost-as-bright textured focusing screen. This finder is what all other super 8 finders must compare to. More than any other, it gives you a feeling of how the projected image will appear on a screen. I did some of my best shooting with it.

Since the Beaulieu uses a moving mirror behind the lens for taking the light to the reflex system, the image flickers. I didn't find this bothersome.

The promotion hype for the camera suggests that it gives extra light to the film since 100 percent of the available light reaches the film. Most other super 8 cameras' beamsplitters rob part of the light for the finder image. But the Beaulieu has a fairly narrow shutter angle: at the standard 18 fps, you are working with a shutter at 1/65th of a second, rather than the more usual 1/40th second. So what would be an advantage in terms of exposure turns out not to be one because of Beaulieu's inefficient shutter. Moreover, the f/1.8 Optivaron T stops at about T/2.2, I estimate. Like other super 8 production machines, this is a bright light camera.

It's a fine French machine, looking more like Barbarella's ray gun than a super 8 camera. The designer who first solved the problems of lens interchangeability and autodiaphragm control and achieved the definitive viewfinder deserves the highest praise.

Beaulieu came across with the first quality super 8 camera, the 2008 S, right after Eastman's introduction of super 8. Designer Marcel Beaulieu, the only designer in this field generally known by name, since his is the brandname, understood the potential of the

**Bell & Howell 670/
XL** Moscow
proletarian camera
with Detroit trim.
(Bell & Howell)

medium better than anyone else. It has paid off. The recent
Beaulieus are basically the same camera, but mellowed by a decade
of development.

Bell & Howell The Bell & Howell catalogue has retreated from
their once fuller, more interesting line of cameras to an abbreviated
one, primarily of interest to the Sunday snapshot set. Their prod-
ucts now run from a simple camera, the Autoload 72G at about $55,
to the compact 670/XL at $130. The two middle models, the 492F and
the 493F, offer the ingenious trigonometric focusing scheme: you
point the camera at the feet of the subject, and a plumb-bob focus-
ing gauge is automatically activated.

They offer a simple-to-use but internally sophisticated machine,
the Filmosonic 1230, made in the Bell & Howell/Mamiya factory.

Bell & Howell is making a strong comeback these days with their
sound cameras and attractively designed sound projectors.

Bolex Bolex once made the cameras they market in their factory
in Switzerland. These days their production cameras are made in
the Eumig factory in Austria, and their XL and sound-on-film
machines in the Chinon factory in Japan. You'll find a full report on
the Eumig Mini 5, on page 84, which is virtually identical to the
Bolex 350 Macro Compact.

Canon and Pathé　Why lump these two together? Because these are the only manufacturers offering the double super 8 camera. While Canon has a line of cartridge-loading super 8 machines, Pathé offers only one, its DS 8 Electronic which, like the Canon DS 8, is really an adaptation of a 16mm camera.

Mind you these are not scaled-down versions; they are the full-sized 16mm camera optically and mechanically adapted to the requirements of super 8. This means they're big and heavy, some three times the weight of a typical super 8 machine. The chief difference between the two is that the Canon has a built-in 7.5 to 60mm, $f/1.4$ lens, while the Pathé offers lens interchangeability, accepting super 8 and 16mm standard C mount lenses. The Pathé lists at $2995 with its macrofocusing 6 to 80mm Angenieux, $f/1.2$ lens, while the Canon is a mere $1300.

Both offer reflex finding, naturally, backwinding for multiple exposures and variable shutter for fades and dissolves. Both have a wide range of speeds, and while the Canon must be modified for double system sync, the Pathé comes that way. The Pathé will also take a monstrous 400-foot load (800 feet, processed, slit and spliced together).

The virtue of these cameras is also their drawback: I'm talking about the 100-foot spool-loading double super 8 film—16 millimeters wide and super 8 perforated; processed and slit, this yields 200 feet of super 8. Advantage: longer continuous run—twice that of your 50-foot cartridge (but half that of the 200-foot cartridge). Eastman offers 100-foot spool loads of many kinds of super 8 film. And there's the low cost: a spool of what finally turns out to be 200-feet of super 8 film costs about $9, a bargain compared to the approximately $13 total cost for four cartridges.

So what's the fly in the ointment? It's the size for one. The 100-foot 16mm spool makes the camera a lot bigger and heavier. Also, be careful to load these machines in dim light, or you'll fog the edges of the film. While cartridge loading is an understandable

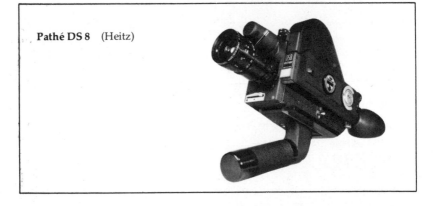

Pathé DS 8　(Heitz)

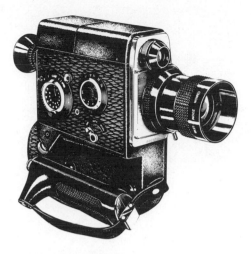

Canon DS 8 (Canon)

advantage, the Canon and Pathé have automatic threading.

Many a time your absentminded author double exposed his similar standard 8mm film, reversing feed and take-up spools once (or even twice) too often, resulting in double exposures, often of outstandingly beautiful quality, if surprising content. True, it's been years since I shot double 8mm, but the memory still smarts, so forgive me if I don't stand up and cheer for double super 8.

For example, it's far less expensive to make workprints from double super 8 original than cartridge-loaded super 8 (page 219). One filmmaker reported to me that he felt he got professional treatment with double super 8, since labs handle it like 16mm.

Before I leave Canon, a few words about their cartridge-loaded cameras: the 814 is one of the nicest feeling machines I have picked up, and it has one of the best fast (f/1.4) lenses going. I wish that Canon would add an XL shutter to the design. Canon now offers three fairly compact XL cameras.

Eastman Kodak (Supermatic 24) The Supermatic 24 is Eastman's audio-visual version of their XL cameras. The 24 has a darker, more unobtrusive finish; it operates at 18 and 24 fps, as opposed to the usual 18 and 9 fps; its zoom is manual (with a 2 1/3:1 zoom lens who needs power zooming?); it lacks a rangefinder, which is just as well since the ones employed in other Kodak XL cameras aren't terribly good. The Supermatic 24 (list, $190) is similar to the consumer-oriented XL 340 ($182.50). The 340 runs at 18 or 9 fps, and has no cable release provision, whereas the Supermatic 24 runs at 18 or 24, and has cable release.

The Kodak XL cameras do away with the damn ubiquitous pistol grip. The Supermatic 24 resembles a pair of binoculars, and while I was using it, people mistook it for just that. The camera is meant to

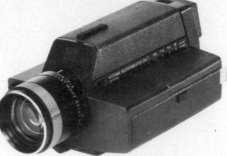

**Supermatic
24** (Eastman Kodak)

be held with both hands on the side housings; the left one holds the batteries and drive motor housing, while the right hand holds the viewfinder housing. A rubber bumper on the rear-loading door can be rested against your forehead for added steadiness when hand-holding. A similar forehead-resting scheme was introduced first by Leitz in their 1963 double 8mm Leicina.

There are few controls. You can zoom the 9 to 21mm, $f/1.2$ lens with a handy little lever located directly below it; this also sets the adjacent direct zoom finder (the finder does not see through the lens). You can focus the lens, but only to six feet. There is a selector for adding or subtracting the type A* filter from the optical path. (Too bad there is no filter status indicator in the viewfinder. My most frequent error with this camera was wrong filter setting.) There's a battery test button and a large run button with a lock. You can focus the very bright finder to suit your own eye, and there's a footage counter on the side of the camera next to the fps selector. There's nothing you can do about the exposure; the camera makes the selection and won't even inform you about it. Too bad. If only there was some way to fix the stop (even without knowing what it is), or at least a backlight control.

What's so hot about the 24? It's an XL camera with an extraordinarily crisp Ektar zoom lens. You can take good quality movies in just about any light—in color and black and white. It's one of the few super 8 cameras able to be cartridged keyed for the 400 EI 4-X.

The finder of the Supermatic 24 is of the direct optical type. Eastman employs this alternative in all their XL models, while other manufacturers have for the most part opted for reflex finders in conventional and XL cameras. Reflex finders appropriate part of the light from the image-forming system, leaving less available light for exposure. But direct optical finders, similar to telescope optics in design, have a crack at all the available light because they don't have to share any of it with the image-forming system. Therefore they are much brighter than reflex finders and more useful in less light, exactly the point of the XL concept.

Eastman takes advantage of plastic lens elements for the finder, and they work well. (It wasn't until February 1975 that Eastman publicly admitted they used plastic optics.) There's only the slightest trace of color fringing and the least lowering of image contrast through the finder, the expected weak points of injection molded plastic optics finders. The finder's zoom is coordinated with the lens' zoom. Also visible through this finder, right-eyed because of the rear layout of the camera, is an underexposure warning device. Much of the time I've disregarded its advice, and what I shot turned out just fine.

Compared with a reflex finder, the direct finder has one decided disadvantage: it's subject to what's called parallax error. An example of parallax: hold your hand directly in front of your eyes. You'll notice that if you cover one eye, then the other, you see a different relationship between foreground and background. Similarly, the finder and the lens are never going to see exactly the same view of the scene you are shooting. But for distant subjects, beyond six or eight feet, there'll be hardly any difference between what you see through the finder and what the lens transmits to the film. For closer subjects there's more need for caution; since the finder is offset to the left, however, simply shift the center of the composition slightly to the right.

The camera runs on four penlight batteries, and you can shoot about twenty cartridges on a set of alkaline AA cells. The camera's highly touted handhold is a grasp in the right direction, but it isn't all it could be. The binocular grip is a better solution certainly than the pistol grips most of us have to endure. But the strictly horizontal lines of the side grips force your hands into an unnatural position. The design would have been more successful with the hand grips tipped downward at between 30 to 45 degrees to the horizontal. Place your hands at your sides, slightly cupped, and raise them to either side of your face. You'll find that they fall into place at cheek height with a natural 30 or 40 degree angle.

Many cameras emulate the original 1972 Kodak XLs, the XL 33 (fixed focal length, 9mm, $f/1.2$ Ektar) and the zoom model XL 55. In fact Eastman initiated this increasingly popular design trend for silent and sound cameras. Since this is the case, it is only fitting that I describe the XL system, and how it allows you to dispense with additional illumination, like movie lights, in many, if not most, filmmaking situations.

XL Cameras With an XL camera and fast film, you can take movies in relatively meager light levels, less than a thousandth as bright as sunlight. To give you an idea of what I mean, in an average size room, even one with dark walls, a single 100-watt frosted bulb

inside a conventional translucent white lampshade will allow acceptable exposures.

There were two things Eastman had to do to make low light level, or existing light, movies possible: produce fast film like Ektachrome 160 and devise the XL cameras themselves. The film ordinarily used in XL cameras is Ektachrome 160 with a tungsten EI of 160 and 100 EI daylight through the 85 filter. This film is four times faster than Kodachrome 40, but you may prefer Ektachrome G (see page 24) or fast black and white film.

The other basic necessity was to improve the efficiency of the camera's optical and mechanical systems. Here's a rundown of what was done to the Supermatic 24 specifically, but all XL cameras by various manufacturers use the same scheme, more or less.

The Supermatic 24 has the direct finder I've already mentioned. Since, typically, a reflex finder uses 20 percent of the light coming in through the lens, the XL camera gains this much because of the design of its finder. For another thing, the $f/1.2$ XL lens is a full stop more, or twice as fast as the $f/1.8$ lens used on most super 8 cameras. XL lenses have relatively few air-to-glass surfaces, so they T stop faster. Your typical $f/1.8$ zoom lens (including finder losses) may T stop at only $T/2.8$, making the XL lens actually some six times faster.

Moreover, other super 8 cameras incorporate electric eye systems that drain their optical systems just like the reflex finder. How electric eye systems work has already been described when I went over general camera construction in the Typica (page 47), so I'll just pinpoint where these losses occur. The specific amount of light needed to operate the electric eye sensor, usually a cadmium sulfide photocell, comes from another beamsplitter in the optical system; this can lose almost as much light as the viewfinder beamsplitter. Many XL cameras use a light sensor adjacent to the lens, housed on the front of the camera next to the viewfinder lens. Since it's outside the image-forming optics, the sensor uses none of that system's light.

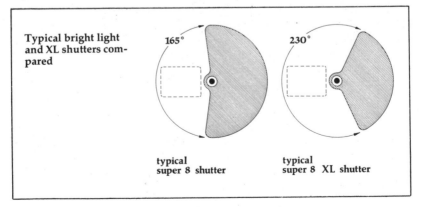

Typical bright light and XL shutters compared

165° 230°

typical
super 8 shutter

typical
super 8 XL shutter

Many super 8 cameras' iris diaphragms are unusually constructed, that is, they depart from the optically preferred circle. Some, like the Beaulieu, use a motor-driven series of diaphragm blades that approximate the most efficient circular aperture. Most other cameras utilize the electric current modulated by the photosensor to drive a single tear-shaped galvanometer vane. This vane passes in front of another fixed vane whose twin prongs, in conjunction with the moving tear-shaped vane, control the light passing through the lens. Even when the moving vane is swung out of the way to allow maximum light to pass through, the twin prongs have to remain, so that some light is lost even at full aperture. The Kodak XL cameras employ two moving galvanometer vanes, more nearly approximating a circular configuration, for an iris diaphragm; this eliminates the prongs' inefficiency at the widest opening, $f/1.2$.

And Eastman designers saw a way to add even more exposure light by making a basic mechanical improvement: a broader shutter angle. The typical super 8 camera has a 170-degree shutter for a 1/38th second exposure at 18 fps.

XL cameras have a 230-degree shutter for a 1/28th second exposure. While the typical super 8 camera exposes its film for a little less than half the time of the intermittent cycle, the XL cameras' film is exposed for about two thirds of the intermittent's cycle.

Practically speaking, you can take XL movies in most situations. With a film like black and white 4-X reversal (EI: 400 daylight, 320 tungsten), you can shoot in Stygian darkness. Black and white film provides a reasonable simulation of what happens to your perception in very low levels of light, since you are then beginning to see more with your rods than your color perceptor cones.

To sum up: the XL system is made up of two aspects: fast film, and our concern here, more efficient camera use of image-forming light. XL cameras usually achieve this efficient use of light in two ways: first, by having a broad shutter, or to put it another way, a fast

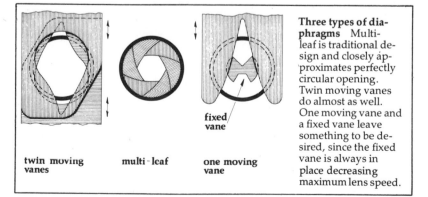

twin moving vanes

multi-leaf

fixed vane

one moving vane

Three types of diaphragms Multileaf is traditional design and closely approximates perfectly circular opening. Twin moving vanes do almost as well. One moving vane and a fixed vane leave something to be desired, since the fixed vane is always in place decreasing maximum lens speed.

pull-down portion of the intermittent cycle; and second, by having a fast lens. The shutter angle is usually about 230 degrees, while the optical system speed is probably better than $T/1.3$.

As super 8 XL cameras proliferate, we see departures, more or, usually less, from these criteria. Some cameras use $f/1.1$ lenses, others $f/1.3$ lenses, some 210-degree shutters and so on. The important part about the lens system is its overall efficiency, taking into account losses for air-to-glass surfaces, finder and exposure meter systems and so on. As the XL concept broadens, we see cameras with fairly efficient reflex systems, using only 10 percent of the image-forming light, as opposed to 20 percent. A manufacturer who says his camera uses a 220-degree shutter is telling you a hard fact. A manufacturer who tells you his lens is $f/1.1$ is telling you a factoid. The lens system might well T stop at appreciably less. The best way to find out how XLish a camera may be, is to use it. When all is said and done, you may be more than willing to sacrifice half a stop or less for through-the-lens viewing and metering.

The XL Shutter Look Some people reason that the more efficient the shutter—one with a greater shutter angle like the Supermatic 24's 230-degree shutter—the less sharp the resulting image. This kind of thinking is brought over from still photography when clearly, by any reasonable criterion of sharpness, this is indeed correct.

But movies are not still photography, and in our context this argument is not valid. Movie image sharpness is quite different from still sharpness: the blur of moving objects contributes to the appearance of movement smoothness. Examine frames in an editing viewer and this point will be demonstrated: a limb in motion will show more blurring than a more static subject, say a closeup of someone. But it's just this blurring that makes up the illusion of movement. The amount of footage I've shot with XL cameras convinces me that the broader shutter angle contributes to the goal of image smoothness, by contributing heavily to the moving image counterpart of sharpness. If you have a camera with a variable shutter, experiment and see whether action filmed with a partly closed shutter actually looks more or less smooth than the same action filmed with the shutter fully opened.

Panning has always been one of the bugaboos that the novice filmmaker is warned about, and rightly so. Pans are hard on the eye. But the XL shutter, with its longer exposure, leads to blurrier frames when panning, or during any camera movement for that matter. Shooting at 18 fps with an XL shutter yields an exposure time of 1/28th second, as opposed to 1/36th second at 18 fps with a super 8 camera and conventional shutter.

XL pans look decidedly smoother than pans made with conven-

tional cameras. I'm not saying that you should get panning fever with an XL camera, unless there's a good reason for it. But many related and annoying defects of the motion picture system are lessened by the 230-degree shutter: these include picketing—the flickering and flashing of vertical lines—when, for example, the camera moves or pans by picket fenceposts; and strobing, which can arrest or reverse the apparent rotation of a spoked wheel. Your XL pans will resemble TV pans more nearly than movie pans. There's a swishy creamy look to XL pans that I find very pleasing. I suggest you not take my word for it, but again try comparing actual XL and non-XL results.

The XL shutter also turns out to have a decided advantage for filming subjects under fluorescent illumination. Fluorescent lights are fired by an intermittent discharge of ionized vapor within the sealed tube chamber. This discharge is produced by and is in sync with the 60 Hz line current. The inside of the fluorescent tube is coated with phosphors which fluoresce, or radiate, usable illumination after being energized by the less useful radiation produced by the internal discharge. Although the light produced by the phosphors usually does not decay rapidly enough for you to see 60 Hz flickering, most cameras will, from time to time, depending on their shutter and the type of fluorescent lamps employed, pick up an annoying flickering effect. This results from the shutter's being out of sync with the fluorescent's flicker. Since the XL shutter is opened longer than the conventional shutter, it tends to integrate the disparate pulses of fluorescent light. XL movies have done away with fluorescent flicker!

We encounter the same kind of problem when we try to film the face of a TV set. It too has a 60 Hz flicker: it presents sixty fields of picture information to the eye each second through a similar excitation of phosphors. Often, when filming a TV screen, we pick up roll bars: dark or light bands traveling across the face of the screen. The XL shutter can get around this to a large extent because it exposes each frame for a longer duration, decreasing the likelihood that any of the TV pictures will be missed.

Elmo Elmo offers a number of machines from the box-styled camera 103 to the 110 with its 7 to 70mm zoom lens. The one I tried was the 311 Low Light ($240), an XL machine with an $f/1.1$, 9 to 27mm zoom lens and a 230 degree shutter. The camera features a separate or adjacent superimposed-type rangefinder device that could use more magnification to make it more accurate for low light and longer focal lengths. The 311 is a pretty good machine with good optics wide opened, but it gets a touch soft stopped down all the way. Elmo offers a complete line of sound-on-film cameras (see page 129).

Eumig Mini 5 (Bolex 350 Macro Compact) The Eumig Mini 5 is a compact, precision super 8 camera. Even though super 8 cameras are small by the standards of all film and video formats, the Mini 5 is compact by super 8 camera standards, for it packs a lot into the nine inches spanning the collapsible rubber lens shade to the end of the viewfinder eyecup. It's only three inches tall and an inch and a half wide and weighs one and three quarter pounds.

It has a 13-element, 8 to 40mm, *f*/1.9 Makro-Viennon zoom lens, which focuses to about three and a half feet, in macro mode to about half an inch from the front of the lens. The instruction book is particularly inept here. Not an understandable word in it about how to go about focusing for the macro mode. Sadly, the through-the-lens reflex viewfinder does not allow for focusing, since it has a brilliant, or what is sometimes called an aerial, image. It has cross-hairs in the center that, as far as I am concerned, serve no useful purpose; it has a useful readout of *f* stops in the lower left corner. (Some people can focus accurately with such an aerial image and crosshairs. Your author cannot.)

Maybe the lack of a focusing or rangefinding device is to Eumig's credit. I focused by scale, that is, estimating the distance from the camera to the subject, and then setting the distance on the lens mount; I achieved focusing accuracy, which was as good, if not better than I usually do with the lousy focusing devices of most super 8 cameras.

You might think that the lack of a focusing device would be heavily felt for shooting in the macro mode; but in the extreme macro setting, subject distance is always about half an inch, and I had little trouble estimating this distance.

The lens produced very crisp images, even wide opened, at any focal length setting. This is an extremely good lens. Even so small a camera has that almighty selling point, power zoom, enabling you to perform perfectly smooth zooms; the controls on the top of the body are convenient; I thought the zooming speed of six seconds

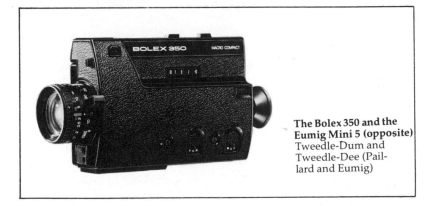

The Bolex 350 and the Eumig Mini 5 (opposite) Tweedle-Dum and Tweedle-Dee (Paillard and Eumig)

was just right. Some people might call it slow, but for power zooming it's harder to make a good slow smooth zoom than a fast smooth zoom, and that's what it's all about. The manual zoom lever on the lens has a right feeling. When you zoom all the way to 8mm, by the way, and release a catch on the body adjacent to the lens, you can slide into the macro range.

The camera will run at 9, 18 and 24 fps. By pressing a button on the side of the camera, you can maintain the exposure picked by the through-the-lens meter. Too bad you have to keep holding it during the shot, though. It should simply stay put and disengage itself when the shot is completed. Although you can't really set the opening manually since there's no iris control, in practice you can by moving the camera around or placing your hand in front of the lens until you get the *f* stop you want; then, depress the hold button. For added convenience, there's also a plus one stop backlight control.

The shutter is broader than usual: it's a 210-degree shutter. This coupled with the short range of the zoom lens—only 5:1—and its correspondingly fewer air-to-glass surfaces, adds up to about one stop exposure improvement over your ordinary 8:1 zoom ratio production camera with a 170-degree shutter.

The run button, which some call the trigger, the shutter release or the on-off button, is poorly located right below the lens. It's the biggest mistake the designers have made, and I consider this to be a serious error, all the more vexing in an otherwise laudable body design. Obviously the run button has been placed where it has for use in conjunction with the added-on pistol grip, available as an accessory. If ever a camera didn't need a pistol grip, here's the one. It holds perfectly well without the extra grip, and the fingers of both hands fall naturally on the top surface of the machine, where the zoom control is. And that's where the run button should also be.

The camera is beautifully finished in black with leatherette inlay; it loads easily, runs with only two penlight cells and has a tripod

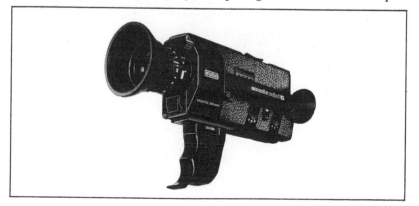

socket on the base. List price for this camera is about $300, a few bucks more than its spitting image, the Bolex 350 Macro-Compact, made in the same factory with only minor differences here and there. My words of wisdom in this instance have to be, buy the one you can get at the best price.

The Mini 5 shows how elegantly the concepts of miniaturization can be combined with the full features of a production machine. Eumig has even gone part way toward the XL concept with a 210-degree shutter, and with a faster lens they could easily go all the way. Indeed, Eumig has shown an interesting silent XL, and sound-on-film cameras are made for the company in Japan.

Fujica Z800 This is the only single 8 camera I've decided to include, since it is Fuji's most advanced offering. To refresh your memory about the single 8 system, page 32 begins a description of the heart of the system, the cartridge. The essential difference between super 8 and single 8 cameras is the cartridge design.

But even though the Z800 is the most advanced single 8 camera, and not a super 8 production machine, it has typically super 8 features. It has a sturdy metal body, single frame for animation, 18, 24 and 36 fps settings, a folding pistol grip housing four AA cells, variable shutter, a rotating shaft, sync sound output similar to the Beaulieu's, a tape recorder start output, and a very complete exposure control system. Unlike super 8 cameras, it allows for total backwinding of film. If you are passionately interested in achieving multiple imagery by successive passes of film through the camera or other trick effects, this may be the machine for you. The only super 8 machines that can do this are the spool-loading Canon DS 8 and Pathé DS 8.

For $470 list, the Fujica Z800 offers a multicoated optic, the electron beam coated Fujinon Z, 8 to 64mm, $f/1.8$ built-in zoom lens, which T stops to $T/64$.

The Fujica's images are excellent, but I am somewhat handicapped in evaluating the results; the difficulty in comparing film shot

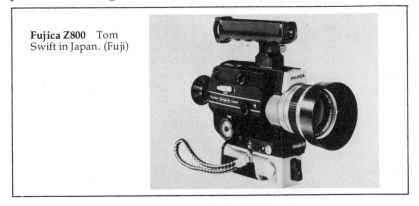

Fujica Z800 Tom Swift in Japan. (Fuji)

86

with this camera and super 8 cameras is that Fujichrome is available only in single 8, and my standard of comparison—Kodachrome—isn't produced in the single 8 format. So it's hard to tell the specific contribution to overall image quality of the camera and film. But the combination is impressive. As far as I could tell, multicoating in this instance produced no increase in lens speed. As well, it would be difficult to say whether multicoating decreased flare and spurious images when shooting into the sun. Spurious images originating from diaphragm blade reflections weren't so much eliminated as made crisper.

The camera offers a very flexible exposure control that can function totally automatically, or lock at a predetermined f stop, or the f stop can be selected manually. In addition, the variable shutter may be used for exposure control, as well as fades and dissolves; there is also a very fine backlight control.

The footage-frame counter is not to my taste. Its design seems inconsistent with the conception of the camera. Although it is helpful for dissolves, which are made manually by working the fade control, backwinding and then fading in, it is difficult to use for more extended backwinding, which is, after all, this system's forte. The combined footage-frame counter just takes too much concentration to work. A separate, easy-to-use frame counter would be preferable.

This well-balanced, easy-working machine's bright viewfinder with f stop and variable shutter indicators has a unique feature: as you run out of film, the finder turns bright red, a reminder that cannot be overlooked. Like most super 8 machines, there's the usual split-image rangefinder in the center of the finder. And like most other super 8 rangefinders of this kind, it's all but useless.

The Fuji System This is a good place for an overall survey of the Fuji single 8 system. In my opinion the deficiencies of the scheme have to be balanced by the single real advantage of unlimited backwinding you get in some single 8 cameras. But even this is compensated somewhat in the many super 8 cameras that feature automatic dissolves. So if you are not deeply attracted by unlimited backwinding, you'd probably be better off pursuing super 8. This isn't to say that Fuji doesn't offer good cameras and film. But if Fuji were to offer their film in super 8 cartridges, then the value of their system could be greatly extended; for example, a movie needing the facility of a backwinding single 8 camera could then be paired with say, an Ektasound camera. In this way footage shot with a single 8 camera would *match*, or have the same look, especially color rendition, as footage *intercut* with a super 8 machine.

Fuji now offers the 2X300 and AX100 XL cameras and fast, 200 EI tungsten color film, and they've also shown an inventive

single 8 sound camera. It uses optical, not magnetic, sound in the area usually reserved for the mag stripe in super 8 Ektasound cartridges. The user simply buys the standard Fujichrome cartridge, draws out a loop of about a foot of film and loads it manually in the camera over sprocket wheels and soundhead parts in a threading scheme much like that of a 16mm optical sound projector. A light-emitting diode exposes the sound track. After processing the film can be played back on a single- or super-8 optical sound projector. Such a system precludes erasing or future recording, but still has something to recommend it—it's cheap compared with magnetic talkies. In Japan only, at this time, you can buy the classy ZC camera with C-mount interchangeable lenses. With the 7.5 to 75mm, $f/1.8$ lens the price is $1250.

Fuji, it seems to me, despite their innovative design group, has passed up a number of interesting possibilities. Their cartridge, with its strong resemblance to the Philips audio cassette (page 151), would be a perfect medium for super 8 magnetic film.

Another good bet Fuji has passed up was the possibility of returning their film after processing in its original cartridge so the user could enjoy cartridge projector loading. The Fuji cartridge is a natural for this method because of its open gate area. A mirror could reflect the needed illumination through the film and then to the lens. Some amateurs would love this approach.

For what it's worth, until 1972 or 1973 Fuji single 8 sales were reported to be taking some 80 percent of the home movie market in Japan. This was a considerable accomplishment when you realize that Fuji is competing against a host of Japanese super 8 camera manufacturers, not to mention Eastman Kodak film. The latest estimates (1974) show a fifty-fifty split of the market, still a respectable share, but perhaps the herald of a downward trend.

As of late 1974, Fuji black and white single 8 film was no longer offered in the United States. With this omission, and without a mag stripe sound-on-film system, single 8 can hardly be called fully competitive.

Leitz So famous for their Leica cameras and their great tradition of quality, Leitz has often been called the "Wizards of Wetzlar" by the photo press. Present-day Leitz offers the Leicina Special based on the design of the standard 8mm Leicina, featuring both long, slim lines and forehead rest. It is similar in design philosophy to the Beaulieu—with interchangeable lenses and three (to the Beaulieu's two only) viewing screens available at the flick of a finger —obviously designed to be reckoned with by scientists who do a significant portion (perhaps 15 percent) of their filming with super 8. The list with 10mm, $f/1.8$ Macro Cinegon fixed focal length lens

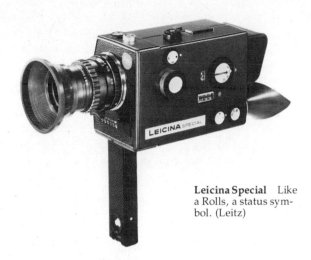

Leicina Special Like
a Rolls, a status sym-
bol. (Leitz)

is $1026. The 6 to 66mm Optivaron by Schneider is also available,
and will up the total to $1400.

This machine produces footage as good as the best super 8 I have
seen. It's likely that the design of the sliding loading door would
make it simple to adapt the camera to accept 200-foot silent car-
tridges. However, the drive motor may not have adequate torque
to take up film in the larger cartridges.

The Leicina uses an M-type Leica bayonette mount lens, and not
the super 8 standard screw-in C mount. It pains me to tell you,
reader, that C mount lenses cannot be adapted to M-type bayonette
mounts, although the Arriflex 16mm lens can be so adapted, as can
many mounts used for 35mm still cameras. If you have a Leica M
series camera, you're all set, no adapters needed. It is true that the C
mount is only borderline acceptable for massive 16mm zoom
lenses, but for smaller super 8 optics it's adequate. The M mount
would be a good choice for a 16mm camera, but it's a bit overdone
for super 8.

I have a 16mm camera with five C mount lenses, so I wouldn't
dream of owning a Leicina. If the Leicina had been fitted with what
I suppose can no longer be considered the standard C mount,
M-type Leica lenses could have been adapted to that. But since this
isn't so, prospective users weigh this carefully. There is a great
proliferation of C mount lenses, both new and used, and the availa-
ble focal lengths are more suited to the needs of super 8 filmmaking
than M-type mount lenses, since the 35mm still format is so much
larger than super 8.

Oh, wizards of Wetzlar take heed; remember the fate of that other
wizard, from Oz.

Minolta Minolta offers three production cameras, the Autopak-8 D4 ($230), the D6 ($320), the D12 ($875), and the low light XL-250 ($220). These cameras are very neatly designed machines with the standard features. Top of the line is the feature-loaded D12, with 6.5 to 78mm variable speed power zoom, autodissolve function, 8 to 54 fps rates, and much, much more. The D12 sports a Minolta exclusive, the electromagnetic shutter which allows for a variety of remote control and release cords, radio remote control and two very versatile intervalometers. This is one of the most interesting and advanced super 8 machines offered. Minolta is sure to have a single system sound camera, perhaps based on the modest XL design they offer.

Nikon Nikon offers two cameras, the R8, with an f/1.8, 7.5 to 60mm optic, and the R10, f/1.4, 7 to 70mm. Both feature fades and automatic dissolves and the ability to do double exposures up to 100 frames in length. They also have single frame switches to work in sync with double system sound schemes. Of course there's power zoom, through-the-lens metering and even a macrofocusing range.

Nizo S-560 This camera (list, $645) is manufactured by the West German Braun organization. Many people are surprised because the name Nizo sounds Japanese, and I wonder how this has affected Nizo sales.

There's a new version of the S-560, the S-561, with a somewhat more visible f stop scale in the viewfinder. Nizo offers a very broad range of cameras, with different features and lenses, and three curious machines they are daring to call XL, despite the fact that they have f/1.8 lenses, putting them far behind true XL's in low light capability. The S-560 has a 7 to 56mm (8:1), f/1.8 lens, with a two-speed zoom control, speeds of 18, 24 and 54 fps and an intervalometer dial adjustable for speeds from about 6 fps to one per minute. It has a single frame switch that can be used with sync systems using a digital pulse, and it can generate a 1000 Hz digital pulse for use with any stereo recorder.

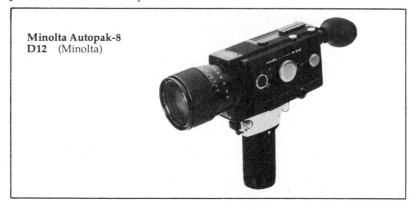

Minolta Autopak-8 D12 (Minolta)

Through the finder you can see a bright, brilliant image with a split-image rangefinder containing an *f* stop scale on the bottom. Your eye has to reposition to see the scale, and you have to be very careful to see the finder image which tends to black out. Surprisingly I found it much easier to position the finder image with my glasses on. Like most super 8 finders, this rangefinder is only so-so.

The pistol grip holds six AA penlight size cells and folds out of the way. The camera I used, which had been in use for some time and was pretty scuffed up, had the tripod socket on the grip, not the body; a recent Nizo I saw, however, had a body socket. Better to have the socket on the body than the grip if you plan to do much tripod shooting.

The intervalometer is useful for time-lapse work, clouds zipping by and the like, and Braun has put some English on this one since setting the proper control keeps the shutter open for the entire exposure of a single frame, not just for the more usual fraction of a second. This permits you to do time exposures and time lapse at the same time, which could be useful for very low light levels.

Since I rarely zoom, I can't get too excited about the power zoom, whose primary virtue is incredible smoothness. I feel power focusing might be much more useful. I find selecting the exact focal length for a shot to be difficult with power zoom and prefer going manual for this. I use my zoom lens for picking out the best focal length, and then I pretty much stick with it.

The 7 to 56mm, *f*/1.8 Schneider Varigon was far from being a first-rate performer. I have heard people rave about what a great lens this is. Mine wasn't. To put it bluntly, the lens was soft, soft, soft! Most people viewing test footage found it acceptably sharp, until I showed them some really sharp footage shot with other cameras. I assume I used a poorly performing sample. Remember, check out your camera. Don't go by reputation alone.

The Nizo is one of the many super 8 cameras to have automatic dissolving: you simply push a button and it does the entire trip of

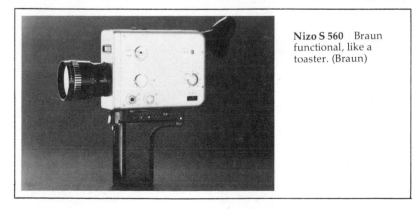

Nizo S 560 Braun functional, like a toaster. (Braun)

fading out and backwinding. Push another button and it fades in, creating a technically marvelous dissolve. However, you can ruin a perfectly good shot by melding an inappropriate second shot to it; then you'd have to cut off the dissolve and the unwanted shot in editing. Given this limitation, which applies to all in-the-camera autodissolve devices, the feature is great fun and works well.

The camera is nicely designed in an admirably straightforward fashion, and it is easy to hold even for long periods of time. The controls are just right, well-placed and simple to operate.

Sankyo Sankyo has the broadest line of super 8 cameras with more than a dozen models, the most outstanding of which, as far as I'm concerned, are the Hi-Focus CME-1100 ($550) and the Super LXL-255 ($265).

The CME-1100 has a 6.5 to 65mm zoom lens, and the inventive hi-focus system, an ingenious solution to the super 8 focusing problem: you simply pull out the end of the lens, or the lens hood, and a greatly magnified rangefinder pops into place filling the reflex finder image.

The LXL sports a 9 to 22.5mm, f/1.2 lens, a 230-degree shutter, reflex finder and a close focusing range. It is one of, if not the first XL designs to reach the public, combining its XL system with advanced creative controls and features. But like the Bauer C5XL, and a lot of other super 8 designs, it will not key speeds beyond 160 EI. And I wish that it and the Bauer had a single frame switch usable with double system sync recorders. Sankyo offers a couple of single system cameras.

Yashica Three very clean production cameras are offered by Yashica, the Electro 8 LD-4, LD-6 and LD-8, with 4 to 1, 6 to 1 and 8 to 1 zoom lenses respectively. They offer dissolves and fades and the usual goodies.

Strengths and Weaknesses In my ambling way, I have been detailing what I like and don't like about contemporary super 8 design. There's a lot right with it, as well as whole gaps that need rethinking.

One of the most ticklish areas of evaluation has to do with design execution. Every first-rate design must take into account fabrication on the assembly line. A designer can't be satisfied with, "Well, this is great design; I hope the people on the assembly line can build it." Obviously more effort has to be devoted toward creating final production designs that can be made with quality at what the manufacturer considers a reasonable price.

But something's gone wrong. Half the hardware (cameras and projectors) to reach me arrived in bad shape, unreliable even unusable. Can it be that super 8 machines with complex combinations of

electronics, optical and mechanical design are too difficult to manufacture consistently? Film is also hard to manufacture well, but it rarely suffers from defects (forgetting the photofinishing trade for a moment).

The ceaseless monotony must make it difficult for workers to care a hell of a lot about any particular machine that comes down the line. Maybe bringing in a bugless super 8 camera with 8:1 power zoom, reflex finder, auto-exposure meter, remote control and all the rest of it is just too much to expect every time for a few hundred dollars.

For this reason you have to be prepared for flaws and defects in any machine you use for the first time. Once you get the camera tuned by the repair people—again with the provision that this is done properly—in all likelihood then you will have an instrument that will perform exceptionally well, perhaps even for years.

So the attitude I assume is that I am part of quality control, that very last stage of manufacture check, supposed to take place at the factory. Maybe it does, maybe it doesn't, and maybe cameras are abused in shipping. I don't know and neither probably will you. But considering myself as the last tester helps chase the new camera blues away, replacing frustration with action.

Now let's turn to the problem of design as abstracted from execution. Here's what I think about the state of the art.

Generally speaking, although super 8 lens designs are very good, improvement is certainly possible: for example, most zoom lenses achieve maximum performance for only part of their focal length range. And a great deal can still be done to improve optical system (the taking lens plus finder and lightmeter sensor) efficiency in terms of light transmission. This is probably the most important area to be worked on, and XL designs have pointed the way.

Designers have opted for longer and longer focal lengths for zoom lenses to jack up the zoom ratio in the easiest way they know. This facile way to make a selling point is comparable to the horsepower race of the auto industry of yesteryear. Work needs to be done on the shorter end of the focal length scale: we need lenses that start in the 4 and 5 millimeter range!

Mechanical engineering is so difficult a branch of applied science that it comes as some surprise that super 8 cameras, mechanically speaking, are very sound. The heart of the motion picture cameras, the intermittent mechanism, has been all but perfected in areas of steadiness—or indexing of film—and reliability. Eighty years of continual effort has paid off with mechanisms that can advance film in only one third, rather than the traditional one half, the intermittent cycle; this increases exposure, reduces annoying visual effects—like fluorescent flickering—and makes a smoother apparent movement of camera and subject.

However, there's still one clinker in intermittent design: its noise. The mechanisms are far too loud for silent or sound recording. For any kind of shooting the whirr of the super 8 mechanism is a sure tip-off, alerting the self-conscious subject. Electric-drive motors, already fairly quiet still need further improvement, as does power transmission to the intermittent and the sound of the intermittent itself. In addition, and perhaps most taxing, the singing, or chatter, of the claw as it enters the film perforations must be eliminated.

Buying a Camera So you'd like to buy a camera? Handling a camera for comfort is more important than staring blankly at catalogue pages while in toilet repose. But a useful starting point for the prospective buyer is the section in the yearly *Photography Directory & Buying Guide* ($1.50) on your newsstands, in camera shops or by mail from Ziff-Davis (see address section).

What I'm now suggesting might be just a crazed attempt to help you get over the hurdle of buying a camera, but this strategy will at least lessen the chances of your getting a lemon.

It's just possible that those salespeople in your camera store may know a great deal about moviemaking. But it's more likely that they know less than you do, especially after you've read this book. It's all too true that many of these camera hawkers rank second only to used car salesmen in their guile and cunning.

Anyway, after you've selected the model you want, ask the salespeople to let you shoot a cartridge in the store; have them process the film through their photofinisher, and then look at the results on their projector.

Tell them to put aside the specific camera you used during the two or three days of processing time. Write down the serial number of the particular camera. Choose a film compatible with the situation. With an XL camera, you'll probably be able to shoot in a bright store interior even with Kodachrome 40.

Shoot your cartridge. A camera store has many wonderful opportunities for camera testing: signs, rows of cameras, people's faces. Go to the doorway or window and shoot the street. If they agree, step out into the street and shoot as much as you like. If it's a sound camera, naturally enough take lip sync footage. When you've finished putting it through its paces for focus and zoom lens setting, fps setting and everything else you want to try out, give them the cartridge to process.

When you return, look at the film with the salesperson. If something's wrong, you'll both be seeing it. If you like what you see, assuming you like the camera in the first place, you have eliminated some of the risk involved. If a camera is really defective, it may show up in the first cartridge.

If the sales department won't go along with the test, go somewhere else.

Cheap Thrills There's really no valid reason for buying a camera at anything but the lowest price. I fail to see the argument advanced by slick photography magazines that camera shops give better customer service. Buy your camera at a drugstore, discount shop, wherever you can get the best price—with the assurance that if the camera goes goofy within the first two weeks, they'll take yours and hand you another one. They might try to tell you that you can have it repaired through the manufacturer or distributor, and this is perfectly true; but in most cases be prepared to wait a month or longer. It's also possible that the people at the discount store will go along with an in-the-shop test.

Another way to find a camera at a good price is risky, but the savings can be substantial: purchase your camera through a discount mail-order store. If you've had experience with such an outlet and it has been good, use them again. More than likely though, you'll probably have to shop around in the back pages of the slick photography magazines for one with the lowest price for a particular camera. What safeguards do you have for good service—I mean prompt delivery and people who'll stand behind a defective machine?

Modern Photography, for one, publishes a full-page explanation at the beginning of their mail-order section. I suggest you read this before you decide to do business with one of their advertisers. What it comes down to, if I understand the jist of the long-winded rap correctly, is that as far as the magazine knows the advertisers in their pages are okay. If you get ripped off, *Modern* says it will back you up. I know that they have dropped ads from people who proved to be disreputable, they have informed the appropriate legal and government agencies about possible fraudulent retailers, and they do publish warnings to readers about swindling mail-order houses. But exactly what they can do for you if you get stuck is still a question. Anyway this is the most protection for the prospective mail-order purchases I know of, so you still pays your money and takes your chances.

For accessories like filters and gadgets, the finest, most reputable mail-order house I know of is Spiratone (see address section). They publish many catalogue pages in each issue of *Popular Photography* and *Modern Photography,* essentially aimed at the still photographer, but also offer many good deals for the super 8 filmmaker. Their filters and closeup lenses are first-rate at very low prices.

The Price You Pay Listing the list price these days is all but meaningless. There are three factors which make this the case—inflation, currency reevaluation and what's happening in the marketplace. The prices I've listed for super 8 cameras and film stock are intended as approximations. Of course you should never pay more

than list, and I suppose that's the function I intended: a guide to the maximum.

But what's the minimum? For cameras it's anything from 20 percent to half off list. In practically all cases I think it's fair to say that you're being ripped-off if you don't get at least 15 percent off the fictional list price. Check the back pages of photography magazines for some of the best-going prices.

Cameras are heavily discounted for a number of reasons. One of the best is that the model has been discontinued. Usually it's being replaced by one almost exactly the same, with maybe the addition of one or two features, like a longer ratio zoom lens or macrofocusing.

Focusing The focusing devices in most super 8 cameras leave quite a bit to be desired. And there's nothing wrong with focusing by scale—estimating distance and manually setting the lens—if you do it accurately. But assuming that you are using your focusing screen or rangefinder, make your determination for sharpness by zooming to the maximum telephoto setting. This will give you the greatest accuracy, since depth of field is at a minimum for this condition.

Super 8 cameras with built-in lenses invariably take their finder light in front of the iris diaphragm, so that you are always viewing at maximum lens opening, hence minimum depth of field. After you've focused at your longest focal length, zoom back to your desired focal length. This will guarantee the best possible focal length, even if you decide to zoom in on a particular detail of the shot. However, if you have a camera like the Pathé DS 8 or the Beaulieu 4008 which takes its viewfinder light after the iris diaphragm, you must open the lens to the widest aperture, in addition, to produce the least depth of field.

Close focusing at the shorter focal length, or wide angle, positions is different. Suppose you have a zoom lens that focuses to only four feet, not untypical, and you find you are shooting outdoors at $f/8$ with Kodachrome 40, also typical. Your depth of field (table on page 67) for this situation is one and a half feet to infinity. That means that you can get as close as one and a half feet from your subject, or two and a half feet less than the focusing scale indicates. If you tried to focus the lens by zooming to tele position, you might come to the conclusion that you couldn't take the shot, but this doesn't take depth of field into account.

Panning and Zooming None of my comments about zooming, panning and moving your camera are in any way definitive. They should be taken for what they are, one man's way of working a camera; you'll be making a mistake if you take this as dogma or

anything more than a starting point for your own learning and experimenting. I'm emphasizing this because I have found some readers of *Independent Filmmaking* have taken what I had to say too rigidly.

Perhaps my advice will seem outlandish, primarily because I am reacting against the maxims usually handed down in simple-minded guides on the subject, the camera instruction books and the too-slick magazine articles. But even though there is little here that is bizarre, you, reader, must establish the validity of this advice on your own terms in your own way for your own purpose.

Zooms are usually described as mechanical effects. Zooming is said to be difficult to bring off properly because it's so hard on the eyes. The notion is that rapid or overdone zooming wears out the viewer. This is also the dominant esthetic critical judgment concerning the zoom. Since it is such a relatively new technique in the language of the cinema, the zoom has been subjected to this intensive criticism.

Writers do not seem to question the validity of the pan, even though camera instruction books caution the user to avoid pans altogether, or if pan one must, then one must learn to pan—side-to-side horizontal camera movement—ever so slowly. Obviously if you've ever looked at a movie, you have seen that pans—as well as their vertical counterpart, tilts—are much harder on the eyes than zooms. You know this because unlike critics and writers your eyes are still sending messages to your brain.

In the very early days of the silent cinema, the field of view of the lens was treated as if it were the stage of a theater. Filmmakers were afraid to move in their cameras for medium shots or closeups because they feared that audiences would not accept truncated views of actors. The grotesque and now laughable notion was that the spectator, seeing anything less than a full view, would believe he was seeing a cut-off person, perhaps the victim of a terrible accident. So for many years the movie screen imitated the stage, and all that transpired on it was a re-creation of what would have taken place beneath the proscenium arch.

Nobody is subjected to this particular foolishness anymore. But it's important to understand that this notion, as strange as it seems today, immeasurably retarded the creative expression of the earliest theatrical filmmakers. Just as the medium shot and the more radical closeup had to undergo a waiting period before they became perceptually acceptable, so must the zoom. But its time is long overdue.

Film writers do not seem so concerned with the pan as a problem probably because pans have been with us for many years. Yet the effect of a pan (short for panoraming) on the screen is quite unlike anything encountered in normal perception.

Move your head and "pan" your eyes around. It's comparable to shaking your head no. What do you see?

Take a look at a movie pan. Remember what it's like? A motion picture pan is quite blurry generally. And it has a distinct motion to it, a backwards motion. Pan, and the world seems to turn around backwards on the screen in a direction opposite to the camera's motion. Move your eyes, and this doesn't happen: the world doesn't become blurry, and the world doesn't seem to swish around opposite to the direction your eyes are moving.

A pan is a difficult effect to execute. There's nothing you can do to make it resemble direct perception of the world, with the possible exception of panning with a moving subject. By keeping the subject relatively fixed in the field of view while it is in motion, the subject will remain fairly sharp, while the background blurs. Try it for a runner or a moving car or a bird in flight.

By raising the fps rate, you can execute a smoother, less blurry pan, but there's nothing you can do to eliminate the backward motion you're going to get. By shooting at, say 36 fps, with a normal 18 fps projection speed in mind, you will have slowed down your pan by a factor of two, and greatly added to the overall apparent clarity of the shot. Even higher fps rates may prove helpful in other situations; however, be warned that if the rate of the action you are filming is known or identifiable to your audience, it'll be seen as slowed down, since after all, you are shooting in slow motion. Bearing this in mind though, you can greatly smooth out and clarify, if that is your desire, your pans (see page 82 for additional comments about XL shutter pans).

Pans and tilts are mechanical movements resulting from a rotation of the camera. The zoom is obviously an optical effect. Nothing mechanical is involved, except for the movement of certain internal sections of the lens. It's absorbing to speculate how the misconception about the "mechanical" nature of the zoom could have become so widespread. Without a doubt the epithet mechanical used for the zoom is a put-down, but a wrongly based, snobbish premise. Obviously, in both origin and effect, it is the pan which is mechanical and the zoom optical.

Zooms, unlike pans, are generally easy on the eyes. There's very little apparent blur as there is with the pan, and a zoom is, for the most part, more easily executed than the pan. Implicit in this is the assumption that smoothness is a virtue. It is not. This standard may be applied only to the overall context of the film, and what is a virtue in one film may be a defect in another. However, if you can execute an effect smoothly, you can execute it jerkily at your option; the converse, however, is not true.

The zoom has a logic of its own. It has no real physiological counterpart as does the pan. However, it does have a strong

psychological correspondence to suddenly noticing a detail of something you're looking at. I'm talking about a zoom in, as opposed to a zoom out. Also, zooming in, or out, acts in a manner corresponding to the straight cut. In point of fact, most of the time, cutting out the zoom frames will provide a perfectly good cut.

People are always being cautioned not to overdo the zoom. Anything overdone is a bore by definition. But the zoom is singled out for a couple of reasons. They are so much fun to do when you are using your camera that they can become irresistible. Don't resist then, what's the harm? Maybe it will work itself out of your system, or maybe you will discover something about zooming the rest of us have overlooked.

The other reason for zoom censure is its newness, and the psychological and perceptual prejudice inherent in this fact. I see the zoom as being in the same relationship to film history as the proscenium arch restriction to medium shots and closeups.

The rate at which you pan or zoom is up to you and the suitability of the subject. Since there is a delay in feedback—from the time you shoot to the time you project your footage—it's difficult to learn what works best in short order. Set yourself a program of zooming and panning exercises to learn from when you screen your footage. That's how you'll know for yourself.

I don't zoom too often. This is my position, roughly: the zoom lens provides me with all the focal lengths between two extremes. I select the one that suits the shot. Maybe this approach stemmed from the fact that I am more used to prime or fixed focal length lenses than zoom lenses, but thinking back now, I suspect this isn't the case; my very first movie camera was an 8mm Camex Reflex, with an Angenieux zoom lens. Whatever the reason, I keep my zooming to a minimum, a procedure many filmmakers follow. But this isn't to be taken as advice to do it this way. If filmmakers tell you this, they are forgetting how much fun they had zooming their way to wisdom.

The Long and Short of It Notwithstanding what I have just said, I believe that you may be pleased more times than not by moving your camera rather than your zoom control. Both panning and zooming tend to flatten the subject you are shooting. Neither of these produce the three-dimensional effect of foreground movement with respect to background. If you pan and zoom across the face of a still photograph, you will get exactly the same effect as you would panning or zooming in our three-dimensional world.

Movies, in their present form, are two dimensional. Life has that elusive but important sense of three dimensionality that we perceive because we have two eyes, each seeing a slightly different image of the world. The effect of depth comes about not only from

the two-eyed sensation known technically as binocular stereopsis, but also from a number of other clues in the visual field. These include overlapping of background by foreground objects, cast shadows, haze in the distance, and the movement of near objects relative to far objects when the observer is in motion.

While filmmaking doesn't now rely on stereopsis, all the other clues, and no doubt other factors as well, play a part in our appreciation of the world in depth in film.

Let's examine the motion of near objects with regard to their background. The most familiar example of this is telephone poles along the roadside seen from the windows of a moving car or train. Hills in the distance remain essentially fixed in their position. This relative motion of the foreground with respect to the background gives the scene three dimensionality.

Moving a camera, in or out, or from side to side, can result in this kind of three-dimensional effect. Panning and zooming either flatten the world, or, more accurately, they add nothing to the perception of depth.

People usually approach shooting from a strangely alienated point of view. They tend to stand back and use their longer focal lengths to get close. Now sometimes this is just what you have to do if, for example, you are shooting strangers and getting too close might make people uptight, or you might be standing back to keep out of danger and so on.

Sometimes this use of longer focal lengths is very effective. It allows a filmmaker to show what's happening in a scene with a minimum of effort. And most of the film shot for the movies and TV, and for the home movie screen, is done just this way. But there can be disadvantages: filming with long focal lengths from distances can lead to unsteady images, since it is very difficult to handhold greatly magnified images. The obvious cure is to use a tripod. But unless there is a good reason not to, I prefer to promote the use of handheld camera shooting for super 8.

I think you are likely to get more intimate results by getting close and using shorter focal lengths or a wider angle approach. Moving your camera and body may be more effective than standing back from the world and zooming and panning. You can practice this by using your camera without film, or by merely pretending you have the eye of the camera as you go about your daily activities.

Of course, if you are trying to suggest a coolness toward your subject, you may prefer the long focal length approach. But using the wide angle setting, getting close, and moving yourself with your camera to explore your subject will probably pay off in a number of ways. It's far easier to handhold wide angle focal lengths than long focal lengths because the image is less magnified so you will get smoother, steadier images.

You will have little trouble with having to refocus your lens when you move in and out because super 8 lenses of short focal length have a great deal of depth of field. By contrast, when using longer focal lengths and standing back, you may have to refocus often to keep a moving subject sharp. Using shorter focal lengths and moving your camera and body will add the depth quality I have been describing, and at the same time, your close proximity to the subject will heighten intimacy with it. By contrast, long focal length zooming and panning lead to a flat perspective of the subject and a more standoffish feeling to your shooting.

Exposure Control Here are the major ways of controlling exposure: you can change the f stop, alter the variable shutter, add a filter or change the fps setting.

Practically all super 8 cameras offer automatic exposure control, and many simpler super 8 cameras don't even allow you to set the f stop, with the possible exception of a one stop opening for backlight situations. Some super 8 cameras, inexpensive and usually externally simple machines, don't even show you your f stop.

The only excuse for cameras that rob you of the ability to set your choice of f stop or even know what stop the electric eye has selected is that they work well most of the time and cost less to make because of this compromise. But no matter how lacking in creative controls and operator manipulation, there's still no excuse for the omission of a backlight control. There are just too many everyday situations when the automatic meter can be fooled.

Backlight is strong, bright light, typically illuminating a person's head from behind. Say the sun is at 45 degrees to the horizon, and your subject is facing away from the sun and into the camera. Properly exposed this configuration yields some of the loveliest and softest portraits of the human face.

If you look through your viewfinder you might be seeing a face lit essentially by light reflected from the ground and light from the ambient sky. Behind your subject is the bright blue sky and sun. The meter sees this bright surrounding and since it responds to an average balance of light and dark, it will conclude that your overall subject is very bright and stop down the lens. The result is underexposure and a consequent darkening of the face and loss of detail. The cure is to activate the backlight control, which usually opens the lens up one stop, say from $f/8$ to $f/5.6$. This exposure will record the face much more as you yourself are seeing it.

Similarly, there are other times when a backlight control is useful; and you can decide these conditions for yourself simply by looking through the finder and seeing if there are very bright portions of the scene that will fool the meter into underexposing more important areas of your shot. Your automatic lightmeter is a good instrument

and works well within its limitations, but you have to know what they are and exercise your own decision-making power by being able to estimate the exposure yourself. There still is no mechanized substitute for experience and common sense, the hand and eye of the beholder.

Another feature that some cameras have is an *f* stop freeze control. Once activated it will lock the *f* stop at whatever aperture the camera has selected. An *f* stop lock is especially useful when panning to regions of varying brightness that could upset your overall exposure. A typical example might be indoors, moving the field of view of the camera around a room. When the electric eye sees light bulbs, or in the daytime light through a window, it's going to stop the lens down, underexposing your main subject, usually people. The same kind of thing can happen outdoors if bright sky or sun get included in the shot.

Most of the time, if the automatic meter is going to screw up, it will be in the direction of underexposure, producing darker images. Sometimes though you may encounter situations where the meter will be fooled into overexposure for images that are too light. Some cameras have a control for this fairly rare occurrence that will close down the meter a stop, say from *f*/2 to *f*/2.8. One situation that readily comes to mind is stage photography, when your subject is in a spotlight and the field of view of the lens includes a great deal of surrounding black. In such a case the meter will be fooled into opening up too much.

You have to remember that a lightmeter is adjusted to set proper exposures for absolutely typical situations in which light and dark elements of the shot add up to a given intensity of reflected light. If the elements of the shot add up differently, the meter will be fooled.

Cameras that allow for the manual setting of the *f* stop as well as automatic setting are extremely versatile. You can compensate for backlit situations or make any other alterations you desire. For just about all of my shots, I find I get better exposures if I set my camera to manual, after basing my decision on the stop the electric eye thinks is correct.

What it comes down to is this: I observe the *f* stop the camera selects, usually by the indicator I see through the lens. If I agree with it, I set the camera to manual; if it has an *f* stop lock, I use it to keep the diaphragm setting constant. If I disagree with the exposure reading—based on the illumination of the most important subject, portion of the subject, color or density of the subject— either I will open up or close down the lens (choose a numerically lower or higher *f* stop) and then fix the setting. (Almost all such corrections require opening up the lens, or choosing a numerically lower *f* stop.)

I do this because, for most exposure situations, no change in

exposure during a shot is far and away better than poor automatic exposure correction: if a subject moves against a background of sky and I pan to another, brighter region of the sky while following my subject, the meter, reacting to the brightness will stop down the lens. The subject will noticeably darken, and this usually looks terrible on the screen. A fixed stop would be better here than one that varies this way. And there are other situations where overcontrol by the autometer will mess up your exposure. For example, if someone wearing white walks into the scene, many sensitive meters will stop down. Nothing looks more foolish to me.

The key to exposure control is visualization, or previsualization if you like, of how your projected image will look on your screen in a darkened room. It takes practice to get it down, but between the built-in meter and your good sense, you should be able to achieve perfect exposure nearly all of time.

If you are in a situation in flux, where you will be panning or zooming from bright to dark lighting conditions, the autometer comes into its own.

Spot Metering One useful way to use the zoom lens is setting the longest focal length to find the exposure of a particular part of the scene, and basing your overall exposure on just that. Then you can judge whether the exposure should go up, down or remain fixed, in which case you'd just lock the meter and zoom back to your shot. This is called a spot metering technique, since you are basing your exposure on a small portion of the subject.

Variable Shutter If your camera has a variable shutter it will probably be used, most of the time, for effects, fades or dissolves. However, your variable shutter also allows you to control exposure. The variable shutter works by reducing the angle of the shutter opening. If your camera has a 1/40th second shutter at 18 fps, and you close the variable shutter down halfway, the new shutter speed is 1/80th second. For this approximately 180-degree shutter, closing halfway would give you a 90-degree opening.

Suppose you are shooting with a fast black and white film like 4-X reversal, and you find yourself outdoors without slower film. If the camera is going to overexpose your film because it's too sensitive to light and cannot stop down far enough, what do you do? Try the variable shutter. Some cameras have indented positions halfway closed, so you may conveniently fix the shutter.

Super 8 cameras do not couple the variable shutter control with the automatic diaphragm (except for the Nizo S-481, 561 and 801). If they did, when you tried to get a fade-out, the diaphragm would try to open up to compensate for the reduction in exposure.

You can also close down the shutter halfway and then open up the lens one stop. Of course you will be getting the same exposure,

but you will also be getting less depth of field. This can help to isolate foreground from background, just the ticket for an occasional shot.

Filters Usually the only filter a super 8 filmmaker needs is the one built into the camera, the 85 daylight filter. Many others are available, but the ones designed especially for exposure control are neutral density (ND) filters. They let you shoot with a fast film outdoors when your camera's diaphragm may be unable to stop down enough for good film exposure. A fast film like 4-X black and white, for example, may be overexposed (too light) if used in many cameras in bright sunlight. (In most cases it's best to use the slowest film possible—so in this case switch to Plus-X if you can.) The neutral density filter in place will cut back the light, permitting a proper exposure. These filters don't change the color balance of the light, and as you can see from the chart they come in many different densities.

Neutral density filters can also control depth of field, and as you may have noted, they are employed very much like the variable shutter. If, like most super 8 cameras, yours has a through-the-lens meter, it will automatically make the proper exposure compensation with the ND filter (or any filter for that matter) in place.

For most designs, with the major exception of XL cameras, the film in the gate area is in transport half the time, and only the other half is it being exposed. At 18 fps it takes about 1/36th of a second to position the film, and 1/36th of a second to make the exposure (page 44).

If we choose a speed of 9 frames a second, instead of the standard 18 fps setting, the film will spend half its time, or 1/18th second, in transport and 1/18th being exposed. It's easy to see that halving the fps rate doubles the exposure, and doubling the fps rate halves the exposure.

You can use the fps camera control at 9 fps when you don't have enough light to take your shot—and if you won't mind the screen action being sped up. If 9 frames per second are exposed in the camera, and 18 frames are projected each second, twice as many frames will be on the screen each second as were shot; so, in this case, the speed of the action will be increased or doubled. This is called undercranking or fast motion. Similarly if you shoot more fps than the projection speed, the projected action will be slowed down. This is called overcranking or slow motion.

The usual use of the fps setting is not for exposure control, but for slow or fast motion. A camera operated at 18 fps will produce footage, projected at 18 fps, that appears to have action of the normal duration. If fewer frames per second, say 9 fps, are used at the time of shooting, upon projection twice the number of frames

shot will be projected per unit of time, resulting in speeded up or fast action. On the other hand, slow motion can be achieved by shooting more than the usual 18 fps.

As far as I can remember, all super 8 cameras couple the fps control with the meter circuitry so that changing the fps rate will not alter the exposure, since the diaphragm will compensate automatically.

Penlight NiCads You really have to use alkaline cells, like Mallory Duracells or Eveready alkaline power cells for good results from your super 8 camera (or cassette recorder for that matter). This is especially true for a single system camera with its two motors for film and soundhead drive. Other super 8 cameras use power zoom and motor-driven electric eyes as well, so with these power-hungry machines you have to use the best batteries available.

The Ektasound 130 runs on six batteries, I am using a Eumig Mini 5 which operates on two, and a Sony TC 55 recorder has four. I found myself making trip after trip to the local store to purchase penlight or type AA energy cells, or what we used to call batteries. I felt that I was on my way to the poorhouse at $2.80 list for a package of four cells.

Now you may ask, why not try recharging the alkaline cells with any of the rechargers on the market sold for that purpose. Trouble is, according to my tests, they don't work worth a damn. One acquaintance reported that some of his actually exploded in the charger, and indeed the alkaline cells often carry a warning to that effect.

Why not use rechargeable nickel cadmium cells? Good NiCads have about the same current capacity as alkaline. The only thing that held me back was that NiCads are rated at 1.25 volts, while the alkaline cells are rated at 1.5 volts, and I was concerned about the fps rate of my cameras with a lower total voltage. The Ektasound 130 uses six cells in series for a rated total of 9 volts, so six NiCads would produce only 7.5 volts.

But I bought some Radio Shack NiCad penlights for $3.79 a pair, and a charger for $7.95. I followed the instructions, charging my cells for fourteen hours, and measured the voltage. It turned out to 1.35, not the rated 1.25 volts; so in the case of the Ektasound 130 I would have 8.1 volts. Then I shot the face of a clock with a sweep second hand. I found that the NiCads ran the Ektasound at exactly the same speed as the alkalines. While the alkaline cells were giving seven or eight cartridges per set, the NiCads powered more than ten cartridges per charge. My experience indicates that the NiCads can be recharged indefinitely, and the cost in electricity turns out to be less than a cent. So I don't buy alkaline cells anymore.

Although NiCads have proved a fine substitute for alkaline cells

in all the applications I have tried, most super 8 equipment is designed to be powered by alkalines, so I suggest you make your own tests. (GE also offers Perma-Cell brand NiCads.)

Tripods Despite the fact that I clearly favor the use of hand-holding super 8 cameras, I nevertheless recognize the need for complete camera steadiness for many purposes. The use of a tripod may more nearly suit the mood of your shot or film than any handheld technique. A tripod adds a sense of stillness and omnipotence, lending almost a kind of objectivity to the shot. Moreover the use of a tripod is the only really satisfactory way to shoot titles. And a tripod may be very useful for doing animation, or for steady results with very long focal lengths, or for many other uses you can dream up that I haven't listed here.

Don't make the mistake of assuming that because super 8 cartridge-loading machines are smaller and lighter than their counterparts in larger formats, you can get away with an extremely skimpy lightweight tripod. It doesn't work that way. As far as I know, you can't get a new steady tripod for less than $60 list. I use a Husky IV, made by Quick-Set. Many camera shops offer this tripod, or others very much like it. It is made of aluminum and has telescoping tubular legs that end in rubber tips. And the camera is mounted to a central elevator section which, for maximum steadiness, should not be extended. It has what is generally known as a pan head, allowing for pans, tilts as well as sideways adjustments that can be locked.

You can spend four or five times as much and get a relatively compact tripod with a fluid-type head that will allow you to make super smooth camera movements. Hervic for one distributes a compact tripod, the Hydrofluid Jr. for super 8 that would fill the bill nicely. Miller also supplied a very neat fluid-head tripod for super 8 cameras, its total cost (about $260) includes both head and legs, but each can be purchased separately.

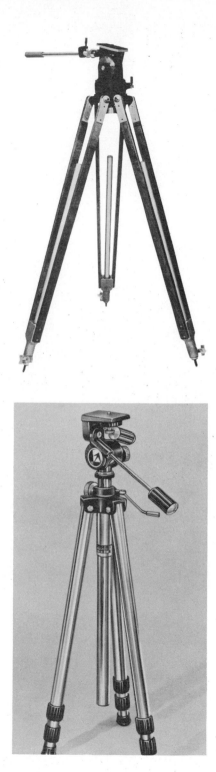

**Super Mini Hydro-
fluid Tripod**
Handholding a cam-
era is not a religion.
There are lots of times
when you need a
good tripod. (Hervic)

Husky IV Tripod
Very sturdy, and
worth its $60 list.
(Quick-Set)

SOUND

Harris B. Tuttle gripping an Ektasound 130. (Eastman Kodak)

History From inception movies were intended to have lip sync sound. According to Dickson, in 1888 and 1889 he and Edison projected images on an 8 by 10 foot screen in lip sync with an Edison phonograph. The projector's motor was governed by "the film stop-motion (intermittent) device, which made it impossible for one to get behind the other. This was done electrically from an auxiliary commutator on the phono-motor.''*

Although the description is sketchy, it's clear that Dickson and Edison provided double system lip sync sound as soon as movies moved. In double system a sound recording or reproducing apparatus, today a tape recorder, is run in sync with a camera or projector. The other alternative, a single system setup has the image and sound on the same piece of film.

But it wasn't until 1927 that the first commercially successful sound movies were introduced. The story goes that the Warner brothers were in such a bad financial shape that they were desperate enough to try anything. So they tried talkies, and the rest is history. Jack L. Warner, in his autobiography, *My First Hundred Years in Hollywood,* has vigorously denied that talkies were introduced only as a last-ditch attempt to save a sinking studio. Be that as it may, Warner Brothers studio gets the credit for the Al Jolson vehicle, *The Jazz Singer,* with synchronized musical numbers and occasional bits of dialogue. The system used, the Vitaphone, was the echo of Edison and Dickson's first efforts. However, in place of an Edison phonograph cylinder was a disk record rotating at 33 1/3 rpm. The rate of the turntable was controlled by the projector.

The big thing Vitaphone had going for it was amplified sound. Edison and Dickson had a hand here, for in 1883 they patented the Edison effect, the primary discovery that led to vacuum tube amplification.

*Terry Ramsaye, *A Million and One Nights,* (Ess and Ess Paper, 1964) page 68.

110

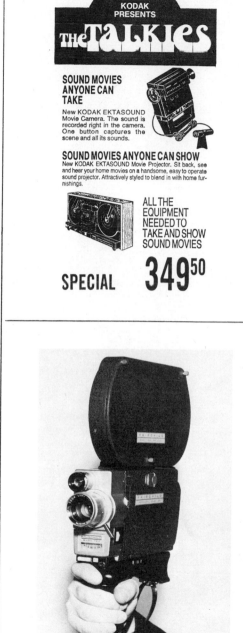

Ektasound ad, circa 1974 Super 8 is the least expensive moving image-sound format, whether film or video. The camera in the ad is an Ektasound 130, and the projector a 235. (Eastman Kodak)

SOUND

Fairchild 900 Shown with a 200-foot magazine. (Fairchild)

The original Vitaphone double system gave way, within a year or two, to optical single system sound-on-film. An optical record of the sound was photographed on a track alongside of the picture frame: image and sound were on the same 35mm print, but original recordings were still made double system.

In a very real sense, everything important about lip sync sound technology was invented by 1930; you can even argue that by 1889 Edison and Dickson had completed the basic work. It's amazing that it has taken about 85 years for super 8 to place the wonderful tool of lip sync motion pictures in the hands of the people.

Talkies arrive In the late summer and fall of 1973, the super 8 medium finally fulfilled the promise of its introduction in the spring of 1965. A variation on the original cartridge design was shown for shooting sound-on-film movies. A 50-foot cartridge—the Ektasound cartridge—and cameras designed around the device were offered to the public in August; then in November a 200-foot version, and the camera to accommodate it, were shown to the press, although two years were to pass before these went on sale.

In a nutshell, Eastman Kodak had done it: they made it as easy to make talkies—before, a technical farrago—as it is to point, press a button and shoot. And this is not only an incalculable boost for the home moviemaker or independent filmmaker, but a whole new dimension for television news and a host of other applications.

Although we are describing the fully realized system of Eastman Kodak, this is not the first time that somebody has tried to solve the vexing problems of easy-to-use, low-cost lip sync sound movies. Something heavy must have been happening in the heavens, for at the time the silent super 8 system was being announced, Fairchild was introducing their double 8mm automatic sound-on-film 900 camera, which pioneered servo drive, used eight years later in the Ektasound camera, and the German giant Agfa patented their sound-on-film cartridge, whose design is similar to the Ektasound cartridge. And all of this within the bullish month of May 1965.

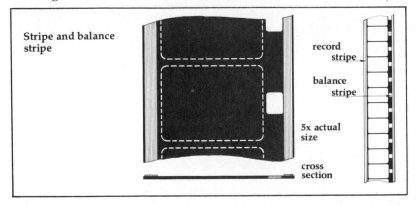

Stripe and balance stripe

record stripe

balance stripe

5x actual size

cross section

Super 8 Software Now here's how Kodak's 1973 system works: the sound film is encased in a rapid-loading cartridge. The plastic cartridge contains the usual super 8 movie film, but with this plus factor: the base of the film has gained a sound stripe of magnetic oxide. This simple addition makes super 8 a twin medium for image and sound recording. The tendency—especially when you've been working in the medium—is to think of film in terms of its image-storing capacity alone; but we have to expand our universe: super 8 now is both photographic film and magnetic sound recording film.

Before Kodak, the only people to make a serious attempt at super 8 single system sound was the Williamson Camera Company of Northridge, California. They modified the Minolta D 10 camera to accept a 200-foot magazine, and added sprocket drive and sound-head parts to the body of the camera. Something like fifty of these spool-loading $5000 conversions were sold to TV stations.

But most people wanting to make super 8 talkies still have to use any one of a number of double system schemes involving camera and tape recorder, usually tied together by a cable. Although double system components like this appeared from such luminaries as Bell & Howell and Fuji, with their respective Filmosound 8 and Puls-sync systems, many variations were offered by enthusiasts and specialists for use in conjunction with cameras produced by other manufacturers. Among these are (or were) the Carol Cinesound, Cine Slave, Hamton-MIT-Leacock, Farnell-Tandberg, Optasound and Rivendale systems.

It has been my repeated experience that systems like these are very difficult to make work, at least in the field when shooting, as well as for the postproduction procedures that are an intrinsic part of the process. But putting down all of these efforts with a blanket indictment would be as foolish as it is untrue. Some people have experienced happy results using the double system approach to sync sound super 8 shooting. But having to use two machines instead of one, in my estimation, more than doubles the complications.

For example, I have yet to find anyone who had consistently good results from the Bell & Howell system. Bell & Howell was forced, in effect, to opt for double system because they are weak on software and strong on hardware. If anybody could have made the double system approach work, I think Bell & Howell could have.

Kodak dominates film supply and packaging. Bell & Howell could not supply film with a magnetic stripe in a foolproof rapid-loading cartridge, so they did the next best thing: in 1968 they supplied a cassette recorder that ran in sync with a camera during shooting and then in sync for projection. Although the Bell & Howell system looks good on paper, it had many many bugs, and was phased out, as they say, by 1973. For the amateur, a single

system approach to sync sound is without a doubt the easiest way to go, but Bell & Howell and practically everybody else working in the field, has had—for reasons of software—to go for double system.

But all of these compromise double system approaches aimed at the home moviemaker or amateur were eclipsed by the introduction of the Ektasound system. And they deserved to be. As of this writing some are still on the market, but they cannot long endure.

But I haven't meant for all of this to be one colossal putdown of double system sound for super 8. One fact to bear in mind is that double system and single system have specific applications in the three related areas of filmmaking: shooting, editing and projection. As a matter of fact, some dedicated and serious workers may well have need for double system from time to time or on a regular basis. There are times when double system can get the job done better than single system. Most of the time, however, most users, I maintain, will be happier with single system shooting. The hard part about giving advice like this is that it runs counter to the practice of filmmakers for many many years; double system traditionally has been considered to be the very best possible way to record sync sound film. In the past this has been correct, but no longer. Technology marches on, like they taught me in school.

The promise of super 8 has always been the marriage of simplicity and quality at a low cost. And the ease of loading the Ektasound cartridge and the quality of its results fulfills every expectation. Kodak's system of super 8 sync sound may well be the most important advance for a revolutionary cinema.

The creators of a technology cannot control how it will be used. Even if Kodak had botched the job, we would be living with their system for years to come, so strong is their hold on motion picture marketing and technology. But they didn't botch it.

Like all other movie systems, the cameras are built around—

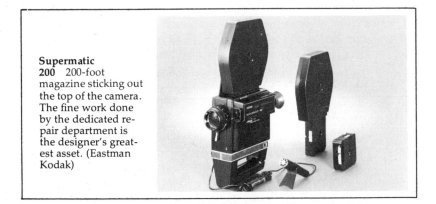

Supermatic 200 200-foot magazine sticking out the top of the camera. The fine work done by the dedicated repair department is the designer's greatest asset. (Eastman Kodak)

actually conform to—the film supply. The Kodak cameras are one basic design with variations: the original two were the Ektasound 130 (without zoom) and the Ektasound 140 (zoom). By the spring of 1975, Eastman offered the 150 (power zoom) and 160 (power zoom and rangefinder) and the Supermatic 200, based on the 140 design, with the ability to accept a 200-foot cartridge.

Soon after the introduction of the two basic Kodak machines, three cameras made by Chinon in Japan and marketed by GAF in this country appeared, as did the Beaulieu 5008.S with a choice of fast or slow zoom lenses. Bell & Howell quickly followed with their design, made in the B & H/Mamiya factory in Japan, as did Bolex with two models made in the Chinon factory, and Sankyo with one camera made, naturally enough, in their own factory.

And seen at booths at various trade shows or in the designer's studio, either proudly presented or surreptitiously shown, are single system cameras by Agfa, Bauer, Eumig and Nizo. Both Eclair and Arriflex have shown prototype machines accepting film loaded into their own metal magazines.

But enough of this. It's time to study the Eastman system for sound-on-film recording.

Sound Cartridge The 50-foot and 200-foot sound cartridges are based on the silent 50-foot design. The 50-foot sound cartridge is a little over ⅜ inch taller than the silent one, providing an opening for transporting film through the camera's sound recording mechanism. This sound interface, or sound port, is an open area on the bottom of the cartridge.

The sound cartridge does double duty: the image is recorded in standard fashion at the pressure pad at the camera's optical interface, and the sound is recorded by a magnetic head at the sound interface, just as it's done in a tape cassette recorder.

Super 8 film within the cartridge is sound striped on the base, or dark side. If you twist the film slightly in the sound interface so the

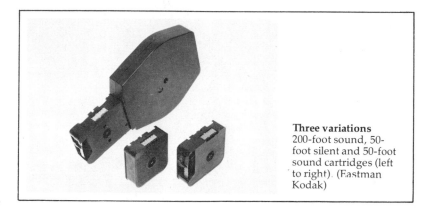

Three variations
200-foot sound, 50-foot silent and 50-foot sound cartridges (left to right). (Eastman Kodak)

115

base faces you, you'll see the brown record and balance stripes. The film emulsion or image recording side is a uniform light tan sort of color.

Besides the external size difference between the silent and sound cartridges, there are additional features built into the sound one enabling it to move the striped film smoothly by the soundhead. A nylon friction-reducing ring acts as a supply hub; at the tightest bend in the film's path, there's a roller bearing; and the antiback-up ratchet of the silent cartridge has a new wrinkle: it disengages in the sound cartridge when inserted into the camera. This is accomplished by the locating prong pushing against the back of the locating notch; this allows film to be taken up smoothly and quietly by the feed core.

At the standard speed of 18 frames per second for super 8, a 50-foot cartridge, silent or sound, will film for three minutes and twenty seconds. At the larger format standard of 24 fps—handed down to us unmodified from 16mm and 35mm—a 50-foot cartridge gives two and a half minutes of running time. Obviously, a 200-foot cartridge gives four times the running time for each given fps rate. But not so obvious is the fact that these cartridges have a kind of upward compatibility. The smaller cartridge will fit in the camera designed for a larger one. The 50-foot silent cartridge is accepted by all sound cartridge cameras, just as the 50-foot sound cartridge can be used in cameras accepting the 200-foot loads. But a 50-foot sound cartridge, 0.6 inch taller than its silent counterpart, cannot fit into a silent camera.

Ektasound 130 I think the Ektasound 130 camera is one of the best values ever for consumer bucks; at the same time it's a landmark in motion picture technology. Although it has received less ballyhoo in the popular press, it is as important to the history of photography as the Polaroid Land SX-70 with its two-second ejection of a processing color photo.

Ektasound 130 The least expensive sync sound camera in the short history of motion picture technology. (Eastman Kodak)

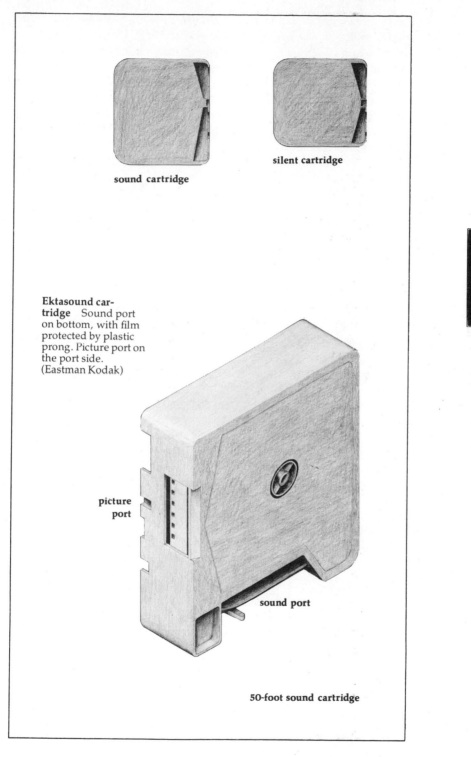

sound cartridge

silent cartridge

Ektasound cartridge Sound port on bottom, with film protected by plastic prong. Picture port on the port side. (Eastman Kodak)

picture port

sound port

50-foot sound cartridge

The Ektasound 130 accepts the 50-foot Ektasound cartridge loaded with Kodachrome 40, Ektasound 160, Ektachrome SM or Ektachrome 7242 magnetically striped film. As it exposes picture at the optical interface, it records sound in perfect synchronization with that image at the sound interface. Thus the 130 combines the function of both movie camera and cassette recorder.

The 130, which I have seen discounted as low as $149, is both XL camera and lip sync filmmaking instrument. This is the least expensive instrument for shooting talkies. The 130 and other Ektasound models are the direct descendants of their silent XL counterparts. The sound cameras side load and are held by a bottom grip. You see, the designers had to forsake the benefit of binocular handholding because, for now at any rate, cameras accepting the Ektasound cartridge must side load to allow for the sound interface of the cartridge to match up with the soundhead parts of the camera.

Cartridge loading and unloading is as simple in this camera as it is in silent cameras. After all, except for the sound interface the Ektasound cartridge is basically the same as the silent super 8 cartridge. Cartridges are loaded by swinging open the side door, left side of the body lens facing you, and introducing the front edge first and pushing down. If you ever have had to thread a 16mm single system sound camera, you'll realize what this means. Sixteen mm machines are difficult to load, contributing to the high failure rate that 16mm TV news teams experience.

The loading side of the camera has three electrical inputs. Two are for your microphone, and the other is for an external 9-volt power supply you can buy to hype the six internal penlight cells; this is especially useful in cold weather shooting when battery power falls off.

The finder side of the camera has a switch for activating the built-in type A filter and a button for testing drive-battery strength. Depressing it for a second should set off a blue light through the finder, just below the picture rectangle. No blue light—change

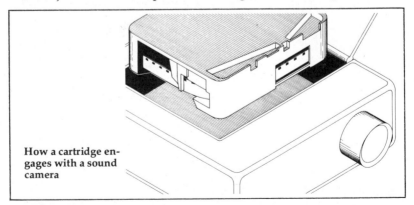

How a cartridge engages with a sound camera

your batteries, which are housed in the grip. The battery cover swings out of the way for access, and it is unlatched by turning a slot immediately adjacent to the tripod socket.

The run button that sits on the back of the grip is thumb activated. Not far from this button is a continuous run control which, when pressed down, keeps the camera going after the run button is pushed.

Next to the finder eyepiece is the footage counter making you aware of how much film you've shot. It's just about the worst footage indicator ever. It's terribly difficult to read at a glance, especially indoors. It seems designed to tease rather than tell. But on the plus side, a broad black arrow appears at the top right side of the finder about ten seconds before you run out of film and descends to about midpoint by the time the cartridge has run out. It's hard to ignore this warning device.

Servo Drive The basic design problem for the Ektasound 130 camera (and all similar super 8 sync ones) are these: how does the intermittent, or pulsed, motion of the film at the gate get turned into the smooth film flow needed by the soundhead at the sound interface? There are only 18 frames, or three inches of film, in which to accomplish this. Next: granted that we can smooth out the film flow, how can the loop between aperture and magnetic soundhead be kept precisely at 18 frames for exact lip sync? All other single system cameras use sprocket wheels to drive film past the gate and soundheads. In this way the length of the loop is mechanically fixed. The Ektasound cartridge has no sprocket wheels.

The general solution to this problem for camera design, called servo drive, first appeared in the Fairchild 900 sound-on-film double 8mm camera (page 12). The designer of the 900 is Hans Napfel, formerly of Zeiss. When Napfel came to Fairchild in the early '60s, they were making a sound-on-film 8mm camera, but it was not a precision machine. Napfel totally redesigned the camera and produced the 900, whose most important innovation was servo drive.

130 viewfinder The arrow appears during the last ten seconds of filming. One bottom light indicates inadequate illumination for a good exposure, and a second fluctuates with the sound level.

This concept has been used in Fairchild rear screen cartridge-loading projectors, in the Fairchild-Eumig 711 projector and now, in its present form, in the Ektasound cameras and Kodak super 8 magnetic sound projectors.

Since we are specifically concerned with the present 130 camera, here's how it works: it has two motors, one to work the intermittent, or camera drive, mechanism—the same as that found in all silent machines—and the other to drive the flywheel and sound capstan assembly. The capstan is the metal shaft that drives the film held against it by a rubber pressure roller. It's the turning capstan, a system used in all tape recorders, that smoothly moves the film past the soundhead. The capstan motor drives a flywheel; the capstan is actually an extension of the flywheel.

The capstan is motor driven at a constant speed of 3 ips at 18 frames per second. The intermittent motor (nominally 18 fps) must match its rate to that of the capstan. It's important to note this here: in the usual sound-on-film camera (or projector), the flywheel is actually driven by the moving film, which is advanced through the machine at a constant rate by claw and sprocket wheels.

Here's how servo drive works: the intermittent motor's speed is responsive to a spring-loaded loop-sensing switch. The loop sensor touches the bottom of the film in the sound interface. It senses the size of the loop between aperture and soundhead. If there are, for example, more than 18 frames between the two, the loop sensor tells the claw exactly how much faster to go, on an exact moment-to-moment basis; if the loop is too small, it tells the claw to slow down. This establishes the proper image-to-sound separation needed. So while sprocket-driven single system cameras use mechanical means to maintain a fixed loop, the Ektasound 130 uses electronic sensing.

The speed control of the intermittent is also electronic and virtually instantaneous, since the loop sensor can immediately sense the result of its correction; based on this, it can make further, more accurate calculations. When a silent cartridge is placed in the camera, it runs at 20 fps, which is acceptable for silent movies supposed to be shot at 18 fps. Since the silent cartridge is some 0.6 inch shorter than the sound device, it doesn't engage the soundhead parts. The intermittent motor is set to drive the film at 20 fps. It's the servo drive that holds it to a steady 18 fps, based on the size of the film's loop.

Optics and Electronics The Ektasound 130 lens is a prime, or fixed, focal length six-element, 9mm, f/1.2 Ektar, rather than the 9 to 21mm, f/1.2 Ektar on the Supermatic 24 (page 78). Optical quality, compared to the 24, is similarly good, as is the unalterable auto-exposure system. But the important difference is that the lens is

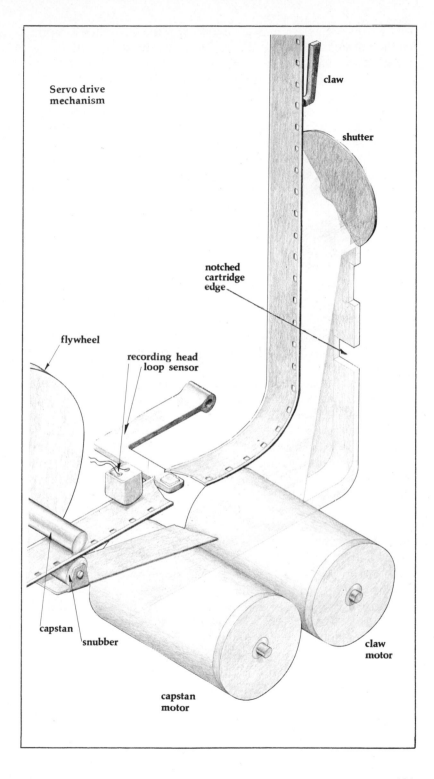

Servo drive
mechanism

claw

shutter

notched
cartridge
edge

flywheel

recording head
loop sensor

capstan

snubber

claw
motor

capstan
motor

SOUND

121

nonfocusing, the designers reasoning that there's enough depth of field at 9mm. While this is correct outdoors with the lens stopped down, it's a pain in the ass indoors with the lens wide opened producing shallow depth of field, in which case you can't get closer than eight feet.

The camera's sound recording machinery and electronics work well. There's rarely any audible wow or flutter—that is, inconsistency of speed—for voice recordings. The automatic volume control works efficiently, and I don't miss having a manual sound level control. There are two mike inputs, the standard one, and one which attenuates the recorded sound by 10 decibels (db). The alternate lower level input is useful, according to Kodak, for suppressing camera noise reflected from walls in small rooms. A similar high and low input was also used on the 1965 Fairchild 900. The low level option is especially useful for close miking when the camera is near the subject, but it is rarely needed.

The frequency response of the camera is a claimed 150 to 500 Hz, which is just right for voice recording. Some recorders, like the Stellavox, are able to roll off, or turn down, low frequency response for voice recording, since all that usually can be heard below 200 Hz is unwanted rumbling sounds, like traffic noise.

The microphone that comes with the 130 is an omnidirectional, or all-direction, device. It indiscriminately hears sound coming from every which way, when all you usually want is directly ahead of your camera. Moreover, this microphone won't pick up the rich, full sound of voices. It's exactly like the mikes that come packaged with tape recorders. Most of the time, the best thing you can do with this microphone is leave it in the box.

Treat yourself to a good low impedance (200 to 600 ohms) directional or cardioid microphone, costing about $50 to $150 (or even more). Electro-Voice, AKG, Shure and many other manufacturers supply at least a score of suitable models. Check out the line of Sony electret condenser directional microphones for inexpensive good designs. The models ECM-19B, 250, 21 and 280, with prices from about $30 to $80, look promising. I use a Sennheiser 421, a microphone which set me back about $120 in 1969. (Today it's $155.)

Because of its two motors, this camera uses a lot of power. The instruction booklet claims a ten-cartridge run with each set of six AA alkaline cells. You certainly won't get more, and usually not even that many. Use the battery check button to see the blue warning indicator through the finder (it's difficult to see—blue is just the wrong color, especially when you're out-of-doors). If the blue light isn't bright, change the AA cells. I suggest you try more dependable NiCad rechargeable cells (see page 105). They'll save you money in the long run, and your camera will run better with them.

Don't be offended by the faltering sound of the camera as it starts up. For the first second or so, the intermittent motor strives to reach the rate of the flywheel motor. While the camera is getting up to constant speed, the recording amplifier is turned down. Then the sound automatically fades up.

It's easy to trim out the portions at the head of each new shot that have no sound, although there are times, between scenes for example, when it makes the perfect transition. More about this when we get to editing sound movies.

One last word of advice. Try to always use your camera with the lock switch set after depressing the run button. The designers ought to change the run button, allowing it to remain depressed until you push it again to end the shot. The thumb-actuated button just takes too much effort to keep constantly depressed, and if you let off on it even a little, you will get some wow and flutter.

I think it's very important to realize that the 130 is a new kind of sound-on-film camera; we can expect continuous development and variations as designers learn more about it. Despite the fact that the 130 is only as noisy as the average super 8 camera, it's too noisy for a really first-rate sync sound machine. I expect that designers of even low cost cameras like this one will learn how to quiet their machines, and eventually include built-in microphones like the electret condenser units built into video cameras and many good cassette recorders.

If you were one of the human guinea pigs who bought one of these machines during the first year of sales, you deserve to have Eastman do the appropriate repair work. Or you deserve another camera. A lot of people had a lot of trouble with these cameras, and I went through three of them averaging twenty cartridges or so before a final breakdown. The good thing about Kodak, though, is that within the first year the guarantee is very good, and they promptly repaired or replaced each camera within two weeks. (But they don't replace film screwed up by the machine.)

The Eastman engineers discovered that in the first place, the soundhead parts were not self-cleaning as the early instruction booklets stated. It's easy to clean the soundhead parts with denatured or rubbing alcohol, as outlined in the instruction book or supplement prepared by Kodak, but a closed loop Ektasound cartridge with a cleaning film similar to that used for cassette recorders might make an interesting product that could clean the soundhead parts without any fuss at all.

The Eastman engineers also improved the switching, and I know the thumb switch on successive machines got easier to actuate, although it is no dream by any means. One or both of the motors were improved, and you can really hear the difference when the

camera starts up. You can also see the difference on the screen. The first second—silent to prevent unpleasant fluttering sounds as the camera gets up to speed—used to have fluctuating exposures. Now the exposure for the first second is more or less constant.

The microphone inputs have also been moved, and this, has resulted in a decided reduction of background noise, which was a low crackling in the middle frequencies, probably a result of induction from the motor's magnetic fields.

The situation became critical for a while, and a team of engineers actually traveled around the country opening boxes in warehouses and used special apparatus to update the cameras.

As a result of this first year of corporate confusion, the machines have gotten a "goon camera" reputation, as a colleague put it. By this he meant that the camera was aimed at an average buyer who would shoot a dozen or so cartridges a year in which case the camera might last very well. But cameras are to film as safety razors are to shavers. Eastman wants to sell film. That's the best part of their business.

For me, the most vexing thing about the Ektasound 130 and the other "amateur" Kodak sound-on-film cameras is the inability to do anything about the exposure. You would think that the people in Rochester would be into the user's getting a pictorially excellent image. The meter that can do this has yet to be added to a camera. It cannot be done with an automatic meter. No way. My four Ektasound 130's were fooled time and time again into underexposing anywhere from a half to two full stops in most (I repeat—most) indoor situations. That's either because of lights included in the shots, or because people are painting walls lighter colors these days.

Beaulieu 5008.S Certainly this is the most sophisticated and expensive single system camera to reach the public. Its price tag of about $2200 leads me to expect a lot of camera. At first glance it's a camera that sells itself. It's lovely to behold solid to the touch, a

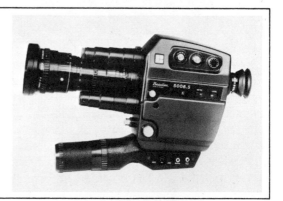

Beaulieu 5008.S
The arrow points to the lever release, added in the winter of '75. It can be retrofitted to existing cameras, at no cost. There are versions with a fast 6 to 70mm Schneider plus 8 and 48 fps, and a 3008.S with an 8 to 50mm Schneider and no manual sound level. (Hervic)

substantial machine, seemingly ready to do its owner's bidding.

Let's look at the lens before the body, since Angenieux, the respected manufacturer of zoom lenses, has come up with a brand new high speed interchangeable optic, the only super 8 lens they currently manufacture.

The new Angenieux lens has a zoom range of 6 to 80mm, with a speed of $f/1.2$ at 6mm, actually T stopping at $T/1.4$. The lens gets slower in proportion to the focal length and reaches $f/2.1$ at 80mm. Power zoom and automatic diaphragm have been retained, as you can see from the twin housings above and below the lens; but the 4008 lenses, while optically okay, will not operate automatically with the new body because of circuit changes (see page 71 for a review of the silent 4008 ZM II) and vice versa.

Unlike the 4008, power zoom is retained even after the body has been set for manual exposure control, and a new servo system is used to reduce aperture hunting for changes in exposure.

After the five-foot mark on the mount, there is an inscribed red line indicating close focus. It's there because the lens is subject to vignetting—darkening of the corners of the frame for certain focal lengths—when focused close. The instruction booklet is at fault here: it doesn't adequately explain how to use this close-focusing feature.

The performance of this hefty lens doesn't always match its statistics. I tried three 5008.S cameras; the first lens showed severe vignetting, like shooting out a porthole, for any focal length under 40mm when focused a little less than five feet.

The second example I tried had less vignetting; the lens peaks at about 11mm for the macro range. Despite this marked improvement in performance, this lens did not hold focus. That is, when zooming to a new focal length after having focused, the image lost sharpness.

The third sample, tested a year after the first two, performed admirably. Although this versatile 13.3 to 1 zoom lens is fast, the combination of lens and body put it a full stop behind the fastest XL cameras.

Manual zooming is a must for rapid focusing at 80mm, after which one returns to the desired focal length. The placement of the zoom lever here is diabolical: you have to reach awkwardly across the top of the camera to grasp it.

Fortunately for you Beaulieu fans, a less expensive version ($1650) of this camera is available with the fine $f/1.8$, 6 to 66mm Schneider Optivaron, the same lens offered on the 4008ZM II.

On to the body: the camera operates fairly quietly at 18 or 24 fps. The first rate Beaulieu viewfinder has been retained. There is manual setting of the gain, or one can choose the automatic gain control. The body had neatly laid out controls which are easy to operate.

There is a single frame shaft which can accept 60 or 50 Hz generators, or an Erlson switch, so the camera can do double as well

125

as single system sound; it can even do both simultaneously. However, earlier Beaulieu generators and Erlson switches do not fit this camera.

When I first picked it up I thought, how the designers have improved the grip! They copied the R16 grip with its built-in cylindrical NiCad cell; I have enjoyed using that comfortable 16mm camera for many years. The more efficient shutter—1/40th of a second at 18 fps, not the 1/65th of the 4008—was also borrowed from the R16. The goal here was to approach 1/28th of a second XL efficiency.

After shooting five cartridges in a row, my thumb began to swell, becoming bright red. And at first glance that grip had seemed so fine. The trouble is that the release button got in the way of my index finger, and placed an unnecessary strain on the thumb by blocking a firm grasp. This peculiar oversight has been rectified with the addition of a new lever release (see photo page 124).

Although film smoothly passed through the first camera I used, the second repeatedly jammed. The third sample I tested, made a year after the first two, ran perfectly well. It's highly probable that early production problems have been conquered.

Most people who operate a camera will sometimes want to watch the claw do its thing, if only for curiosity's sake or peace of mind. The first 5008.S machines would bend the loop sensor when run with the loading door opened, resulting in out-of-sync footage thereafter. A simple test with my most recent sample demonstrated that this defect has been eliminated.

While the camera ran far quieter than the $200 Ektasound 130, which you'd expect in a machine costing twenty times more, its sound was less than impressive. In most situations you won't pick up the camera's running noise with close miking, and you probably never will outdoors, but in small rooms, with reflective walls, you'll hear the camera on the track. In fact the camera noise level was on a par with the far less costly GAF 805.

Another disappointment is that the machine will not accept the 200-foot cartridge. Beaulieu tells me that they will design a new machine for the longer loads, but it's too bad that this compatibility isn't already included in a camera with such a steep price tag.

At the moment this is one of few sound-on-film cameras allowing both automatic and manual setting of both exposure and recording level. Both are set with the same pointer, similar to the one used in the 4008 (page 72). And my ears tell me it has the cleanest recorded sound. So love it or hate it, my work often demands it for its great range of focal lengths and manual control capability.

GAF SS Cameras GAF has distributed super 8 cameras manufactured in the Chinon factory in Japan for some time. These

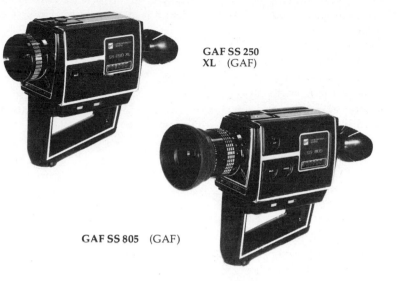

GAF SS 250
XL (GAF)

GAF SS 805 (GAF)

cameras are sleepers, that is they tend to get overlooked. But Chinon makes some very interesting machines with broad range zoom lenses, and a comfortable grip that may well have inspired the Ektasound camera grip design.

But I was surprised to see that Chinon, along with other manufacturers showing single system cameras, are offering bright light machines. I had supposed that single system sound and XL concepts were indivisibly tied together, but everyone doesn't agree with me.

GAF-Chinon offers several sound cameras (page 129) ranging from an under $200 box-type XL to the $550 505 XL. My immediate concern here is the SS 805, a bright light camera. All share the same basic body, which is an exceptionally rugged, heavy metal casting.

The 805 has a 7.5 to 60mm zoom lens, focusing to 5 feet, which I found to be of fair quality. The through-the-lens automatic diaphragm may be set manually. There is also a backlight control. The exposure system worked well. The lens also had variable speed power zoom. Wide open at $f/1.7$, the lens was soft. Stopped down to $f/4$ or more, the lens was a lot better.

The reflex viewfinder has a large circular coarsely grained focusing screen; it's adequate. Through the finder window you can see the f numbers, film run indicator, out-of-film indicator, and to the left, a green light glowing correspondingly to the fluctuations in the recorded sound.

The soundhead parts are obviously a direct copy of the Eastman mechanism, but with Chinon improvements since this camera ran better than the Kodak products. It gets up to speed virtually instantly, and the sound of its mechanism inspired confidence.

The camera runs at 18 fps only. But the camera mechanism ran as quietly or more quietly than the $1650 Beaulieu 5008.S. Recorded voice was exceedingly good. There was very little background noise, no audible flutter, and full, rich sound. In most situations, using a good directional mike, it's downright impossible to hear the camera mechanism when screening film, quite an accomplishment for so relatively low a price tag.

The camera is driven by six penlight cells housed in the grip. A six-volt silver oxide battery, Eveready number 544, fits into the body to operate the meter circuit and amplifier.

High and low gain recording control, similar to the Ektasound cameras, is offered, as well as a remote control input. The mike that comes with the camera has an on-off button, so the camera may be started and stopped from the mike.

I exposed 75 cartridges in the 805, and results were, to say the least, impressive. Practically all of the footage was usable, but better than that, image and sound were of good quality. The machine proved to me that a single system camera could be dependable.

I also had a chance to use the 250 XL, which has a 9 to 22.5mm, f/1.1 lens, that's rather good. It's certainly up to the standards set by the Kodak Ektars of just about the same specifications. The camera has reflex viewing on a bright aerial image screen.

Two things I missed having on the 250 XL was a focusing device and the ability to manually set the f stop. I contented myself with using a tape measure whenever possible, and guessing focus the rest of the time. In dimly lit environments, I put opaque tape over the adjacent meter cell to make sure the meter wouldn't be fooled into stopping down the lens if it saw a light bulb.

About a year after these initial efforts, GAF introduced the 505 XL with an exceedingly good 8 to 40mm, f/1.2 lens. The camera runs fairly quietly, and the quality of recorded sound is very much improved compared with GAF's earlier models: the 505 has far less background noise. My major objection to the design is the omission of a manual f stop control. I don't mind the lack of a manual sound level control nearly as much.

Manufacturing Trends We have seen sync sound cameras progress from the noisy running nonreflex Kodak offerings to more quietly running reflex designs all of which, except for the Beaulieu, are made in Japan. The GAF and similar Bolex cameras are made by Chinon, and Chinon has begun to market their efforts under their

SINGLE SYSTEM CAMERAS

MAKER	MODEL	LENS	SHUTTER ANGLE	fps	FOCUSING DEVICE	POWER ZOOM	REMOTE	EARPHONE MONITOR	MANUAL f STOP	SOUND LEVEL	200 FOOT CAP.	LIST
Bolex	550 XL	f/1.2 8-40mm	220°	18	X	X	X	X		hi-lo		460
Bolex	580	f/1.7 7.5-60mm	150°	18	X	X	X	X		hi-lo		460
Bell & Howell	Filmosonic 1230	f/1.3 8.5-24mm	200°	18				X		hi-lo		340
Bell & Howell	Filmosonic 1235XL	f/1.3 8.5-24mm	200°	18	X	X		X		hi-lo		390
Beaulieu	5008.S	f/1.8 6-66mm	170°	18, 24	X	X	X	X	X	X		1800
Beaulieu	5008.S	f/1.2 6-80mm	170°	18, 24	X	X	X	X	X	X		2400
Eastman	Ektasound 130	f/1.2 9mm	230°	18						hi-lo		209
Eastman	Ektasound 140	f/1.2 9-21mm	230°	18						hi-lo		314
Eastman	Ektasound 150	f/1.2 9-21mm	230°	18	X					hi-lo		364
Eastman	Ektasound 160	f/1.2 9-21mm	230°	18	X	X				hi-lo		414
Eastman	Supermatic 200	f/1.2 9-21mm	230°	18, 24	X				X	hi-lo	X	425
Elmo	300 SL	f/1.2 9-27mm	220°	18	X	X	X	X	X	X		400
Elmo	1000 S	f/1.8 7-70mm	170°	18	X	X	X	X	X	X		740
Eumig	30 XL	f/1.3 8.5-24mm	200°	18	X	X	X	X		hi-lo		400
GAF	SS 250 XL	f/1.1 9-22.5mm	220°	18		X	X	X		hi-lo		300
GAF	SS 505 XL	f/1.2 8-40mm	220°	18	X	X	X	X		hi-lo		550
GAF	SS 605	f/1.7 8-48mm	150°	18	X	X	X	X	X	hi-lo		360
GAF	SS 805	f/1.7 7.5-60mm	150°	18	X	X	X	X	X	hi-lo		400
Sankyo	XL 405	f/1.2 8.5-34mm	220°	18, 24	X	X	X	X	X	hi-lo		400

NOTE: All cameras have both automatic aperture and sound level. This list is not complete. More models are appearing even as we sleep.

SOUND

own name, a practice which has always been the case for Sankyo, Elmo and Bell & Howell. The Bell & Howell/Mamiya Company also supplies cameras for Eumig.

Sankyo, Elmo and the Chinon manufactured cameras now accept mikes mounted on short booms that hook up directly to the camera body, an accessory that works very nicely.

As of now only the Kodak Supermatic 200 can accept 200-foot cartridges, a situation which is bound to change.

Double System, the Basic Idea Unlike single system shooting, where one machine records sound and image on one piece of film, double systems require two machines for lip sync movies—a camera and a tape recorder. What this produces then in any double system sound scheme—and there are many variations—is two separate pieces of film or tape, one for image, the other with sound. The trick in double system is getting and keeping the film and sound track in frame-for-frame sync, so that ultimately a length of image is exactly equal to a length of sound.

If you attempt to use a camera and a tape recorder simultaneously—without a sync hookup—and then project the processed film and tape in sync, you'd discover you had problems. Because tape is capstan driven, it has a slight but distinct tendency to slip between the capstan and its rubber snubber; moreover, tape can change its dimensions with changes in temperature and humidity. This is not good enough for lip sync. Eyeball tests reveal that image and sound must be precisely locked together in sync to within plus or minus one frame accuracy. The heart of every double system scheme is the way in which image and sound are synchronized.

Thus, if we are going to use two machines for shooting lip sync movies, a camera and a tape recorder, there has to be some way to wind up with a perfectly in-sync combination of image and sound. There are many techniques used these days to achieve this end. In most cases a control track is used on the recorder. This track may be recorded at the time of shooting, or it may be recorded before shooting. The rate of the camera may be controlled by the recorder, or the recorder by the camera, or both machines may be running without any control, in which case the control track would be recorded while shooting.

The important thing about the control track is this: it stores the information necessary to synchronize sound with the image. Some people like to call the information stored on the control track, electronic perforations. In effect, this is correct, and electronic perfs are later matched with the image's perfs.

In some cases magnetic film (super 8 film fully coated with magnetic oxide for sound recording) super 8 recorders are used while shooting so that one winds up with equal lengths of picture film in sync with magnetic film sound. The mag film recorder can control the rate of the camera, or the camera can control the rate of the recorder at the time of shooting. Properly interlocked for projection, the image and sound can be run together in perfect sync.

If shooting were done with a reel-to-reel or cassette recorder, the sound may be dubbed to mag film for double system editing, or it may be dubbed in sync directly to striped picture film. The control track on the tape is used to achieve perfect sync, and there are many techniques available to attain these ends.

So far I have assumed that the camera and recorder are joined by a cable which carries the camera-derived control information to the recorder, or vice versa, as the case may be. But there is another technique that avoids cables, sometimes used by the double system worker, called crystal control. The idea behind crystal control is this: the speed of the camera is electronically controlled to within a few parts per million. If a mag film recorder is used, its rate is similarly controlled. If a cassette or reel-to-reel recorder is used, its control track is produced by a crystal controlled circuit so that it has the same kind of accuracy (page 139).

The mag film recorder-camera combination will produce in-sync lengths of mag film and picture film, and for tape recorders, in-sync transfers to mag film or striped camera film are also possible.

We will return to these ideas in short order and at greater length, since a little repetition won't hurt in this relatively complex subject. But let me go back for a moment and try to put some of this information into historical perspective.

History of Double System Double system sound got started with movies in the laboratory of Thomas Edison. Warner's Vitaphone system linking disk and film rapidly gave way to single system projection with an optical track record of the sound printed alongside of the image. But original recordings using double system equipment were still made in the studio. Both camera and recorder used synchronous motors driven by the same line frequency to stay in frame-for-frame sync. Since the rate of a synchronous motor is frequency dependent, using the same 60 Hz current for both would guarantee sync.

Recording machines in the early days used photographic film for optical track; this was a vast improvement over disks for the purpose of editing. After editing of image and sound, "married" release prints, containing both image and sound, were made: this simplified playback for the projectionist.

For newsreel work special single system sound-on-film cameras

recorded optical sound on film. The technique of using single system for news carried over to TV with this exception: film is now striped with iron oxide to record magnetic sound on the film simultaneously with the image. In this country people seem to agree that single system for news is the way to go, although in Europe a lot of double system work was and is still being done.

The Germans did a great deal of work on magnetic recording during the Second World War, and their efforts were greatly improved upon by the California-based Ampex Corporation. Within a few years after the war, optical sound recording equipment in the studios was converted to magnetic sound, and soon magnetic film recording equipment was designed from the ground up. By the '50s optical sound for making original recordings was all but dead, and magnetic sound for release prints was progressing.

Today the universal standard for 35mm theatrical release films is still optical sound, even though magnetic materials are used for all original recording and editorial work. Recent improvements in optical sound projection include the Dolby system for background noise suppression and interesting proposals for stereo optical sound. It is likely that optical sound is here to stay for 35mm (and 16mm), although 2.33:1 aspect ratio films are often distributed with four-track mag stripe sound.

For 16mm the original recordings are made on quarter-inch reel-to-reel tape traveling at 7½ inches per second (ips). A control track is recorded on one channel, frequently a 60-cycle tone produced by the camera for later resolving (transferring in sync) to 16mm mag film. These days the theatrical film industry has converted to the 16mm technique, and reel-to-reel tape with a sync pulse is used for shooting features.

The improved quality of magnetic tape sound over optical track sound encouraged the use of magnetic sound-on-film for standard 8mm in the late '50s. Eastman and Eumig produced magnetic sound standard 8mm projectors that were the precursors of today's super 8 machines.

But the desire for sync sound in 8mm became an absolute passion among dedicated workers, especially in England, where a host of double system techniques appeared in the early '60s. All these systems were based on running a standard 8mm camera in sync with a magnetic tape recorder. Usually the user would transfer the sound in sync to mag striped original camera film.

Super 8 gave amateur sync sound a giant shot in the arm and began to nurture people's "professional" aspirations. For one thing, all super 8 cameras used electric drive, a must for sync sound. Most standard 8mm cameras had used clockwork motors. For

another, the better quality of super 8 image and sound made the goal more appealing.

The late '60s saw the introduction of an interesting effort on the part of Bell & Howell, the now abandoned Filmosound 8 system.

The early '70s introduced the then most advanced super 8 double system ever to come down the pike, the Hamton-MIT-Leacock system. We'll bring up a few basic concepts about double system, and then we'll get back to this now discontinued system on page 140.

Sync Pulse For any double system scheme, the super 8 camera must be synchronized with a recorder. There are three kinds of magnetic recorders in general use: reel-to-reel recorders using quarter-inch magnetic tape, cassette recorders using the Philips-originated Compact Cassette and super 8 magnetic film recorders which record on super 8 magnetic film (sometimes called fullcoat).

All of these recorders are similar: basically they use the same kind of recording medium, usually an iron oxide material coated on acetate or polyester base. Reel-to-reel recorders have been around since the Second World War. The cassette recorder was introduced in 1964, a year before super 8. Although there have been magnetic film recorders in the larger formats for many years, only since the early '70s have quarter-inch reel-to-reel designs been modified for super 8.

There are at least forty models (page 135) of super 8 cameras having a single-frame switch. A few cameras had these switches, which are similar to the points of a car's distributor, installed for syncking electronic flash with time-lapse work. Although I am sure there are some people who will profit from intermittent illumination for cinematography with the built-in intervalometer, there are many other people interested in getting good double system sync sound. So what was originally intended for specialized time-lapse filmmaking has turned out to be more generally useful for sync sound. It is not too much to say that a camera manufacturer omitting this feature drastically reduces the versatility of his machine, no matter how many other features are piled on. There are also some fluke designs that have appeared using their own standard, like two pulses for each frame or one pulse every four frames. My best advice is to forget about these cameras for double system. Standards are a wonderful thing. They make life easier and they can save you money.

Some cameras use the PC contact which is actually the name of a specific kind of a connector, a cylinder about an eighth of an inch across. The name PC is derived from Prontor Contact. Prontor is the West German shutter manufacturer who introduced the connector for still photography. Some cameras use other kinds of connectors,

SOUND

133

CASSETTE SYNC SOUND RECORDERS

RECORDERS	SYNC PULSE	CONNECTOR TYPE
Bell & Howell Filmosound 8 (discontinued)	KHz burst	special
Chinon Synchrosound	1/2f KHz burst	
Elmo Cinematic SR-1	KHz burst	special DIN
Fuji Puls-sync Corder	KHz burst	DIN
Grundig C420	1/f spike or KHz burst	
Optasound Recorder	1/f switch recorder controls specially modified to camera	5 Pin 180° DIN
Philips 2209 A V	1/f spike or KHz burst	6 Pin 240° DIN
Scipio	1/f spike or KHz burst	6 Pin 240° DIN
Uher 124, CRZ10	1/f spike or KHz burst	7 Pin DIN

NOTE: The sync pulse column gives the type of signal the recorder accepts. KHz burst stands for a 1000 cycle burst. 1/f stands for one pulse per frame. The chart on page 136 shows the types of sync pulses. All the machines record the pulse on track 4, as shown on page 138 for the Scipio, with the exception of the Optasound unit which uses cine (perforated) cassette tape.

In addition to these cassette recorders, you can also use super 8 mag film recorders by Inner Space or Super8 Sound. Any standard Pilotone recorder used for larger format work, like the Nagra or Tandberg models, may also be employed with cameras that provide their own sine pulse, like the Beaulieus or Pathé. These cameras, or some Nizos providing a tone burst, can also be employed with any stereo cassette or stereo reel-to-reel machine, with one channel used for the pulse, and one for audio.

NOTE: The cameras listed on the opposite page can each provide a one pulse per frame signal for a suitable sync recorder. The Beaulieu cameras and the Pathé can also provide a sine pulse. The Nizo professional has a 50Hz pulse (used for European TV at 25 fps). The Nizo S560, S800, 481, 561 and 801 can also provide what is called a tone burst for each frame. Cameras with a tone burst or a sine pulse can be used with a stereo recorder, but cameras with a one pulse per frame feature require an appropriate sync recorder (see above). (Charts adapted from Super8 Sound).

DOUBLE SYSTEM
SYNC SOUND CAMERAS

CAMERAS	CONNECTORS	TAPE RECORDER STOP/ START
Agfa Movexoom 4000	special socket	
Argus 736, 738, 7310	PC	X
Bauer C-Royal 8E, 10E	8-pin Mini-DIN	X
Beaulieu 4008ZM2 4008ZM3	Erlson contact switch 50 & 60 Hz generators	X X
Beaulieu 5008.S	Erlson contact switch 50 & 60 Hz generators	
Bolex 450, 480	PC contact	
Canon 814E, 1014E	PC contact	X
Canon DS-8	Subminiplug (2.5mm)	
Elmo Super 110R	special plug	X
Fujica Z 800	sync pulse generator	X
GAF ST/802, ST/1002	PC	
Leicina Super RT 1, Special	special 9-pin plug	X X
Minolta Autopak-8 D12	PC	X
Nikon R8, R10	PC	X
Nizo 136, 148, 156, 136XL, 148XL, 156XL	PC	
Nizo S560, S800, 481, 561, 801	PC & 8-pin Mini-DIN	X X
Nizo 800 P Professional	PC & 8-pin Mini-DIN & 50 Hz generator	X
Pathé DS8	special 4-pin plug	
Rollei SL84	PC	X
Sankyo CME 444, CME 1100, CME 666	PC	X
Most Optasound-modified cameras	Subminiphone (2.5mm)	

SOUND

like mini plugs or whatever, for the electric connection between camera and recorder. Obviously, the important thing to look for is not the kind of connector, but rather whether the camera has a contact switch for producing what is called a digital pulse. A digital pulse is a single electric burst of information, one pulse for each frame exposed. In most cases the recorder itself supplies the current, leaving the switch to create the pulse by opening and closing. Specially modified recorders produce about 5 volts for the camera's contact switch. Only a few cameras, like the top of the line Nizo models, can actually produce their own electrical signal for output to the recorder.

The super 8 standard then, is a single pulse per frame for sync work. If I were writing these words a couple of years ago, I would have had to hem and haw and qualify this statement. Today, this is no longer true: systems based on other kinds of signals are not standard. Things have firmed up wonderfully well recently, and super 8 double system is healthier because of this standardization.

The larger formats have for years employed an analog, or sine wave pulse. In this country for films at 24 fps, a 60 Hz pulse has been used. That works out to a weird 2½ cycles per frame, but the 60 Hz frequency was chosen to correspond to alternating current.

When it was introduced, the sine wave sync pulse was a good idea. It conformed to the best ways people knew of for handling information for this kind of a sync application. Today's digital pulse is far less expensive, besides having the advantage of working as well for 18 as 24 fps.

The addition of a dynamo to generate a sine pulse adds several hundred dollars to the cost of a camera. The addition of a simple on-off switch for a digital pulse per frame adds pennies, and works as well, or in fact, better. A 60 Hz output at 24 fps may be fine, but if you choose to shoot at 18 fps, the super 8 standard rate, a 2½ cycles per pulse generator will produce a useless 45 Hz output.

Here's one possible way the digital pulse can be used: while the

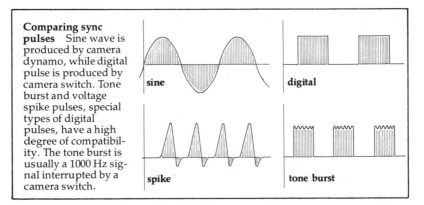

Comparing sync pulses Sine wave is produced by camera dynamo, while digital pulse is produced by camera switch. Tone burst and voltage spike pulses, special types of digital pulses, have a high degree of compatibility. The tone burst is usually a 1000 Hz signal interrupted by a camera switch.

sine

digital

spike

tone burst

camera runs, its pulses can be recorded on one track of a reel-to-reel or cassette tape. Nothing is controlling the speed of the camera or the recorder. The camera simply adds a digital pulse to the control, or sync track, for every frame exposed. This helps you wind up with image and sound that are finally in sync, but for now let's take for granted that a tape with an audio track and a digital pulse track can be used for syncking sound and image in some later step in projection or in the editing room. To make things specific, let's take a look at one camera-recorder possibility.

The Scipio conversion of the Norelco 150 cassette recorder, modified by Matt Skipp of England, is sold in this country by Super8 Sound. Take a look at the diagram of the track positions. The 150 is a monaural machine recording on half the tape. You can see that half the tape is devoted to audio information and a quarter of the tape to the recording of the digital pulse (drawing on page 138).

An open head is used for recording the pulse. It does not require any amplification because the incoming sync signal is off or on at 5 volts. (Another advantage for the digital pulse; the 60 Hz pulse requires recording amplifier circuitry.) That's enough voltage to set up a good field in the gap of the recorder's head without any help from an amplifier. This reduces cost since less electronics are needed to handle the sync signal.

The Scipio recorder sends 5 volts to the camera; the camera switch opens and closes once for each frame exposed, producing the digital signal shown in the illustration. This on-off signal is then recorded on the sync channel with an open head.

To use this system, in which the recorder provides the voltage for the camera to modulate, you have to have your recorder suitably modified, or buy one already modified. In the case of the Nizos, or any camera that can originate its own digital or analog pulse, a stereo recorder may be used to record the sync pulse output on one track while the other track is used for audio. This applies equally to reel-to-reel machines.

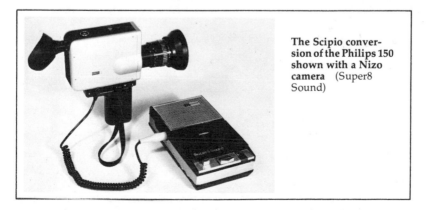

The Scipio conversion of the Philips 150 shown with a Nizo camera (Super8 Sound)

The weakest point about using digital pulse and the open head for sync is what's generally called cross talk, or specifically motorboating: the sound of a distant rasping like that of a motorboat, picked up by the audio track. But this varies with the make and the particular machine; for example, some Scipio conversions have practically no noise, while others have more. So you have to test the specific machine you are going to use or buy.

Start Marks To achieve perfect sync between image and sound, there has to be some way to start both together. There may be a perfect one-to-one correspondence between the tape's control track and the perfs of the picture film; but without being able to start the image and sound together during playback, sync cannot be easily achieved. So there has to be some simple way to reference both picture and track so that both can be started together.

The usual method for getting reference points, or start marks, on both film and track is to use a clapboard. At the head or the tail of the shot, the camera films the board and the recorder picks up the sound as the hinged arm is smacked together with the larger part of the board. This technique is sometimes called slating, since the lower half of the clapboard can be a slate for notes about the shot for later use in editing.

In the editing room, it is possible to observe the exact point, or the exact frame, in which the clapper is in contact with the slate. The picture can then be syncked with the loud bang of the clapper on the audio track.

These start marks provide a positive reference point for each shot. In most systems each and every shot must be referenced, either at the head or the tail. Of course it isn't necessary to use a clapboard. Filming and recording clapping hands can achieve the same end. Some systems have used what is called electronic blooping, to fog a few frames, or the edge of the film with a light in the gate of the camera, while a tone is being recorded on the audio or control track of the tape.

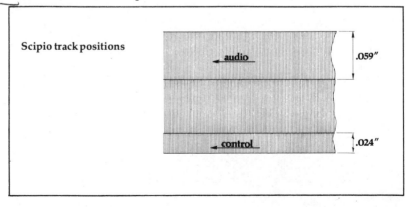

Scipio track positions

audio .059"

control .024"

Crystal Control In what has gone down so far, the camera and recorder are tied together with an umbilical cord. Lots of times the cord can get in the way. Freeing the filmmaker from the entangling umbilical has been one of the prime goals for designers of super 8 (and larger format) sync sound equipment.

Little quartz crystals, used in the proper kinds of resonant circuits, can provide an extremely accurate basis for an electronic wristwatch, or a camera drive system. The technique that has been universally adopted is to control the speed of the camera by using a resonant crystal with an extremely stable natural frequency. This quartz-crystal oscillator has a frequency of tens of thousands of cycles which must be divided down electronically to a useful value. The stable rate of the crystal frequency is compared to the rate of the camera's intermittent, and the intermittent is controlled accordingly.

This explanation is highly simplified, but I don't see any useful purpose in elaborating it. The important thing to understand is that servo control, like automatic exposure control systems, is employed here. The servo system watches itself, and based on observing its own rate, speeds up or slows down in a fraction of a second.

It works so well that it becomes possible to provide an accessory control system for a super 8 camera that can run in sync to better than half a frame for a ten-minute take. Crystal control units are almost always provided at 24 fps. I've never seen a crystal control designed for 18 fps, but there's no reason why it can't be done.

The silent Beaulieu cameras are the easiest to crystal control. They don't need any modification at all. Inner Space, Super8 Sound and Digital all make crystal control units for super 8 cameras. The Nizo cameras are another popular choice for crystal control, even though some conversion work is required. The Canon DS 8, requiring conversion too, is also used for crystal work.

So much for the camera, but what about the recorder? In the case of a super 8 mag film machine, the recorder can be crystal controlled

Clapboard or clapstick Usual information: working title, camera operator or director, production company (if any) and take, tape and film cartridge numbers.

139

(or more accurately, indexed) just like the camera. At the end of a shooting session, there will be a length-for-length correspondence between picture and camera film, and they will be in perfect sync. In the case of a reel-to-reel recorder or a cassette machine, the crystal reference provides the digital or analog pulse for the control track. In other words, an extremely accurate pulse, as accurate as the camera movement, will be laid down so that the tape can be eventually resolved to mag film or striped picture film.

One bonus of this approach is that several crystal controlled cameras may be used simultaneously, each in sync with the recorder.

Specific Systems We're now going to take a look at three ways of going about producing double system sync sound. The first system, the MIT-Leacock system is presented because it is of historical value. Although you can't buy it anymore, it has many features that are interesting because they come up again in later systems.

The two viable systems of major interest these days are produced by Inner Space and Super8 Sound. Like the Leacock system, they adapt off-the-shelf commercially available products, and when they have to, create their own components from scratch.

MIT-Leacock system The MIT-Leacock system was manufactured by Hamton Engineering Associates, Inc. of Norwood, Massachusetts. The system is no longer available. Business and technical trouble zapped it. It consisted of five major pieces of hardware that purchased together totaled about $7000. The hardware included a camera, a cassette recorder, a resolving machine, an editing deck and a projector.

The camera was an adapted off-the-shelf Nizo S56. Here's how Hamton modified this machine: it was blimped—quieted—to make it more suitable for sound work, and it was crystal-controlled to run at 24 fps.

The cassette recorder was a Sony TC 124 with a crystal-derived sync signal added to a control track. In this way the tape was indexed, or "electronically perforated," so it could provide a one-to-one correspondence with the exposed camera film after having been resolved to super 8 mag film.

The resolving machine was the first-rate Tandberg II. Originally designed for use as a reel-to-reel quarter-inch tape recorder, the Tandberg—like the Super8 Sound Recorder which it directly inspired (both were engineered by the same people)—had been redesigned for super 8 mag film. The audio and sync signals from the Sony TC 124 recording were fed to the Tandberg to produce a resolved super 8 mag film in frame-for-frame sync with the camera film.

Unlike the other components of this system, the editing machine

Leacock system
Cassette recorder, Nizo camera and editing bench are shown. Camera must film mike-mounted light when it flashes, and a tone is recorded on tape for start marks. This system is no longer available.

was built almost from scratch. It could handle a roll of picture film and a roll of mag film. Since it used a feed and take-up plate for each roll, it's called a four-plate machine. Because it was horizontally laid out, it's called a horizontal editing deck, or table. Film was projected on the surface of a rear screen viewer, and the sound was played through an adjacent squawk box, or speaker.

The final component of the system was a Bauer T 40 mag sound projector. It could be interlocked with the Tandberg resolving recorder, that is, run in sync, if picture and track were properly cued. With the movie completely edited, you'd have the camera original film, now sound striped, threaded on the Bauer. Then you'd use the edited mag film as the source for transferring to the camera film's mag stripe. After the dubbing procedure, you'd wind up with a super 8 film with standard magnetic stripe sound which could be played back on any super 8 magnetic sound projector.

With the engineering talent at MIT and the filmmaking knowhow of Ricky Leacock (who studied to be a physicist), an interesting system was bound to result. Leacock told me that the primary reason for the system's failure was that he and his engineering associates and the manufacturer, Hamton, were lousy capitalists, and couldn't get the business end of it together.

The system wound up costing twice its expected price. Although cheap by 16mm standards of available professional systems and equipment, the $7000 price tag was an insurmountable difficulty for most individuals. Such an expensive system, clearly, is not in the spirit of low-cost super 8 filmmaking.

Some people actually made films with the system, but I have heard so many reports of equipment failure, that without a doubt this also contributed to its demise.

Super8 Sound The Super8 Sound system consists of their con-version of a Sony TC-800B reel-to-reel quarter-inch recorder to accept super 8 mag film and other equipment which supports the use of super 8 fullcoat (fully coated—with iron oxide—magnetic film). They provide modified cassette recorders for field work, and modified projectors for running in sync with their Super8 Sound Recorder (the Sony modification to mag film). Super8 Sound also sells all of the forty cameras providing a digital pulse per exposed frame that can be run, unmodified, with their system.

They also sell editing gear for handling super 8 mag film, and a myriad of sync sound accessories, cables, microphones and the like. Most of the products they offer are unmodified off-the-shelf equipment that you can buy anywhere. But the heart of their system is the Super8 Sound Mag Film Recorder. (They also offer a modification of the 10½ inch reel-accepting Crown recorder, at $1700 for the monaural version.)

Super8 Mag Film Recorder As a field recorder, this $640 ma-chine will produce up to 380 feet (it uses five-inch reels) of super 8 mag film in frame-for-frame sync with the camera. Any of the many off-the-shelf cameras with digital pulse output can be used— unmodified—with this recorder. The speed of the mag film (which can run at 18 or 24 fps) is controlled by the speed of the film in the camera. As the mag film passes through the recorder, a photosen-sor counts perfs as light shines through them. The digital pulse of the camera is compared with the digital pulse produced by the mag film's perforations. In this way moment-to-moment correction may be applied to the rate of the film-driving capstan.

The Super8 Recorder is very versatile and will also sync itself with the large format standard 60 Hz signal used in some super 8 cameras like the Beaulieu 4008 ZMII.

If you look at a 16mm magnetic film recorder, you'll see spring-tensioned sprocket wheels used as mechanical flutter filters to smooth out the mag film's motion. The Super8 Recorder bypasses this elaborate, costly and really obsolete mechanical method of driving magnetic film by using photoelectric sensing and servo control instead, ensuring a perfectly smooth flow.

142

While the machine will pace itself to an umbilical connected camera, it will also run itself dead on in perfect sync (at 24 fps only) through the use of its internal crystal control system; so it may be used in conjunction with a crystal-controlled camera without connecting umbilical.

The Super8 Sound Recorder can provide super 8 mag film recordings from a variety of sources—microphone, tape or phonograph recording. Super 8 mag film used with super 8 picture film will allow you the flexibility of double system editing.

One major use of this machine is in conjunction with a Super8 Sound modified cassette portable, like the Scipio conversion of the Norelco Carry Corder (page 137). The digital pulse is recorded on the control channel during shooting, the audio on the other. Later, the Super8 Recorder in conjunction with the cassette recorder can resolve, or transfer in sync, the cassette tape to mag film so that it will be in frame-for-frame sync with the camera film.

The Super8 Recorder can also be used with single system, transferring to super 8 mag film the original camera film played back on a projector, thus allowing the flexibility of double system editing. For this you'd need a mag projector with some sort of simple device, like a reed switch, producing a digital pulse per frame so that the recorder can compare its speed with the speed of the projector. Super8 Sound will send you a modification kit for about $30, good for adapting most any projector. Modifications can also be performed by them, or a good repair man.

Up to six Super8 Recorders can be run together in sync so that you can mix from two or more mag film sources in sync, if that is your desire.

The Sony TC-800B is not a particularly distinguished reel-to-reel portable. Its construction simply did not inspire my confidence, but after using it, I changed my mind. The sound was first rate for voice recording, and very good for music too. The TC-800B was chosen for conversion, I would think, because it has an unusual speed

Super8 Sound Recorder
(Super8 Sound)

tuning control and a servo control drive system. The tuning knob will allow for setting the speed of the recorder plus or minus 5 percent of the set ips or fps rate.

When used for shooting with a digital pulsing camera, the VU meter is put in the sync mode and the state of sync can be observed on the meter. Once the tuning control is set to stabilize the meter and keep the pointer in the center of the scale, sync is guaranteed.

The most widely used mag film is the .003 inch thick polyester-based product made by Pyral in France, and available from Super8 Sound for $.03 per foot. This is what I have come to expect to pay for 16mm mag film. These prices are exactly twice what they should be. This being the case, I suggest that the Super8 Sound Recorder is best utilized in the studio or editing room as a transfer machine. It'll wind up costing far less for software used this way.

The machine may also be used as a squawk box (page 201) in the editing room.

Super8 Sound in operation It will be instructive if I give you more of an overview of exactly how it is possible to arrive at a finished sync track with the Super8 Sound system. Several varia-

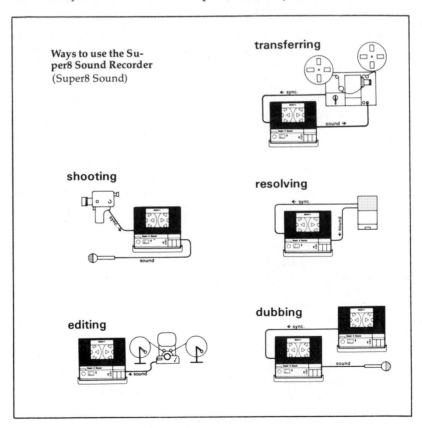

Ways to use the Super8 Sound Recorder
(Super8 Sound)

transferring

shooting

resolving

editing

dubbing

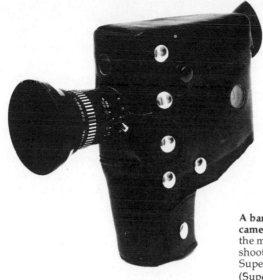

A barney for a Nizo camera Helps quiet the machine for sync shooting. $130 by Super8 Sound. (Super8 Sound)

tions are possible, but for simplicity I'll run through the most important way.

In brief, a converted cassette recorder produces a 5 volt output which is sent to the camera by the umbilical connection and interrupted once per frame by the built-in switch. Super8 Sound can provide one of several recorders for this purpose, or they can also modify one you may own if they've already done the necessary research and development. An open head for recording the sync channel must also be added.

During shooting the audio track is recorded on the sound channel, and the digital pulse is recorded on the sync channel. A clapboard is used at the head or tail of each shot for start marks.

The original cassette recording is dubbed to super 8 mag film from the original recorder to the Super8 Sound mag film recorder. The sync track output of digital pulses is used by the Super8 Sound Recorder to control its speed. It does this by comparing its rate with the rate of the cassette pulses. The mag film recorder produces its own pulses optically by a light-emitting diode shining through the perforations of the mag film. The phase difference between the internally produced pulses and the cassette recorder's pulses provide the basis for the moment-to-moment servo control of the rate of the mag film.

145

When resolving from cassette tape is completed, we have a frame-for-frame in-sync copy of the track on mag film. Now it is possible to edit the image and track using double system techniques (page 208), or we can transfer the sound in sync directly to the striped original camera film.

The processed camera film is striped by the user or sent out to a striping service (page 175), after which it is ready to be threaded onto a magnetic sound projector. This projector must be modified with the addition of a single-frame switch, similar to the one employed in the camera.

Now the Super8 Recorder and the modified projector are used together. The projector and recorder must start up so that the image and sound start marks are in sync. Both are plugged into what is called a common start box, nothing more than an on-off switch in series with an octopus power receptacle. You don't really need this special start box; all you need is an extension cord with power receptacles at one end. Both projector and recorder are plugged into the extension cord, and the cord is plugged into the line to start both simultaneously.

Although both will start up together, the machines will not get up to running speed at the same moment. This defect can be overcome by experimenting to learn just how much footage must pass through each machine for them to be running at full speed. Once this had been done, the appropriate length of leader can be spliced onto each shot, so that the start marks of each will be in sync when the image of the clapboard passes through the gate of the projector and the sound of the clap is heard through the recorder.

This is the crudest part of the system, and some attempt has been made to make things a little neater by adding a sensor to be held in front of the projector which watches a flash frame (frame of clear leader) at the head of the picture. This flash is used to trigger automatically the remote start function of the recorder.

Any projector which can start with film threaded in it will work

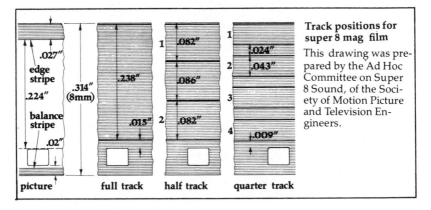

Track positions for super 8 mag film

This drawing was prepared by the Ad Hoc Committee on Super 8 Sound, of the Society of Motion Picture and Television Engineers.

Interlocked Eumig 807s Picture on one machine, and sound on the other, may be locked together. If one projector is reversed, so will the other, keeping in sync. When one stops, so will the other. Note that when using a mag film recorder and projector interlocked with sync pulses, it is impossible to maintain sync for stopping and starting and forward and reverse modes. Unit costs $900. (Super8 Sound)

for the common start technique. The flash frame technique is the only way to get the system to work for machines that lack a motor with sufficiently high torque to start under a load.

Once both machines have started up, the recorder provides the necessary 5 or 6 volts for the single frame switch in the projector to interrupt the current once per frame. The projector then controls the rate of the recorder, just as the camera originally controlled the rate of the mag film recorder.

In this way an in-sync transfer can be made from the original cassette to mag film and then to striped original. But the Super8 Sound system must use the mag film recorder. Sync transfers cannot be made directly from the cassette recorder to the striped original. My tests reveal this extra step produces no loss in sound quality, if everything is done carefully.

Similarly, Ektasound footage dubbed to mag film and then back again to striped original was absolutely perfect. This is a technique of importance to people who want to shoot single system, but edit double system. The best results I got were with an Elmo 1200 projector used with the Super8 Sound Recorder. The combination was impressive: the sound was far better than anything I have become used to for 16mm optical tracks.

Super8 Sound publishes a very complete catalogue. It's well worth the $2 it costs.

Inner Space systems If you think about it, there are two basic ways to go for super 8 double system sync sound. Super8 Sound has built an electronic interface (to use the current jargon) into a magnetic film recorder, while Inner Space has taken the other route: the electronic interface is a separate entity used between machines, like the recorder and camera. While the heart of the Super8 Sound system is their mag film recorder, the heart of the Inner Space system is their accessory interface Cine-Slave black box.

This is a very sophisticated and intelligently designed system, and exceedingly eclectic in the sense that it will interface with a great deal of equipment. The Cine-Slave control box is of modular design and can accept circuit boards that extend its application to practically any known sync signal or even crystal control. The basic Cine-Slave box costs $350. For $95 you can purchase the Sensit control box, which is the heart of Inner Space's editing system for use with magnetic tape, as opposed to magnetic film. Inner Space is now offering single function pocket-sized units, as opposed to the multi-function Cine-Slave.

Super8 Sound has gone the conventional filmmaking route by basing their editing procedures on the use of mag film. Inner Space favors the use of magnetic tape for what they call "real-time" editing. Recently Inner Space has also introduced a couple of mag film recorders (which must be used in conjunction with a control unit), demonstrating their willingness to learn from competition and further extend usefulness for their customers. I, for one, cannot believe that real-time editing of tape in conjunction with picture film is worth a damn, but according to Inner Space many of their customers really get off on it. But I'm getting a bit ahead of myself.

From what I have seen, based on a company demonstration and the experience of a friend who used this equipment, this is a gadgety approach to sync sound. By this I don't mean to put it down, because double system sound is inherently gadgety, but

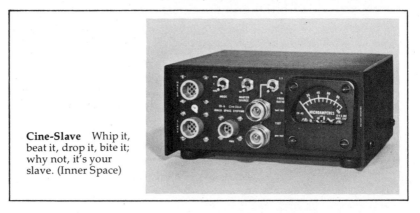

Cine-Slave Whip it, beat it, drop it, bite it; why not, it's your slave. (Inner Space)

having an interface outside of the equipment leads to more connecting cables than I am used to.

Inner Space uses the terminology *master* and *slave,* so I'll go along with them. A master machine is one which controls the speed of the slave. In the Super8 Sound system, when recording a sync track on a cassette recorder there is no master-slave relationship, but what is in essence a passive system. The Super8 Sound recorder, rather, has the ability to slave itself to camera or projector.

The Inner Space system is more flexible. You can decide to run it passively, or you can choose which machine will be master or slave. You need to have suitably modified equipment. Inner Space offers a number of modified reel-to-reel recorders which can be slaved to a camera with the Cine-Slave. Until very recently Inner Space has favored reel-to-reel machines, like the portable Uher 4000L. They started off by providing 16mm users with low cost sync sound systems, and the 16mm worker usually prefers reel-to-reel tape machines. They are more or less scaled to the size of 16mm. But cassette recorders are more appropriate in terms of size and ease of use, in my opinion, for super 8, and lately Inner Space has offered suitable cassette recorder conversions for use in the passive mode.

At any rate, the user is expected to prerecord a sync track on the quarter-inch tape. In effect, these become "electronic perforations," and they are the equivalent of the mag film perfs perceived by the Super8 Sound Recorder photo sensor. When a modified Inner Space recorder is used with a tape with a prerecorded sync track, the Cine-Slave box and an unmodified camera control the rate of the recorder.

The sync track may be prerecorded on the tape by using the 60 Hz line current stepped down in voltage by a suitable transformer. The camera may have a single frame switch. The Cine-Slave is able to compare the 60 Hz signal from the recorder and the 18 or 24 fps digital signal from the camera. By controlling the speed of the recorder, it can achieve perfect sync between the two machines.

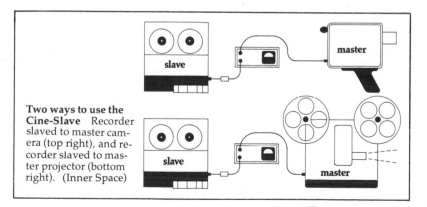

Two ways to use the Cine-Slave Recorder slaved to master camera (top right), and recorder slaved to master projector (bottom right). (Inner Space)

Actually, one may choose to use practically any reasonable frequency or type of waveform for the sync signals. The camera could have a 50 or 60 Hz output, and so on.

You can also run a modified camera in conjunction with a Cine-Slave box and a modified recorder, in which case the recorder can be the master and the camera the slave. The recorder then controls the rate of the camera. The Cine-Slave box compares the sync pulses of both machines, and then controls the power to the camera to slave it to the recorder.

You can also have what the company calls an auto-slating system, which is what I have referred to as electronic slating or blooping.

Inner Space claims that their recorders get up to speed so rapidly that it is necessary to slate a roll, even when made up of many shots, only once. If this is true, they have added significantly to the ease of using double system, since the slating procedure, with its clapboard, can be very distracting.

While Super8 Sound offers a separate crystal control package ($250) for use with a Beaulieu or suitably modified camera, Inner Space offers a circuit board ($150) that plugs into the Cine Slave, turning it into a crystal control unit.

I've only just sketched in some of the broad outlines of this system, so you will have to turn to the company to learn more about it if you are interested. I should complete my rap with an account of their editing system, but my heart isn't in it. I think only they can do it justice, since they have the necessary enthusiasm to properly explain it.

I just can't get a feeling for what Inner Space expects to achieve from editing tape in conjunction with picture film. While it is true that a sync track on the tape can provide the same information as physically cut perfs on mag film, electronic information must be handled electronically. I like to be able to physically manipulate mag film and picture film.

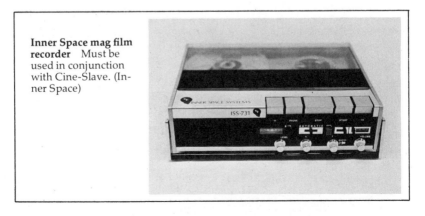

Inner Space mag film recorder Must be used in conjunction with Cine-Slave. (Inner Space)

Inner Space provides the wherewithal for projecting and transferring your double system recording in sync with any suitably modified projector. Instead of a single-frame contact switch, they use an optically derived pulse by shining a light through the film's perfs. That's just what Super8 Sound does for the control system of their recorder, and the optically derived digital pulse is similar to the mechanically derived pulse.

The Inner Space advantage here, compared with Super8 Sound, is that you don't have to transfer to mag film and then to stripe. The Inner Space system allows for direct transfer to stripe from the original quarter-inch recording.

The interesting part of comparing Inner Space and Super8 Sound systems, for me, is not how different they are, but, rather, how similar they are and how well their equipment will interface, or in plain English, work well together.

Philips Compact Sound Cassette For many sound recording applications, you'll find a good cassette recorder does a fine job, takes up little space and usually weighs under three pounds. I think we are at the point where good cassette recorders deserve the serious consideration of people who presently rely on bulky reel-to-reel machines for many kinds of field work.

The Philips Compact Cassette is practically the spitting image of the Fuji single 8 film cartridge (page 32), since the Philips cassette uses tape which is just about half the width of super 8 film—1/8 inch—the compact cassette is thinner than its Fuji counterpart. In fact it is only 5/16 thick compared with the Fuji cartridge's 1/2 inch.

The next obvious difference is that the Fuji device has rounded corners, while the Philips' is squared off. But more important, the tape in the sound cassette is entirely enclosed with felt pressure pads built in for good tape-to-soundhead contact, while film in the single 8 cartridge is open at the optical interface for insertion of the camera pressure pad.

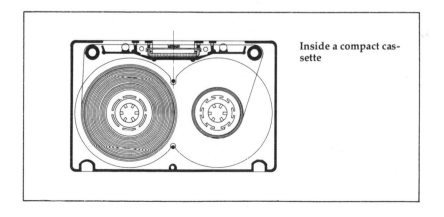

Inside a compact cassette

Otherwise the devices are remarkably similar. The film/tape path is the same, and the feed and take-up hubs have the same dimensions. Tape or film within both is reversible, that is, tape or film may be rewound—unlike the Eastman super 8 cartridge which allows for only very limited backwinding.

Many manufacturers offer compact cassettes with different formulations of oxide for recording. Usually this oxide is coated on polyester, and the only time you'll need to tape splice this stuff is in the unlikely event that it breaks. You don't edit sound in a Philips cassette: you must first copy (dub) your recording with a good quality reel-to-reel tape recorder or a super 8 mag film recorder.

Compact cassettes are offered in different thicknesses for varying playing times. You're usually better off staying with cassettes no longer than the C-60 variety, since the thinner tape has had a way of jamming too often to be really reliable. And it is subject to print-through to adjacent layers of tape for an echo-like sound. A C-60 cassette will play for thirty minutes monaurally or stereophonically on each side. Once you've run through one half of the tape, you flip it over and run it for another half hour.

Monaural cassette recorders record half the width of the tape at a time. There are stereo recorders that do this, but in two adjacent channels. When stereo tapes are played on a mono recorder, the mono head automatically blends or mixes both channels, so you can hear the entire program, but not stereophonically.

The loading of an audio cassette is simple. Just slip it into the recorder, usually rear end first, and press down. What happens is this: when inserted, a thin metal shaft—the motor driven capstan—engages a small hole in the cassette behind the tape. When the record or playback control is activated, a rubber roller is pressed against the oxide side of the tape, which faces front. With the capstan turning on the base side, and the roller pressing against the oxide side, the tape is driven from feed to take-up cores. A spring-loaded felt pressure pad is used to push the tape against the

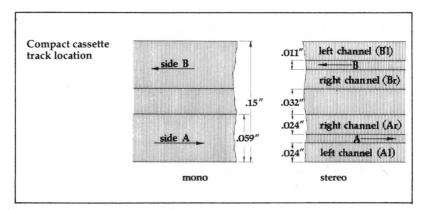

Compact cassette track location

side B / side A — .15" / .059" — mono

.011" left channel (Bl) / B / right channel (Br)
.032"
.024" right channel (Ar) / A
.024" left channel (Al) — stereo

record/playback head. Many machines offer an eject button for popping out the cassette.

Tape cassettes run only at one speed, the relatively slow 1⅞ inches per second. At one time this was considered a terrible disadvantage in terms of recording or playing back hi-fidelity recordings. But tape technology has advanced some in the decade since the Philips audio cassette was introduced: the sound from good quality recordings played back on the best machines is truly hi-fidelity, and the technology can only get better.

There are new low noise, high sensitivity oxide formulations, as well as the more and more pervasive Dolby B circuits for electronically enhancing tape sound by greatly reducing background noise or tape hiss.

So the twin bugaboos of the cassette system—low tape speed and narrow track width—have been overcome, even for inexpensively priced equipment and tape.

The Philips cassette is not to be confused with the automotive accessory Lear-designed 8 track cartridge, which is of no use to the filmmaker.

The Philips cassette has found its way into a number of super 8 double system recording schemes as I have noted in previous pages. The cassette is also important to the super 8 moviemaker who is making nonsynchronous recordings (sometimes called wild recording in filmmaking parlance).

You can use a ballpoint pen point or similar object to punch out the tabs in the rear. When this is done, the cassette will function in the playback mode only and it is impossible to record. Cover the hole with tape, and you can record once more. The ability to key the cassette for nonrecording is an important feature that can save you from disastrous reuse of a valuable tape.

Cassette Recorders There are many cassette recorders on the market, and not surprisingly, a number will serve very well for sync sound work, or for the recording of wild tracks.

Punching out cassette tab to prevent unwanted recording (Norelco)

Sony TC 55

I've had good results with a Norelco 150 Carry-Corder (about $60). This is the original cassette recorder, and it has been under continuous development for more than ten years. I think you may be happy with it if you don't knock it about too much, since the transport mechanism is sensitive to moderate acceleration. You may prefer one of the many inexpensive Japanese machines to this European effort. They usually offer superior keyboard controls. The 150 uses the less convenient joy stick. Super8 Sound provides a sync conversion of the 150, the Scipio (page 137). Unfortunately, the 150 is presently available in this country in limited supply.

If you are into two-channel or stereo recording, check out the Uher 124 ($800), or the Sony TC 152SD ($300). Properly modified, these machines can record both sound channels and a digital sync channel. Without modification they can record one audio channel, and a sync channel when used in conjunction with a camera that provides its own sync signal, like the Beaulieus with a 60 Hz generator, or the top of the line Nizo models with their generated digital signal.

Let me make this clear: there are forty super 8 cameras that have built-in single frame switches. They will work with a sync modified recorder that supplies a 5 to 9 volt current that can be interrupted by the switch. But an unmodified stereo recorder (cassette or reel-to-reel) will operate with the appropriate Nizo or Beaulieu with accessory sync generator, if you are willing to forego one audio channel. Since these cameras generate a tone, the amplifier of one stereo channel can properly handle the signal.

If you are planning to use these or any other recorder in a crystal control setup, you must have the proper accessory added for the crystal reference signal, and either of our specialized sound houses can help you here.

I've done a lot of recording with a Sony TC 55, a very compact cassette, only 4 by 5¾ by 1¾ inches. It costs about $200, and it's worth it. The quality of its voice recordings is not distinguishable from the best reel-to-reel portables, although it has a little too much flutter for first class music reproduction. The look and feel of it reminds me of the old Leica rangefinder cameras.

And then there's the Nagra SN which isn't a cassette even though it uses the same ⅛ inch tape. I suppose its designers figured they would get better quality from a reel-to-reel transport. But by doing away with the cassette, they eliminated the built-in pressure pads and use geometry alone to guide the tape past the heads, the way it's done on some of the very best recorders.

The $1500 SN is the same length and width as the Sony TC 55, but it's half the thickness and lighter. It is regularly used by the theatrical film industry for voice recording when planted on actors or actresses; it's probably the best miniature recorder anybody has made.

Cassette recorder accuracy It is very important to use the same recorder for the original recording and for dubbing. Some people think they are going to get better results by dubbing with a hi-fi cassette deck, and maybe this is true, if it can be speed-tuned. The trouble with using a different machine for dubbing is that cassette recorders usually aren't better than 2 or 3 percent accurate. If you don't want to change the pitch of recorded voices, or the running time of the recording, you have to use your field machine for dubbing.

The interesting thing is this: while the overall error may be plus or minus 3 percent for any individual machine, it's not unusual for cassette machines to hold their operating speed to an error that can be measured in tenths of a percent. This means that your recording can sound exactly like the original, when played back.

It also means that for brief segments it is possible to do a wild track in perfect lip sync, providing you have a magnetic sound projector that can be made to run at precisely the same speed as your camera. The Eumigs, for example, with their sliding lever fps control can be set for anything from 17.5 to 24.5 fps.

Microphones I'm not going to say anything about how these microphones work. That is, nothing here about the physics that makes them run. All I'm interested in is their characteristics that relate to the needs of people making films.

155

My advice: don't bother with the microphone that comes with the recorder. But there can be exceptions, and using the mike in question is a sure way to learn how good it is. If your recorder comes with an electret condensor microphone, there's still hope. The inexpensive electret, invented at Bell Telephone labs, is a superior transducer and does a splendid job of turning sound into electricity.

Some cassette machines also feature built-in electret microphones. Many are not so hot, but I have had good results with a Sony TC55 and its amazingly good built-in mike.

Impedance, measured in ohms, is the electrical analog of mechanical friction for AC current (the term resistance is used for DC). With a low impedance mike, between 200 to 600 ohms, you can use a cable fifty or more feet long without any signal loss. This means that there can be a wide separation between camera and subject. Single system cameras and the recorders we are most likely to use can readily accept low impedance mikes.

Next we must consider the directional characteristics of the mike. The most useful microphone—for filmmaking—is the cardioid, or directional microphone. You can spend from $20 to $160 or more for a good cardioid. These mikes essentially hear only in front of them. They focus on sounds coming from one general direction, and help suppress camera noise coming from behind the mike.

However, there are times when you may have need for a good omnidirectional or nondirectional mike. Since they hear equally well from any direction, they are useful in some situations where the cardioid mike isn't. For example, for recording a conference with people placed around the room, a single nondirectional will give acceptable sound. But its usefulness is strictly limited, I feel, for sync work because it can pick up distracting noise all too easily.

There are also superdirectional microphones, sometimes called shotgun mikes, that can be used to pick out sound from loud background noise, or to record good sound when large distances are between mike and source. They are usually rather expensive.

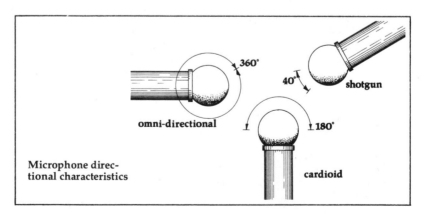

Microphone directional characteristics

Lavaliere, or necklace, mikes hang around the neck or pin on clothing, and are used for recording the voice of an individual. The Sony ECM-16 ($35) is a popular choice, and it comes equipped with a tie clip—revealing its bias.

Radio mikes are also useful, but very expensive. Any mike can be hooked up to a radio transmitting unit, like a lavaliere worn around the neck, with the transmitter in a pocket, and the sound can be broadcast to the receiver which is plugged into a single system camera or double system recorder. The signal is broadcast FM, and each mike needs its own channel, so multichannel receivers are the order of the day. The biggest hangup with these units is interference from citizen band transmitters and the like.

Your best bet in microphones is probably a good low-impedance cardioid, exactly the same mike that usually works best with a single system camera.

Shooting sync sound There are almost limitless possibilities for recording sync sound—single or double system. The most important concept to have in mind for getting good sound is to keep the mike as close to the speaker as possible—and out of the frame. Some mikes will produce excessive sibilance when placed closer than a foot or maybe six inches, but this problem rarely comes up. Usually, getting the mike close enough to the subject is the problem.

Radio mikes, shotgun mikes, all of these exotic tools offer solutions to the most formidable problems. Most of the time though, your sound recording problems can be solved with a good cardioid.

I have stressed the applications of super 8 single and double system in terms of a one-person operation. If your outfit can be operated this way, there probably won't be any hangup when it's being run by two or more people. Double system sound is often handled by a sound person operating the recorder and the mike. In a two-person setup, the recordist who is concerned about getting good sound is usually responsible for making the start marks.

With a larger crew, this is often the responsibility of a third person, whose services are also employed as an equipment-schlepper and odd-job doer. Then the action is directed by the cameraman, the rest of the crew, and the sound person especially, get their instructions from the director-cameraman. This is the usual setup for shooting vérité and documentary work, but it can also be made to work for theatrical filmmaking.

Obviously each crew will have to work out the way they work best. Use the least number of people who can get the job done, unless you are more into hanging out than filmmaking.

My last suggestion for sound recording is prerecording. A super 8 mag film recorder or a tape recorder plugged into the input of a

157

single system camera makes for perfect playback machines. Playback machines have their origins in the early days of talkies when Hollywood got interested in musicals. Musical numbers were prerecorded and played back for the actors to mime their parts during shooting. It makes for good quality sound and helps reduce the actors' fatigue. It can also be useful for recording dialogue, since you won't pick up location noise.

The One-Man band If the equipment is comfortable, there are certain advantages to being a one-man band, with camera in one hand and mike in the other.

This kind of filmmaking, I think, has the greatest possibility of achieving intimate cinema. The usual way to record sync sound is with the help of a sound person who carries the microphone, and recorder (if double system). But two people can change the scene more than one.

Even if you are shooting double system, you can hold your own mike, with the cassette or mag film recorder over your shoulder and the camera in the other hand. It's more difficult than the single system approach, since there are two machines to operate. The recorder can be started by the camera, provided both have the appropriate output and input. Or the camera can be started by the recorder, if the machines will operate in this mode, in which case it is possible to start up the works with the microphone if it has a built-in remote start button. The operation of one on/off switch can start both machines, bringing some of single system simplicity to double system.

There remains the problem of slating the shot for a start mark, since most super 8 systems do not have electronic blooping. One solution is to get a subject to clap his hands at the head or tail of a shot.

Multicamera and Recorder setups There are occasions when shooting sync sound with more than one camera is an advantage. Action may have to be covered from more than one point of view, and it may not be repeatable.

For double system the most flexible option is crystal control of the cameras and crystal reference of the recorder or recorders. If everything is crystal referenced, or controlled, then you can wind up with image and sound in sync. Even with two or more crystal controlled cameras, people will usually prefer to use one recorder. But it's possible to use more than one recorder. Cassette machines like the Sony TC55, modified with crystal reference, and used with a necklace mike, could provide good sound from each person being filmed.

Multicamera and recorder setups can get to be pretty complicated, and complications can increase in editing when there is a

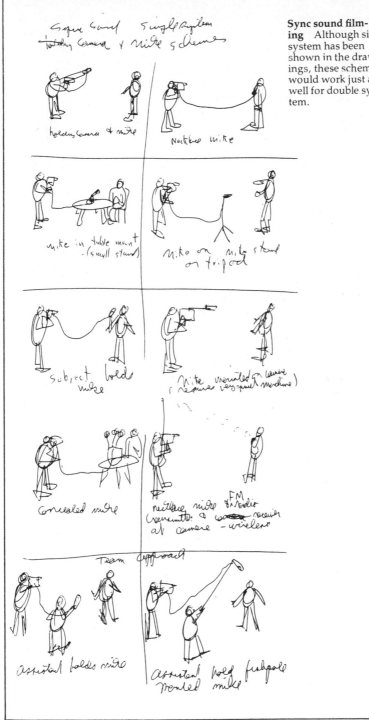

**Sync sound film-
ing** Although single
system has been
shown in the draw-
ings, these schemes
would work just as
well for double sys-
tem.

need to coordinate all the image and sound that came out of shooting.

The Inner Space system would allow a single reel-to-reel recorder to control the rates of a number of cameras. Other setups are possible, too many to mention here. Let your needs and the size of your purse dictate the extent of your experimentation.

Shooting with more than one single system camera can solve many editing problems. When cutting from one shot to another taken with a second camera, there will be no loss of image or sound (page 206). However, and this is a big however, the single system cameras you use must run to, I would estimate, within 1 percent of each other for really good results. Otherwise there will be annoying changes in pitch of voices from camera to camera. The best way to find out if the cameras you want to use are compatible, is to test them by actually shooting and sound recording.

Single vs Double I am an advocate of single system sound in shooting. In the editing room, I am happy with either single or double as long as they match my purpose. In projection, single system is easiest and most troublefree.

For now though, we are discussing shooting. At this moment, there are more than three dozen super 8 cameras that can be used right out of the box with Inner Space or Super8 Sound double system equipment. There are about thirty single system cameras accepting the 50-foot Ektasound cartridge.

Clearly there is more choice in the double system machines; however, and this is another big however, none of these cameras have XL capability. As of Spring 1975, no manufacturer offers an XL camera with a single frame switch. And all of the double system super 8 production cameras run noisy.

Cameras accepting the Ektasound cartridge usually are XL cameras. A couple from GAF are the usual bright light machines. The Beaulieu 5008.S is about a stop behind the Kodak and GAF offerings, but it still has low light capability.

There is a law in engineering called Murphy's law, that, simply put, states: anything that can go wrong, will go wrong.

Compared with single system, using double system is looking for trouble. Not only are you dealing with two machines, which I think quadruples your problems, but you are also usually dealing with cables that tend to break and disconnect. I've had everything go wrong that could go wrong. I once tried to shoot some double system footage of my goat Wilbur, and Wilbur did just what he was supposed to do and bit through the umbilical cable.

Maybe you think that my example is ridiculous. And so it is. But it is the ridiculous that is commonplace.

Because of the great simplicity involved in single system, I think

most people reading this book would be served better with it than double system. You have every right to disagree, and many of you will. So I hope I have provided you with enough information to get started and to understand what lies before you. And there are going to be times when, for whatever reason, double system will have answers that single doesn't. For example, if I wanted to make a black and white film in sync sound (which is exactly what I would like to do), I'd have to shoot double system since, for now, there is no black and white film packaged in Ektasound cartridges.

18 vs 24 fps All super 8 sound projectors can operate at either 18 or 24 fps. So can many super 8 cameras. What does this really mean to you as a filmmaker? What are the reasons for the choice?

People coming to super 8 from the larger 16mm or 35mm formats will probably advise you that the only speed to use is 24 fps. That's the way it's done in the larger formats. Although most 16mm projectors in service will operate at either 18 or 24 fps, few, if any, are suited for sound projection at 18 fps: the amplifier is usually turned off at the slow speed. And 16mm projectors designed for theatrical projection usually don't operate at the slower speed.

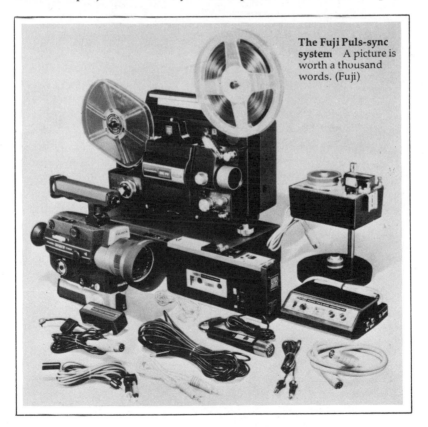

The Fuji Puls-sync system A picture is worth a thousand words. (Fuji)

Thirty-five mm projectors also rarely operate at what is considered to be the silent speed by professionals.

All in all it's fair to say that a sound film at 18 fps for the 16mm or 35mm formats is totally incompatible with projection facilities.

How we inherited the two fps standards is an interesting story: Edison and his research associate William Dickson chose 48 fps for their battery-operated camera in 1889. (It's interesting to note that the very first movie camera was battery operated. People didn't hand crank cameras until the rate was lowered to 16 fps.)

While Edison was exclusively interested in peep show or nickelodeon display of his movies, the Lumière brothers, Louis and Auguste, had other ideas. They adapted early Edison apparatus and produced the first theatrically projected motion picture images. The Lumières, who were photographic plate manufacturers, decided that the Edison rate of 48 fps was too high to be economical, so they experimented with lower rates, and in 1895 settled on 16 fps. Twenty years later the Gestalt psychologists exhaustively determined this very same value for the phi phenomenon in their laboratories in Germany.

The Lumières were trying to produce an acceptable illusion of motion while using the least amount of film. So in the silent days of theatrical motion pictures, the standard was a nominal 16 fps. This was an era of hand-cranked cameras—and hand-cranked projectors as well. With an active audience in the theater, and a musical ensemble in the pit, the projectionist was creatively tied and profoundly alive to the dynamics of the moment, cranking the projector faster or slower to suit the dramatic circuit of images, audience response and music.

With the coming of sound, all that disappeared. (I was going to say forever, but the description reminds me of the great light shows that flourished in the rock houses of the psychedelic late '60s.) Sound forced the decision to raise the fps rate to 24 to get the most out of the unperfected optical tracks of those days. For the technol-

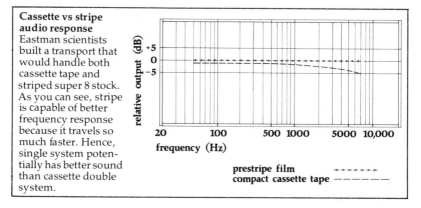

Cassette vs stripe audio response Eastman scientists built a transport that would handle both cassette tape and striped super 8 stock. As you can see, stripe is capable of better frequency response because it travels so much faster. Hence, single system potentially has better sound than cassette double system.

relative output (dB)

frequency (Hz)

prestripe film ++++++
compact cassette tape —————

ogy of the '20s, running 35mm at a higher speed meant less flutter, that gargling sound or poorly reproduced recordings; and it also meant better high frequency response for clearer speech and more treble for music.

As I look at it, 16mm optical sound really didn't click until the '40s and the wartime need for sound entertainment and training films for the armed forces. Naturally enough 24 fps was needed for good quality 16mm optical sound; as an important feature, it also provided compatibility with 35mm films optically reduced to 16mm.

In the early '50s, magnetic sound tracks for 35mm prints were developed, notably with four-track stereophonic sound for CinemaScope; but many theaters balked at having to install new sound equipment as well as screens and lenses, so Fox retreated from their original standards and added an optical track to their release prints. That's why you're more likely to hear optical than magnetic sound at your local theater.

Despite the fact that it's really a hell of a lot better sound than optical, 16mm magnetic sound never caught on in a big way in this country. It had two strikes against it from the beginning: magnetic sound prints are more costly than optical prints, and magnetic recordings can't be played back with the optical soundheads installed in hundreds of thousands of 16mm projectors in service.

But now we have super 8. It's a whole new ballgame, a new era, and an opportunity to develop standards that are not locked into the technology of the past. Films made in super 8 with magnetic sound meant for super 8 projection or TV display ought to be shot at 18 fps. In terms of sound quality, there is no reason not to. Why stick to standards based on an obsolete medium for original sound recording developed in an era that used tubes instead of printed circuit chips?

A super 8 film at 18 fps travels at three inches per second (ips) past the soundhead, and 4 ips at 24 fps. The difference in sound quality with good equipment is hard to hear, although test equipment may show some slight improvement at the higher speed. And for magnetic recording this marginal improvement will become all but meaningless as technology improves in the immediate future.

If you have a reel-to-reel tape recorder, you know it uses quarter-inch tape (6.35 millimeters). The 27 mil super 8 track is just about the same width as one of the four stereo tracks these machines use. Your recorder probably runs at any of, or all, these speeds: 1⅞, 3¾ and 7½ ips. You can get great results at 3¾ with your machine. So can super 8 at 3 ips.

If you have a quality tape deck, using Philips audio cassettes, you're getting hi-fidelity sound with stereo tracks only 21 mils wide, running at 1⅞ ips.

If you have listened to a good super 8 track played back through good speakers at 18 fps, you know the sound is really good; and if you bother to run a test, you'll find you have a hard time telling the difference between 18 and 24 fps. Make the test for music and voice recordings: your ears are the judge.

Now what about picture quality? Won't an image projected at 24 fps look a lot better than one at 18 fps? Won't it have less flicker and be less jerky?

There's a vast amount of research that has been done on the phi phenomenon: Gestalt psychologists were practically obsessed with it because they used it as the experimental basis for their theory of electrical fields moving through the visual center of the brain. While people working in psychology and neurology today think this theory is not correct, the mass of experiments they performed are valid nonetheless. The phi phenomenon requires from 12 to 16 fps for the illusion of motion, the figures varying with the sources I've looked up. Certainly 18 fps is more than enough for this illusion. Try it out. Take shots of the same action at 18 and 24 fps. Do the movies projected at 18 fps look any less smooth? I think you'll agree that they look just as good as those taken at 24 fps.

Now what about the constraint imposed by the persistence of vision, the Critical Fusion Frequency? Simply put, if a light flickers about 50 times a second, or more, you won't see a flicker, but rather a continuous light. This 50 flickers a second is called the Critical Fusion Frequency, and it varies with the brightness of the light and other factors. Well, for shutters used in projectors designed to work primarily at 24 fps, there usually are 48 flickers or effective frames per second; in most super 8 projectors, at 18 fps the shutter produces an effective 54 fps (page 242). So, all things being equal, you'd expect less flicker at 18 than at 24 fps. Using the same projector at 18 or 24 fps, you'll be experiencing 54 or 72 flashes per second respectively, since the shutter is usually set up to satisfy the Critical Fusion Frequency for the lower speed; you will probably not be able to see (or hear) any difference.

But why the pressure to shoot and project at 24 instead of 18 fps? Elitism, ignorance, snobbism, conservatism; or simply hanging on to standards that once had meaning? Who cares?

Don't be taken in. Think the thing through for yourself. Try the simple comparisons I've suggested. Lucky home moviemaker, shooting at 18 fps, look how much money and film you save! Three 50-foot cartridges at 18 fps will equal the running time of four cartridges at 24 fps. Both will run for ten minutes. Both will give fine quality. Only someone planning a blowup to 16mm or 35mm, or super 8 optical sound release prints, has to choose the faster speed.

But there's even more: you gain about half a stop shooting at 18 fps. This means that in marginal low light situations you can take

movies at 18 that you couldn't have at 24 fps. Also, all hardware runs more quietly at 18 fps. It's a fact of life: machines' motors and other running parts make less noise running at a slower speed. Not only does this apply to the camera, but your projector will run more quietly too.

I think it's an absolute disgrace that 24 fps is being palmed off as necessary by an industry rapidly expanding to fill the needs of people deeply into super 8 filmmaking. And a few items of good equipment will operate only at 24 fps. For shame! Moreover, as long as 24 fps is considered to be the professional standard, designers are likely to maximize their equipment specifications for this speed, letting the 18 fps user take second best. If designers want to make superior 18 fps equipment, they can easily enough, since the difference between 3 ips and 4 ips is not very great.

And even if video presentation is planned, there isn't any excuse for this. The Eastman videoplayer will operate at both speeds, so films can be shown closed circuit, broadcast live or transferred to tape, if need be, all at 18 fps, the home moviemaker's humble speed.

The case for 24 fps Obviously I have championed the use of 18 fps in this book, and I hope manufacturers and filmmakers come around to my way of thinking. Nevertheless, here's what can be said on behalf of the faster running speed:

—There can be a marginal improvement in high frequency response which may be important for music. It all depends on the equipment you're using.

—Some TV film chains will operate at 24 fps only.

—Shooting at 24 fps is a must for blowing up super 8 to larger formats.

—Editing single system at 24 fps may prove to be marginally easier, since the time lag between image and sound is ¾ of a second compared with 1 second at 18 fps.

The Equalizer I'm not talking about the six-gun of the old West, but the device that can alter the frequency response curve of your recordings during transfers. These are offered for the hi-fi freak who needs an elaborate bass-treble control. Several models, list starting at $100, are offered, usually in at least two channel designs; and they can have extraordinarily fine quality.

I'm using a $100 BSR equalizer with ±12 dB control using sliding pots in increments of 60, 240, 1000, 3500 and 10,000 Hz. More elaborate models by BSR and MXR are available. Typical uses are reduction of 60 Hz hum and camera noise in the 1000 to 3500 Hz range where there's a lot of voice response, so move those pots judiciously.

PROCESSING & STRIPING

First continuous home movie processor Harris B. Tuttle (seated) is at it again. This time he's at work on a 16mm reversal film processor at Kodak Park, Rochester, in the fall of 1923. (Eastman Kodak)

Getting your film processed I use the term processing to include the entire chemical and physical procedure that turns the latent image of your exposed film into a projectable image. Generally, about a dozen separate steps, performed in sequence, are required to make your film ready for screening.

If you step up to the drugstore counter with film in hand and ask the salespeople to have it processed, they may not know what you are talking about. But they'll know what you mean if you say you want your film developed, even though this is only one step in processing. The people at commercial motion picture laboratories, who also handle larger format work, will understand either term.

For super 8 color film, you have a number of interesting processing choices: you can let the manufacturer do it, let a photofinisher do it, let a professional or commercial lab do it or, if possible, do it yourself.

Only Kodak color film is always sold without processing included in the purchase price. Every other super 8 color movie film is usually sold processing included, so you simply send the film back to the manufacturer's lab in the enclosed mailing envelope. Why is Kodak film the only super 8 film sold PNI (processing not included)? It's the result of a Justice Department ruling made in the early '50s. The decision was based on the idea that photofinishers should also be given a crack at processing Kodak products. So, as a result of an agreement with the US of A, Kodak color film is sold without processing in the purchase price. Some people selling Kodak film like to tack on their own processing mailers; but that's their trip and has nothing to do with Kodak.

It's more than twenty years since the Justice Department prevailed, and Kodak no longer totally dominates the manufacture of color movie film. Now they merely *nearly* totally control it. But there are many, many outfits, for better or worse, processing Kodak film. Better is when you pay less and get good processing; worse is when you pay less for poor quality processing.

With other people processing Kodak film, you pay less. Kodak usually charges more to process their film than anybody else ($3.15 list for Kodachrome or Ektachrome). Why, you ask? Mostly because they can get it, I think, but also they do a very good job; and despite seasonal fluctuations, they usually get the film back to you in a reasonably short time. Seasonal fluctuations in photofinishing affect prompt return of your processed film. Not just people shooting a lot of film on July 4th weekend: I mean photofinishers being swamped every time there's a big football game in town.

Generally Kodak maintains a processing setup ready to handle peak loads all the year round. If you want Kodak·processing, you have to pay for extra manpower retained at slow times. When other photofinishers are loaded with work, they will often farm out the job to Kodak, so when you think a local or independent outfit is doing the work, you may be getting Kodak processing.

So the Kodak film user, most of the people most of the time, can drop film off at many retail stores and get Kodak processing. There are tens of thousands of these places that will give you first quality processing of your color movie film.

My experience with drugstore super 8 processing is that the rate of screwed-up and lost film is about the same as with the professional labs. Processing machines do break down, people do goof on the job and film does get lost or mixed up with somebody else's footage. There's nothing you can do about it; you can only pray it doesn't happen too often. The most frequent processing goofs I have encountered are scratches or tram lines. Scratched film can sometimes be salvaged by Film Life (Products & Services, page 293).

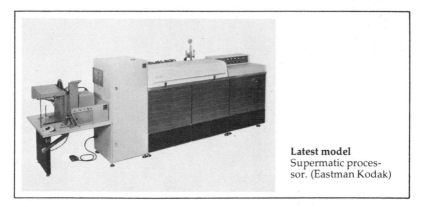

Latest model
Supermatic processor. (Eastman Kodak)

THE EASTMAN E-25 PROCESS FOR EKTACHROME 40, 160 AND G

Prehardener The emulsion is hardened in this step to prevent excessive swelling during processing. Hardening permits processing at elevated temperatures with reduced danger to film; it also reduces the chances of physical damage to the emulsion in the subsequent steps of the process.

Neutralizer The neutralizer reacts with the prehardener preventing reactions with the dye couplers added later in the process.

Rem-Jet Dip The Ektachromes have an antihalation backing. By briefly immersing the film in the rem-jet dip solution, the backing is softened so that it can be easily removed in the next step.

Rem-Jet Removal The softened antihalation backing is removed by water sprays and buffer rollers.

First Developer The action of the first developer solution converts exposed silver halide grains in the film (the latent image) into metallic silver (silver image).

The silver image thus formed is a *negative* of the original scene that was exposed on the film in the camera. This developed image in the film emulsion essentially consists of three superimposed silver negatives.

This is the most critical step in the process. Variations from the standard process will affect speed, contrast, stain, color balance and maximum density.

First Stop Bath This acid bath quickly stops the development action of the first developer carried over by the film, and it also reduces emulsion swelling during the first water wash.

First Water Wash Carry-over of the first stop bath solution, and minute traces of first developer, are removed by this step.

Color Developer The remaining undeveloped silver halide grains in the film emulsion are first made developable by a chemical reversal agent incorporated in the color developer which simulates the action of light in exposing the silver grains prior to color development. The developable silver halide grains are then reduced to silver by the color developer.

As the silver is being formed in the film emulsion, the chemically oxidized color developing agent reacts with color couplers in the emulsion layers to form dyes. Each emulsion layer has a specific coupler; yellow, magenta and cyan dyes are thereby formed in their respective layers.

Second Stop Bath This bath removes the excess color developing agent.

Second Water Wash Carry-over of the second stop bath solution, and minute traces of color developer, are removed by this water wash.

Bleach The bleach solution converts all the metallic silver grains into silver halide so that they can be removed in the fixing that follows.

Bleach Neutralizer The bleach neutralizer reacts with any bleaching agent carried over from the bleach.

Fixer The fixer converts the silver halide in the film into soluble silver compounds.

Third Water Wash This final wash removes the fixer and any remaining silver compounds from the film.

Stabilizer This solution stabilizes the dye images, facilitates spot-free drying and further hardens the emulsion layers.

Drying

Lubrication In this step of the process, the film is lubricated to improve its performance in a projector; unlubricated film will have a jerky motion and may be damaged during projection.

(Adapted from Eastman Kodak)

I have never been able to make up my mind, once and for all, about where to go for processing. In fact, my next cartridge of Kodachrome, which is in my camera, could be processed any one of a number of ways. Let's see, I could take it to Long's, a department drugstore, and have them send it to Kodak who'll have the job done in three or four days. At many of the retail outlets where you can buy Kodak processing, you can also get the job done by some other photofinisher, usually for half Kodak list, and in about three or four days also. Sometimes it's a local independent outfit, sometimes a national one like Berkey. You can also buy processing mailers from some independents like Technicolor. And of course, there is a flourishing through-the-mail trade doing business via, for example, the Sunday supplements. And there are organizations like Fotomat, which in my part of the country runs a chain of drive-in huts, that do nothing but sell and process film.

Or I could put the film in a PK59 mailer I have on the shelf behind me, but that would add postage, but of course it does cost something to drive to the retailer.

You can buy Kodak PK59 mailers for processing your various Kodachrome and Ektachrome silent and sound film. (Silent and sound film processing is the same price. Processing of 7242 requires the more expensive A-V, or audio-visual mailer.) When you place your cartridge in one of these little envelopes, you've got every mailbox in the country working for you. (Stay away from unshaded mailboxes on hot days. They can cook your film causing color shifts.) Last time I looked, mailers were listing for $3.15, but 20 percent discounts are possible. However, Kodak will not process their own black and white film. You can also buy AVP-1 mailers for Kodak processing. It's called expedited service, and you can get your film back "within a predictable time (3-day maximum)" by paying a 20 percent increase over the PK 59 mailer.

Maybe I'll take that Kodachrome cartridge over to the drive-in Fotomat hut, and the Fotomate (so help me that's what they call the pretty girl sitting in the hut; they like it so much it's a registered trademark) will take care of my film for only $1.79 (tax is extra, only 6½ percent here in beautiful Contra Costa County) and Fotomat (or whoever they farm it out to) does a good job.

Getting black and white processed, which usually means Plus-X, Tri-X, 4-X or GAF 500, is a job for your commercial lab. Look in the yellow pages for Motion Picture Laboratories to find out who specializes in super 8. If the first lab you call doesn't, they may be able to tell you who in your area does this work. (You can also look up lab names on page 290 for possible black and white service.)

As you can see, the Justice Department ruling has led to many alternative processing choices for Kodak color film users. When you

buy a cartridge of 3M Color Movie Film, or GAF Color Movie Film, there's no choice. The cost of film and processing are lumped together, generally at a price highly competitive with what you will have to pay for the combination of Kodak film and non-Kodak photofinisher processing. What every customer wants is clear: a good quality job, done at the lowest price in the least amount of time. Perfect processing for nothing in zero time? Hmmm, sounds like video tape.

Forced development Increasing the time your film spends in development increases its sensitivity to light. But color film may have to pass through a dozen chemical treatments for a finished image. One of these steps is called first development, and that's where more time may add speed. But usually at the price of increased granularity and contrast, reduced sharpness and unpleasant shifts in color.

How much any or all of these effects occur depend on the film being forced, or pushed as it is sometimes called, and who does the pushing. One lab may do better than another. Some films push for a doubling in speed, or one stop increase, but not for two.

Some films cannot be pushed: it's generally true for those without built-in color couplers, like Kodachrome 40. Practically speaking, it is also true of Ektachrome 40, 160 and G, since these films are designed to be processed in a special photofinishing machine; photofinishers are generally not too interested in departing from routine for an occasional cartridge.

What this leaves you with is 7242 or any black and white film, and the forced development has to be done by a commercial lab, or if you are so inclined, you can do it yourself, as we will discuss shortly.

Kodak Supermatic Processor It started out to be a desk model processing machine that would cost a few hundred bucks; it wound up a floor model half-ton piece of hardware costing about $12,500. But compared with the monolithic motion picture processing machines that are the usual order of the day, the Supermatic (SM) Processor is a great big step toward simplicity. Despite its departure from the original designer goal, the SM Processor is of real interest to TV stations and any organization or institution that needs to "develop" a lot of super 8 film. Anybody, from a film school, a hospital or a corporation making films for internal communications, to any group or individual with sufficient need, will find the SM Processor a major advancement. It's even been suggested that this innovation, first unveiled in November of 1973, could be used for consumer processing.

And why not? If you have enough population density to support it—given the usual entrepreneur's markup—one of these

machines at the local shopping center could turn a handsome profit. Film can be daylight loaded into the machine, and in 13½ minutes, a 50-foot roll emerges processed. Cost of chemicals for this is less than $.45.

The device is essentially goof-proof, and with little training we'd be experts at working the SM Processor. Only four chemicals are needed in the color- and shape-coded bottles on top. An Ektachrome process using four chemicals would be sensational enough, but Eastman has advanced the state of the art with Ektachrome SM, the SM chemistry and this shade-under-a-thousand-pound (when filled with chemicals) machine; hook it up to the usual plumbing and electrical outlets and it's ready to go.

However, here's the catch: this machine will not work for Kodachrome or any Ektachrome other than Ektachrome SM (for Supermatic) 7244, which is similar to 7242.

I feel certain that within the next decade we will see the hobbyists' SM Processor. Cutting out the photofinisher will be one of the most important steps in maturing the super 8 medium. It will make film more like tape, or what is best about video tape.

"Polaroid" and instant movies The SM Processor naturally leads in to the subject of Polaroid instant movies. I wish I had something to tell beyond mere speculation, but alas, dear reader, the word is that we are a year or two away from Polaroid's offering the world this long awaited system. Edward Land—I think it was at the 1970 Polaroid stockholders' meeting—showed a rapid processing movie system. That's all anybody outside of the company knows about Polaroid instant movies. They are working on it.

If you think about it, the requirements for instant movies are quite different from those for still photography. You don't need to have the film processed in the camera; you can't screen the footage without a projector. And instant, or super-rapid, processing can be accomplished anywhere between the camera and projector, or in the projector, if you please.

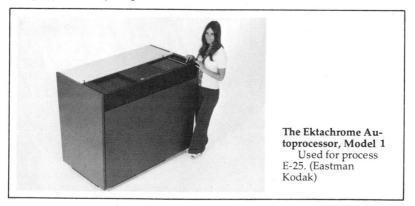

The Ektachrome Autoprocessor, Model 1 Used for process E-25. (Eastman Kodak)

Here's the goal: take the completed cartridge out of the camera, slap it in the instant autoprocessor, and in less than five minutes you are ready to thread the projector and screen the film. Or put the cartridge in the processing-projector, and pronto, in seconds, view the film as it passes through the processing section and then through the gate.

Late word has it that the Polaroid system will take the form of a combined projector and processor to be manufactured by Eumig. Polaroid will stick with the standard cartridge, offering rapid processing to all super 8 users. Can Polaroid offer high speed (160 EI) for XL shooting, as well as stripe for sound? If they can, wow! In any case, this will be the first "instant" process transparency film to be offered.

Do-it-yourself processing　The first question many people ask when they enter my studio is, "where do you develop your film?" Because still photographers develop their own film, they suppose filmmakers do too. And processing is one of the first things many people try to set up when they have a communal sharing of filmmaking equipment and supplies.

But more often than not, it's a gigantic waste of effort. Too many otherwise intelligent filmmakers have tried to resurrect ancient processing equipment in a crazed attempt to do it themselves. Filmmakers are not still photographers doing darkroom work. They are filmmakers who do editing, in place of darkroom work.

Most of us shoot Kodachrome most of the time: there is no way you can process this film yourself. Kodachrome, unlike Ektachrome, is a color film without color couplers; the effort needed to turn what is essentially a triple layered sandwich of black and white emulsions into color film is a major industrial process. You can't buy the chemicals, and you couldn't process Kodachrome if you could. So forget it. The same thing applies to Fujichrome, or GAF Color Movie Film, but you wouldn't want to do these yourself since processing is included in the purchase price.

But there is some logic in doing it yourself for the Ektachromes or Kodak black and white film, sold without processing included in the purchase price. One, it's cheaper: maybe half or a third the cost of having Kodak or the photofinisher do it. Two is time: you can be projecting your movies two hours after you started processing them. Three is weirdness: you can solarize your film, or experiment with solution times and so on. You may get strange effects whether or not you planned for them, since Ektachrome kits containing all chemicals and instructions—E-3 or E-4, or the Unicolor Slide Kit—were designed for slides, not movies. While these kits will give acceptable results with Ektachrome EF, 7242, more experimen-

tation is required with Ektachrome 160, 40 and G, since these use a somewhat different process. Moreover these films have a rem jet backing (page 20) for antihalation and protection, and this must be physically buffed or scrubbed off the film in alkaline solution. However, Ektachrome SM and EF do not have a rem jet backing, so these may well be the perfect materials for home processing.

If you want consistency of results, I think that you will be better off letting the specialist do the processing. However, if you are determined, a list of companies that can supply advice, chemicals and developing tanks will be found on page 290 and following.

Sound stripe Film shot in Ektasound cartridges is prestriped, that is, it's striped in manufacture. If you want to do sound work with film shot in silent super 8 cartridges, or shot in double super 8, your film has to be poststriped, that is, it must be striped after processing.

But let me qualify this: double super 8, unlike cartridge-loaded super 8, may be prestriped so that it can run through your camera that way. There are professionally oriented laboratories that can do this for you. Although there are no double super 8 single system cameras, prestriped film may be edited and sound recorded without having to wait for stripe application.

And this brings us to Lipton's wish. I wish that I didn't have to write about sound striping. I wish all I needed to do was write this sentence: film supplied in silent super 8 cartridges is prestriped.

But it's not. And why is this bad? The wait for striping, if you don't do it yourself, can be a killer, especially if you are in the middle of editing a film and have to send it out to have it striped. If you send it to Eastman, as I think most users are likely to do, you'll wait several weeks because their only facility is in Rochester. On the other hand, local striping services generally take under a week.

But if my wish came true and all silent film in cartridges were prestriped, you might say to me, why should I have to pay for the extra cost of striped film in the silent cartridge when I might not be using it in the making of a silent film?

The answer to this is a little hard to believe, but prestriping would cost Eastman, and consequently you or me, nothing, or next to nothing. Ten years ago, just before the introduction of super 8, I was told by the knowledgeable head of research and development in a major corporation intimately involved in super 8 and sound that Eastman was planning to add mag stripe to super 8 film at no extra cost to the customer. His argument was that it would cost them very little to do, and that it would advance the medium.

Nearly a decade after this didn't happen, I decided to check the story out. I asked someone at Eastman who had been involved in the planning stages of super 8 if it were true. The answer: yes, it was

true. Of six departments' consent needed for approval, five said yes, one said no. Unanimous approval unfortunately was needed, and a sad day began for super 8.

If you check the company cost for prestriped super 8, you will have a better idea of what I mean. Prestriped color positive release print material is 3/10ths a cent more per foot than unstriped positive print film. In the 50-foot cartridge, that works out to $.15 more per cartridge, not the $3.50 poststriping costs, or the $1.90 prestriping in the Ektasound cartridge costs.

If only all super 8 camera film were prestriped! It would be a terrific shot in the arm to super 8 and those of us who want to combine Ektasound and silent production camera footage. It would be a boon to those of us who want to simply add sound to film shot in production cameras. In one stroke it would turn super 8 irrevocably into a twin medium, a medium of sight and sound. Indeed, super 8 is a medium of sight and sound, but practically speaking, this is still only a potential until the film is striped.

Chances are, if you want the advantages of an Eastman striped track of your processed film, one with a balance stripe and a record track whose sound quality will exactly match your Ektasound footage for best possible intercutting, you will have to pay $.07 per foot list, and have to wait a few weeks, while your hot ideas cool off.

The Eastman stripe is of very fine quality: it matches the Ektasound stripe in frequency response and background noise, and Eastman will also balance stripe the footage. One more plus factor: any retail outlet offering Eastman processing also offers Eastman striping. The drugstore people may not know about it, but it's true all the same; let them look it up in the price sheet if they doubt you. On the debit side, Eastman has one of the highest prices for striping, listing at some $.08 per foot and a several weeks wait. Once the footage gets picked up by the Kodak truck, it goes to the central processing station and then to Eastman in Rochester for striping.

Lab striping There are many independent sound striping services, ranging from people doing it in their garages to professional quality labs. You can find these advertised in the back pages of *Super-8 Filmaker* or *Filmmaker's Newsletter*. Prices are from $.02 a foot on up. Many do not offer a balance stripe; others do. If you live in or near a large population center, there's probably such a service near you. However, it has been my experience that Eastman does the best job of base or emulsion side striping.

Do-it-yourself striping I am editing six super 8 films at the moment. Some were shot with an Ektasound camera and are prestriped single system. Some were shot with super 8 production cameras and are unstriped silent. One silent film has been away to

Eastman for three weeks to be poststriped. Eventually, all of my silent footage needs to be striped. Some of my films contain footage shot exclusively with Ektasound equipment. Some will be made up of silent footage which must now be striped.

Some of a film shot silent will be intercut with Ektasound footage. I've got a problem. The silent footage to be intercut must be striped before I edit it in. I am editing it outside the main body of the film, but sooner or later it's got to be striped and cut in.

Maybe I am hung up. I should send the silent stuff out to be striped right away. But if I do, it will be gone for weeks in gloomy Rochester. If I felt I could do without Eastman's service, I'd call a friend and have the stuff striped today on his Bolex striper.

You will probably be facing situations or problems—however you want to look at it—just like this one. The answer for you may be to stripe the film yourself: no wait and lower cost per foot for materials—without considering amortization of the cost of the striping machine.

With the exception of the Juwel Mini Sound Striper ($200), distributed by Eumig, none of the do-it-yourself stripers offer a balance stripe. How important is the balance stripe? You want your film to spool as evenly as possible. A stripe is usually only 0.4 or 0.5 mils above the height of the base. If film piles up on one edge, it will sag on the other. The balance stripe is a nicety, even though you can live without it, as many do-it-yourselfers have learned. It is entirely a mechanical consideration unless, of course, you are into using the stripe for sound information, with the Bauer or Heurtier stereophonic projectors.

There are two kinds of sound striping techniques in general use, and something of a controversy about which is best. There is what is called the liquid (or paste) striper, which applies a thixotropic (gooey to you) liquid, through a nozzle, to the base of the film. The solvent in the paste is acetone, or something similar, which evaporates leaving iron oxide particles bound to the base of the film. In essence, the paste is a thick mixture of iron oxide and splicing cement.

This is very much the way Eastman and other film manufacturers apply stripe industrially. The troubles with the do-it-yourself liquid method fall into two areas. First off, the noncommercial stripers do not offer a polishing step. The surface of the stripe must be super smooth to make the best contact with the soundheads. Simply spreading the liquid on through a nozzle, no matter how well done, will leave a rougher surface than a specially polished stripe.

The second trouble is one of orientation of the iron oxide particles. In manufacture the drying stripe passes by a powerful magnetic field where the iron oxide particles are physically oriented, or

lined up, by the pull of the field. By reducing random particle alignment—the particles are themselves tiny magnets—background noise, a high frequency hiss called tape hiss, is reduced.

It's true that some users of paste striped tracks like them. I also know that some people complain that the stripe and the film part ways on too many occasions, causing loss of sound signal, or what is called dropout.

The second method used for applying stripe by the user is the laminated technique, so called because a very narrow roll of magnetic tape, the width of the stripe itself, or some 27 mils (about 0.7 millimeters), is guided into proper position by rollers and then laminated to the base of the film with a thin coating of cement. This method overcomes the theoretical difficulties of paste striping, since the surface of the stripe or actually the tape, has already been polished in manufacture, and the oxide particles are presumably properly oriented. A laminated striping machine, like the about $400 Bolex unit, can do a very good job: the stripe seems to stay in place, and material cost is about $.02 per foot.

However, you can wind up with the same practical problems with a laminated striper that you have with a liquid striper. If too much or too little cement is applied, the stripe will be uneven, producing changes in record and playback volume. The Bolex striper, available from Paillard, is said to eliminate this problem by carefully controlling the amount of cement applied to the film. In many cases people who are really into striping and quite expert report that after several months the laminated stripe will start peeling or curling at the edges. This may be a minor effect, but it can cause a slight change in signal strength.

Some people advise that you first clean your film with liquid film cleaner (without lubricant). If your film isn't perfectly clean, they say, the stripe won't stick. Do not get your film treated with processes like Vaccumate or Peerless before you stripe. After, is okay.

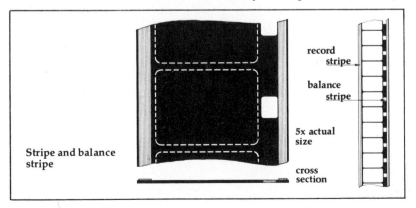

record stripe

balance stripe

5x actual size

Stripe and balance stripe

cross section

There are also inexpensive liquid and laminated type machines. None of the machines that I know about can do a balance stripe or stripe polyester film, which is what you are into if you use Fuji single 8 stock or super 8 3M Color Movie Film. You can get polyester striped by Fuji (page 290).

What remains to be said is that there are two good reasons for doing striping yourself: time and money. But if you can wait, and you have the bucks, as I see it, it's Kodak all the way. Don't forget, although list is $.08 a foot (with a 100-foot minimum), there are the usual 15 to 20 percent discounts through your retailer.

If you finish about an hour of super 8 film a year, and need to get it striped, that's about 1000 feet, so it would cost you about $70 the most expensive route, without discounts, by Kodak. Is it worth it for you to buy a striper and do it yourself if you turn out this much film, or need to stripe double or triple this amount?

Of course your working techniques are important. You may have to stripe more than your completed footage. Some people, to work as freely as possible, will stripe only after their final cut, and some will need to stripe while they are still editing, or even before they start to edit.

One further complication must be taken up in greater detail when we discuss printmaking: print emulsion positioning. Throughout my discussion, it has been implicit that we were talking about striping original camera film. In this case the emulsion or picture information side of the film faces the lens of either camera or projector, and the base side carries the stripe. If contact prints are made, then stripe and emulsion must be on the same side. But stripe cannot be applied directly to emulsion. It can be applied to base only. Some labs can gouge out the emulsion, a process some people call channeling, and then apply stripe to the exposed base. Kodak, it would seem, has a process where they are able to somehow apply stripe directly to emulsion, for contact printed film. But I can't get any information from them about the technique.

Bolex striper
(Paillard)

EDITING

Handling film I shoot, edit—cut, tape, file and handle—and project super 8 original camera footage. When I need prints, I can always have them made. Until then, I stick with the original. I don't use a workprint. If you're coming fresh to filmmaking, it may surprise you that these are revolutionary words.

People who work in the larger 16mm and 35mm formats invariably order a workprint, a copy of the original camera footage to use for editing. The British say cutting copy, and that description gets the point across. A workprint enables the larger format editor to feel completely free about splicing and resplicing, cutting up film and moving pieces of it here and there. After much handling and many screenings, a workprint picks up dirt and scratches and the perfs get worn. It can get to look pretty lousy. Part of this is inevitable, but another part is because nobody using a workprint expects anything but damage and deterioration. After editing is completed, the safely stored camera original film is matched to the workprint and it is used for making prints.

This same procedure can be applied just as well to super 8 as for the larger formats. Why then do I advocate working with the original super 8 film?

Handling the actual film that passed through the camera is an absolutely direct experience. It is one of the most stimulating feelings I have encountered in super 8. In a sense there is no big news here, since every home moviemaker who cares enough to edit his film works this way. But if I sound a little frantic about it, please understand that after ten years of the trouble and expense of workprints, being able to work with the original is a big deal for me.

Now that I am projecting the original, and I have been doing this with success for two years, I'm able to put off a peculiar time of decision—the commitment to making a print. For a number of technical reasons—as well as the expense—once a lab does that, a filmmaker is usually disinclined to make further changes or alterations, especially extensive ones.

182

With super 8 I can keep on cruising with my original footage, puttering around with it for months and months. Since I am my own projectionist and attend all my public and private screenings, I often wake up bright and fresh the next morning, inspired by the audience reactions, my own perception and my dreams, head downstairs to my studio to rework portions of the film. And the next time I screen that film it's a new film, if ever so slightly, and usually I feel much better for the changes.

Throughout this section on editing and later in projection, I am going to stress what you have to do to keep your original film free from scratches, abrasion, wear and tear and dirt and dust. There are a number of simple techniques to follow, but they all add up— they're cumulative. I think you will have great satisfaction working directly with the very film that passed through your camera, and you will save yourself a pile of bucks. And for filmmakers who need to make workprints, I haven't forgotten you. There's some advice here toward that end too, before we get into printmaking itself.

I do realize though that there are people who are temperamentally unsuited to working with original, and many projects will preclude this approach.

Basic silent setup I am going to propose a basic editing setup, a bench or table for working on silent films. As you will see, the addition of a few supplementary tools will allow you to edit single or double system sound also. But your fundamental editing table should consist of a viewer, a tape splicer, rewinds, the table itself and various odds and ends.

I once tried learning to play the guitar, so I bought a $15 guitar. A $15 guitar is much harder to play than a $150 one. For one thing the strings are harder to press; another, the tone is lousy. I never learned to play the guitar, even though I admit, reader, there may have been other factors involved. Buy an inferior viewer and you will get an image that isn't sharp and a hard-to-use machine. The beginner, most especially the beginner, needs the best possible tool to avoid being turned off. And it's false economy to scrimp on any part of your basic editing setup, since its total cost will probably be less than the cost of either your camera or your projector.

I can say without the shadow of a doubt that the best viewer you can buy is the Hervic Corporation's Minette 5, available through most large retail photographic outlets at some 15 percent off its $110 list price. You may balk at this flat statement, the price may seem stiff, but I have yet to find anything even approximating the Minette's quality. Its competition doesn't deserve mention, with the exceptions of the Elmo or Bolex units which allow for inexpensive add-on sound readers.

The Minette 5 can even be compared to 16mm units costing two to

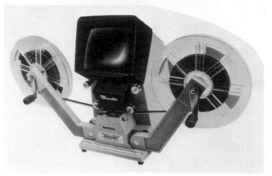

Minette 5 viewer
(Hervic)

three times its price. For example, it is head and shoulders above the highly praised Zeiss Moviscop I have been using for ten years for my 16mm work. The optical and mechanical layout of the Minette is similar to the Moviscop: light is beamed from a light bulb and condenser lens section through the frame and sent to an image-forming lens. Next, the light passes through a prism which rotates as the film is moved through the viewer. The prism is driven by the action of a sprocket wheel turned by the film's perforations. From the prism the light is reflected by a couple of mirrors onto a ground-glass screen. The image is viewed through a magnifying plate, or lens, covering the ground glass.

As the film is hand driven through the viewer, the prism sweeps out an image across the ground-glass screen. The prism's rotation is syncked with the film to avoid a moving projected frame; the effect is that each frame is projected as if it were at rest. But since there is no interrupting shutter, like those in projectors, there is some image flicker. It's tolerable.

The 3½ by 2¾ inch overall size of the image is adequate for good viewing. What you see is extraordinarily bright and sharp, easily seen in most room illumination, unlike other super 8 viewers. Moreover, when the film channel is kept clean, the Minette will not scratch your film!

After you raise the pressure plate, simply insert the film into the threading channel. Once you make sure that the perfs have engaged the sprocket wheel, close the pressure plate with the little lever. You can easily tell if the film is properly threaded by rocking it back and forth a few frames. There should be only a little drag, and the image should be properly aligned on the screen: the perforations must not be projected on the screen.

Immediately below the projected frame is a glass coverplate. It

184

protects the innards of the machine from dirt and dust. Clean it periodically: just pull it out and wipe it with lens tissue. Other kinds of tissue present the risk of adding rather than subtracting lint. You can see how good a job of cleaning you have done by looking at the screen without any film in the viewer, with the projection lamp on, of course.

The Minette is designed to work with the usual 60 Hz/120 volt current, but it could also make a good field editing unit if the transformer were bypassed and the lamp was powered directly by a 6 volt battery.

This is what is missing from the instruction booklet: the built-in swingout rewinds are hard to work with. There's just no working room between the reels and body of the viewer. But when properly mounted to the right and left of the viewer on a plywood board, or similar surface, they work just fine. Try mounting the rewinds about two feet apart, then you can position the viewer itself anywhere between them—wherever you feel is most convenient.

Here's how to do it: unscrew the four screws in the rubber feet of the bottom black coverplate. Loosen the set screws immediately below the bolts holding the rewinds in place. Use a wrench to remove the nuts on the inside of the viewer. Slip the bolts out, and remove the rewinds. Put the bolts back in place, so you won't have any gaping holes in your machines, and tighten the set screws. Replace the bottom plate.

I found that Sterling International doorstops, with the plastic stop itself removed, provide the perfect right angle irons for mounting the rewinds to the board. Some people prefer the Craig Jr. rewinds for use with the Minette, and these can be purchased for about $25. And don't call it an editor, it's a viewer. An editor is someone who edits film. A viewer is a machine used for viewing film in the editing room. This usage may be as arbitrary as any, but we'll understand each other better if we all speak the same language.

I feel it would be remiss not to mention the number of serviceable viewing units on the market. Some people like the Vernon, others the Baia or the Craig. All of these, and others, may cost less than the Minette, say down to a quarter of its price. I saw an intriguing motorized viewer at Sears that wasn't half bad for only $40.

So let me dispense with my let-'em-eat-cake attitude. If the only way you can afford a viewer is to buy an inexpensive one, sure, do it. It's better to have something to work with than nothing. But if you have set your sights on single system Ektasound movies, remember the Minette and Elmo and Bolex are the only viewers that can be converted easily to sound playback for viewing and listening to lip sync movies. It would be possible to convert some of the other units, but nobody who is doing this commercially bothers.

Cement Splicing My sentiments are entirely with tape splicing for super 8 for a number of reasons I will give in the next few pages. However, some people prefer cement splices so I'll have some words to say about this first.

Cement splicing of film involves overlapping of portions of base to which cement is applied. Emulsion must be scraped away to reveal the acetate base, since this is what is dissolved by the cement. Tape, on the other hand, covers two adjacent frames neatly trimmed exactly at the frameline.

Cement splicers are offered by Agfa, Bolex, Eumig and others. Two of the best are the Hahnell Kollmatic and the Braun FK 1; they appear to be similar basically and use a spinning abrasive wheel to scrape the film. All of these machines are bevel-edge splicers, which chamfer both sides of the splice at a 45 degree angle to the surface of the film. Cement is applied to one scraped and bevelled edge, and the two pieces of film are brought in contact under pressure for about 20 to 30 seconds of drying. You are reasonably sure of a good join if you have done everything properly.

If you must do cement splicing, don't go for the straight overlap splicer. This kind of splice lays the base of the film right on top of the scraped away emulsion side, for a film-on-film splice. Even the highly touted Maier-Hancock hot splicer, which uses an electric heating element to speed up drying time makes this film stacked on film splice. These splices will go through most projector gates harder, causing not only more of a chatter, but a momentary pulling away of the sound stripe. This results in a temporary reduction in playback (or recording) level.

There are a number of other problems with cement splices that, as far as I am concerned, far outweigh the advantages they may have. Making a cement splice involves the destruction of portions of two frames. Nothing wrong with sacrificing these frames so long as you don't change your mind about the cut. If you do though, you have to sacrifice two more frames to make a new splice. Then your shot

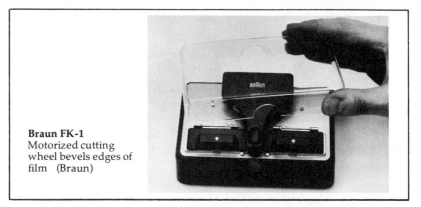

Braun FK-1
Motorized cutting
wheel bevels edges of
film (Braun)

will become marginally, possibly even significantly, shorter each time you remake a cement splice.

People sometimes ask if it is possible to part a cement splice carefully and then remake it. The answer is that it is, but you won't get a good remade splice. You'll get a splice very likely to come apart easily.

Because I am advocating working with original camera film—and most people working in super 8 have been and are going to be cutting original camera film—anything that makes it difficult to preserve the original is a no-no. But making and remaking tape splices is a snap, and you don't lose any frames. If you shorten a shot too much, you can always add back what you have excised with an all-but-invisible tape splice. In the same situation, a cement splice will usually stand out like a sore thumb because of the two frames sacrificed to remake the cut.

Since I am into working with original, I don't want a lot of grime and grit and dust and stuff getting on my film. Tape splices involve a simple, straight cut of the film across the frame line. No mess. Cement splices that involve a scraping of the film, result in base and emulsion dust which, if not completely cleaned up, contribute to deterioration of the original. Cement splicing is a messy process. Tape splicing is neat.

Guillotine tape splicing The Guillotine uses unperforated polyester tape wide enough to cover two adjacent super 8 frames: two models are available; a $15 plastic unit, and a $40 metal one. The metal version is decidedly superior. It makes more accurately aligned splices. Two rolls of tape cost $3.50—good, they claim, for 700 splices. That works out to half a cent a splice, making the Guillotine splice the least expensive tape splice. I have never counted the number of splices I got from a roll of Guillotine tape, but the company claim doesn't seem out of line. Other machines use preperforated splicing tape, sometimes paperbacked—all of which adds to the cost.

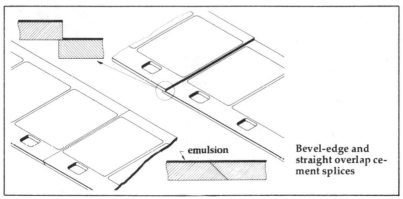

emulsion

Bevel-edge and straight overlap cement splices

The tape is applied to the film after the ends to be butted together have been trimmed with the splicer's cutting bar. You align the tape to cover the frames by eye, an easy enough process. Next you press down the tape with a finger to make sure you have good contact and all air bubbles are eliminated. Then you bring down the pressure plate, the sprocket hole cutting bar on top of that. Lift the plate and bar, and remove the film from the splicer. With your thumb (the way I like to do it) score or rub the tape hanging over the edge of the film, and fold it back to cover the other side. The Guillotine is designed to cover both sides of the film. The perf cutting bar perforates both sides of the tape, so when you fold over the tape to cover the other side of the film, it is already perforated.

If the tape splice covered the stripe it would diminish playback volume since the track would be held away from the soundhead, if ever so slightly. The Guillotine conquers this problem simply enough. The tape folded over the base sound track simply isn't wide enough to cover the stripe. It ends just at the edge of the frame and track area. A copacetic arrangement, if ever there was one.

When the time comes to part a splice, if you make a change in editing, simply peel off the tape on the base side, using a fingernail to start the process (nail-biters too bad!), and then you can get the rest up neatly. Rub off any lingering adhesive with your fingertips.

Splices may be easily taken apart and remade as many times as you like. Work carefully when you peel apart a splice, and you'll find the truth in this statement. If you cut a shot too short, you can add back, and few people will ever be able to tell you did just that. But for this to work, you must cut your shots with the Guillotine trimmer, not a film snips or scissors, so that the cut is made exactly at the frame line.

Your splicer comes with a piece of tape laid over the cutting portion of the registration-pin bed. Don't remove it. Its purpose is to help keep the cutout perfs on the bottom side of the bed. Helpful friends are always pulling this tape up.

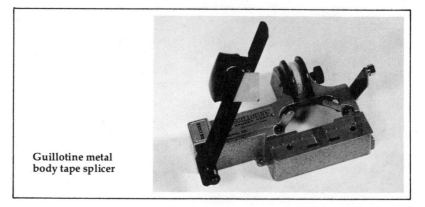

Guillotine metal body tape splicer

You will find, I think, that tape splices are hard to see. They certainly are all but invisible for dark or detailed subjects. You will be able to see them more easily with lighter tones, say shots of sky. Chances are your audience won't be able to see them at all. Although some super 8 projectors handle splices silently, you may be more likely to hear the splice as it goes through the gate of most projectors than see it.

As to whether or not a tape splice is more or less visible than a cement splice, it all depends, as the sage once said. Generally speaking, a good tape splice is about as visible as a good cement splice. I happen to think tape splices are a little less visible, actually, but I am a tape splice freak and not to be trusted.

Even a perfectly made Guillotine splice may leave a minute space between the butted together frames; this shows up as a white hairline on the screen. If the frame line control, or the framer, of your projector is adjusted properly, you can totally eliminate this white line.

There's no reason why you can't make your first splices in the store on the very machine you plan to take home. Then you'll see if that particular unit is working properly and in perfect alignment.

The Guillotine splicer (like the Fuji metal one) makes rapid tape splices that cover two frames, one on either side of the splice line. Other splicers, like those using the Kodak Presstapes, or some brands with peel-off paper, will cover four or five frames, two to two and a half on either side of the frame line. These splices are very visible.

Fuji tape splicing Many of the remarks I have made about the Guillotine tape splicer are applicable to the $15 metal-bodied Fuji unit. Although the final splice is identical to the Guillotine splice, the Fuji machine uses rolls of perforated tape. The tape is aligned with the perfs of the film, and the machine trims the tape to cover the film and leave the sound stripe untouched. Fuji raised the price

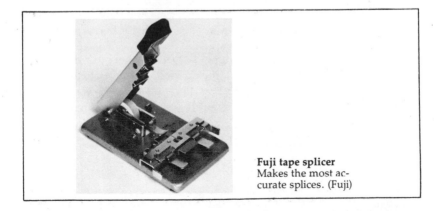

Fuji tape splicer
Makes the most accurate splices. (Fuji)

of their tape in the later part of 1974, or at least that's what's happened in the Bay Area; now a Fuji splice costs about a penny, or twice as much as a Guillotine splice.

Nevertheless, for $15 the Fuji tape splicer is a remarkably good buy. It's a first rate precision machine, and both it and the metal body Guillotine make really good tape splices. As a matter of fact, my recent experience with several units of both indicates that the Fuji machine may be making more accurate splices. I consider it to be the first choice among tape splicers. Many dealers do not regularly stock this unit, but all of them can special order it for you from Fuji. And remember to order a dozen rolls of tape too.

The case against tape The case against tape splicing is in two areas. The first isn't of any importance unless you are using one of the few stereo projectors which record a second channel on the balance stripe. The three tape splicing machines by Guillotine and Fuji make identical splices that cover all of two frames except for the record stripe area. Since the balance stripe is covered, its sound quality would be greatly impaired. So for this purpose, tape is out, and cement is in.

The second consideration is more troublesome and involves making prints. Depending upon how the printing machine and the people at the lab handle your film, tape splices can gradually stretch. When this happens the distance between spliced frames becomes greater, and a broad white frameline can appear visibly on the screen.

Labs don't always accept tape splices. Most do, but they sometimes have to run their printing machines at half speed to avoid damaging the film.

I have had good results with a number of labs making prints from my tape spliced original film. I think that filmmakers have to be very careful to make good splices in the first place (this applies to cement as well); labs have to be careful while working with tape, and manufacturers of splicing tape have to improve its adhesive quality.

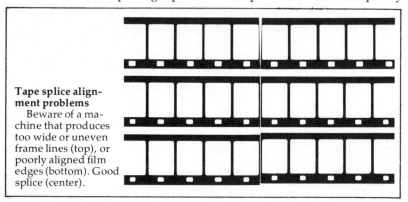

Tape splice alignment problems
Beware of a machine that produces too wide or uneven frame lines (top), or poorly aligned film edges (bottom). Good splice (center).

If the labs that complain about tape splices were honest about it, they'd have to admit they do have trouble with cement splices breaking in their printers, also.

Heavy-duty rewinds There is one piece of optional equipment you may wish to add to your basic editing setup, consisting so far of the viewer and a tape splicer: heavy-duty rewinds, handling up to 2000 feet of super 8 film. The 800-foot capacity of the Minette rewinds, if you choose to go with the Minette, is usually acceptable since most super 8 projectors will take a maximum of 400 feet of film. Many of the Eumig models and the Bolex SP80 will take up to 600 feet, the Heurtier and Bolex SM8 (Silma) up to 800 feet, but the Elmo 1200 will accept a 1200-foot capacity reel. So Elmo users may have to have heavy-duty rewinds.

These, offered by Hollywood Film Company, Moviola and others, are costly, running between $50 to $75 a pair. They have a high gear ratio, that is, for every turn of the handle you will get between three and four revolutions of the spindle, or shaft, on which the reel is placed.

They are most useful for rapidly rewinding a lot of film, and they are nice to have when cleaning film. They are almost as useful as the low gear ratio Minette rewinds for hand cranking your film through the viewer. They give you the option of using longer shafts for driving two or more rolls of super 8 for double system sound editing or the preparation of A and B rolls.

Accessories A few odds and ends will round out your editing room: a grease pencil, say a yellow one for good visibility is useful for marking film; a scissors for cutting film when you don't want to use the splicer cutter. You'll also need a notebook, for logging and cataloging shots, and black india ink with an appropriate pen for writing on the emulsion side of the leader legibly. Lately I've taken to using felt-tipped pens or ordinary lead pencils for marking film (on the stripe or balance stripe) and fullcoat.

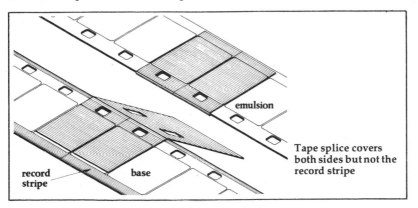

emulsion

Tape splice covers both sides but not the record stripe

record stripe

base

About leader: You should have one to three feet of black leader at the head and tail of each film to keep the annoying bright light of white leader off the screen at the start (head) and finish (tail) of your work. You can make black leader simply by keeping the lens cap on your camera and running off the needed footage, or by running the camera in a closet or darkroom.

You can buy white leader (Kodak offers this) which is good for protecting the head and tail of projected footage.

Try some Protect-a-Print leader to help clean the projector's gate area. Splice three feet of it to the head of every finished film. It won't do much to eliminate the essentially harmless but annoying dust that all too often appears as a shadowy spectre on the screen, but it will help prevent emulsion pile-up on the metal parts of the gate. These become the burr-like built-up masses that can gouge out emulsion or base, and make annoying vertical tram lines.

I suggest you clean your film often, after every editing session and after every few projections with an antistatic cloth, sold in electronic or hi-fi shops for cleaning tape and records. You can buy four for $1.20 at Radio Shack.

Stock good reels. Cheapo reels frequently are warped, will warp easily or sometimes do not have slots for anchoring the film; they rely entirely on pins on the reel core, which often will not engage the film. Avoid reels that are packaged in transparent cans. Storing your film in the dark will retard the color dyes' fade rate.

I like Baia plastic reels and cans as well as those supplied by Bonum (Eumig). The Baia are offered in 200- and 400-foot sizes, as are the Bonum which also comes in a 600-foot size. Goldberg makes good metal reels and cans, if you prefer these kind.

A pocket calculator, when used in conjunction with a synchronizer's footage counter (page 211), can convert a length of film into time. For example, suppose your counter reads 140 feet, 28 frames. Multiply 140 by 72 (72 frames in a super 8 foot) and add 28 to get the total number of frames. Then divide by the fps rate, which we'll take to be 18 fps. This gives you the time in seconds. To get minutes divide by 60. The operation looks like this:

$$140 \times 72 + 28 = 10,108 \text{ frames}$$
$$10,108 \div 18 = 561.56 \text{ seconds}$$
$$561.56 \div 60 = 9.36 \text{ minutes}$$

The whole thing took me just 15 seconds to do. Less time than using the table.

Look Ma, No Gloves Forget about cotton gloves for tape splicing. The tape will stick to the cotton and drive you nuts. Some people are now asking, how can this guy advocate working with the original camera footage and tell people not to use cotton gloves? Well, I thought the very same thing nearly two years ago, but I

SUPER 8 RUNNING TIMES & LENGTHS

fps ips	18 3		24 4	
	min.	sec.	min.	sec.
Film length, feet				
50	3	20	2	30
100	6	40	5	0
150	10	0	7	30
200	13	20	10	0
300	20	0	15	0
400	26	40	20	0
500	33	20	25	0
600	40	0	30	0
700	46	40	35	0
800	53	20	40	0
900	60	0	45	0
1000	66	40	50	0
1100	73	20	55	0
1200	80	0	60	0

fps	18		24	
	feet	frames	feet	frames
Screen time, seconds				
1	0	18	0	24
2	0	36	0	48
3	0	54	1	0
4	1	0	1	24
5	1	18	1	48
6	1	36	2	0
7	1	54	2	24
8	2	0	2	48
9	2	18	3	0
10	2	36	3	24
20	5	0	6	48
30	7	36	10	0
40	10	0	13	24
50	12	36	16	48
minutes				
1	15	0	20	0
2	30	0	40	0
3	45	0	60	0
4	60	0	80	0
5	75	0	100	0
6	90	0	120	0
7	105	0	140	0
8	120	0	160	0
9	135	0	180	0
10	150	0	200	0

fps: frames per second
ips: inches per second

EDITING

decided to give it a try. At that time I was busy cleaning my baby's bottom with Diaparene baby wash cloths. Like it says on the plastic bottle, they are premoistened pop-up towelettes. You can get 70 5¾ by 8 inch sheets for about a dollar. (The same product for adults is called Wet Ones.)

Every half hour or so, or whenever I have handled stuff away from my clean editing area, I wash my hands with a baby bottom wipe, and my hands are clean and free from oil for quite some time. Or, you can wash your hands with soap and water, if you prefer.

And having completely dispensed with cotton editing room gloves, to the horror of my professional colleagues, I have yet to mar so much as a frame of my film with a visible mark. Go ahead, try it. It's a great tactile experience to handle the very film you shot with your own flesh and blood fingers.

Using your editing setup　The viewer is a marvelously versatile device for examining and making transitions or studying footage in detail. You *can* get a good feeling for how the film will project by cranking the rewinds as steadily as possible. With experience, you will be able to do this very well. But you'll never be able to simulate precisely the exact dynamics of the film with hand winding. Hand cranking film through a viewer can't show you how the film will move through real time. It can't really tell you anything about duration, or how shots flow, or don't, together. Only your projector can show you the exact rhythm or tempo and pace of your footage.

The editing bench and your major tool, the viewer, make it convenient for you to sort footage, to file and catalogue, and splice together. The process of editing with a viewer is one of successive approximations that requires continual checking and rechecking by projecting the film. So you'll want to have your projector in your editing room.

Some projectors are more nearly suited for editing than others. The majority of super 8 machines are not convenient because they have automatic threading. Most of these have to be literally taken apart if you want to remove film midway through a roll. A manual threading machine allows for easy removal, or loading, of footage at any point. Except for the Eastman channel threading Ektasound machines, or the Fuji sound projector, however, there aren't any manual threading projectors, sound or silent.

But a projector with an in-path fast forward or rewind, so it doesn't have to be unthreaded, may turn out to be almost as good as a manual threading projector. Even if you have to thread up the machine from scratch, you still have rapid access to a particular section of film, since you can get to the head from a distant section in a matter of seconds. In this way you can rapidly get to whatever interests you, even if it lies buried deep in the interior of the roll.

I know this is also going against the grain, but there is a need for nonautomatic versions of some of the best projectors we are using, like the Eumig models, for example. Only time will tell if manufacturers agree with me and are sympathetic to the needs of people who want a machine for both editing and projecting.

Be that as it may, you can still get away with an automatic threading projector because film is most often edited in short sections or sequences that are joined together to make the main body of the work. So this reduces the problem; automatic projectors may not be much of a hassle some of the time.

I'd like to suggest to you that you wind your film in this way: from under the feed reel to under the take-up reel, or under-and-under. This is no small point. Projectors almost always will take up the film so that under-and-under threading is demanded, unless you want to waste a lot of time and possibly increased wear and tear on your film with needless rewinding.

Stick to the under-and-under winder scheme and you will make life easier for yourself in the editing room. It is this kind of small consistency that will allow you to concentrate on the important parts of editing. Unfortunately some editing equipment, like the Bolex and Elmo viewers, cannot be used under-and-under because their sprocket wheels have teeth on the edge near, rather than away from, the operator.

Your rewinds are your only fixed equipment, the only machines screwed or bolted down. Everything else should be able to slide around since different phases of the editing procedure may call for different positions of viewer and splicer. Your experience will determine the nicest way to place things. For example, if you have allowed enough room between rewinds, say two to three feet, you will be able to slide your viewer to the left side (facing the machine) and use your splicer on the right side. If you make your splices on footage drawn through it to the right side, you won't have to constantly rethread the viewer.

Although your editing setup uses little power, for convenience you will need a number of outlets. I used a strip-type outlet, Tap-a-line, which accepts a dozen or more plugs. Use molly bolts to screw into the wall if you can't find studs behind the wall board, or mount the Tap-a-line right on the editing table.

You'll need some good overhead lighting, and most advisedly a parallelogram desk lamp, with spring-loaded arms, so you can easily change your light's position as need arises. I bought a Luxo lamp with a 60 watt light, for $14 at a local campus bookstore. It's the small model, which I have seen in other shops for $20.

Filing and storing shots I usually file my shots on the 50-foot reels that are used by photofinishers for processed super 8 car-

195

tridges. I number the shots or sequences, and log them in a notebook. You can use color-coded peel-off labels, like PRES-a-ply file folder labels by Dennison, if you have more than one film in the works at a time. Each color would indicate a film.

You may like to use the clothespin-type film hangers. With some people the use of this type of arrangement approaches religious, or worse, professional dogma. Leave your original hanging out, and it may get dusty or accidentally damaged. That's the way I look at it.

There are many, many ways to file and sort film. Some people even use egg cartons. More power to them. Whatever works well—whatever makes for easy access and retrieval without damaging the film—is fine.

Carefully file your shots, and log them in a notebook, with appropriate descriptive entries. You will have to enter the time of each shot, either the footage, if you have a footage counter (see page 211), or with a stopwatch when projecting the footage. A good stopwatch is worth its cost, and it is an indispensable editing tool, as are footage-time conversion tables, like the ones reproduced on page 193.

Since it is much easier to shuffle shots around in your head, using paper as a memory aid, try your hand at this kind of initial composition of your shots and sequences. On the other hand, you may be better off simply plunging in and working with your hands without writing anything at all. In fact, you may discover, as I have, for some films, you don't have to write a word.

The Kindest Cut Editing a film is falling out of love with individual shots and becoming aware of the whole work. If you keep in shots that are beautiful, when you know in your heart of hearts they don't belong, you are not editing film; you are getting ready to show the world your favorite footage.

After you have screened your film a few times, decide what shots you like the least. I find it's easier to do this, since repeated viewing of dull shots makes looking at the footage very difficult. So I look forward to dropping this stuff as soon as possible. These are called *outtakes*. You can splice all your outtakes together on one reel for ready reference, or you can choose to file them. I like to tape splice all of my outtakes end-to-end as editing goes along, and from time to time I make it a habit to screen them, or at least look at them with the viewer. As editing of the film progresses, shots which seemed to be useless sometimes take on importance and can be cut back into the film.

Pulling out as much film as possible as soon as possible is one key to getting started in editing. The less footage you have to deal with, the better you can concentrate on what is to be done with useful shots.

196

If you shoot 400 feet in the course of making a film, and wind up with an edited film that is 100 feet long, your *shooting ratio* was four to one, or as it can be written 4:1. That means that for every four feet of film you shot you used a foot of it for your finished film. It doesn't make a bit of difference whether you shot 1:1, that is, use every foot of film you shot, or whether you shot 100:1. The only real virtues, as far as I am concerned, about a low shooting ratio are less cost and less film to deal with in editing. What finally counts is what appears on the screen. I stress this because it is a mistaken source of pride for people to brag about their low shooting ratios. At least it sounds like they know what they are doing.

Since shooting super 8 is relatively inexpensive, the cost consideration may be minimal. Only you can decide how much money you have to spend for film stock and processing. If you are shooting five hours of film to make a five minute finished film, something is probably wrong, unless of course you are trying to get all but impossible shots, say of the ground hog's annual appearance.

I think you should bear in mind that there are all kinds of ways to make film, and the general advice I have to give you about editing may be totally unsuited to your efforts. My work consists usually of shooting unscripted action, so my advice may be best suited to this kind of filmwork.

Shooting is a time of explosive creativity. It is an expansive, outgoing, essentially nonintellectual activity. That doesn't mean you don't use your head. It does mean that you may not have time to figure things out to a T, to tie them up neatly in little knots.

Sitting down to edit a film, for me, is a more implosive experience. It is a gathering together, a more cerebral trip. To be able to do both is a rare privilege for the filmmaker working within the commercial filmmaking establishments. To be able to do both is a matter of course for the super 8 filmmaker.

I have found that editing effort generally falls into three areas: 1) putting aside outtakes, 2) constructing sequences out of shots and 3) putting sequences together into a meaningful whole.

An observation like this may be so general as to be totally useless. It's really hard to know what to tell you beyond this. I think you have to find your own way and learn to work in accordance with how your head works.

The beautiful thing about film editing, unlike shooting, is that feedback is instantaneous. With present film shooting technology, you usually have to wait days to see what you have shot. This is one reason why people have more trouble than need be learning to operate a camera.

Film editing has this distinct advantage over film shooting: you can see the results of your work right away. Working with a viewer

will show you the results of the transitions you have made through editing (or in the camera). Projecting your film will show you the true tempo of what you have edited in a way you can never get from hand winding through a viewer.

Unfortunately you already have an extensive and not entirely helpful filmmaking education based on the hours you have looked at movies in theaters and on television. This is probably the greatest single handicap anyone could possibly have when beginning to edit, or for that matter, when learning about any part of filmmaking.

But you are not Pavlov's dog. You may have been conditioned, but you can unlearn, even if unlearning is the most difficult prerequisite to learning for those of us who are out of infancy. Which is why some of the best film work is done by untrained little kids, who can teach us a thing or two.

16mm vs super 8 I have heard it said again and again, or read it over and over, that editing 16mm is easier than editing super 8. This belief has worked its way into the mythology of filmmaking to such an extent that I feel I must address myself to the subject. Many of the people who report this as a fact of life haven't edited a super 8 film.

The argument is based, in part, on the fact that the 16mm frame is almost four times the size of the super 8 frame. As a consequence, it is far easier to look at a 16mm frame with the naked eyeball than a super 8 frame. Very true, but how often does anybody editing film eyeball each frame? It may happen, from time to time, but the standard procedure is to work with film in the viewer and look at it that way. In point of fact, both the super 8 and the 16mm frame are so small that even if one is extremely myopic, it's difficult to see what's happening in those pleasant little rectangular worlds.

After many years of 16mm editing, and the past two of super 8 editing, I can state for what it is worth, that it is far easier to handle, manipulate, file, sort, in short edit super 8 than 16mm. And here again it's a matter of size. Super 8 is simply far easier and more pleasant to work with because it is half the width and about a third the weight of 16mm film. My half dozen films I'm working on at the moment are sitting comfortably in a space that would be taken up by the same number of hard covered books. For this much running time in 16mm, I'd have film all over the place, coming out of my ears.

Super 8 has encouraged me to work on film after film, even more than one simultaneously. Although there are factors besides editing, handling super 8 in the editing room is so much easier than handling 16mm, I honestly think that people who say the opposite can't possibly have worked with both formats.

Minette viewer with soundhead. (Hervic)

Setup Cost So far we have run up the following tab for your basic silent setup: $110 for the Minette Viewer (or maybe the Elmo 912 silent unit at $80); $15 for the plastic body Guillotine or Fuji tape splicer (or $40 for the metal Guillotine), and if you want them, maybe $75 for the heavy-duty rewinds. These are all list prices and you can probably find good discounts.

To the bill you have to add the cost of your table itself, which you can buy used in a thrift shop, or construct yourself for something like $30 using a door or plywood for a top. You will also have to add a nominal figure for tape and other supplies I'll list shortly.

It is interesting to compare this setup with one for 16mm. The 16mm viewer will cost certainly two or three times what the Minette costs, and usually won't come with rewinds, so you have to get a pair of the heavy-duty units (which you'd want anyway for 16mm). The Guillotine tape splicer for 16mm will set you back something like $200. So a basic 16mm setup will cost several times more than one for super 8.

I am sure that some of the readers of this book have worked in video tape, or have considered getting into video, so it might be to the point to compare setup costs.

A basic video setup for the popular half-inch format requires at least two tape decks and associated equipment, which usually cost something like $3000 to $6000.

Basic Sound Setup You can turn your basic editing table into a single system sound editing setup for less than $50, by attaching a magnetic head unit to the viewer. Since the head is 18 frames in front of the image, the editor can see and hear movies in perfect lip sync.

At one time the only head conversion was one available through Filmkraft of Hollywood, a long-standing manufacturer of professional motion picture equipment. It was designed especially for the

Minette viewer, but Minette finally introduced their own $44 add-on magnetic sound reader for listening to single system movies.

The Minette unit attaches to the viewer and consists of a playback head and a miniature amplifier and battery. You can listen to the sound through the ear plug which is supplied, or by using the appropriate headphones or speakers.

Both Bolex and Elmo distribute viewers that can accept accessory units such as a soundhead, a footage counter and a film cleaner (one at a time, not all together). The Bolex V 180 Duo and the Elmo 912 Dual will also work with standard 8mm and, like the Minette accessory, they do not require a squawk box and its additional expense. I have been informed by an Elmo representative that both the Bolex and Elmo units are made in the same Japanese factory, but I cannot vouch for this. The machines have somewhat different styling.

I have had a chance to work with the Elmo viewer-reader, and it is very good indeed. The image isn't quite up to the standards set by Minette. I'd give it a B, and it is one of the better and more enjoyable units to use, at about $140 with sound reader.

The sound reader assembly, like the other optional devices, slides neatly into an accessory shoe, and the mag striped film is easily threaded past the head. A 9 volt transistor radio battery powers the device, and you can listen to the sound with a mini-earplug which is supplied, or you can run the sound through better 16 ohm headphones or speakers.

Using the Reader Often you will need to find your exact cut point with your reader. Unlike your viewer, the reader won't work unless the mag stripe is in motion. Therefore you have to keep the film moving to hear anything. By rocking the film back and forth, you will learn exactly where you need to make your cut. It may seem a difficult technique at first, but it's not: practice will make it perfect in no time at all. Once you have found your cut point, grease

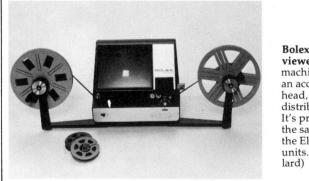

Bolex and Elmo viewers To the list of machines accepting an accessory mag head, add the Goko, distributed by EPOI. It's probably made in the same factory as the Elmo and Bolex units. (Elmo and Paillard)

pencil the base of the film directly under the reader, so you will know exactly where to cut when you put the film in your splicer. Or use an ordinary lead pencil right on the stripe itself, since its mark can't clog magnetic heads.

Tape Splices and Sound Splices made with a tape splicer are at right angles, as opposed to the diagonal cut splices of many tape and mag film splicers. How does this angle affect the quality of the splice? Are you more likely to hear a right angle splice of mag stripe track than one cut at a 45 degree angle? Not if it's properly made, as it will be with a tape splicer in good adjustment. The 90 degree splice is the preferred method for tight or exceedingly accurate editing. Moreover, from listening to thousands of my own cuts, I know the splices are impossible to hear, and can even be recorded over successfully. On some projectors, however, recording over splices can produce some dropout or wow.

Squawk Box Having a magnetic head with a track running across it isn't enough, you also need an amplifier-speaker, if you are using a Filmkraft conversion. The Minette, Elmo or Bolex units may be used with any 16 ohm headset or speaker, or an amplifier-speaker. You can buy a ready-made squawk box for about $70 from a professional motion picture supply house or a large photographic retailer. I use one made by Ediquip of Hollywood (they also distribute Precision synchronizers), and the sound of this device and of squawk boxes in general is nothing to write home about.

But you don't have to use a squawk box. Many tape recorders will accept the cable from the head so that they will play the sound directly through their amplifier and speaker. The Super8 Sound recorder, a modified Sony TC 800B, allows you to do just this. So do some other recorders.

Almost any recorder can be modified. Essentially, this is what you have to do: wire an input in parallel with the record/playback head, and plug your reader cable into this input. You can also wire a switch in series with the motor of the recorder so it can be turned off.

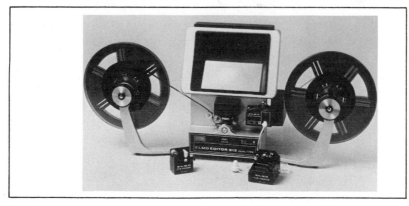

Or you can use a hi-fi amplifier and speaker. Do you have old monaural equipment around that isn't being used? Just plug the reader cable into the tape input of the amplifier, hook up a speaker to the amp, and you should be all set.

Editing Single System The single most important fact of life about editing single system super 8 movies shot in cameras accepting the Ektasound cartridge is that the sound is three inches or eighteen frames ahead of the picture. The three inches of film between the gate area of the camera or projector and the soundhead parts of the camera or projector are used to turn the pulsed motion of film into continuous motion. If the distance between gate and soundhead parts is maintained for both camera and projector, image and sound will be in exact sync.

When you sit down to edit your first Ektasound movies, you will leave all such theoretical discussions behind and enter the realm of the practical. You will be able to see in your viewer-reader that there is a distance of three inches between its gate and its soundhead. Now, where to make your first cut: what's going to happen to this shot if I cut it here? For if I cut for the sound at the head of a shot, I will be including three inches of unwanted image, or if I cut for the image, I will be excluding three inches of wanted sound.

Before I answer this question to your satisfaction, I want to butt in and tell you not to be fearful. If you have no filmmaking experience, and have not read any of the monthly publications devoted to filmmaking, you don't need this advice. Keep an open mind until you try your hand at editing single system. I have talked to a number of people who have absolutely no experience editing single system, but are convinced, even before they try, that because of the image-sound separation good results are out of the question. It is one thing to understand the drawbacks of a system without ever having had any experience with it, and it is another to have some experience, in which case you may be more likely to be challenged by its constraints.

My experience editing staggered image and sound (where the recording precedes the image—stacked sound would place the sound recording immediately adjacent to the image frame) has been very, very good. I approached my first editing efforts with fear and trepidation, but I was rewarded with fine results. Can it be, I thought? Well, I plunged in further and further, and I can tell you that though you cannot do everything with staggered image-sound that you might with stacked image-sound, what you can do generates vast creative possibilities.

For years people editing TV news in 16mm have had good results with single system, with only a limited time, barely hours, for their broadcast schedules. You probably won't have such tight dead-

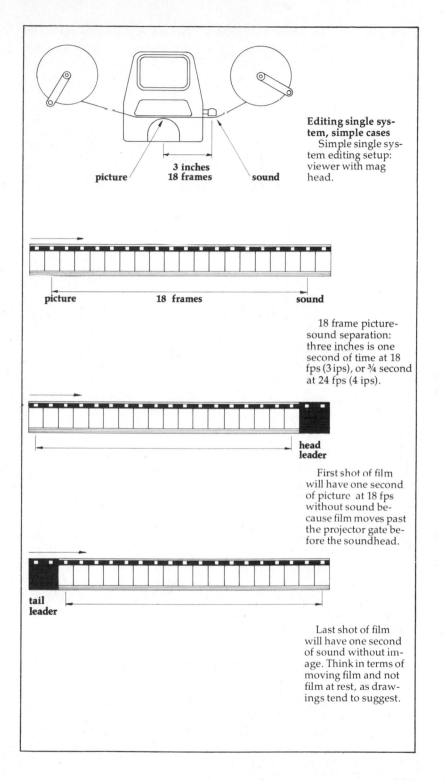

Editing single system, simple cases
Simple single system editing setup: viewer with mag head.

picture **3 inches
18 frames** sound

picture 18 frames sound

18 frame picture-sound separation: three inches is one second of time at 18 fps (3 ips), or ¾ second at 24 fps (4 ips).

**head
leader**

First shot of film will have one second of picture at 18 fps without sound because film moves past the projector gate before the soundhead.

**tail
leader**

Last shot of film will have one second of sound without image. Think in terms of moving film and not film at rest, as drawings tend to suggest.

EDITING

lines, and can take days or weeks to mull over a single cut. Like every other part of filmmaking, experience leads to improvement; and I must repeat, film editing has instant feedback—you can use the results of editing single system right away. Given time to refine a cut, or to consider how it can be made best, you will discover that editing single system sound is in many ways easier than editing silent films.

Silent footage is assembled and composed according to montage techniques enunciated by Eisenstein. Even if you never read Eisenstein, you cannot help but assemble silent film in this fashion. Shots are the building blocks of film editing, and adding block to block can result, if you have edited successfully, in an assemblage which is more powerful than a straight arithmetic summation of the parts. The juxtaposition of one shot with another can totally alter the effect of either.

When editing single system sound footage we are not so much concerned about building dynamic and pictorial montage units, but rather, we are carried along by a logic of sound leading to inevitable cuts, quite independent of image structure. In other words, you are probably going to be more concerned with the progression of dialogue than with the sequence of image. This inclusion of dialogue creates new rules that determine how a film will be constructed. There is a narrowing of the choices which would have been possible from considerations of image structure alone. This, in effect, makes editing single system movies easier than editing silent footage.

Within and Between Scenes When editing single system, there are usually two major areas of concern: working within a scene or a sequence, or working to put together scenes or sequences. Film editing usually proceeds along such lines: we are building sequences, or scenes, which are made up of shots. Once these sequences (a sequence can be one shot long) have been edited, our concern is then directed toward putting the sequences together. I want to stress that film editing does not have to follow such cut-and-dry patterns. In fact, you may not always be able to clearly identify specifically what phase of the process you are in when editing film.

However, when editing individual shots within a sequence, our concerns are generally different from adding sequence to sequence. Within a scene there is a kind of continuity which is different from that employed between scenes. This is essentially a matter of transitions. There is a class of transitions tolerable between shots in a sequence, and another between sequences.

Within a dialogue sequence, which I assume is of prime concern when editing single system, we are essentially interested in main-

taining background level tone, from shot to shot. Usually you have this going for you. Background level tone, or room level tone, is all the ambient noise in the environment—like a clock ticking, street noises or even the camera noise—adding up to background noise. When you cut from one shot to another in a sequence and there is an abrupt change in level or quality of background noise, the effect can be jarring. When shooting single system, this is usually taken care of for you, since background level noise will be carried over from shot to shot.

We are not concerned, however, with a continuity of background level tone when joining sequences together. It's okay if the background sound changes from one scene to another. In fact it points up the transition.

There are a great number of other things that can work when making transitions from scene to scene. You might consider adding slugs of black leader between scenes for an instant of darkness and silence. This will work in some cases, as will the addition of titles between scenes. Usually though you are going to want to cut one scene directly to another. Sometimes it is perfectly okay if the sound of the first scene is carried over to the image of the next one. It all depends on what works.

Eastman cameras take about a second to get up to speed, and only when they are finally running properly does the sound automatically fade up. This can make a perfect transition for the head of a shot to be added to the tail of another, between sequences.

Other in-the-camera transitions are a real possibility. I think before too long we may have single system cameras that will be able to fade in (or out) the image as the sound fades in (or out). This will greatly aid in the editing of single system. So would a single system camera that would automatically dissolve both image and segway (sound dissolve) sound. But we still have to wait for these.

In the past, chemical dissolves, first used in Hollywood many, many years ago, had been offered to the amateur moviemaking market. This is the way they worked: you dunked your film in the dye, or coating agent, for the full length of the desired fade. In our case, with 18 frames of film to be cared for, we'd dunk 3 inches of film into a glass full of the chemical fading agent. Slowly the film would be withdrawn from the bath. Since the frame out of the bath last would become the most dense, the differing gradations of density would produce fade-ins or fade-outs. A fade-in, for example, would make a fine transitional device for the head of a shot starting a scene. There would be silence the first second, as the image faded in.

Unfortunately, there is no such product on the market at present, or at least I cannot find it. Too bad. It would work quite well on transitions in super 8 silent original.

Appliqués, or tape overlays, might also apply for transitions. An appliqué of graduated density could be used for dissolves, and one of solid black could be used to blank out picture at the head of a shot until the sound comes on. Guillotine offers solid black appliqués that would work well for blanking out picture, but I know of no graduated tape appliqué on the market.

Just Within Scenes When we are concerned with cutting within a scene, here's one trick that can be employed to ensure a continuity of action and sound. Look for pauses within the shots that you want to join together. By studying your footage, you can usually find the potential transition points. Shots cut together at pauses in sound often flow together smoothly.

There are many, many devices that can work; I have never been stuck editing single system. I have always been able to solve the problems of editing within a sequence in a satisfactory way. My best advice to you is that you shoot some single system footage and tackle it at the editing bench.

Of course, no matter how hard you try there are some things that you simply cannot do when working with single system. It is difficult to do a cutaway, for example. Suppose you have a shot of a man talking about a process, and you want to show that process. If you cut a shot of what he is talking about into the shot of the man, you will have to lose the corresponding dialogue. Double system editing would probably be the best technique to use here. More about this shortly.

More Than One Camera One of the most interesting ways in which to extend the editorial possibilities of single camera system is to cover what you are shooting with more than one camera. I've discussed the requirements for accuracy on page 273.

When you use more than one camera, the action is covered in TV style, so that you can get a variety of shots of the participants. When time comes to edit footage you can cut from a closeup of a speaker to a medium shot of another speaker. Continuity of sound will be maintained if you cut for image, since both pieces of film have the same sound track in sync with the image.

Hand Cranking It is not easy to get good quality sound by hand cranking single or double system sound footage through your sound viewer-reader. You will have, at best, an eccentric rate of travel of the mag stripe past the soundhead. If you are careful, you will be able to make out the dialogue. With a little practice, you can get to be reasonably good at it, but thorough familiarity with the track usually comes only from repeated screenings of the film.

Editing music is very, very difficult when hand cranking.

Head Demagnetizer A head demagnetizer (at something like $5) bought at a hi-fi shop will be useful for demagnetizing the heads of your recorder, single system camera or sound projector. After running many hours, these machines' heads can be permanently magnetized, causing a background hiss upon recording or playback. The head demagnetizer, which looks like a pen, eliminates these residual traces of magnetism; for best results follow the instructions that come with your unit.

But my concern here is with the demagnetization (or erasure) of short lengths of the mag stripe. You can use these demagnetizing devices to erase unwanted pops and other annoying noise that can creep into your recordings. Simply bring the tip of the demagnetizer slowly downward to the mag stripe, and gently pass it across the area to be erased. You don't have to touch the mag stripe, but if you do, apply no pressure. After a few passes, lift the tip away slowly and once it is two or three feet from the film turn it off. Run the mag stripe through the reader.

However, I have discovered a better method for removal of clicks and pops is to cover the noise with a little bit of splicing tape. The tape is applied directly to the oxide and can be removed and reapplied until perfection is achieved; this method avoids the danger of an uncorrectable error, as can occur with the head demagnetizer.

Displacement Recorder TV news film editors have, for some time, been grappling with the problems of editing single system news. Practically all of their film is shot single system with 16mm cameras. One of the tools they sometimes use is the displacement recorder. I know of only one such machine for super 8 single system original, the Autosync S-8 made by the Moser Development Company and sold by Filmkraft of Hollywood, Super8 Sound of Cambridge and other outlets as well.

Now a little nomenclature, not too belatedly. The sound recorded by a single system camera, and staggered 18 frames from the image, is in what is called *projector sync.* In other words, it's suitable for use on a projector. The other kind of sync people who edit film have to deal with is called *edit sync,* or sometimes *dead sync,* or sometimes, *printer sync.* In this book we will call it edit sync, and for single system it's when the image and corresponding sound occupy the same place on the film, or to put it more accurately, the sound is recorded to be in sync with the adjacent picture frame. I've already used the term stacked to describe this image-sound relationship.

With a single system original in edit sync, cutting for picture is the same as cutting for sound, and cutting for sound is the same as cutting for image. If you have a viewing-reading device with the

EDITING

picture and soundheads in edit sync, cutting edit sync original would be the easiest thing imaginable. While the Autosync S-8 will turn super 8 projector sync original into edit sync, I know of no corresponding viewer-reader with soundhead in the gate, but one could be made.

The layout of the displacement recorder is this: the machine has a playback head that picks up the sound, and a record head some 18 frames away to lay it back down on your mag striped original. Between the two is an erase head to clean the mag stripe in preparation for the edit sync track.

The Autosync lists for $1295 and will operate at more than 100 frames per second, so it will do a 400-foot reel in less than five minutes. The frequency response is claimed to be virtually flat in the voice range, and its background noise is below any projector's capability, so one would assume the displacement transfer would be essentially perfect.

Displacement recording sounds a little scary to me. If something happens between record and playback head, you are plain out of luck unless, of course, you have already made a dub of the track on mag film or sync-pulsed tape.

After editing is finished, the original is placed back into the Autosync, and the process is essentially reversed with the track laid back in projector sync.

Displacement recording may well turn out to be the answer to many users' needs. Perhaps we will see less expensive units if demand grows, or the displacement recording feature could also be built into a projector design.

While displacement recording will solve some of the problems inherent in single system editing, others remain. For example, the insertion of reaction shots is still impossible. For this we must use double system editing.

Editing Double System Whether or not a film has been shot in single or double system, you can edit using double system techniques. It is relatively easy to dub a magnetic film track from your single system original camera film so that you can edit double system by using the original and the dubbed mag film. We have discussed this procedure on page 147, but for now let me say that I think single system original will come to be the dominant source for double system editing. In other words, the simplicity of single system shooting can be combined with the flexibility of double system editing by copying the single system original on mag film and editing as you would for double system. There will also be people who want to use their super 8 production cameras which are capable of producing double system in conjunction with an appropriate recording machine.

In some ways double system editing is simpler than single system editing. You don't have to be as ingenious when you edit double system. You don't have to seek special cutting points. Most anywhere you feel like cutting you can, since the image and sound are not staggered three inches apart and locked together on the same piece of film. Simply cut the mag film at the same point as you cut the image, and you have a perfect cut.

Double system editing allows you to add more than one track to your finished sound. You can have one track of dialogue, one of sound effects, a track of music, all blended together in the final mix for the finished track. This is exactly the way theatrical films are sound edited. There, a dozen or more tracks are locked together while a few sound men work the pots of the mixing console to blend together a complete track.

There are times when it is possible to achieve certain effects with double system editing. This is as true for lip sync dialogue as for passages that must have non-lip sync image and sound closely syncked.

Before we run down the tools needed for double system editing, it might be well to go over the original sources of double system material.

Double System Sources Conceptually, and maybe practically as well, the simplest way to get a double system image-sound recording is to use a camera in conjunction with a super 8 magnetic film recorder, like those provided by Super8 Sound or Inner Space. At the time of shooting, every exposed frame of image has a corresponding recorded frame of sound. It doesn't matter if the camera and recorder are umbilically tied or crystal controlled.

The next way you might go about producing double system sound could be with your camera and a tape recorder. For super 8, a good cassette recorder is often used because of compactness. The digital or sine (60 Hz) pulses recorded on the tape are used as a reference for resolving your recording. Resolving is dubbing to magnetic film under the control of the sync pulse track. The resolving procedure yields mag film which is in frame-for-frame sync with the camera film. This is like the first procedure outlined, with the addition of an extra step, namely, resolving. If you have a good original recording, you will be hard pressed to tell the difference between original mag film or resolved mag film, even though the resolved material went through an extra step of duplication.

If you have a mag film recorder you can use it to do your own resolving. Some systems allow you to resolve your mag film on your projector. (No reason why mag film can't be used on your projector.) There are also studio services which you can hire to resolve your original recording to mag film. Whatever approach

you take, you must be able to follow through to completion. Make sure your recording is compatible with your resolving machine or service.

The last major way of producing double system would be to dub your original single system film to mag film. Then you could edit your camera original and the dubbed mag film. Most users will probably dub directly from their projectors to their mag film recorder. A single frame switch must be installed in the projector so that it can provide a suitable digital pulse for the recorder.

We mustn't forget this: just as double system derived from a camera and a recorder needs to have a start mark, or a visual and an audio cue for syncking up the head (or tail) of a shot, so must double system derived from single system original. It can be very difficult to establish perfect sync without start marks, especially when working with hand driven as opposed to motor driven equipment.

This is one way you can obtain the appropriate marks. Your original is placed in the viewer-reader, and you add a few inches of leader to the head of the shot. If you are working with black leader, scratch an X into the emulsion. Now, with the X projected on the viewer screen, you must add your sound start mark at the reader, or soundhead. One idea I have come up with is to prepare some mag film for this, or some striped film, by humming a nice tone. Or you can record one with a harmonica. Now cut a few inches of your tone to the leader so that the last frame of the tone can be heard when the X is viewed. After the transfer of the sound from the original to the mag film, you can use the last frame of tone to sync up your start mark and sound. An alternative method would be to use Sync Beeps (D.P. Upton Company, page 290). These are adhesive-backed magnetic tapes which have been recorded with a 1000 Hz tone. Simply cut and apply the Sync Beeps where needed.

Now, the tools.

Synchronizer Some people, especially on the East Coast, like to call this piece of equipment a sync block. I call it a synchronizer. But

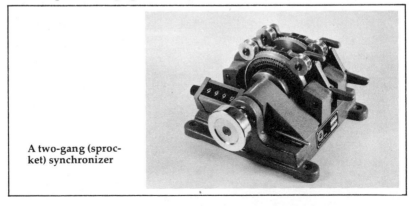

A two-gang (sprocket) synchronizer

they also like to call mag film by the name fullcoat. Does it make a bit of difference?

I'll describe a synchronizer: it is a series of ganged sprocket wheels used to drive more than one roll of film in frame-for-frame sync. It's a very simple mechanical device that allows you to manipulate film, say picture and mag film, length for length. The synchronizer helps the filmmaker edit double system sound by locking a track (or several tracks) in sync with the picture. It can also be used for measurement, so that you can know in terms of feet and frames how much film has passed through it. There are 72 frames of super 8 to a foot of film. Super 8 synchronizers have 72 frame circumference sprocket wheels. A counter is driven by the sprocket wheel to measure feet, so that the user can then read frames off the calibrated forward sprocket wheel, and feet off the counter.

A synchronizer with but a single sprocket wheel and a footage counter is no synchronizer at all, since it can't hold two or more separate lengths of film in sync; rather, it is a simple frame and footage counter. Some people call the sprocket wheel of a synchronizer a gang. So to have a synchronizer, and not a simple footage counter, you must have two or more gangs or sprocket wheel units.

It would be possible to calibrate the scale running around the circumference and the counter in seconds and in minutes, rather than frames and feet, but this would turn out to be an inconvenience in the long run, since you may be working at either 18 or 24 fps. You can use a simple conversion table to look up time, given a length of film and the appropriate fps rate. Or you can use a pocket calculator, page 192. The synchronizer shows clearly that film is the art of plastic time manipulation. While we cannot hold time in our hands, we can hold a length of film, which to the filmmaker is the same thing.

The basic accessory for the synchronizer is the soundhead or reader. It can be mounted on the gang so that it can read sound on any sprocket wheel. With just a screwdriver, a mag head can be mounted on a gang in a matter of a few minutes. You can mount several heads if you need to hear the resultant mixing of more than one track. For this you will need a mixer as well as the usual squawk box.

In the simplest double system setup, a two-gang synchronizer has a soundhead mounted on one of the gangs. The head is plugged into your squawk box, and you can hand drive both image and sound. In this setup, the image and sound would be out of sync if threaded in the synchronizer in edit sync, because you cannot view the image right from the sprocket wheel.

One way people usually solve this problem is to place the synchronizer to the right of the viewer with the corresponding in-sync

frames positioned in the gate of the viewer and under the head of the sound reading gang. When you turn the crank of your rewinds, you will be driving both picture and mag film in sync; you will see and hear the film in sync, since the synchronizer locks both image and sound together on your editing bench even if the pieces of film are not in edit sync.

You will need to use heavy-duty rewinds and employ long shafts so that more than one reel may be driven at a time. Spacers are available so that your reels will be kept the appropriate distance apart to work in coordination with the synchronizer.

Many people buy at least a three- or maybe even a four-gang synchronizer with more complex filmwork in the future in mind. One synchronizer, the Precision unit, allows the user to add gangs as needed. It's the only unit like it, but even so, most people usually buy these ready made at the size they anticipate will fit future needs. There are several companies making synchronizers such as Hollywood Film Company and Moviola/Magnasync.

You are going to pay through the nose, as the expression goes, for a synchronizer. Maybe $200 for your basic two-gang unit with sound reader attachment.

Sound Reader An independent sound reader is a device that is usually used right in front of your viewer, with the soundhead in line with the viewer aperture, so sound and image are in sync. With a synchronizer to the right or left of the viewer, you will be able to maintain a perfect edit sync system. The reader has no sprocket wheels, but rather is a simple assembly of guides and soundhead. The synchronizer provides frame-for-frame sync by locking both rolls of film. In some ways you may find it easier to edit double system this way than with the soundhead mounted on a synchronized gang. Certainly what you are doing is conceptually simpler, since your picture and track will be directly opposite each other.

Sound Projectors I should point out that just as your projector may be used in the editing room for silent film, so may your sound projector work for single system editing; and equally as well, a silent or sound projector can be interlocked with a super 8 mag film recorder for editing double system. Briefly, the usual method is to install a switch on the projector which produces a single pulse for every projected frame. Although this can be done to either a silent or a sound projector, people usually use sound machines for this application.

The sync pulse from the projector is used by a mag film recorder, like those supplied by Super8 Sound, Inner Space or others, to maintain frame-for-frame sync between picture and mag film.

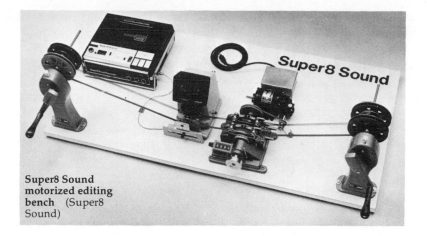

Super8 Sound
motorized editing
bench (Super8
Sound)

Motorized Editing Bench A few firms offer motorized double system editing benches, and Super8 Sound has a double system motor-driven synchronizer and associated contraptions at about $900 (photo above). I think you will get the general idea of how these units are set up from examining the photographs. If you like what you see and want to order one, make sure it runs at the speed you need. Since most super 8 filmmakers work at 18 fps, you will probably need an 18 fps unit. The best deal is to have one that will operate both at 18 or 24 fps. (Specialties Design Company offers a similar four-gang unit.)

Some of the larger shops specializing in super 8 motion picture equipment may have a motorized bench on hand for you to examine. Or you may be able to find one at a local film school. It's always a good thing to be able to look and touch something that is going to set you back $800 or $900. I find it surprising that people can order products like this without physically examining them, but to each his own.

One of the problems with double system editing, whether hand driven or motorized, is that super 8 mag film and picture may not be of the same thickness, so that their radii will differ as they take up on their respective reels. This happens because the rate of take up is radius dependent. What you will get in this event is a slopping over of one (or more) reels. This usually calls for judicious hand jockeying of the reels. But there are devices called differential rewinds that solve this problem by mechanically taking up each reel at the appropriate rate.

The Super8 Sound motorized editing bench adds some polish to the usual designs by overcoming many obstacles. But in the process it makes clear that using even the best motorized editing bench requires considerable skill. You have to have your wits about you to

213

avoid fouling up, and it takes a lot of manual dexterity to work the thing. Having said this, let me also say the Super8 Sound motorized bench is the very best I have seen, and it is half the price of the next option, the MKM horizontal editing bench. The whole thing costs about $800, and that's without a squawk box. You can buy components separately, but from my experience, buy the entire package if possible, or when ordering, state which component you already own.

However, one of the nicest things about this editing bench is that you can add components to your basic setup as your needs increase. You can start with a Minette, then add the heavy-duty rewinds, then the synchronizer, then the motor and so on.

The Super8 Sound bench uses a Minette viewer, a two-gang synchronizer driven by a Bodine motor, a sliding soundhead with a plus or minus 12 frame adjustment mounted on a reader, heavy-duty rewinds and differential rewind gadgets mounted on the rewind spindles. The package comes with a predrilled mounting board. (Three- and four-gang units are also available.)

There's a lot of equipment to go over here, but essentially you've got a viewer with a sound reader (page 190) mounted in front of it. The motor driven synchronizer advances both picture and sound through the viewer and sound reader. Depending upon which plastic gear you hook up to the motor shaft, the synchronizer can be driven at either 18 or 24 fps. Film must still be hand wound onto the take-up spools.

The major advance in design is that once the motor is turned off by a handy (or should I say footy?) pedal switch, the motor is automatically declutch so that film may be wound by hand. A magnetic clutch, supplied with 90 volts of DC, is mounted on the Bodine motor drive shaft. When the motor is off, the clutch decouples the motor from the synchronizer. If you have used other motorized editing benches, you know that you have to manually, mechanically declutch the motor from the synchronizer. An extra step eliminated, one less small thing to sweat.

The head on the sliding bar makes it possible to avoid repositioning either picture film or sound film in the synchronizer. Simply slide the bar and you're in sync. A small advance, but along with the magnetic clutch, this adds up.

The differentials are a neat piece of mechanical engineering, and I think they are the best I have seen. Four rubber rollers set at right angles to each other are mounted between the spool drive plates, allowing for limited slipping of either spool of film; this adjusts for varying film and core thicknesses.

Proper back tension on the feed rollers is required to get acceptable sound quality. The sound is only fair, but it's good enough for

editing voice or music. If a soundhead is added to the Minette, you're all set to do motor driven single system as well as double system.

The Super8 Sound bench offers a lot—maximum manipulation of image and sound—for a comparatively modest price. After using it for six months, I like it a great deal.

Flatbed Editing Machines The flatbed horizontal editing machine offers these advantages: the user can motor drive film, forward and backward, at fast and slow or sound speeds, with picture and track in perfect sync. Not only is such a machine useful for sound work, but it is a pleasure to use for silent work. No more jumping back and forth between editing bench and projector.

The first super 8 machine, a $3000 editing deck, was introduced by Hamton Engineering as part of the MIT-Leacock sound system.

I think the most interesting horizontal editing machine you can buy is the MKM Model 824. Most properly it should be called a deck, since it is meant to sit on top of a table, although a stand is available. This deck sells for $1800 list which, relative to larger format standards, is a bargain. It looks like a beautifully made, precision machine that advances the state of the art. I say "looks like" because the only unit I've examined was in a showroom, and it was inoperative.

The 824 is a four-plated model, which means it has a total of four take-up and feed reels. It will take a roll of picture, and a roll of mag film, and run them together in sync from a creeping pace to what the company claims is 62 fps. Of course sound speeds of 18 and 24 may be set, and a sync motor for 24 fps is available. Too bad MKM doesn't offer the same option for 18 fps. Be that as it may, you don't need the sync motor since appropriate sync speed can be established by ear. A single system soundhead is available for $150 extra (it must be ordered at the time of purchase) and a six-plate model is expected.

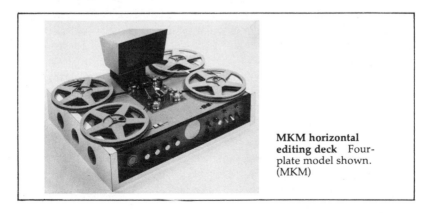

MKM horizontal editing deck Four-plate model shown. (MKM)

Film is threaded past the two heads, the one closest to the screen is for picture, the one nearest the user for sound. The threading path conforms to the under-and-under projector scheme I advocate for editing setups. The image of the viewer is on a bright 3¾ by 5 inch screen, good for bright light viewing. The sound comes out of a four-inch speaker located on the control panel. Both image and sound are reported to be of good quality. A hand inching knob, indispensable for many editing operations, has also been included.

There are a number of editing machines on the super 8 market, or should I say almost on the market. I think half a dozen or more have been shown at various trade shows. How many, and which you can buy are another question.

The Hamton and the MKM unit are horizontally laid out. This is in the tradition of 16mm and 35mm equipment. Super 8 reels are so much smaller that the advantages of a horizontal design are less spectacular, and Murray of France has shown a vertical flatbed editing bench.

Also editing benches by European manufacturers have been shown, including units by Steenbeck, KEM, Schmid, CTM and EGM. Moviola/Magnasync, an American firm, has threatened to offer a horizontal editing bench if they get enough orders.

Super 8 Research Associates offer what appears to be a sophisticated four-plate machine that is expandable to six plates so that it would be possible to view picture and mix two tracks.

Edge Numbering Since you are involved in manipulating two pieces of film for each shot, double system editing can get to be complex, at least in terms of filing and keeping image and corresponding track together and in sync. Once you cut off the head and start mark of the shot, you have to be able to keep picture and mag film together.

So except for the simplest kind of double system work, you may find it necessary to have your picture and mag film edge numbered: small code numbers printed by a lab on the edges of your film. These numbers appear every foot or two, running consecutively. Both picture and mag film are numbered to correspond with each other when in sync.

For simple double system jobs, you can do without edge numbers. In some cases, you may even be able to employ peel-off labels, noting where the shots sync. This is especially true for efforts that involve non-lip sync sound. When trying to juxtapose music with image, or what's usually described as sound effects, or narration, or similar kinds of tracks, exact sync is important, but you probably won't need edge numbering. This class of sound track is easy to work with and they are sometimes called wild tracks, to designate

that whether recorded in the field or in the studio, they are non-lip sync.

When working with the Super8 Sound motorized bench, I found I could get by without edge numbers and edit with facility by first doing a rough cut with single system footage. Once the shots are in the proper sequence, more or less, I transfer from original to mag film and then cut double system.

You may wonder why you need to transfer to mag film for wild tracks in the first place. You can transfer to your striped original, but you may find that no matter how perfect your work is, you will be stymied by the lack of exact frame-for-frame sync in the transfer from cassette tape, or reel-to-reel tape, or phonograph record, to mag stripe.

For many, many films, you can do perfectly fine work with a direct transfer to striped film. You can sometimes combine the techniques used for single system editing here. After your transfer you may be able to refine the film by editing it as if it were single system original.

But you may find that transferring your recordings to mag film and then working double system with your original can give you more freedom to cut as you please. Or you may be into mixing more than one track, in which case double system is probably your best bet. Let experience be your guide. You don't know what kind of effects are possible until you try them, and adding wild track to picture can work in either single or double system.

Tape Splicing There is one important variation in technique to bear in mind when tape splicing super 8 magnetic film. If you allow the tape folded over the oxide (dull) side to go clear across to the position of the record stripe you may be covering some of your track. Let me make this clear: the mag film has no record stripe, for it is fully coated with iron oxide from edge to edge. I'm talking about the position where the record stripe would be for picture film.

You may recall that tape splices made with the Fuji or Guillotine splicers reach just up to the record stripe. The position of the track used for mag film corresponds to the position of the record stripe; however, it is wider. The width of the record stripe is often given as .027 inch. But the full width of the track made on a Super8 Sound or Inner Space mag film recorder is about .110 (page 152).

If you make the tape splice for mag film as you do for striped picture film, you would be covering .08 inch of the mag film track. So, with a scissors, slightly trim the folded-over tape before pressing it into position.

Multichannel Tape Machines The usual method of preparing multiple channels of sound is to employ independent rolls of mag

film. The rolls are prepared in the synchronizer, or on a horizontal editing bench, and then studied for the final track. If three tracks are to be mixed, three mag film recorders are run in sync; the sound from each is mixed and dubbed to mag striped picture film, or to another roll of mag film which will serve as the master duplicating copy.

The introduction of quadraphonic sound, and the equipment it has inspired, has lead to great advances in working technique for super 8 filmmakers. For example, the $2000 Sony 859-4S, which uses quarter-inch reel-to-reel tape (there are far less expensive machines by Teac and others), may be employed for three-channel mixes. The fourth channel is used as a control track for synchronizing the 859-4S and a mag film recorder or projector, or reel-to-reel or cassette recorder.

The 859-4S may be employed in conjunction with the Inner Space or Super8 Sound systems. Inner Space offers a conversion of the 859-4S to a four-channel mag film recorder. The limitations of this piece of equipment are set by the technical knowledge, skill and imagination of the filmmaker. It can lead to fantastically complicated mixing efforts that up until now have been the sole province of the professional mixing studio.

This only serves to point out one of the strongest things about super 8 sound work: a filmmaker, by fooling around in his own studio can achieve effects that would have been impossible without great expense and professional sound studios.

Mag Film all the way The great thing about editing double system is that an exact length-for-length correspondence exists between image and sound. This makes handling and manipulating film relatively simple and straightforward.

In the strongest possible terms, I think that the best and simplest possible way to edit super 8 double system sound is with a synchronizer (or a conceptually similar flatbed machine) and super 8 mag film.

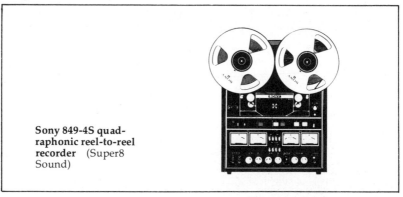

Sony 849-4S quad-raphonic reel-to-reel recorder (Super8 Sound)

218

There are some systems that attempt to do away with either super 8 mag film or with the synchronizer or with both. To be blunt these systems are bad ideas. Stay away from them if you value simplicity. A synchronizer is a beautifully efficient mechanical device requiring the minimum of figuring and concentration. Some people, like those at Inner Space, have editing systems that dispense with the synchronizer. They interlock a projector and a recorder so that you can edit picture and sync-pulsed tape in tandem. I think that's substituting electronic artifice for mechanical simplicity. We may be in the age of electronics, but this is no reason for looking down on the mechanically simple synchronizer.

Optasound offers an intriguing nightmare, a $2400 "computerized" editing bench, which interlocks cinetape (perforated tape) with camera film. Since tape is too floppy to handle in a synchronizer, systems like the Optasound have tried to deal with this problem by providing essentially electronic counting of the tape's perfs. (The Optasound system now uses ordinary tape.)

The Carol system and others like it use regular quarter inch tape recording sync pulses on one stereo channel. When editing time comes, the user must count electronic perfs to match with film perfs. Perhaps the Optasound system, with its automatic electronic counting, is some improvement over this. But as I examine these editing systems and compare them with the traditional method of editing double system with mag film, I wonder why they think they've improved anything.

Then we have the use of 16mm mag film and super 8 picture. It's an inconvenient combination. This mixture is purely the result of our transitional times. Super 8 is only about a decade old. There are synchronizers on the market that use a transmission drive coupling gangs of super 8 film and 16mm mag film in frame-for-frame sync. A transmission box sits between the picture and sound gang, and one turn of the synchronizer advances one frame of both, even though there are seventy-two super 8 frames and forty 16mm frames to the foot.

You'll find hybrid setups like this in places like film schools where large capital investments have been made in 16mm mag film recorders. It seems an appealing idea to be able to work on super 8 tracks with 16mm equipment, and then to dub down to super 8 in the final transfer to stripe. The chief virtue of editing film, the length-for-length correspondence between picture and sound, is destroyed with this scheme. What is especially damaging is that these setups are used by people trying to learn to make film.

Workprints Some people prefer to work with a print of the original camera film, rather than the original itself. The best method for using a workprint in super 8 editing, I would think, is to shoot

double super 8, say with a Pathé DS 8 or a Canon DS 8 or perhaps with a Bolex H8 standard 8mm camera which has been converted to double super 8. Then a professional motion picture lab will make a workprint, which must be edge numbered to correspond with similar numbers printed on the original footage. After editing is completed, the original is cut to conform to the workprint, a procedure known as *negative cutting* (even if you are working with reversal film, as invariably is the case for super 8) or sometimes, *conforming*. In this application the synchronizer is an indispensible tool serving as a comparative measuring device to keep print and workprint together.

The reason for preferring double super 8 is cost, and cost alone. Labs will generally charge something like $.11 to .15 a super 8 foot for prints made from the usual 8 millimeter-wide super 8. On the other hand, prints can be made from unslit and just processed double super 8. The prints are made from the 16 millimeter-wide double super 8 onto color reversal print film 16 millimeters wide, which is slit after it has been processed. Then the price works out to something like $.06 to .08 a super 8 foot.

To all prices about $.02 a foot must be added for laboratory printed edge numbers. Some labs will also charge for slitting and spooling super 8.

A and B Rolling The A and B printing technique is an ingenious method for making prints with invisible splices, dissolves and double exposed footage, like burnt-in titles over a background. Fades can also be produced using A and B rolling techniques, but these can also be done by many labs for super 8 prints made from a single roll.

You need a synchronizer for doing A and B rolling. The A roll is set up in a gang with the B roll in another. You can also choose to have even more printing rolls, say C and D rolls.

Tape splices can be used for A and B rolling, despite the fact that cement splices are usually employed.

For straight cuts, one shot ends on one roll and another shot starts on the other roll. Opposite each shot we have black leader. The method for A and B'ing using tape splices, is called zero cut printing. Here, a few frames, two, three or even dozens, overlap the splice point. The shutter of the lab's printing machine makes the cut, so the tape splices are not seen. Hence we get invisible splices.

Dissolves may be set up using A and B'ing by overlapping the necessary frames; anywhere from 16 to 100 frames can be done, depending upon the kind of printing machine your lab uses. First one roll, say the A roll, passes through the printer and is exposed on the print film. Wherever you have called for a dissolve, the lab fades out the shot. For the next roll, the B roll, on its pass through the

printer, the lab makes a fade-in. The result of a fade-out over a fade-in, as you know if you have any one of many super 8 production cameras, is a dissolve.

Before you prepare your A and B rolls, check with the lab or labs you think you may be using. Because there are so few labs presently doing this for super 8, compared with the 16mm format, it is not uncommon for filmmakers to do business by mail with an organization in some distant part of the country. In such a case, it is particularly important that the filmmaker establish an understanding with the people who are going to make the print. A telephone conversation with the lab's technical representative may do you more good than weeks of correspondence.

It is true that splices for super 8 can be very difficult to see, and that in-the-camera automatic dissolves make the need for A and B rolling less pressing. However, there are people who will want to A and B roll super 8 film to get double exposures or multiple-image effects, dissolves where they need them, burnt-in titles and other effects that can be decided upon as part of the editorial, not shooting, process.

For those who are interested, there's more information about the specifics of A and B'ing in *Independent Filmmaking*.

Handling Original Throughout this chapter and in other parts of this book I have discussed ways that you can keep your original camera film fresh and alive. This is a serious business that faces practically every super 8 filmmaker. Working with the original camera film is alien to larger format filmmakers, but commonplace for the super 8 worker. And it should be: it cuts costs, and it turns the filmmaking process into a more direct and powerful experience. Filmmakers who know they need prints, should have them made as soon as possible after cutting the original. In other cases people want to protect their original as much as possible, so they will make workprints. But most of us will make prints only as we need them, screening our original. Here then, is a gathering together of suggestions aimed at extending the life of your original.

Screen your film on a safe projector. Make sure the projector doesn't scratch the picture or damage perfs. Run a loop of leader (emulsion side toward and then away from the lens) through the projector. That's leader spliced end-to-end. You'll need a few feet of it for most machines. Closely examine the leader. Do you see any scratches? A projector should be able to run the loop for a hundred passes without much film damage.

Always project your own film on your own projector. Don't let anybody else do it, especially if you are not there. Don't use any other projector before you have thoroughly checked it out. Stay

near your projector throughout the screening, so you can save your film if any goof occurs.

If the film gets fouled up midroll, there's usually no way to get it out short of taking the projector apart. If such a thing happens, don't lose your head. It may be better to accept a single unwanted break in the film that you can repair with a good tape splice than five or ten feet of reperforated, crumpled footage.

But the worst damage to super 8 film happens because of the autothreading (some people call them autoshredding) mechanisms. Automatic threaders often fail to accept film when first put into them. If you are familiar with your machine, you can tell what's going on by the weird sound it will make when this happens. Moreover, if your film does not emerge from the other end to the take-up reel in a reasonable length of time, you know you are in trouble. At least it's only leader getting the business, so use enough of it, at least five feet at the head of your film. Your leader can be made up of three feet of Protect-A-Print leader (page 192) and two feet of black leader.

Also, beware of those auto take-up spools. They don't always do their thing. They will, nine times out of ten; but if you trust them all the time, the tenth time you are going to get a pile of film on the floor.

Clean your projector and viewer. Use cotton swabs or a soft flannel cloth and a toothbrush or a similar kind of brush to remove emulsion build-up and other harmful dirt. Dampen your cleaning implements with denatured alcohol (shellac thinner) available from any hardware store. Use it sparingly. Some people use acetone, but it can mar the finish of painted machine parts.

Your machines must be tuned. If any scratching is occurring, or damage to perfs attributable to the machine's being out of adjustment, bring it to a good repair man, along with a sample of damaged film. Everything in your setup must be tuned and cleaned.

Never cinch film, that is, pull it tight on the reel. Never, never, never do this. You are going to add many little scratch lines and abrasion marks if you do. Film which has passed through the projector onto the take-up reel is usually wound snugly with even tension, so why not leave it there if you can? Nice and even hand winding is probably preferable to a fast rewind on most projectors.

Use tape splices. I think cement splices can add to wear because of all the emulsion dust produced when making one.

Have your film Vacuumate- or Peerless-treated. This is usually best to do after silent footage has been striped since the last steps of these similar processes is lubrication, which can interfere with the striping application. As I understand it, these treatments, which are performed by many motion picture laboratories, replace the mois-

Peerless machine
The technician is pouring chemicals in the delivery cup. Film under low pressure is within the bomb-shaped chamber. (Photographed at W. A. Palmer Films)

ture in the emulsion with compounds to toughen it up. Peerless or Vacuumating treatment is relatively inexpensive, something like a dollar or a little more for 400 feet of film.

After each editing session and every few times you project your film, run it through an antistatic record-cleaning cloth. Hold it gently between your thumb and fingers as the film is rewound by hand. If you have to use liquid cleaning solutions something is wrong with your setup.

Look at your cleaning cloth after you use it. Is there any orange dust on it? Trouble indeed if there is, a sure sign that emulsion is being scratched. Time to tune up your setup and find out where this is happening. A little brown from the mag stripe is okay, as is the grey dust you are trying to remove, or subtle tints of color from the film itself. But watch out for orange!

When using the viewer you may be more aware of scratches on the film than when you project. In fact, practically all the scratches you do see with the viewer will probably not show up on projection since most of these are base, not emulsion scratches. I think the Minette, for example, uses a more collimated light source, which shows up defects better than the projector's more diffused light source. That doesn't mean you can ignore the scratches. They shouldn't be there! Scratches mean your film is getting worn, and you should start tuning up your system and taking more care.

223

You should be able to get hundreds of shows out of your original footage. Hundreds of shows without worn or torn perfs, without any damage to the picture area of the film. I have worked with film through months of editing and hundreds of editorial screenings, and then through maybe a hundred screenings for friends and other audiences without any noticeable damage to the film.

The time may come, however, when you must have your film cleaned and treated and "rejuvenated" by the only super 8 specialist in the field, Film Life (address on page 293). They will clean your film and fill in the scratches, base or emulsion, with a silicone material which tends to eliminate or suppress scratches while lubricating the film. The treatment is especially good for base abrasion, and how well it works for emulsion damage will vary with the depth of the scratch. Liquid gate printers will also suppress or eliminate scratches when it's time to make special kinds of prints: optical print blowups or optically printed super 8 to super 8.

My last bits of advice on this score should be obvious. Keep everything clean. People who edit film in a dirty room get what they deserve. Carpets have no place in an editing room. They accumulate dust and film scraps, and they are hard to clean. I have used an air cleaner (see page 277) with good results, and I have found that keeping one near a projector helps eliminate the annoying dust particles in the gate that can cast unwanted shadows and can often plague our small format, more than the larger formats.

Shooting Single, Editing Double In the past couple of years I have evolved a technique for shooting super 8 sync sound that may be of some help to you. Much of the time I shoot single system and edit double system, which should come as no surprise to you after reading pages 147 and 208.

This approach is not a universal panacea for sync sound problems. For example, interviews are often shot double system with the recorder left running from start to finish, but with the camera operating only at key moments. This economical approach can save costly film stock. Of course it is up to the director or camera operator to be alert about sensing when to start shooting. Parts of the rap which are not covered with film can be used for voice-over segments of other footage.

However, I find single system shooting to be very attractive, so here's a rundown of my approach: after shooting, I roughly assemble the footage. Generally speaking I'll take the single system film to the point where I have eliminated most of the out-takes, and have broken the film down into distinct segments. No fine cutting yet.

Next comes dubbing to mag film, from a projector to a super 8 fullcoat recorder. I usually use an equalizer between projector and recorder to suppress street noise, camera noise and emphasize in-

telligibility. I will also try to adjust the volume properly. I try to introduce all possible correction at the earliest stage, so that future transfers or mixes will be as simple as possible. Some people do not agree with this approach and leave all sound "equalizing" or "sweetening" to the final dubbing step.

Now the film is cut double system on a motorized editing bench. If I have done my work well, everything is in sync and cutting is straightforward. I find I do not need edge numbers if my rough assemblage is tight enough.

During editing the camera film and mag film are viewed repeatedly in interlock projection. Once the film is completed, the lab is presented with the picture roll (or rolls) and they make a striped print for me. Now I dub from the edited mag film to the striped print, adding any further EQ, and the print is completed.

He: "I feel an attack of movie editing coming on."

She: "Me, too. If we both pitch in, it shouldn't take long. Fixing up our movies is going to be as much fun as taking them."

225

PRINTS

Why Prints? I advocate working with super 8 original camera film as much as possible because I think it is most direct and, certainly, the least expensive way to work. The alternative is to make a workprint, and super 8 filmmakers are certainly free to take this route. It's the one usually followed by the larger format users.

Making a print is still the best way to preserve your film, since repeated screenings of the original are bound to wear it out sooner or later. In my own work, I edit the original to a state of completion by screening my camera film for months, or maybe even a year or more, until I feel completely certain about what I have done. If I want maximum protection of the film, I retire the original from projection service, using it thereafter exclusively for printmaking.

Making prints is mandatory if you want to distribute a film. I wouldn't dream of sending any of my originals off to some unknown projectionist and his projector.

Printing Machines Super 8 prints are usually made on a contact printer. This machine transports camera film in contact with printing stock, while light through an aperture passes through the camera film to expose the print stock. Since camera and print stock move past the rectangular aperture continuously—emulsion to emulsion—the machine is called a continuous contact printer.

Optical printers are used for blowing up super 8 to the larger formats, or for reducing the larger formats to super 8. An optical printer is actually a camera facing a projector, both usually operating one frame at a time. An optical printer that exposes each frame, one at a time, and not continuously, is called a step optical printer. There are some continuous optical printing machines used for high speed reduction of 16mm masters to super 8 prints.

228

Printing machine Closeup of the gate area of a Bell & Howell model J continuous contact printing machine that has been converted to super 8. Large roller, center left, is swung out of the way to show aperture (arrow), which is interchangeable for single or dual rank printing. In the operation, light shines through aperture, and camera film and print stock are sandwiched together, pressed against aperture by roller. (Photographed at W.A. Palmer Films)

229

Printing machines usually have a means for controlling the intensity of light exposing the print film. For example, if your original is dark, brighter printer light can correct the original exposure error. This kind of correction can be regulated shot to shot so that each shot is printed with the best possible light. Some labs offer color correction, so that the overall color balance of each shot can be selected.

Who makes prints Motion picture prints are made by motion picture laboratories. The equipment includes printing machines of various designs, sound recording and reproducing apparatus, and motion picture processing machines.

These labs do most of their business for 16mm and 35mm, but some of them have begun to take more than a passing interest in super 8. Since the technology is similar, there's no reason why a lab that does good work for 16mm, for example, cannot make good super 8 prints.

Despite this, super 8 printmaking is in a tentative state. Many filmmakers seeking good quality prints have had unhappy experiences. The newness of the format and professional prejudice are the barriers, as they were years ago when 16mm began to catch on as a commercially acceptable filmmaking format.

When your original arrives at the lab, a specialist, called a timer, evaluates it and selects the best possible light and color correction for each shot. Sometimes he does this by eye, looking directly at the film, and sometimes by using a color television monitor. If you have fiddled with the knobs of a color TV, you know that you can achieve a fairly broad range of color. That's just what the timer can do with one of these TV monitors if his organization employs such a device for super 8.

Information for the lights and color correction are often stored on a paper tape, so that each time your film is used for making a print, it can automatically cue the printing machine so it will produce identical prints.

Some labs can print super 8 in the form of A and B rolls (page 220). Many labs can add fades to your super 8 print, whether it is A and B rolled or in single roll form.

The first print the lab makes from your film is called the answer print, and it is billed at a higher rate than subsequent prints, called release prints. You may have to pay twice the price for an answer print. Super 8 release prints, because they are made on double super 8 stock which is 16 millimeters wide, are often made two at a time.

Labs can also duplicate your film's sound track. Most of the time we are talking about magnetic sound for super 8, so the lab will duplicate your track onto a mag striped print in a separate operation

Optical printer
Camera on the right,
projector on the left.
The enclosed
magazine on the right
holds print stock so
the unit may be oper-
ated with room lights
on. This new design,
priced to be attractive
to many labs and even
film schools, is only
$13,500. (PSC
Technology)

requiring a mag film recorder and reproducer. Your print track can
be dubbed directly from your striped camera original, or from super
8 mag film.

Something you ought to bear in mind: while some labs may offer
all the services listed here, others may not. Some labs may have
printing machines that can do color correction, and others may not,
for example.

It's better to do business with a local lab than with one by mail.
Direct communication is simpler and less subject to error. You can
ask local filmmakers which labs they prefer for super 8 work, or you
can have the lab make a short, say 50- or 100-foot print to dem-
onstrate their capabilities. If you live far from a large population
center, you probably live far from a super 8 lab, so there is a listing
on page 290 of labs offering super 8 services, or you can consult the
ads for super 8 laboratories in the back pages of the filmmaking
magazines listed on page 297 .

Prices vary widely from one lab to another, so you have to shop
around. Quality also varies: another reason to shop.

Print Stock There are three kinds of print stock suitable for
general purpose super 8 color and black and white prints. By
general purpose I mean prints that have normal contrast and a full
range of gradation. Some films—those with animation or very
strong and contrasty graphics—might profit from higher contrast
stock, like Ektachrome 7390 or Kodachrome 7387 (unflashed). But
for the rest of this discussion, I am assuming you're filming the
usual photographic subjects, like people and the everyday world.

231

The three print films of major interest, then, are Ektachrome 7389, Gevachrome 9.02 (processed to low contrast) and Kodachrome 7387 (flashed). These produce prints with contrast similar to the original black and white or color super 8 camera film.

Generally speaking, it is the job of the print stock to reproduce the qualities of the original camera film as nearly as possible. These include contrast, color, grain and sharpness. When you look at your print and compare it with the original, be mindful of these categories and I think they will help you understand what you see.

Obviously when evaluating sound prints you will listen carefully to the quality of the duplicated sound compared with the original. Also pay close attention to the image steadiness of the print. It takes a very good super 8 printing machine to produce prints whose registration is on a par with the original.

Photographic reproduction tends generally to increase contrast, change the color, increase granularity and reduce sharpness. From my experience, though, super 8 prints can, at present, do a fair job of preserving the original's quality. I would like to add this comment: as print stock and super 8 lab work improves, prints can only get better. This means that your original film will make better prints in years to come.

I sent three labs the same roll of film, containing samples of commonly used super 8 camera film: Kodachrome 40, Ektachrome G, Ektachrome 160, Fujichrome, 3M Color Movie Film, and the black and white films Tri-X and 4-X. (I've had subsequent films shot on Ektachrome 40 and 7242.)

The labs are specialists with the print stocks they use: Leo Diner Films, San Francisco, for Gevachrome 9.02, W.A. Palmer Films, San Francisco, for Ektachrome 7389, and Eastman Kodak of Rochester, for flashed Kodachrome 7387. Both Diner and Palmer will make prints on other kinds of stock, but, as far as I know, only Eastman offers flashed 7387. (Unflashed, its contrast is too high for general purpose work.)

Flashing is an exposure of the film to a very low level of illumination just before exposure or processing. Film cannot be flashed in manufacture because such a low exposure level tends to change rapidly in a short period of time. Therefore, labs wishing to use flashed stock must do it themselves.

The similarities among the returned prints were more striking than the differences. All produced only a slight to moderate increase in grain. I hadn't expected this. I had been warned that there would be a big jump in graininess, but that just isn't the case.

Contrast was only slightly greater than the original's, and noticeably so in only a few shots, especially on Ektachrome 160 which had been underexposed about a stop. I'd rate the flashed Koda-

chrome 7387 as being the most nearly like the original in terms of contrast, with the Ektachrome and Gevachrome close behind in that order.

Kodachrome 7387 was the sharpest, but by a hair. For whatever reasons this showed itself most clearly for black and white camera film. Ektachrome prints were almost as sharp as the Kodachrome prints, but the Gevachrome produced unsharp black and white prints. Ektachrome 160 and Ektachrome G seemed to lose the least in terms of sharpness on all three stocks. Kodachrome 40 camera film, while printing acceptably sharp on all three materials, lost the most sharpness. Fujichrome looked sharpest on Kodachrome or Ektachrome, but not on Gevachrome.

The print stocks' responses to color are the most difficult to report. Gevachrome had the warmest rendition of the three, and produced very good skin tones, even though the colors of all three materials was quite good; none, however, was up to the purity and saturation of the original films. I presently prefer Gevachrome stock because of its more natural skin tones, blacker blacks and brighter highlights than the more generally available 7389.

Printing black and white film on either flashed Kodachrome or Ektachrome is the way to go. Prints had good sharpness and contrast, a richness they don't have on black and white stock. From what I have seen, black and white prints printed on black and white stock have too much contrast.

What does all of this mean to you? For one thing, you must make your own tests for your particular film. It's a simple matter to prepare a sample roll of film for various labs. The tests I did are valid only for the labs I used. Other labs using the same materials can produce different results. Some printing machines will make sharper prints than others. As important, variations in processing of print film, from lab to lab, can have a great effect on the appearance of the print. So more important than my subjective appraisal of these tests is your evaluation of your own tests.

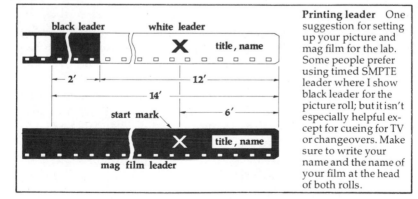

Printing leader One suggestion for setting up your picture and mag film for the lab. Some people prefer using timed SMPTE leader where I show black leader for the picture roll; but it isn't especially helpful except for cueing for TV or changeovers. Make sure to write your name and the name of your film at the head of both rolls.

I might add that I would probably prefer Kodachrome 7387 flashed prints, but these are done only by Kodak, and they do not time their prints. So, since the entire film is printed with one light, the marginal advantages of 7387 may be more than offset by the lack of proper timing. Moreover, Eastman is charging answer print prices for this service, some $.28 list per foot, out of line for one-light work. That's for the Ektasound print service, which gives you a mag stripe and duplicated recording. The cost is $.20 per foot list for silent prints (the usual retail discounts can be applied).

Sound Prints Super 8 camera film, like any photographic material, has its emulsion facing the camera lens. If you were to examine the image on the frame, you'd see that it was upside-down and backwards, or mirror image. It's a general property of lens systems to invert and flop image. The image that the eye's lens projects on the retina is also upside-down and backwards, and the brain translates this into the rightside-up, normally oriented image we see.

If super 8 film is threaded in a projector with the emulsion facing the projector lens, or the screen (which usually comes to the same thing), the upside-down and right-to-left image will be restored to normal. Therefore, the emulsion position of camera original film in the projector must be the same as it is in the camera.

The mag stripe track is on the base side of camera original. That's a standard followed by all super 8 manufacturers. The emulsion, or picture, of camera original is on one side, and the stripe is on the other, or base side.

When a contact print is made, the frame is printed as a mirror image of itself, much as the typeface of the typewriter I am now using is a mirror image of the letters on the page. For this reason, contact prints of camera original must be threaded on the projector so the emulsion is facing away from the screen, or lens, or towards the lamp. In this case, the mag stripe must be applied to the emulsion, since this side is now in contact with the mag head.

Magnetic stripe, or iron oxide material, is generally applied to the acetate base itself, and not the gelatin emulsion. Print stock designed for contact printing often has to have the emulsion removed from the track position so that mag stripe can be added. This step might be done inexpensively in the manufacture of the film, or it can be done by some labs at the time of making a print.

Neither Gevachrome nor Kodachrome print stocks are offered with mag stripe in the emulsion position. As a matter of fact, neither is Ektachrome 7389, as a catalogue item, but 7389 can be special ordered base-striped. Special ordering requires buying an entire emulsion run, or some 125,000 feet of super 8 print film. This is too much stock for the average size lab to order.

The most important step that Eastman Kodak could take to advance the state of the art of super 8 printmaking would be to offer 7389 emulsion striped. Right now they do offer a first-rate emulsion striping service, but this separate operation is vexing, since it adds several weeks' delay and extra expense to printmaking.

A word about quality: just as image duplication varies from lab to lab, so does sound duplication quality. The very best labs can make prints with tracks that are very close copies of your master material, whether striped original or mag film. Super 8 prints' sound can be superb, far better than the distorted, hissing tracks we have come to expect from 16mm optical sound.

And you always have the option of dubbing your own sound on a lab printed and striped duplicate. In some cases, with your own good equipment like a mag film recorder and projector, you can do better tracks than the professionals.

Optical vs Magnetic Sound There has been a growing tendency to advance the cause of super 8 optical sound. Lately there have been new optical sound projectors by Elmo and Eumig, and other makes are bound to follow. It is a relatively simple task to make projectors that can play back one or the other or both types of tracks, but please bear in mind that optical is a distribution medium only. Optical sound cannot be user recorded, it has to be added to prints by a lab.

The major motivation for using optical sound is that it costs less to make these prints than magnetic sound prints. Mag striped release print material from Eastman costs $.04 more per foot than unstriped stock. The major part of the extra cost (about a cent a foot) for the lab comes not from the stripe then, but rather from the fact that magnetic sound must be recorded in an entirely separate operation using another machine in addition to the printer. Optical tracks, by contrast, can be printed at the same time with the same machines that can print the picture. (However, some super 8 printing machines can also combine operations.)

Optical tracks in 16mm must be specially processed with the application of viscous chemicals on rollers. Since the super 8 track is one third of the width, this operation would be perilous at best. The reason for the special processing is to increase the opacity of the optical track to match the sensitivity of the photocell soundreaders used in 16mm machines. These photocells do not have the same sensitivity to light as the human eye and will not respond properly to a track made up of three layers of colored dye.

There now exist photocells, or actually photodiodes, that see just about the same way that the human eye sees. These are the devices that are used for super 8 projectors. Therefore, a dye track, which requires no additional processing, will give good results with super

8. It was impossible to use dye tracks for 16mm since so many projectors in service would not be able to play them. But super 8 is a new ballgame, as the expression goes, and we are able to take advantage of new technology.

While there are obvious advantages for the super 8 filmmaker for mag track, optical track has relevant advantages for people exclusively interested in showing or displaying movies. Print cost will be lower, although this might not be passed on to the print buyer or renter.

What troubles me is that super 8 prints using mag track at 18 fps cost about the same as super 8 prints with optical track at 24 fps. It seems that optical track will have to travel at the faster rate to achieve a reasonably good high frequency response, exactly the practice for the larger formats.

My point then, is that super 8 mag track prints at 18 fps can have superb sound while super 8 optical track prints will have only acceptable sound at 24 fps. Costs should be just about equal for either kind of track, at their respective rates. It's been my experience that super 8 mag prints at 18 fps have better sound quality than 16mm prints with optical track. Certainly with their lower linear rate and narrower track width, super 8 optical sound will be inferior to super 8 mag sound.

Making many prints The techniques for printmaking described so far are applicable for making up to maybe a score of prints from the camera original. For more prints than this, you'll probably want to go with an intermediate printing master in order to preserve the life of your original and reduce costs. Sometimes a dual rank super 8 printing master is prepared to make prints two at a time which are slit after processing. Some labs also offer the option of making what are known as quad masters on 35mm film, or four prints at a time. There are labs that suggest a blowup to a 16mm master so that reduction prints may be made optically. There are continuous optical printing machines that are designed to print dual or quad rank super 8 prints from 16mm film. Some labs claim that a 16mm master reduction printed gives better quality than prints made from a super 8 intermediate master. Given the present state of the art, I think this is the case.

If a dual or quad super 8 printing master is made from the original camera film, or a 16mm master is prepared for continuous optical reduction to dual or quad prints, prints are usually made by the negative-positive system. This is different from reversal prints made directly from the original by what can be called the reversal-reversal system.

The intermediate printing master will probably be an internegative, or a negative printed from the original camera film. The prints

are then made on positive release print material. These prints are less expensive—by approximately half—than reversal-reversal prints because positive print stock is less expensive.

But do not expect quality equal to that of reversal prints made directly from your camera original. Every extra step of duplication—in this case the internegative—reduces overall release print quality. Specifically, be prepared for increased contrast, color shifts, decreased sharpness and increased grain.

Excessive contrast buildup might be controlled by appropriate flashing of the internegative, but labs are still doing very little in this area. As has been noted, labs favor going to a 16mm internegative which may be used for quantity reduction prints. The larger 16mm frame may minimize granularity and increase sharpness.

I strongly suggest that people interested in this area—before you go ahead and print the whole film—get the lab to make sample prints from a printing master derived from your camera film. Usually fifty feet is considered a minimum testing length.

Some labs are running Eastman material all the way. That is, they employ Eastman color internegative and positive stock. Some labs employ Agfa-Gevaert, Fuji or 3M materials as well. This introduces another degree of variability and offers the filmmaker more choice and possibly reduced cost. All to the good.

Some people prefer to make a reversal printing master, in which case prints are made by the more costly reversal-reversal printing method. Masters are usually made on Ektachrome 7389 print stock, Ektachrome Commercial 7252 camera film or on Gevachrome print film processed for low contrast. Release prints can be made on any of the reversal print films already described. Some people think that prints made this way show higher color saturation and less grain than negative-positive prints. Try it out for yourself. Even if I cannot make a definite statement on quality, one thing is certain: the price of reversal prints is higher than positive prints. There are so many possibilities with camera film, intermediate master mate-

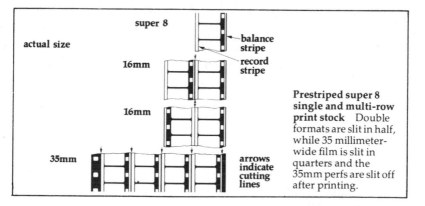

super 8

actual size

balance
stripe

16mm

record
stripe

16mm

35mm

arrows
indicate
cutting
lines

Prestriped super 8 single and multi-row print stock Double formats are slit in half, while 35 millimeter-wide film is slit in quarters and the 35mm perfs are slit off after printing.

237

rial and print stock—I estimate at least 125 possible combinations—that you are on your own.

All of this assumes the prints to be in color. The same kind of rap can be run down for black and white, but almost invariably the negative-positive system will be used.

Blowups and Reductions There are two general ways super 8 blowups to 16mm may be accomplished: directly to reversal release print from the camera original, or from the camera original to an intermediate master and then to the release print. If you choose to make a master, you have the choice of making an internegative or a reversal printing master. Eastmancolor internegative is usually preferred for the interneg, while some labs use release print material by 3M, Fuji or Eastman.

There also are the options of making a reversal master on Ektachrome 7389 print film, or a Gevachrome print film processed to low contrast. Some labs like to use 7252 Ektachrome Commercial film for this purpose, but I wonder why, since it has higher contrast than the other print films mentioned. Prints are then made from the reversal master on reversal print film. For example, the blowup could be made to a Gevachrome master and then printed on Ektachrome.

If you choose to blow up your film directly to reversal print stock such as Gevachrome or Ektachrome 7389, I think you will be very pleased with the results. You may get marginally better quality than going the intermediate master route; however, this method can be seriously considered only for making a few prints. In quantity, direct reversal blowups are more expensive than positive prints; and you will probably want to prevent your super 8 original from meeting a premature death through wear in handling by going to an intermediate master.

Full timing and color correction and effects are available for either single rolls or A and B rolls. It's usually advisable to use a printer with a liquid gate to help eliminate abrasion and scratches. If you have shot a film at 18 fps in sound and expect to blow it up, I am tempted to tell you to forget it, since 18 fps is not standard for 16mm sound. However, there are printing machines that can double print every third frame, turning 18 fps movies into an equivalent 24 fps. Transferring the sound from super 8 at 18 to 16mm at 24 fps is possible, but may require special mag film recording equipment most labs don't have. The problem here is to make a super 8 mag film recorder at 18 fps interlock in sync with the faster 24 fps 16mm mag film recorder.

Consult with your lab for all sound work involved in your blowup print. You may have to have your super 8, 24 fps, striped original or mag film transferred to 16mm mag film, or to an optical sound

printing master because 16mm prints most often have optical rather than magnetic sound tracks.

Dupes on Tape Super 8 original camera film may be successfully duplicated on videotape. It's a sad comment on the state of the art, but some knowledgeable filmmakers prefer "prints" on tape to prints made by labs.

Your best bet for duplicating super 8 on any of the tape formats is to use the videotape recorder in conjunction with an Eastman VP-1 videoplayer (page 285). It's easy to make first rate tape copies of super 8 original films, and in the popular half-inch reel-to-reel or three-quarter-inch cassette formats, costs are significantly less than super 8 prints on motion picture film.

Super8 Sound sells the VP-1 with a digital switch installed for double system sound, and they, or others, will probably offer a conversion in frame-for-frame sync for electronic dissolves and superimpositions from A and B rolled super 8. They, and other organizations, can do film-to-tape transfers.

Super 8 may even turn out to be a very important production format for the new MCA-Philips vision disks.

PROJECTION

The film your audience finally sees is heavily influenced by the screening environment. Super 8 film can be displayed with conventional optical projection equipment in a theater, a living- or school-room, anywhere that can be darkened and has a screen. It can also be electronically projected, or displayed with a videoplayer on a TV screen.

All of the effort in filmmaking finally comes down to things like this: how will my movie look on a particular screen? Will it be possible to darken the room enough? How will the recorded sound emerge from the speakers? How will it be influenced by room acoustics?

Only at home, in your studio or in some fixed regularly used installation, can you fully enhance your image and sound quality. In the field, the super 8 filmmaker is like a traveling roadshow, and should be prepared for any and everything. If it's any compensation, this is the way movies were displayed in their earliest days: the filmmaker traveled with his camera, filming by day, converting the camera into a projector by night.

The mechanism of the projector and the camera is very similar. One frame of film at a time must be advanced, held steady in the gate or optical section, and exposed or projected. While the film is being advanced, or during the pull-down phase of the cycle, the projector shutter passes between the light source and the film preventing the blurred image of a moving frame. The shutter is made up of three segments and rotates continually between the lamp and the frame so that each projected frame is interrupted twice (or broken into three parts) at the super 8 standard speed of 18 fps. This produces a total of 54 (3 x 18) flashes of image each second.

This shutter, introduced by John A. Pross in 1903, raises the number of projected flashes of light on the screen—actually image flashes—to eliminate the flicker. While about 18 images are sufficient to impart a good illusion of motion, about 54 images per second are needed to eliminate flicker.

Camera

Projector

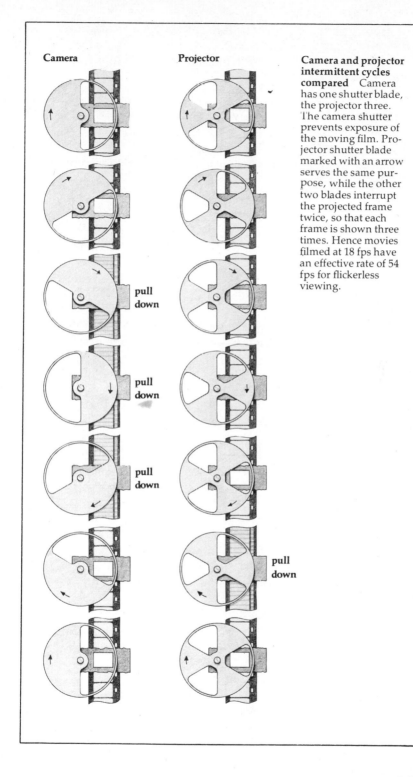

pull
down

pull
down

pull
down

pull
down

**Camera and projector
intermittent cycles
compared** Camera
has one shutter blade,
the projector three.
The camera shutter
prevents exposure of
the moving film. Pro-
jector shutter blade
marked with an arrow
serves the same pur-
pose, while the other
two blades interrupt
the projected frame
twice, so that each
frame is shown three
times. Hence movies
filmed at 18 fps have
an effective rate of 54
fps for flickerless
viewing.

In a sound projector, once the film passes through the gate it goes to the soundhead for sound reproduction. The 18 frame loop of film is used to turn the intermittent motion for image into continuous motion for sound.

Projectors: A First Look This may seem obvious, but there are two kinds of super 8 projectors you can buy: sound or silent. Sound projectors can be used to show silent footage, and silent projectors can screen sound footage, although silently.

Any projector that can accept super 8 film will also accommodate the sister single 8 format. Although super 8 and Fuji single 8 (or other polyester stock like 3M Color Movie Film) can be tape spliced together, most projector designs—which have a pressure plate on the lens side of the film—cannot hold both acetate and the thinner polyester film in focus because of the differing thickness of their bases.

However, a minority of projectors have their pressure plates on the lamp side. These will maintain focus for both single 8 and super 8, and a mixture of the two, since the distance of the image-carrying emulsion from the lens remains constant. When the pressure plate is toward the lamp, the fixed lens-side aperture plate determines the emulsion distance from the lens.

Many super 8 projectors will also accept standard 8mm film. Although I can't honestly advocate the use of standard 8mm, for those people who have lots of film shot in this gauge, it makes sense to buy a dual projector. There are sound and silent machines which will work with either related format. I had thought that by now new projector designs would omit this compatibility feature but most haven't. It will be interesting to see how long this continues.

Sound projectors all operate at both 18 or 24 fps. Silent projectors will operate at 18, rarely at 24 fps. Many silent projectors operate at various fps settings, and can show a single, or freeze frame. Despite drastic reduction in image brightness in this mode, it's useful if you need to study a single frame.

In general, sound projectors are more costly than the silent ones, besides being heavier and bulkier. The other major difference is that there are no sound projectors that feature what is often called instant slow motion, the ability of silent projectors to turn footage shot at the regular speed into slow motion footage. Right now you have to buy two projectors, if you want sound and this effect. And for some purposes, sound reproduced at a slower linear rate, say 9 fps (equivalent to 1½ ips), might be entirely acceptable.

Typical slow motion running speeds are 3, 6, 9 fps, but there are projectors with other combinations, other speeds. Many projectors will maintain the full level of illumination, while some cut down illumination moderately to prevent film incineration. Footage shot

at 18 fps and projected at 9 fps will be slowed down by half, with too few images to give a proper illusion of motion. The effect is like watching a series of stills race by rapidly.

Even when the frame rate is reduced, the projector must maintain a constant flicker rate, or the image will flicker. In other words, at 18 fps with the usual three-bladed shutter, we have 54 flickers per second. We must also have 54 flickers per second at 9 fps for flickerless slow motion. While each projected image is broken into three parts at 18 fps, it must obviously be broken into 6 parts at 9 fps.

The use of the slow motion control is great fun and a tremendous creative tool. It allows the super 8 filmmaker/projectionist to orchestrate the work while screening the film. You'll be able to narrate the image, and add music or sound effects with records or tape recorders. Some projectors also offer high fps rates, allowing the projectionist to speed up action, or to race by uninteresting sections.

If you want sound you can try the mixed media happenstance approach, which is dynamic and living, combining projected image and live or recorded sound. Or put your sound right on your film, canning it forever, the way we usually look at movies. Better not to bother with any of the sound synchronizing systems that link silent projector and recorder. I've seen too many people go down in flames trying to make these screwball double system devices work under the pressure of a screening.

Traditional Projector Design Film travels from the feed to the take-up spool in the conventional projector over a well-established pathway. The feed and take-up spools are placed on feed and take-up spindles. Film is driven by the rotating feed sprocket wheel, whose teeth engage the perforations of the film. Next, the film passes through the projector's gate area.

The gate has a pressure plate, usually on the lens side, which keeps the film snugly against the aperture plate, usually on the lamp side of the film. The pressure plate is spring-loaded to push

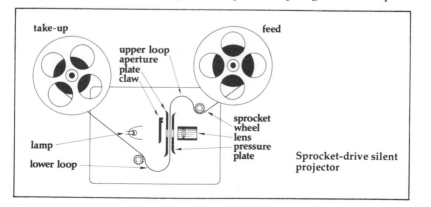

take-up

feed

upper loop
aperture
plate
claw

sprocket
wheel
lens
pressure
plate

lamp

lower loop

Sprocket-drive silent projector

against the film, while the aperture plate is fixed in place. The aperture plate, though, has spring-loaded side guides to help prevent side-to-side image weaving. The light from the lamp passes a rectangular hole cut into the aperture plate, through the film, then a hole cut in the pressure plate and finally through the lens on its way to the screen.

The pull-down claw which emerges through a slot in the aperture plate, engages the perfs, advancing the film one frame at a time. Although this double-pronged device which looks like a tuning fork is usually called a pull-down claw, for super 8 it is more appropriately a push-down claw; it engages the film above the aperture and pushes it through frame by frame. One of the claw's prongs is a backup prong, just in case one of the perfs is torn or damaged.

The action of the shutter is mechanically synchronized to that of the push-down claw. As the claw moves the film, the shutter interposes between it and the lamp. Once the frame is in position, the blades of the shutter pass by it twice, breaking its projected image into three parts to increase the effective flicker rate.

If we are dealing with a silent projector, the film passes from the gate area to a take-up sprocket wheel and then to the take-up reel. The slack of film between the gate and each sprocket wheel is called a loop (one the upper, the other the lower loop). The loops are necessary because the film is fed continuously by the sprocket wheel, but intermittently by the push-down claw.

A sound projector of conventional design departs from this by adding sound reproducing (and recording) parts between the gate and the take-up sprocket.

For super 8 projectors these parts are laid out like this: soundhead (or heads if the machine can record as well as play back), and then a rubber snubber, or roller, which presses the film against a capstan. The capstan roller is a metal cylinder, actually part of a flywheel. The film, pinched between the capstan and the snubber, drives the

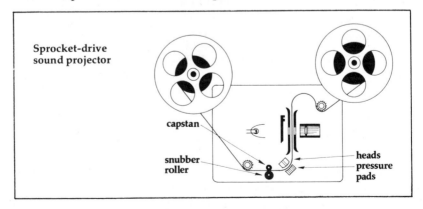

Sprocket-drive
sound projector

capstan

snubber
roller

heads
pressure
pads

flywheel. It's the action of the capstan-flywheel that helps smooth out the intermittent motion of the film into the smooth, continuous motion past the soundhead.

Sprocketless Drive A number of projectors—from Eumig, Bolex, Kodak and others—feature what is called sprocketless drive; these machines advance film through them without sprockets. They must still employ a claw to advance and position each frame of film in the gate, but instead of sprocket wheels, rubber rollers, or snubbers, move the film. This drive system resembles those used in reel-to-reel tape recorders.

Sprocketless designs are interesting because, for one thing, they make for simplified automatic threading; dual format sprocketless projectors are simpler to design, too: no sprockets to change. All the changes for going from standard 8 to super 8 take place in the gate.

Sprocketless designs ought to be especially easy on film, even reducing perforation wear. But it is only fair to say that good traditional sprocket designs don't cause very much perf wear. Most perf wear probably comes from the pull-down claw.

Sprocketless projectors make what is called in-path rewinding, a simpler design since there are no sprocket wheels to withdraw from the path of the film. In-path rewinding achieves rapid forward or reverse, allowing for speedy access or rewinding. For in-path rewinding, the film slides through the gate area with little or no wear. It has been my experience that in-path rewinding tends to sweep the gate clean of any annoying dust. The whooshing of the air created by the film flying by sucks the dust out of the aperture, but you must still periodically clean the gate to prevent emulsion build-up.

Servo Drive In sound projector designs, sprocketless drive is used in conjunction with servo drive. In this system the capstan—part of a flywheel—is motor driven at a constant rate. The rate of film past the soundhead is entirely capstan determined. The loop between gate and soundhead is measured by a loop sensor, or feeler, which rubs against the film at the loop between gate and head.

Servo drive, first employed in the Fairchild cartridge-loading projectors in the mid '60s, has also been used in the Eumig-Fairchild 711 projector and presently in the Kodak Ektasound 235 and 245 machines. The original Fairchild patents were filed in January and October of 1963 and granted in April 1966. These relate to 8mm sound projectors, and specifically cartridge-loading projectors.

The original application stressed this advantage of servo drive: it prevents losing the loop between gate and soundhead parts. In an ordinary projector, a loss of a few frames will result in image-sound

PROJECT

being out of sync. In a closed, or endless, loop cartridge projector, like the kind Fairchild supplies, the loss can be cumulative since the film runs through the mechanism over and over again. Eventually this could lead to serious damage of the film.

In the usual sound projector, the length of film between the feed and take-up sprocket wheels is fixed. There is an upper loop between feed sprocket and gate, and one between gate and soundhead parts, and finally a length of film between soundhead parts and take-up sprocket.

In servo drive no sprocket wheels are employed. Film moves directly from feed reel to gate, and from gate to soundhead parts and then to take-up reel. Film is held firmly against the capstan (by a pinch roller) which is adjacent to the soundhead. The capstan is motor driven at a constant rate. In the conventional mechanism, the freewheeling capstan (and its flywheel) are driven by the film, which in effect becomes a drive belt. In servo drive the capstan-flywheel is driven at a fixed rate by a motor.

A loop sensor, or feeler, rides against the loop between gate and soundhead. It measures the bow of the loop. If the loop is too big, it means the push-down claw is pushing too much film through the

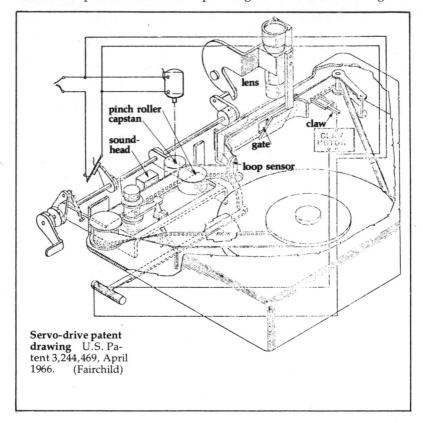

Servo-drive patent drawing U.S. Patent 3,244,469, April 1966. (Fairchild)

248

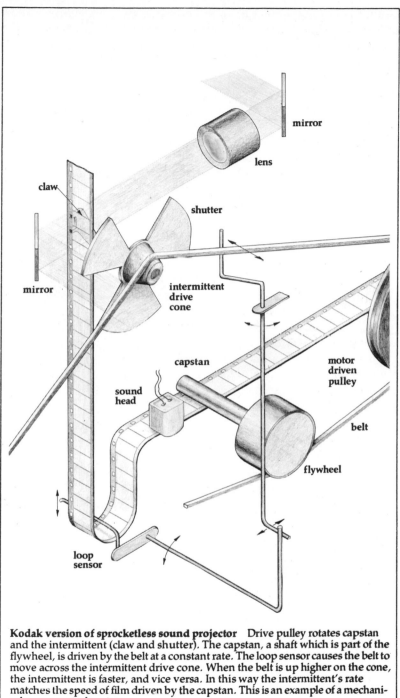

Kodak version of sprocketless sound projector Drive pulley rotates capstan and the intermittent (claw and shutter). The capstan, a shaft which is part of the flywheel, is driven by the belt at a constant rate. The loop sensor causes the belt to move across the intermittent drive cone. When the belt is up higher on the cone, the intermittent is faster, and vice versa. In this way the intermittent's rate matches the speed of film driven by the capstan. This is an example of a mechanical servo control system.

gate with respect to the rate of the capstan. The feeler, in this case, tells the intermittent (push-down claw) to slow down. If the bow of the loop is too small, it would tell the push-down claw to speed up.

These corrections happen virtually instantaneously, and the loop sensor, immediately feeling the results of its correction, can correct its correction. This kind of system is called a closed-loop servo, and it is exactly the same kind of system used by single system cartridge-loading cameras.

Servo-drive projectors usually require only one motor to drive all mechanical systems—capstan, push-down claw, feed and take-up spindles and blower for cooling. A mechanical system is used to speed up or slow down the push-down claw. I point this out because sound-on-film cameras employ separate motors for capstan and intermittent.

Automatic Threading Most super 8 projectors have automatic film threading. In fact, I should say practically all, instead of most. The only ones coming to mind that are nonautomatic are the Kodak Ektasound projectors and the Fujiscope machines—all sound projectors. The Ektasound machines employ channel threading, similar to that used for reel-to-reel tape recorders, and the Fujiscope projector is similar to 16mm manual threading machines.

This is how you operate automatic machines: the first time you show a film, use the trimmer to shape the leader. Some autothreading mechanisms are very fussy, and insist you use the trimmer supplied. Others will accept just about anything short of a jagged, frayed end.

As the film is placed into its slot, blind faith takes over. The projector sucks in the film and—if everything goes well—the film emerges from the projector in a few seconds and scoots right onto the automatic threading take-up reel. If the leader doesn't have just the right curvature, the film won't fasten itself to the take-up reel and you'll have to do this manually.

cutting edge

Leader trimmer
(Fairchild)

If your projector makes weird noises during threading, or it's taking a long time for the film to get to the take-up reel, better turn the thing off and remove the cover of the mechanism to see if the film is really threading.

Often, all too often, automatic threading machines damage film. That's why you need to have a long leader—at least the distance between your outstretched arms (which in the case of your average author is 65 inches). If your projector should foul up during the course of a showing, your film may be severely damaged if you don't turn the machine off in time, or operate the loop restorer. If the loop is all taken up, because a broken perf, for example, has allowed the film to slip, your film will probably wind up with more broken perforations, making it unprojectable and unrepairable.

Stay away from automatic projectors without a loop restoring mechanism. There are some otherwise very good machines that I can't recommend because they don't have this safety feature. Most of the time—if you're on time—the loop restorer will get you past the rough spot and save your film from damage.

One great big pain about most autothreading projectors is that, short of taking the machine apart and probably damaging the film in the process, there's no way film can be removed partway through. It is all too easy to say: don't lose your head, and you'll be able to straighten everything out. I get very nervous during screenings, and my fingers become toes.

If you are stuck with a pile up of film in a projector, the best thing to do may be to break the film and accept having to make a splice even in the middle of a shot. The alternative is worse: scratched, mangled and damaged film.

I think that automatic threading mechanisms can be terribly hard on film, much harder than manual threaders. Some people feel that polyester base film, which is much stronger than acetate, might stand up much better to wear and tear and outright abuse. This may well be correct, but I don't know for sure.

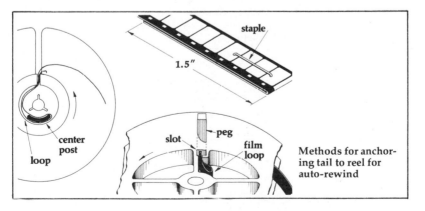

staple

1.5"

center post

loop

slot peg

film loop

Methods for anchoring tail to reel for auto-rewind

251

Projection Cartridges Cartridges for super 8 projection offer the advantage of extreme ease of loading and film which is out of harm's way. Since the film is kept out of the hands themselves, hopefully even people who aren't familiar with motion picture equipment may have an easy time of it. And even for those who are expert at film presentation, something that makes life a little easier is nothing to dismiss.

There are two kinds of projection cartridges available: reel-to-reel and endless-loop cartridges. One design, the Fairchild Cart-Reel, combines both features.

Reel-to-reel cartridges are offered by Kodak, Bell & Howell and Bolex. The three are similar. The user simply places a standard reel inside the plastic cartridge, which is a little bit bigger than the reel. The leader is trimmed and for in-path automatic rewinding the tail must be anchored to the reel. Old style super 8 50-foot reels have a break-off plastic peg for wedging into the reel slot to hold the film. New Kodak reels, introduced in the spring of 1975, use a different scheme: the user seeking to anchor film must loop it around a crescent-shaped post, as shown in the drawing. The method I prefer is to fold over about half an inch of film and staple it to itself with a paper staple. The folded-over stapled film cannot be drawn through the slot and the resistance offered by the tail of the film keys the auto rewind.

Eastman has a processing service in which the film is loaded into a 50-foot cartridge, so that the user may enjoy totally automatic super 8 without ever handling film in either camera or projector. These cartridges do not preclude editing since you can edit as usual and then place the reel into the cartridge.

Both Eastman and Bell & Howell offer 50-, 100-, 200- and 400-foot versions of their cartridges. Actually, the two larger sizes are offered in the Eastman device on what they call C and D reels for 220- and 440-foot capacities. The C and D reels have a nonstandard hub size, which because it has a slightly larger diameter, is difficult to

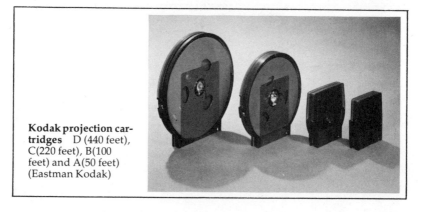

Kodak projection cartridges D (440 feet), C(220 feet), B(100 feet) and A(50 feet) (Eastman Kodak)

use with spindles on editing gear and other projectors. This is a great big pain.

Bolex offers just a 50-foot cartridge and one projector, the Multimatic, for it. Bell & Howell at this time offers only one projector model, the Double Feature—very similar to the Bolex—which accepts only 50-foot cartridges. Both allow for stack-loading of a number of cartridges. Once a cartridge is completed, it is replaced by another within fifteen seconds. The just used cartridge rewinds to be ready for the next show.

This kind of system turns film screening into something not unlike slide shows with automatic slide advance. For most users the limitations of a 50-foot run make the machines less than interesting, but the point-and-shoot/don't-edit filmmaker may get off on it.

There is absolutely no cartridge compatibility. Although the Bolex and Bell & Howell cartridges are similar in design and function, they can't work in each other's machine. The same for the Eastman device. Both Bolex and Bell & Howell use rim drive for rewinding film. That is, a rubber roller turns the reel for rewind by driving its edge. The Kodak cartridge is center, or spindle, driven. It's possible to design a simple loading device so that cartridges may be stacked like records on an automatic turntable with rim driven designs. And both Bolex and Bell & Howell have made this a key selling point of their systems. However, the Kodak center-driven cartridge makes for much more difficult stack-loading, and so far no such machine has yet appeared.

Despite these differences the reel-to-reel cartridges work basically the same way. The reel of film is placed in the cartridge, which is just a plastic shell or container. The cartridge is placed on the projector and a feeler enters it, withdrawing the film to take it into the projector's insides. The film is threaded in standard autothreading fashion through the machine and to the take-up reel which is usually a built-in and integral part of the machine. At the end of the reel, film is automatically in-path rewound.

Bolex Multimatic projector (Paillard)

Super 8 projection reel-to-reel cartridges were introduced in 1969, and it's not too much to say they laid a great big egg. Too many people had to ask themselves if the cartridge was worth the extra expense and bulk. Depending upon the size, prices ranged from about $.60 to $4.00. Moreover, super 8 projectors with automatic threading work so well, the slight advantage of cartridge automation becomes a marginal bonus. For regular automatic threading with a reel, the user must tuck the film end into a slot or channel. For cartridge-loading the user simply places the cartridge in or on the machine.

As of this writing you can still find the Bolex and Bell & Howell stack loaders. If you like the idea, buy one fast. I doubt they will be around much longer. Eastman still offers the Supermatic 60 and 70 sound projectors, and the VP-1 videoplayer is designed for either cartridge or reel-to-reel use.

The endless-loop cartridges, offered by Fairchild, Technicolor and others have been successfully employed in industry and institutional audio-visual application. These machines couple cartridge loading with bright rear screen projection in units simulating TV sets. Fairchild has opted for magnetic sound-on-film, and Technicolor for optical sound-on-film.

In 1973 Fairchild announced the Cart-Reel which, depending upon how it is loaded, is either an endless-loop or a reel-to-reel cartridge. The endless-loop cartridge is used for a program which is to be repeated over and over again. The reel-to-reel mode satisfies the usual super 8 projection requirements, and it will also rewind film automatically at the end of a show.

The Cart-Reel uses an entirely enclosed film path within the device. Soundhead and gate parts enter holes in the front end of the cartridge. This is the way it is done in Fairchild and other endless-loop devices. The difference here is that two reels are employed which are stacked one on another. In the reel-to-reel mode, the film travels from feed to take-up reel via the gate and soundhead parts.

Bell & Howell Double Feature projector (Bell & Howell)

Since the Kodak C and D reels are employed, there's some compatibility with the Kodak cartridge.

The Cart-Reel system became the approved standard of the U.S. Department of Defense (#1497) on March 22, 1973. Presumably this ensures its widespread use not only by the military but by the rest of the federal government and, in fact, most of industry if I am not mistaken. However, time will tell.

One last point: endless-loop cartridges are not really meant to be user loaded. The film must be specially lubricated to ensure repeated unimpaired passages through the projector. It's best to leave this to the specialists—a lab that does it day in, day out.

Lamps Super 8 projectors use relatively efficient electric lamps as their illumination source. I say "relatively" because these low-voltage lamps, which have been with us for more than a decade, give a great deal of light for their rated power compared with the old-style line-voltage (120 volts) lamps.

Typical super 8 lamps are the 12-volt, 100-watt lamp made by Philips for many European manufacturers, or the 15-volt, 150-watt lamp used by Elmo for their top-of-the-line silent and sound machines. The lamp itself, which is peanut sized, is permanently mounted in the middle of a reflector which is shaped like a soup bowl.

Designers have used every trick in the book to make these lamps the brightest possible sources of illumination with the lowest possible heat—since beyond a certain temperature, film will be damaged. The transparent envelope of the lamp may be made of quartz, or special heat-resistant glass. The filament of the lamp, which is made of tungsten or a similar metal or alloy, is very small. Concentrating a great deal of light into a small filament eliminates the need for condenser lenses. The purpose of the old-fashioned condenser lenses, placed between the lamp and the film, was to make the large-filamented high-voltage lamps appear to be pinpoint sources of illumination.

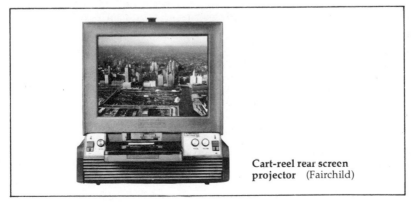

Cart-reel rear screen projector (Fairchild)

The low voltage of these halogen or quartz-iodine lamps makes it possible for the filaments to be so compact. The electric current passing through the filament makes it glow; old-fashioned higher voltage lamps cannot have a compact filament or they would arc over, sending sparks between portions of the filament causing its destruction.

The inside of the low-voltage lamp is essentially an evacuated chamber, or a relatively high vacuum, but containing a nonmetallic halogen, usually iodine. In conventional lamps, when the filament glows hot, metallic ions tend to boil off and coat themselves on the inside face of the glass or quartz envelope. But in recent designs, the heated halogen which turns to gas combines with the boiled-off tungsten ions to recycle them back to the filament. In this way the filament stays intact longer, and the inside of the lamp doesn't blacken with age and reduce illumination.

The reflector itself is a parabaloid, and the filament sits at its focus. This makes for efficient use of all the light, since most of it is reflected toward the film where it is needed.

The reflector is made up of multiple thin metallic layers designed to transmit heat, or infrared rays, which electric lamps produce by the barrel-full. More light and less heat reach the film by its reflecting only the visible radiation, or light, and transmitting and dissipating the heat rays. These lamps are also called dichroic lamps, sometimes diathermic lamps, after the kind of coating used on the reflector.

One pain about buying super 8 lamps is that the reflector is a part of the lamp and accounts for a good part of its cost. Super 8 lamps are very expensive. The Philips lamp costs about $13 list, and the Elmo lamp lists for $21! If designers could leave the reflector in the projector so that we could just add the lamp itself, costs could be brought down. They like to make the reflector part of the lamp, however, since this eliminates crucial alignment problems.

One final word: super 8 projectors have not gotten any brighter. All of what I have described here has been well known for more than a decade; so barring some new invention—or if you opt for an arc projector or arc conversion of an off-the-shelf model—we cannot expect super 8 projectors to get any brighter.

I tested a Kodak M-95 projector in 1965 with an $f/1.0$, 22mm lens and it was within a quarter of a stop of the then current 16mm Bell & Howell projector using the now old-fashioned 1000-watt projector lamps and an $f/1.6$, 50mm lens.

Since then 16mm projectors with modern lamps have doubled or quadrupled their illumination output; but super 8 projectors which have always had efficient lamps haven't gotten any brighter. In fact they are dimmer than the initial Kodak effort, since they use zoom

lenses which may f/stop at as little as f/1.1, but probably T stop at something like T/1.4. Indeed, the brightest machines going, the Elmo 1200 or the Eumig D Lux are, with their zoom lenses, at least 25 percent dimmer than the decade-old champ, the M-95.

Noise One of the most challenging design areas is in the reduction of projector noise. I've subjectively tested a number of super 8 projectors for mechanical noise level. I've listened to them myself, and I've run projectors for friends and students. I come to this conclusion: despite variations, generally speaking, one super 8 projector is just about as noisy as another. They may sound different, that is, some may purr, while others hum; but taken together they seem to be about equally loud.

How loud your projector sounds during a screening is also a factor of room acoustics. Live rooms, with reflective surfaces, tend to make the level of noise worse. Small rooms also tend to heighten the sound level.

I've used super 8 projectors in large halls where they couldn't be heard above the ventilation system. The very same projectors in my studio, a comparatively small room with walls that reflect sound, make a terrific racket.

Having a quiet projector is as important for silent as for sound screenings. Ideally, a super 8 projector shouldn't be any noisier than a tape recorder, which is to say, for all intents and purposes, it would be silent running.

Projector noise comes from three areas: the motor and power transmission, the claw engaging the perforations of the film and the blower fan.

Electric motors can be fairly quiet, but if they are used to drive the intermittent mechanism and the take-up spindle, and the blower, this transmission of power produces a lot of mechanical noise. Belt drive tends to be less noisy than gear drive, and plastic gears are quieter than metal gears. But when all is said and done, I don't think

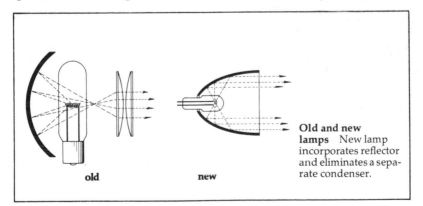

old **new** **Old and new lamps** New lamp incorporates reflector and eliminates a separate condenser.

super 8 designers have thought very deeply about quieting the motor and power transmission, no matter what components they use.

The next source of noise is the claw's engaging the perforations. This makes a singing or chattering sound that is terribly difficult to eliminate. But there are camera designs that have quieted down this clack, so I suppose that whatever techniques are employed for cameras can be used in projectors.

Finally we have the whoosh of the fan as it blows air past the lamp out the exhaust ports. I honestly don't have a clue about what can be done to reduce this noise source, short of having cooler running lamps that need less ventilation. But the present state of the art would seem to preclude this, since bright lamps run hot and the first priority for a super 8 projector is to throw a bright image.

What can be done to quiet your machine? For one thing, you can put it in another room, even a closet, and project through a port. Good quality glass covering the opening is a nice touch, giving the best possible image with little loss of light. You may be able to use a coated optical glass Opticap by Spiratone, in your installation; they come in sizes up to 77 millimeters, or about 3 inches in diameter.

Sometimes the best approach is to build a blimp, a padded wooden box, around your projector. These tend to get rather big and bulky when you include take-up reels as well, but for most super 8 machines this may not pose an obstacle.

Projectors turn out to be terrifically inefficient convertors of electricity into light. Most of the power your lamp consumes is turned into heat, and if that heat is not taken care of you are going to destroy your projector in its blimp. For one thing the lubricant will be terribly thinned, and its reduced viscosity will contribute to rapid wear of moving parts.

For adequate ventilation in a blimp or cabinet use an electric fan. Spiratone comes to the rescue again with their darkroom fan which can handle a usually adequate 50 cubic feet per minute. Since it was designed not to allow light into a darkroom, there will be none spilling out of the blimp. It's best to have the fan exhausting into another room, or you may be saddled with its noisy whoosh.

Specific Projectors Through the course of writing this book my own filmmaking has been concerned with sound films. I have shot a lot of silent footage, and edited some films in final silent form. But for the most part, I have been interested in the completion of sound films, whether in lip sync or in some other synchronized association of sound and film. All sound films are sync films, juxtaposing sound with image in exact placement. Sometimes we confuse this and tend to think of sync in terms of lips alone.

Be that as it may, I have for the most part, only skimmed the

approximately one hundred models of silent projectors.

I have had a lot of experience with the now discontinued Kodak typewriter-style machines like the M-95. These are very good, very bright machines that worked well. They have been replaced by the Moviedeck line which, from the look of them, started off as cartridge-loading designs before being turned into reel-loaders as the marketing department reacted to the public's thumbs down on projection cartridges. The top of the line of the Moviedecks (the 475, for example) are bright with a good quality image. The machines are fun to use, and of compact and novel design. They offer fps rates down to 3, with in-path forward and reverse; many models will also project standard 8mm. The big flaw is that these machines do not have loop restorers. Too bad, because my tests showed that damaged film can become even more damaged if the user cannot make a quick dive for the loop restorer.

Another interesting silent machine—which I have not used—is the Eumig 610D, with its single-frame contact switch. This ought to make the machine interesting to anyone who is doing sound work with a mag film recorder supplied by Super8 Sound or Inner Space. Without any modification it should be able to run in sync with your recorder.

Now I shall turn my attention to a few of the nearly twenty models of super 8 sound projectors you can purchase. It was impossible to overlook machines made in the Eumig factory: they are aggressively marketed, widely used and Eumig, I think, accounts for most of the world's production of super 8 sound projectors. The Bolex SP80 and models SP8 and SM80 are made in the independently owned Eumig factory.

Although the Bauer T60 is now the only stereo projector available here, the credit for the first such machine goes to the Heurtier ST 42. These fussy machines have been imported by Hervic for some years, but blessedly, no longer as of 1975.

Bell & Howell offers a new (spring 1975) line of nicely styled machines made in the Japanese B & H/Mamiya factory. I haven't had a chance to use one of these yet.

Nor have I used the Copel, Sankyo or Noris (the Norisound 110 and 120 are reportedly superb) projectors. Check them out for yourself. I may have missed a champ, but who knows what other machines escaped my burning gaze. But I have used the sound projectors made by Eastman and Elmo, and along with the Eumig and Bolex models, these will be reported on.

If I had to sum up the state of the art, based on my use of many machines in the past two years, I would say that a respectable level of image quality has been achieved. In general, steadiness or image registration is outstanding. Image brightness is adequate for the

PROJECT

259

popular 40- to 60-inch lenticular or beaded screens; and in some cases a decently bright image can be projected on a screen 10-feet wide. All super 8 sound machines run at 18 and practically all at 24, and the good ones run with nearly identical quality at both speeds.

Most projection lenses still suffer from too much image brightness and sharpness fall-off at the corner of the field. Face it: you're not going to get the most out of your Canon or Schneider camera lenses with most super 8 projectors.

Expect absolutely no audible flutter for voice and music. Flutter, or that gargling sound heard most readily in sustained notes, has been conquered by super 8 designers. If your machine has flutter, at either 18 or 24, get it fixed, or get a new one. Don't go by the sound test film supplied by the manufacturer. They are usually full of staccato passages designed to dazzle the foolish. Make your own tests by recording a good LP and playing it back.

Soundheads and electronics are getting better, and it is not too much to say that your super 8 mag sound projector's quality surpasses that of 16mm projectors saddled with optical sound. Some super 8 machines approximate hi-fidelity standards.

The major unsolved problem for practically all models is hum, hum, hum. The mag heads used for recording and playback are super-sensitive reproducers of magnetic fields. That's how tape stores sound messages. The motors used in super 8 projectors produce monstrous magnetic fields. These are high torque motors that have to run the intermittent, the feed and take-up spindles, the sprocket wheels (if any) and the blower. The magnetic field is produced at 60 Hz, but it's the first demonic harmonic we hear, the 120-cycle hum.

It's really very easy to rate the relative hum of various projectors. Simply set them for the same playback level, which can be determined by listening tests, and then play back silent passages of tape. Of course, the same external speaker should be used for the machines you are comparing.

How to get rid of hum? After the head picks it up, a dip filter could cut out the hum without hurting the rest of the sound. Super 8 projectors don't use this technique. They try to shield the head as much as possible, or in the case of the Ektasound machines, the motor is way over in a corner far from the head. But these techniques have proved to be less than entirely successful.

Improvements have been made in the last few years, especially in the Eumig line, but the hum hangs on. Most people will never hear it in playback. Ambient room noise will effectively mask it. But I hate to use a machine like this for recording my tracks, especially if dupes are going to be made from the film. If this is the case, the hum will be built into the original and all prints.

The only projector without hum was the Elmo ST 1200 D.

SOUND PROJECTORS

MAKER	MODEL	LENS	LAMP	RECORD LEVEL	LEVEL INDICATOR	AMP POWER	ACETATE CAPACITY	LIST PRICE
Bell & Howell	1744Z	f/1.5 20-32mm	120V 150W	Auto	VU	3W	400'	$400
Bolex	SP 8	f/1.3 15-30mm	12V 100W	Auto/Man	LED's	3W	600'	475
Bolex	SM80	f/1.2 12.5-25mm	15V 150W	Auto/Man	LED's	10W	600'	650
Copal	401	f/1.3 13-25mm	12V 100W	Auto	none	***	400'	380
Elmo*	ST-800	f/1.3 15-25mm	12V 100W	Auto/Man	VU	6.5W	300'	400
Elmo*	ST-1200D	f/1.3 15-25mm	15V 150W	Auto/Man	VU	12W	1200'	
Eumig	802	f/1.6 17-30mm	12V 75W	Auto	none	3W	600'	353
Eumig	807	f/1.6 17-30mm	12V 100W	Auto	none	3W	600'	428
Eumig*	810 HQS	f/1.3 15-30mm	12V 100W	Auto	none	10W	600'	535
GAF	3000S	f/1.3 15-25mm	120V 150W	Auto	none	1.5W	400'	330
Kodak	235B	f.1.3 15-30mm	30V 80W	none**	none	***	400'	280
Kodak	245B	f/1.3 15-30mm	30V 80W	Auto/Man	VU	***	400'	365
Kodak	Supermatic 70	f/1.3 15-30mm	30V 80W	Auto/Man	VU	4W	400'	640
Sankyo*	600	f/1.4 15-25mm	12V 100W	Auto/Man	VU	***	600'	445
Silma	Bivox D-Lux	f/1.3 16.5-30mm	21V 150W	Man	VU	4W	600'	520

NOTES: If you like, add new models to the list. *Optical sound playback available. **Playback only. ***Information not available but probably about 3W. Manufacturers' different rating methods make all power figures a rough guide only.

Eumig Eumig of Austria makes the largest line of super 8 sound projectors. You can buy one for $290 list, or go up to $650. The bottom of the line, the S-802 D uses the same basic casting as the middle S-807 or the top 810 D Lux. Although coverplates and little dodads may differ, the basic body and intermittent mechanism is the same, and the casting of one model has fittings for features added to other models during other production runs.

The important differences are the electronics, which get better the more bucks you spend, the lamp, which gets brighter, and the lens, which gets faster with a broader zoom range. All machines have a 600-foot capacity.

Eumig is now offering an optical/magnetic sound machine, and the HQS, billed as having high quality sound and an extra bright image. These were introduced too late for testing. I did have an opportunity to make extensive use of the 810 D and the 810 D Lux. The only difference between these machines is that the Lux (for light) uses a faster lens. The 810 D has an $f/1.3$, 15 to 30mm zoom lens, and the D Lux has an $f/1.1$, 18 to 28mm lens. The new version of the Lux, the HQS, has an $f/1.2$, 12.5 to 25mm lens which Eumig claims is actually some 6 percent brighter than the $f/1.1$ lens.

I was able to fill a 10-foot high-gain screen in a darkened hall with a bright image with the D Lux, which tested out about a quarter of a stop (30 percent) brighter than the 810 D. Image quality, which I would rate as good, is similar for both $f/1.3$ and $f/1.1$ lenses.

My standard brightness test was to project without film on a 50-inch screen and take lightmeter readings at the center and six inches on the diagonal from the edges of the frame. The 50-inch screen was used as a meter placement reference, since I measured incident light and not light reflected by the screen. I pointed the cell of a Weston Master V at the lens, and got readings on an arbitrary but consistent scale. I found that the 810 D ($500) and the 810 D Lux ($560) both registered more than a full stop brightness fall-off at the corners. I do not consider this to be good performance. The only trouble with this statement is that with film in the gate it simply is not possible to tell that there is this much fall-off. One tends to concentrate on the center of the image; and the eye, for most images, just isn't sufficiently sensitive to be able to see the difference between a center twice as bright as the corners. Moreover, well authenticated research* has established that this kind of diminution of edge brightness actually makes the overall image appear more brilliant.

The 807 by contrast is a full stop dimmer at the center, but just as bright at the corners as the 810 D. The 807 ($400) has a very evenly

*The Focal Encyclopedia of Film & Television Techniques, Hastings House: article on "Screen Luminance."

262

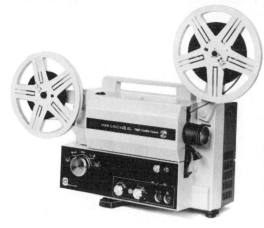

Eumig H.Q.S. Currently there are three H.Q.S. machines: the Mark-S-810 D DeLuxe (pictured), the Mark-S-810 D and the Mark-S-810. (Eumig)

illuminated field, and it uses a 75-watt, 12-volt lamp. The 810 models, like many other European projectors, use a 100-watt, 12-volt Philips lamp. It's a good lamp and lasts for quite a while; it's rated at 50 hours. Image steadiness of the 807 and 810 models is very good. The gate design is first rate; it's easy to entirely remove the aperture plate and pressure pad. This encourages cleaning. Before removing the gate, make sure the claw is retracted fully: properly align the inching knob, located in the rear, so that its rotating dot lines up with the dot marked on the projector body. If the claw isn't out of the way, it can be damaged when the gate is removed.

Sound quality of the 810 model is decidedly superior to the 807. There is much less hum. My impression was that there was no flutter, and good frequency response, far better than the best 16mm optical projectors. A totally reliable colleague informed me that the 810 HQS (high quality sound) he tested had less hum than the 810 D, and even better frequency response. Eumig also offers an optical playback model similar to the 810 D.

Threading the Eumig machines is automatic, so automatic that you cannot remove a film partway through without disassembling the machine. My experience with the 810 D and the 810 D Lux indicates that a clean machine will cause little or no wear even for hundreds of passes of the same film. When the loop was lost because of a bad splice or a damaged section, no harm was done in the few seconds it took me to activate the loop restorer (the auto-threading lever) which always set things straight.

The 810 D and 810 D Lux are dual format machines. They project sound films in standard 8 as well as super 8. The standard 8 head is placed where the balance stripe is for super 8, so it would be possible for Eumig to offer a stereo super 8 projector for only a little

263

extra cost. Eumig doesn't want to do this, I believe, because the narrow balance stripe would have to be amplified so much that the hum would come up a lot. A few people, I have heard, have added the necessary electronics for stereo use. The hard part is already done: the head is in place.

I would rather have the present record stripe split into, say, two 12 mil channels for stereo sound instead of one 27 mil mono channel. Such a standard would be compatible with all mono machines and could mix both stereo channels, leaving the balance stripe unimpaired for other uses. Of course a three-channel stereo setup using balance stripe and record stripe split in two is also possible.

Agfa-Gevaert has shown the Sonector LS model, which is conceptually similar to what I have described. It's not a stereo machine, but it does split the record stripe in two for monaural mixing. Suppose you have single system movies with people talking, and you want to add a musical background. Just add the music to the half width channel, and upon playback both channels are mixed together. If you don't like the recording level of the music you have added, simply rerecord the music until it is satisfactory.

I've digressed here, since the Agfa method is at variance with the method used by Eumig and just about every other super 8 sound projector manufacturer.

The Eumigs offer the usual sound-on-sound feature, which I think is for the birds. By turning down the erase current for the second pass, part erase is achieved and superimposition of the second recording on top of the first, for a mix of sorts, is the result. Make a mistake and the first recording is forever lost, which in the case of single system is probably an irreplaceable loss. Moreover, sound quality of the first recording is diminished, and exact placement of effects is very difficult.

The major drawback of the recording setup is that there is AVC (automatic volume control) only for the 810 D and D Lux. I like to be able to set the level manually. It's probable that many users will be happy with the AVC as is.

The amplifier is powerful enough to drive a fair-sized high efficiency 8 ohm speaker to fill a decent-sized room with good sound; there is a line output which gives good sound in conjunction with the tape input of a hi-fi amplifier.

Eumig has attempted to solve the annoying connector problem with their universal recording lead. There are too many electronic connectors employed for projectors (and recorders and single system cameras) such as the DIN standard, or the mini plugs or whatever. Some machines even mix standards with mini's here and phono plugs there. The universal recording lead sets out to adapt most inputs you can find to the DIN standard. It's a good idea.

I think you'll get your money's worth with these dual format machines especially if you have standard 8 movies to project as well as super 8; shop around for the best buy. I've seen them heavily discounted.

Bolex Bolex markets four projectors in the United States, the SM 8 ($620), made in the Silma factory, and the SP8 Special, the SP80 Special and the SM 80 Electronic, made in the Eumig factory. I am going to concentrate, for the most part, on the SP 80 ($550), very similar to the Eumig 810 D. The machine I tested was a plain and simple SP80 (sans Special). The Special designation was added in the spring of 1975 with upgraded electronics and an $f/1.2$, 12.5 to 25mm zoom lens.

The SP80 I tested had an $f/1.3$, 15 to 30mm lens, and unlike the Eumig 810 D, it is not a dual 8 machine, it handles super 8 only. It has different electronics and manual volume control for recording as well as AVC. It has a larger built-in speaker giving a little better sound. It has a counter which marks off seconds at 18 fps. LED's (light emitting diodes) are used for a VU meter, and two green lights tell you if you are set for 18 or 24 fps.

Although it's obviously a Eumig machine, the styling is a little different, almost for the sake of being different. There's nothing about this product that marks it as being a Bolex machine. At one time there was a Bolex look, but that is a thing of the past. The styling is gratuitous with control knobs that are a little more difficult to grasp than the 810's. The worst feature is the removable lamp coverplate: it ends in a weird fin that obstructs the fps slide switch and gets in the way of the take-up reel. The cover must be removed to operate the fps slide bar, which can be set anywhere between 17.5 and 25 fps, offering precise matching of the projector to your single system camera.

The machine is capable of the quality you'll find in the Eumig 810's, the same simplicity of operation, with the bonus of being able

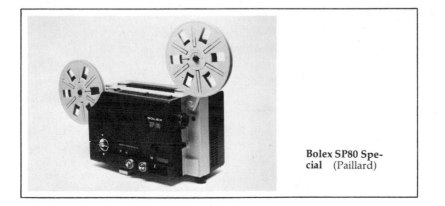

Bolex SP80 Special (Paillard)

PROJECT

to set your own volume on record. If you don't have 8mm films to show and are into super 8 only, the SP 80 will save you about $50, compared with the 810 D.

I worked with this solid machine for eight months and got to like it very much. I liked it so much I modified it by cutting off the rear portion of the coverplate casting so that the fps selector was accessible and the 600-foot reels went on and off smoothly. It took about an hour to hacksaw the end of the casting and paint it auto-engine black.

I decided that I would be happier with an on-off switch. As soon as the machine is plugged in, the motor goes on and the sound of it got on my nerves. You can simply add a switch to the line cord, but I liked putting mine in the front of the projector in the main casting.

I also added an on-off switch for the lamp on the panel near the controls. Although the Philips lamp lasts about 50 hours, I was doing a lot of recording and just didn't like the idea of having to run the machine with the lamp on. All the time the machine is plugged in, the lamp receives low voltage; it's longevity is due, in part, to this preheating of the filament.

I also had a single frame contact switch added by Skinner Studios in San Francisco. Inner Space or Super8 Sound can do the same kind of conversion, but so can any good projector repairman in about two hours with the right parts. I got the parts from Super8 Sound.

And I shouldn't ignore what is an interesting feature for the traveler: the SP 80 and other projectors made in the Eumig factory, like the 810 D models, can be user adjusted, in just a few minutes, for any voltage likely to be commercially generated in any country in the world. The machines can also be set for 50 or 60 Hz. These are the only projectors I know of with this feature. Other machines are factory set for specific localities.

Kodak Kodak offers two distinctly different designs, the Supermatic 60 and 70 series, and the Ektasound 235 and 245 series. I think that the Ektasound design is probably more to the point for my own use, and for the readers of this book, so what I have to say here will be about these machines.

The Ektasound 235 and 245 are the most interestingly designed projectors I have seen in years. To give you a handle on the different choices you have when purchasing one of these, the 235 does not record mag sound, it just plays it back. The 245 records too. You can get either with a fixed focal length $f/1.5$, 25mm lens, or with an $f/1.3$, 15 to 30mm lens. So that gives you four different choices at four different prices. The 235 with the 25mm lens is the world's least expensive super 8 projector. If economy and playback only are what you need, this projector deserves your consideration. It lists for

$220, and 20 percent discounts are frequently available. With zoom lens and record and playback, the 245 lists for $370.

These are servo drive projectors, sprocketless with motor-driven capstan. If the loop should ever be lost, it is automatically restored. It seems virtually impossible for these machines to damage film. You can even thread the film flopped, so the perfs are on the wrong side, and the film will pass through the gate without any harm!

The 235 and 245 are threaded manually. Their threading is so simple that they question the concept of autothreading. They load reel-to-reel tape-recorder style by simply dropping the film into a channel opening. Film is attached to the 400-foot take-up reel by pressing it into the hub slot.

It is very simple to remove film partway through, so that you can take it to the editing bench for examination and cutting. Simply ease out the film from the take-up reel side. I was able to do this repeatedly without damaging the film or wearing it in the slightest.

Film is also easily loaded when partly on take-up and partly on feed reels. All of this makes the machine ideal for editing room use. There is also rapid in-path forward and reverse, similar to fast forward and reverse on tape recorders. (And there is a still frame mode too.) These features are not to be found on other sound projectors. Easy access to film at any portion of the reel is a quantitative step up.

On the new B-suffixed models, the lamp has a separate on-off switch, so it can be shut off during rewind.

The projector is operated with a joy stick that requires too much force to move it. This can too easily move the projector just a fraction of an inch thereby moving the image off the screen. Since it's undesirable to make the projector heavier, the control must be made easier to operate.

The unusual tape-deck design of the projector calls for the lens to face a mirror which sends its beam at right angles to the plane of the reels. Kodak designers use mirrors to gain advantage in projector

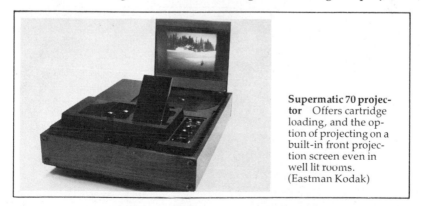

Supermatic 70 projector Offers cartridge loading, and the option of projecting on a built-in front projection screen even in well lit rooms. (Eastman Kodak)

PROJECT

layout: witness the Moviedeck, Supermatic and the Ektasound designs. Although good front-surfaced mirrors will not cause loss of sharpness, each mirror does produce a 12 percent loss of brightness. This design uses a mirror to bend the light from the lamp to the gate and another after the lens. So we lose 12 percent of the light that might have reached the film and then 12 percent of what's left through the lens-screen mirror. This works out to a significant 23 percent light loss.

However, the latest Ektasound models, the 235B and 245B, are some 20 percent brighter than the model I tested: they use a more efficient lamp.

The flip of a mirror allows for the image to be projected from either the control or the back side of the machine. Overall image quality is good, with brightness falling off half a stop to the extreme corners. With its $f/1.3$ zoom lens, the 245 is about a stop behind the Eumig 810 D Lux in brightness.

I had trouble focusing the lens so that the image was entirely crisp on both halves of the frame. Something was out of alignment between gate and lens, or lens and mirror. Focus was acceptable, but not the greatest. The trouble may be the rinky–dink focusing mount. I don't think the lens is sufficiently well supported. You'd think the makers of Kodachrome would want the world to see how sharp it is. (A 235B I subsequently tested was optically first rate.)

The image was steady, and combined with its virtual inability to harm film, I think the 245 has a superb intermittent mechanism.

The sound was very good too. It wasn't quite as rich as the 810 D sound, but it was a close second. And very important: the hum was a bit lower than the Eumig's. On the negative side the hiss, or high frequency noise, was higher. Apparently placing the motor over in a corner has helped to reduce hum. But now Kodak needs to give this projector an amplifier worthy of the design, with fuller sound and lower hiss. The mag stripe they put on film is so terrifically good, you'd think they'd want to show it off.

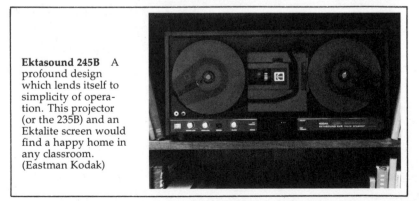

Ektasound 245B A profound design which lends itself to simplicity of operation. This projector (or the 235B) and an Ektalite screen would find a happy home in any classroom. (Eastman Kodak)

There was no flutter to be heard. The machine I used was really a very good reproducer and recorder of even difficult passages of music. There is no line-out for hooking up directly to the tape-head input of your hi-fi amplifier. This strikes me as being curious since the machine is obviously meant to go on the shelf next to your music components. A penny saved may be a penny earned, but this is a foolish penny.

Projector designers have two choices for making frameline corrections: having a moveable—up and down—aperture plate with a fixed claw, or a fixed aperture and a claw that can be positioned up or down.

If the aperture is moved, it's possible to adjust for frameline properly, but the correction may move the image above or below the screen, making it necessary to adjust the tilt, or elevation, of the projector.

If the claw is adjusted so the distance between the film's perforations and aperture is changed, the frameline can also be corrected. This method is more convenient, since the frame will remain positioned on the screen, and the elevation control need not be used. Most designers choose this solution. The Kodak designers have chosen the less convenient moving aperture plate.

These Ektasound machines are continuously variable from 18 to 24 fps by using a sliding control. The one I used started a few percent fast, or about 18.2 fps. With an Ektasound camera that runs slow, as some of them do, this adds up to squeaky voices. Kodak would be better off having these machines start off at 17.5 and run to 25 fps, as Eumig does, to allow the user to tune the projector. I checked out other Ektasound machines and two out of three were running fast.

I think that Kodak had their share of troubles with this machine during the first months of production. It took the repair department three cracks at the one I used before it ran okay. After the intermittent assembly had been replaced, things were better.

If you compare features and design points with the conventional Eumigs, you come up with the fact that both projectors have strengths and weaknesses; finally, the $75 lower price of the 245 with zoom lens may be the biggest factor. Some people will just feel better about the Eumig because it looks and feels more like a projector. Some filmmakers, I have noted, think of the Ektasound machines as toys. Well, they do have something of that feeling about them, but they can deliver the goods, and who said filmmaking wasn't playing with toys?

Elmo The Elmo ST 1200 D projector makes a substantial contribution to the super 8 system. It is a sprocket-drive projector

that weighs about 21 pounds (four more than the Bolex SP 80), and in appearance reminds me of a 16mm machine.

It offers the usual automatic threading. The machine comes with an 800-foot take-up reel, but can also accept a 1200-foot reel (80 minutes at 18 fps, or an hour at 24 fps). This is the largest take-up reel offered for any super 8 projector.

The Elmo's design is conventional, and the projector is easy on film. It's bigger and heavier than other super 8 sound projectors. It has the usual sound-on-sound feature and AVC (manual setting also) and a volume indicator meter. It runs as noisily as any super 8 projector. Everything has been done thoroughly and well, and you'd expect that in a $650 machine.

What makes it so special is this: the image and sound are better than anything else I have seen or heard. With the $f/1.4$, 25 to 50mm zoom projection lens ($150), the image is brighter and sharper out to the corners than any other off-the-shelf super 8 projector. And the sound is superb. There is no flutter and just a trace of hiss. Fidelity from the 12-watt amplifier is very good. The sound is full and rich. The big news is the absence of hum! I could hum about it.

The major difference between the ST 1200 D and the ST 1200 it replaces is the power-driven flywheel which helps the machine get up to speed in one instead of four seconds. This should also help wow caused by splices.

Elmo sound for recording and playback has almost hi-fidelity frequency response and no flutter. The sound is as good at 18 as at 24 fps when played back through the usual high efficiency speaker.

I had some trouble focusing the 15 to 25mm, $f/1.3$ lens to get an image that was evenly sharp across the field. (This is the lens that is offered as standard with the projector.) After a few twists back and forth of the focusing device, I could get a reasonably sharp image.

The best way to focus a projector lens is by concentrating on the image grain. When the grain at the center of the field is as sharp as you can get it, you're in business. I usually step in front of the projector and stretch my hand behind me to focus the lens. This puts me as close to the screen as possible. Even a few feet in a living room setup will put you helpfully closer to the screen and away from spill light: this will make a big difference in focusing accuracy.

I don't think this lens has any more curvature of field than other super 8 projection zoom lenses, but the trouble may be that the Elmo is bright—to within a tenth of a stop of the center—right out to the corners. The Elmo uses a 15-volt, 150-watt lamp which looks like the Philips 12-volt, 100-watt lamps used on Eumigs and other European makes. But the extra voltage and power make a difference not at the center of the field, which is as bright as the Eumig models, but rather at the corners.

Elmo ST 1200 D
Elmo now offers the ST 800, which is similar to the 1200 D. It lists for $400. Valley Projection has a $1500 MARC 300 conversion of the 1200 D. (Elmo)

I should point out that like the other projector zoom lenses I have checked, this one's performance varied with focal length. The particular lens I used suffered much less from edge softness for shorter than long focal lengths.

The optional 12.5 to 25mm, $f/1.1$ lens is a quarter of a stop brighter than the $f/1.3$ lens, and it may have the brightest image of any off-the-shelf super 8 projector. Its quality is similar to the slightly lower optic. The lens will set you back an additional $150, and the projector cannot be purchased with it. This means that if you opt for it, you are going to wind up with the $f/1.3$ lens sitting around in some drawer forever. If only Elmo sold the machine with the fast lens.

The lamp has a two-position brightness switch, which reduces the illumination about a quarter of a stop for lamp longevity. I have been using it in this position for a bright image on a 50-inch screen in my studio. When guests come by and I want to impress them, I put the lamp on bright. I've been using the machine this way on a daily basis for six months and the lamp is still good. The manufacturer rates the lamp at 50 hours, and it had better last with its $21 list.

Elmo sound is on a par with the image, and it's just as good at 18 as 24 fps. And an important plus: the 1200 D is the only sound projector sold with a digital sync switch.

Before I leave this first rate projector, let me add that there are three Elmo ST 1200 D models: the M (magnetic sound only), the M-O (magnetic and optical playback) and the O (optical playback only).

PROJECT

271

System Quality You can look at your projector as the last link in a chain connecting the image and sound to the screen and speaker. The quality achieved depends on the merit of each individual component. If your projector is not up to the standards of your camera and recorder, you are going to be selling your image and sound short.

But when you project your first super 8 films, how can you evaluate each component's contribution to what's on the screen? If you aren't sure of your projector's image and sound, how can you evaluate your camera's image and sound, if it's a sound-on-film camera for example?

The best way I know of to evaluate a sound projector's quality is to hook it up to your hi-fi amplifier and record a good LP. Then play it back. You should have difficulty telling the original from the recording when you run your super 8 projector through hi-fi amplifier and speakers.

To help you evaluate your projector's image quality you might invest in the Society of Motion Picture and Television Engineers' (SMPTE) Super 8 Steadiness Test Film. This 50-foot super 8 registration test film costs $19, and after a few seconds through your projector you'll know all there is to know about how precisely your machine registers each successive frame. An intermittent, which can steadily register each frame without side weave or up-and-down jitter, is the hallmark of a good machine. Your projector should let you observe a test target with only the barest motion. However it won't look like a slide being projected by a slide projector. I've never seen any movie projector perform that well. Slight density and random granular changes, and dust, preclude a projected motion picture from taking on the appearance of a slide. But your projector should come very close to this standard.

Super 8 projector lenses are not, generally speaking, up to the higher standards of camera lenses. Most of the trouble comes from corner sharpness fall-off. Nearly all the super 8 projector zoom lenses I have used suffer in some way from this defect. Usually, it's not terribly distracting, especially if it's confined to the extreme corners of the image. Using a really good projector lens is like giving your good camera lens a shot in the arm.

The loss of center sharpness comes about from curvature of field. This means that your projector would do better throwing its image on the inside surface of a sphere instead of on a flat screen.

I feel it is not possible to run the kind of camera registration tests employed in larger formats because super 8 film is cartridge-loaded. These tests require double-exposing a target like a cross. Even though film can be backwound in a cartridge in some super 8 cameras for something like 60 to 100 frames, and despite the fact

that test results are often good, this is not a fair test since the backwound film has been stuffed into the cartridge and is not properly backtensioned to ensure good registration.

If you are into testing your camera, film a stationary target with clean vertical and horizontal lines, like a cross, and then project it with a steady super 8 projector. If the film looks steady, your camera is okay.

What happens when your camera and projector are not running at precisely the same speed? It is unusual for super 8 silent or sound-on-film cameras to run more accurately than within 2 or 3 percent of marked speed—either 18 or 24 fps. If your camera is running 3 percent fast at its 18 fps setting, its actual fps rate is a little more than 18½ fps. If it's running slow by 3 percent, its actual speed is a little less than 17½ fps. Another way to state the same information is that a camera which is 3 percent accurate at 18 fps runs at $18 \pm \frac{1}{2}$ fps.

Generally speaking, super 8 projectors aren't more accurate than super 8 cameras. If your projector's error is in the same direction as your camera error, if both run slow for example, the errors tend to cancel out. The error will totally cancel out if both are running at exactly the same fps rate. Let me be clear: for the moment I'm talking about the image.

If the projector is running fast and the camera slow, a not infrequent happening, the relative error becomes worse. Films made on a camera that runs at 17.5 fps and shown on a projector that runs at 18.5 fps will be speeded up 1 fps, for a relative error of nearly 6 percent. That's a lot of error, and for some kinds of action people will be able to notice it.

We are dealing with a mechanical system (camera-projector) interacting with a psychological system (eye-brain), and the only thing that finally counts is an image that looks good to most viewers. It's my impression that a relative error like the one in which image is speeded up, is more distracting than slowed down image.

Single frame of the SMPTE steadiness test film (SMPTE)

In the example cited, with a camera speed of 17.5 fps, things would look a lot better with a projector that ran at its marked value of 18 fps. For silent films, half a frame, or an error up to 3 percent, is negligible. We'll consider sound in a moment.

Projector error is actually easier to figure than the camera's. You can measure your camera's fps rate by shooting the face of a clock with a sweep secondhand. If your projector has sprocket drive, simply reference point the sprocket wheel with black tape or a crayon mark, and with a stopwatch in one hand and your eye on the turning sprocket wheel, count revolutions for a fixed interval; or if it's easier, count a certain number of revolutions and measure the time.

You can count how many teeth your sprocket wheel has, so you know how many frames it advances per revolution; it's a simple matter to figure out the actual fps rate of your projector.

If your projector uses sprocketless drive, simply run a loop of a given length of film through the machine; counting how many times the loop passes through the machine in a given interval of time will help calculate your actual fps rate.

For variable speed control projectors like the Eumig models, you can accurately set your fps rate where you like. The Eumig and Bolex machines I have tested can be set anywhere between 17.5 and 25 fps, making on-the-dot accuracy a reality. What's on-the-dot accuracy? Given the present state of the art, I'd call anything 1 percent of the marked fps rate very accurate. However, I ought to point out that Eumig doesn't say a word about this possibility in their instruction book, in effect depriving many users of this option.

It's one thing for me to tell you that something is easy to do, and it's another for the procedure to be really easy. So I just walked over to the Elmo ST 1200 sound projector I am testing and did what I have suggested. I counted the number of teeth on the take-up sprocket: 18 teeth. I decided to run the projector for one hundred revolutions of the wheel at 18 fps, so I put a black mark made with a grease pencil on the wheel and while counting revolutions timed the run.

Using the table on page 193 you can see that 1800 frames (18 x 100) is 25 feet or 1 minute 40 seconds. (25 feet multiplied by 72 frames per foot gives 1800 frames.) I clocked the Elmo at 1:39½ for the 1800 frame run. The Elmo is within half a second of what should have been a hundred-second (1:40) run, so the particular machine that I have just measured is accurate within ½ percent at 18 fps.

Suppose your sound camera (or double system setup) runs 2 percent slow. If you have a Eumig, you can adjust the projector 2 percent slow for dead-on accuracy. You can do this by ear if you like, setting the speed control when you find the voices most natural.

If you have an Elmo, for example, with a two-position setting for 18 or 24 fps, without provision for adjustment, your 2 percent slow talkies will sound okay, since the relative error will be so low.

My experience indicates that for sound movies, like silent movies, a relative error between camera and projector that results in slow running is preferable to fast running. Voices recorded at 18.5 and played back at 18 fps sound better than talkies made at 17.5 and played back at 18 fps. The former case results in a lowering of pitch, the latter in a raising of pitch. Voices sound better low pitched than high: they are more mellow. High-pitched voices begin to make people sound like cartoon chipmunks.

How much of an error is tolerable? It depends on how familiar you are with the voice. You probably aren't too familiar with the pitch and quality of your own voice, so listen for how other people sound. For familiar voices error beyond 4 percent is too much. This is a relaxed standard, I must admit. For really first rate results for voice recordings, both projector and camera should run within 1 percent of the set fps rate. For hi-fidelity results, we'd be measuring error in terms of tenths of a percent.

Recordings made and played back on the same machine should sound perfect. If your projector is running very much faster or slower than its marked fps rate, when the time comes to show your film on an accurate projector, you may be in for a disappointment.

One last point: when doing sync sound transfers from mag film to stripe, be sure to let your projector warm up for five minutes so its speed will stabilize. Bearings have to become thoroughly lubricated, and oil viscosity must reach its proper valve.

Wear and Tear Taking my clue from the home moviemaker, I have investigated the possibility of working with my original film and cutting it instead of going to a workprint as is common practice in larger formats. In order for this to be possible, the projector's contribution to film damage must be minimized.

Most of the violence inflicted on film by projectors, in the form of scratches and abrasion, results from the contact of stationary parts with the moving film. Just about the only place this happens is in the gate. Another source of trouble is perforation wear and tear, frequently occurring at the head of your film because of automatic threading mechanisms.

The emulsion (picture side) position of camera film in a projector is the same as it was in the camera, that is, facing the lens. The base then faces the lamp. Most designs use a pressure plate on the lens side, so it's the pressure plate that can cause emulsion scratches. Emulsion scratches can come about in a variety of ways. Metal burrs or rough spots can gouge out film, but more frequently, emulsion can pile up to form projections on parts of the plate.

PROJECT

It may seem strange that the very same emulsion which is so delicate can scratch itself when it builds up on gate parts, but it's the truth. An accessible gate that swings open or pulls out of the projector will facilitate inspection of the gate and its cleaning as well. Clean the gate with a brush; even a toothbrush can work well. This will mostly remove annoying dust that may or may not contribute to wear. Using a clean cloth dampened with denatured alcohol, gently rub the gate clean to remove caked-on emulsion.

You can also try using Protect-A-Print leader. It helps reduce emulsion build-up in the gate. The other parts of your projector that should be cleaned too are the sprocket wheels and soundhead parts.

But, as far as my experience goes, most of the scratches that film picks up are on the base side. Probably 90 percent of the abrasions occur here, most of which cannot be seen upon projection.

A well-tuned super 8 projector should not add any wear or scratches to your film. I have run the same film through several good super 8 projectors more than two hundred times without any wear. The best way to check out a projector for scratching (page 221) is to test it with leader, looped end to end.

To keep your film alive and well, run it through your projector and your projector alone. You know it works good, and you trust it. Run your original through an alien projector and you are taking a chance; this can be minimized, however, by running the black leader test and cleaning the unknown projector as well.

Be especially careful to make good splices. A poorly made splice that can pass through the projector may in the long run do as much damage as one that fails right away. The perfs which run through the projector immediately after a lousy splice are likely to wear very rapidly.

Dust The world is full of dust, and much of it seems to land on the little highly magnified super 8 frame you're protecting. Dust on

Sea/Air 1000 electronic air cleaner (Spiratone)

the film at the aperture can be a real problem, more than a small annoyance as far as I am concerned. It drives me crazy during a screening, and there is little that can be done about it (try running backwards for a moment, if that doesn't spoil the show); but there isn't a single projector that I know of that has a device for curing it. You'd think that somebody would come up with a dust-blower offer. How about just a few well placed channels at the gate that could be fed by the canned compressed air sold in photographic stores?

Well, that's me dreaming again. Right now, the best you can do, practically speaking, is to keep your film and projection and editing rooms free from dust. Keep everything clean, from floors to work surfaces. Keep your film free from dust by running it through a record cleaning cloth. Do this every time you edit and every few times you project. The cloth will pick up the dust without charging the film. Electrostatically charged film will only attract more and more dust, and rubbing film with an ordinary cloth is the perfect way to charge it.

The idea of electrostatic attraction of dust is used in a few devices for taking dust out of the air. There is an $85 unit offered by Spiratone that will help reduce dust in the air and on film. It sucks air into it and past charged plates where dust is deposited; then the nearly dust-free air is blown out the back of the machine. It's the size of a phonograph turntable, and it must be left on all the time. It uses 85 watts of power.

If you are spending the thousands of bucks required to set up a permanent projection booth for super 8, you ought to run one of these air cleaners in the booth. But before you spend the money on one yourself, make sure you have a real need for it. If you can reduce or eliminate dust by keeping clean, why get one?

Screens Too often taken for granted, the screen is a crucial element in the optical system and can determine overall projected

Typical home movie screen (Hervic)

image quality. Most important is the design of its surface, and the materials used for fabrication.

•All screens will return about the same amount of light projected upon their surface. It's the way they return the reflected light that determines their brightness.

The matte screen will reflect light in all directions without bias. A matte screen has a textured surface; canvas is a good matte example. Matte screens rarely have a place in super 8 projection. They just aren't bright enough for projection on anything larger than a foot or three across. I've seen many super 8 images that were too dim, but never one that was too bright, so most of the time we have to use high-gain screens that return the reflected light in a narrower path than matte screens.

Imagine a line drawn perpendicular to the surface of the screen. We'll call this line the axis. High-gain screens are always brightest on axis. As you move across the room and view the high-gain screen off axis, the image will darken, but a matte screen viewed from the sides will maintain its on-axis brightness.

When considering screening areas, we usually think that views of the screen will vary only horizontally, but, for example, with sloped floors, there can be vertical differences as well. For this reason a high-gain screen must be carefully positioned vertically to maximize the image brilliance for the greatest number of spectators.

The most popular high-gain screen is the lenticular, made of cloth or a similar surface, coated with aluminum paint. Sometimes aluminum metal itself is used for the screen surface. The typical design for the viewing surface is made up of a number of corduroy-like ribs, maybe fifteen to the inch. These ribs run vertically forming a lens-like reflecting surface that directs much of the screen's light in the horizontal plane. At extreme angles a lenticular screen will look rather dim.

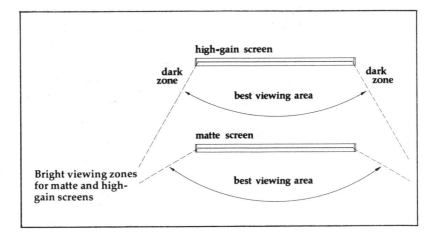

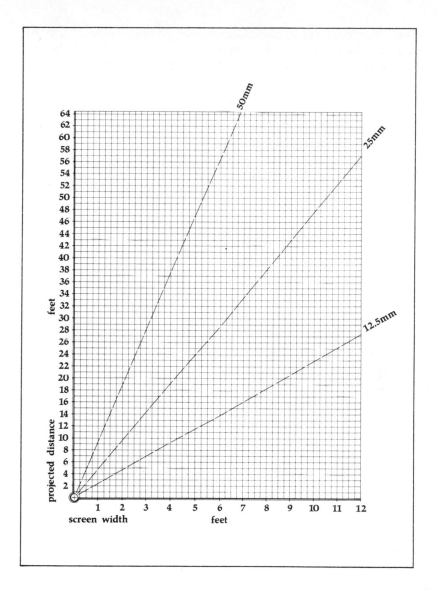

The graph shows the relation between screen size, projected distance and focal length If you know two of the variables, you can find a third. Place a straightedge at the origin, and align it with the desired focal length given on the vertical scale. For example, a 25mm lens fills a seven-foot screen at a distance of 32 feet.

While a matte screen has a light-multiplying, or gain, factor of about .85, a lenticular screen has a gain factor of about 2.0 (more or less). In other words some of the light falling on a matte screen is absorbed by the screen, so some 15 percent of the light projected upon it is lost for viewing.

But the lenticular screen can amplify the reflected light in the good viewing zone by a factor of about two, doubling the image brilliance. It takes light that would have been reflected to the extreme sides and reflects it to the front. The higher a screen's gain factor, the more light it is taking from the sides of the hall, and the more narrow, or confined, a seating arrangement must be used.

The lenticular screen provides a good compromise between gain factor and possible viewing angle. Depending upon the design of the particular screen in use, people can still be seated over a relatively broad horizontal angle, while seeing a very brilliant image.

The beaded screen is usually more brilliant than the lenticular screen, having a gain factor of about 2.8 or more. The surface of a beaded screen resembles sandpaper. Glass chips are glued, or embedded, to the surface, and they reflect an extremely bright but necessarily narrower angle of illumination.

It has been my experience that the properties of high-gain screens vary a great deal with the brand used, or even a particular model within a manufacturer's line. I have used beaded screens that had about the same coverage as lenticular screens, and I have used beaded screens with extremely narrow angles of coverage.

How do you know which you are buying? You don't, usually, since manufacturers rarely provide specifications for the screen you are buying. That's why I have refrained from giving figures for horizontal angles of view permissible with each type of screen. It's best to get a return option on your screen from the dealer. This is possible if you are dealing with a portable screen, but when ordering a screen for a fixed installation, a return option may be out of the question.

I was faced with what seemed to be a virtually insurmountable problem while trying to show movies to handicapped kids at a local development center. The classrooms have overhead fluorescent lights which can be turned off, but the great big windows let in too much light even when the curtains were pulled into place. Even the best lenticular or beaded screens I could find resulted in a washed-out image.

I had heard of the Kodak Ektalite screen (Model 3, 40 by 40 inches, $90) but thought that Kodak had been a little taken away with enthusiasm for their product. A gain factor of 12.0? Sounded nutty to me. But I tried it, and it worked great. Not only did it make

screenings possible in this seemingly impossible classroom, it also helped produce a first-rate image. The screen was hung right on the classroom wall, over a blackboard, using the mounting brackets that came with the screen to angle it downward at about 10 degrees. We've had successful screenings for thirty or forty people.

The screen is made of a subtly textured aluminum sheet fitted to a molded plastic shell. The surface of the screen is concave, like a small section of the inside of a sphere. The nonfolding screen is awkward to transport. Once set up though, it provides the most fiercely bright image—bright enough to overcome background illumination in most rooms.

Coverage is about 60 degrees horizontally and 30 degrees vertically. Beyond these bounds the image cannot be seen. The screen must be very carefully positioned. Think of the projector as a pitcher, and the beam of light as a ball. The pitcher throws the ball at the screen. The projector beam will bounce off the surface of the Ektalite screen just like a ball rebounding from a wall. And you want the ball, or projector light, to reflect right into the faces of the audience.

The best way to set up the screen is to project without any film, and observe screen brightness from various seats. You may want someone to hop around from seat to seat while you tune the angle of the screen. As a matter of fact, this setup procedure can maximize the effect of every high-gain screen.

The Ektalite screen is a little small, but you may be able to purchase a larger one, made under license from Kodak by the Advent Corporation for their Video Beam television projector. This screen is 68½ by 51½ inches and its aspect ratio matches the super 8 format.

Setting up Fairly often now I venture forth into the great unknown and show my movies. Sometimes I wind up in a hall I am familiar with, but more often than not, I take it as it comes in a strange environment. Often I project my super 8 original camera film, so naturally I use my own projector. Although there are several million super 8 projectors in the world, very few are in the hands of museums, colleges, cinematheques, or wherever I may be invited to show my films. Almost all these machines are owned by private parties: *i.e.*, home moviemakers. So I bring along my super 8 projector.

I have shown movies on the run, to audiences of from fifty to three hundred people, on screens up to about 12 feet wide. My projector amplifier often drives the installation's speakers directly, or in some cases, I use the line-out option with the amplifier of the

facility. Sometimes I have projected through glass from projection booths, and sometimes I have set up in the room with the audience. After a while I have felt more confident about what I am doing, but showing my own films makes me terribly nervous, and that screen stage fright doesn't seem to subside.

So I have to have everything as together as possible to minimize hassles, and I am still learning. It isn't easy to set up in a strange place, and it often takes the help of someone who knows the facility. I think that the advice I have to pass on here will also be of help if you are setting up in your living room. I do that too, and it's very much the same thing. Super 8 has brought me back to the roots of cinema and has turned me into a filmmaker/projectionist.

The projectors I have been using during the past year are a Eumig 810 D Lux, a Bolex SP 80 and an Elmo ST 1200. Right now my favorite is the Elmo 1200 for two reasons: Elmo offers a $f/1.4$, 25 to 50mm zoom lens, and a 1200-foot reel capacity. What makes this super 8 projection lens so valuable to me is its focal length range which will allow filling the screen from the back of the hall or from the projection booth. I have found the usual shorter focal length range of, say, 12.5 to 25mm will produce an image that is often too large for placing the projector in the back of the hall.

The other nifty Elmo feature is the 1200-foot capacity which means I can put a whole show on one reel and forget about threading up and changeovers. Even though super 8 projectors thread automatically, it is much, much better not to have to thread in the midst of a screening. Moreover, my longest super 8 film, *Revelation of the Foundation*, running some 68 minutes, doesn't need a changeover, or switching to another projector, for an uninterrupted showing.

On the other hand I have had terrifically good projection experience with the Eumig 810 D Lux, which filled the large screen at the Pacific Film Archive, or with the Bolex SP80 fitted with a Eumig $f/1.0$, 12.5mm lens. I used the Bolex with the Eumig lens at the San Francisco Art Institute theater for a Canyon Cinemathèque screening, setting it up in the first row. This 12.5mm wide angle lens filled most of the screen with a very bright high-quality image.

For the image part of projection, two things are important: the installation must have a high-gain screen, and the hall must be able to be darkened completely. All of the projectors mentioned so far are capable of filling a ten-foot lenticular or beaded screen in a well-darkened hall with a first-class image.

It's usually better to put the projector in the back of the hall. This seems to be smoother, but the 12.5mm Eumig lens on the Bolex worked just great in front of the audience. Generally, in large halls that have good acoustics, a super 8 projector's mechanical noise is very hard to hear. A nice point.

The kinds of speakers found in halls where movies are frequently shown are high-efficiency devices that the projectors should be able to drive adequately.

If the hall doesn't have a speaker, bring your own, or have the people running the place get you one. Low efficiency hi-fi speakers cannot be run directly with our projectors: they require additional amplification. You are better off getting high efficiency bookshelf or similar speakers. These will set you back between $15 and $80. They must be 8 ohms since super 8 projectors' outputs are matched to this standard.

If you are setting up the speaker yourself, get it off the floor. Putting a speaker on a chair will improve the quality of the sound.

If you are setting up chairs in the hall, don't put an aisle down the middle. If you do, you'll be removing your very best seats. The image looks brightest from the line between lens and screen.

If you need to, make up a checklist of things you must bring to the screening: an extra lamp, take-up reel, gate cleaning brush, power cord (many super 8 projectors have a separate power cord), extension cord and don't forget the films (I have, so please don't laugh).

As I see it, one key to a successful screening is for the hall to have a good up-to-10-foot-wide screen. Bigger than this, and you are straining the brightness of your projection equipment, unless of course the installation has an arc projector which can be anywhere from three to ten times brighter than a projector with a conventional lamp. Always go for the smaller, brighter image, if that's a reasonable option. Even if the screen has to be larger than the projected image, picking up a little brightness is terrifically important. Use your eyes as your best guide and walk over to the sides of the hall to see how people will be viewing the film from there.

Screen brightness is proportional to the area of the screen, not its width. A small increase in width can greatly decrease brightness because of the correspondingly great increase in area. For example, a screen 10-feet wide has an area of 10 by 7.5 feet, or 75 square feet. A 13-foot screen has an area of 13 by 10 feet, or 130 square feet, which is almost double the area. An image projected on the 13-foot screen will be half as bright as that projected on the 10-foot one.

And last, but not least, don't forget to set your focus, frame line and sound level before people arrive.

People who are thinking of projection in terms of setting up fixed installations, as well as we who project on the run, would do well to read Kodak publication, *Designing for Projection,* available from Customer Services, Motion Picture and Markets Division, Rochester, N.Y. ($1.50). It's the best thing of its kind I have seen, and may well save you from some mistakes, and help to maximize your projected image quality. Kodak also offers a more concise, and free, pamphlet, *Audiovisual Projecion,* No. S-3.

Optical vs Electronic Projection The biggest drawback with home optical projection is that you can't sit in the best seats in the room or you'd cast a shadow. The geometry of most rooms you're likely to show movies in generally precludes getting the projector beam out of the path of the audience. People have to get out of the way of the projector's beam. But right between the projector and the screen are the very best seats.

If the projector's lens has a short enough focal length, you can place the projector between the screen and the audience. For example, there are quite a few super 8 projectors now that feature 12.5 to 25mm zoom lenses, or in other cases a fixed focal length prime lens can be obtained. You can fill a 50-inch screen from about nine feet with such a lens, so your audience can be seated alongside or even behind the projector.

The next big drawback is the difficulty of projecting in classrooms, living rooms or such during the daylight hours because of the practical difficulties of fully darkening the room. Even a slight level of background illumination can cause a great deal of image degradation. In many cases it's hard to darken the room enough to prevent image wipe-out. You can use an Ektalite super high-gain screen, but the Ektalite has a relatively narrow angle for good viewing, and it's only 40 inches wide.

Another drawback of optical projection is the need to set up. Rooms have to be rearranged so that the screen can be positioned, seats moved, and the room must be darkened.

Practically all these drawbacks of optical projection can be overcome with electronic, or TV, projection. The single major inadequacy with this projection is the size of the TV screen. Based on present cathode-ray tube technology, this is certainly the case; but if the *Popular Science* before me (March 1975) is telling the truth, many electronics firms will be offering a large wall screen, or flat screen TV panel in a few years. Sharp Electronics, for example, has developed, so it says, electroluminescent panels that are easy to manufacture, bright and last more than 10,000 hours. I've been hearing predictions like this, of wall screens just around the corner for the last few years, so forgive me if I yawn.

But when wall screens come along, they may well provide the best solution to motion picture projection in many environments. The viewers can sit where they like, the room won't have to be darkened and there will be nothing to set up. With your super 8 videoplayer hooked up to the screen, you'll get big, bright movies electronically projected. And super 8 is much better matched to the needs of large screen projection than video tape. A four- or five-foot wall screen probably won't look as good with an off-the-air signal or a tape cassette program as it would displaying super 8 film. For big screen presentation, super 8 is much sharper.

Video tape is better matched to the needs of the presently employed small screen cathode ray tubes than super 8. Video tape is a terrifically efficient storage medium for the reproduction of the coarse detail needed by the little screen. Super 8, on the other hand, is not as well matched to the needs of the little screen, but it stays more efficiently sharp for every little leaf and big screen projection.

If I were to try to make a case for the videoplayer and its use in conjunction with present TV sets, I'd be brought down by the feeling that you could get results on a par at half (or less) the price with a good rear screen cartridge-loading projector, like those supplied by Fairchild.

Videoplayer Eastman has really been doing its best to blast super 8 out of the realm of strictly amateur status into the most sophisticated and technologically advanced moving image medium, what with the XL system, the Ektasound system, the 200-foot cartridge, the Supermatic rapid processing system and the videoplayer, VP-1.

The Kodak Supermatic VP-1 is not the first super 8 videoplayer to be shown, but as far as I know, it's the first one you can buy. This 45-pound machine, itself the size of a TV set (21 by 13⅝ inches) transforms the super 8 optical image, in color or black and white, with magnetic sound or silent, at either 18 or 24 fps, into an electronically displayed image. You can view all this on either channel 3 or 4 of any TV set with a simple hookup to the antenna input.

The general name for a device that turns a movie image into a TV display is a film chain. TV stations often have a few of these machines for showing 16mm or 35mm films. They cost tens of thousands of dollars. The VP-1 lists for $1700 and I think it's no coincidence that this is exactly the same list price as the Sony video cassette tape player which uses three-quarter-inch video tape loaded into the U-Matic cassette.

The VP-1 uses super 8 film on reels or in Kodak projection cartridges. The autoloading mechanism asks the question: why

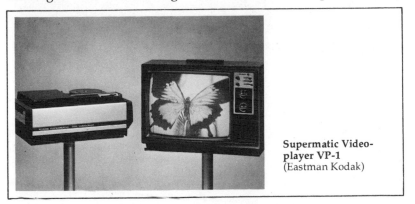

Supermatic Video-player VP-1
(Eastman Kodak)

bother with cartridges? Cartridges are bulkier, most costly and not any easier to use with this machine than film on reels.

The threading mechanism is a vast improvement on that employed in the cartridge-accepting Supermatic 60 or 70 projectors. The leader is trimmed with a device resembling a little stapler. Before the initial use, it punches a small hole and a dimple into the leader. When reel or cartridge is placed on the machine, a small finger reaches out and catches the leader, drawing the film into the loading channel and then deeper inside the machine's electronic innards. This is the neatest, smoothest autothreading mechanism I have seen—if your leader has no splices in its first three or four feet and your reel is nearly full.

Film flows through the VP-1 tape-recorder style. There is no intermittent mechanism. Presumably there is also little or no wear of film since it is scanned by a moving point of light generated by a cathode ray tube.

The density and color of the spot of light projected on the frame are analyzed by transducers which change the optical information into the appropriate electronic signal. The spot, or beam, of light travels across each frame hundreds of times in the engraving-like pattern known as the television raster. This method for producing a TV image from movie film, which is simply described here, is called flying spot scanning. The technique is one of the first devised for turning the world into a TV image. But it never had any popularity for live TV. A successful system of photography must be based on the ability to use existing light. The world cannot be illuminated with a flying spot of light.

The VP-1, which is actually a collaborative effort between Eastman and Sylvania, is a major step in the right direction for super 8 film. If it works as it should, a film ought to be good for thousands of passes through it.

The machine will run at 18 or 24 fps, and it is possible to correct the running speed by a few percent with an adjustment made inside. According to Eastman's technical papers on the video-player, anything from 0 to 60 fps are possible. This machine will play back single frames (0 fps), and either 18 or 24 fps forward; future videoplayers could offer slow or sped-up action, forward or backward.

The VP-1 has many of the same controls for frame line correction and focusing you'd expect to see on an optical projector. And there is a control unique to electronic projection, a steadiness control to ensure good registration. The VP-1 optically scans the leading edge of the film's perfs in order to register each frame. This takes the place of the pull-down claw in an optical projector. As a matter of fact, physical perforations are unnecessary for a videoplayer. Photographically printed perfs will work just as well.

286

The VP-1 can feed a number of TV sets at the same time, either by itself or with the help of an amplifier. Transfers can be made to any tape format (at either 18 or 24), so that films shot in super 8 can be edited in super 8 and viewed on video tape players in reel-to-reel or cartridge form, with anything from the 2-inch broadcast standard to the quarter-inch Aiki format.

A slightly different version, the VP-X at $1800 list becomes the lowest cost TV station film chain available, less than a tenth of the cost of most film chains. Moreover, super 8 film is broadcast compatible and up to FCC standards. Small format video tape, the popular half-inch variety, for example, is not compatible with FCC standards and must be processed through $9000 convertors to correct for sync error (but the VP-X is time-base corrected).

How does this machine perform? The VP-1 is, at the moment I am writing, in short supply so I had to content myself with an afternoon with it at Eastman's San Francisco headquarters. I brought along a variety of film—color, black and white, silent and sound. After a few minutes of instruction, I was left alone to play with the machine and a run-of-the-mill color TV set.

Right off the bat I'll tell you I was snowed. Seeing my films on a

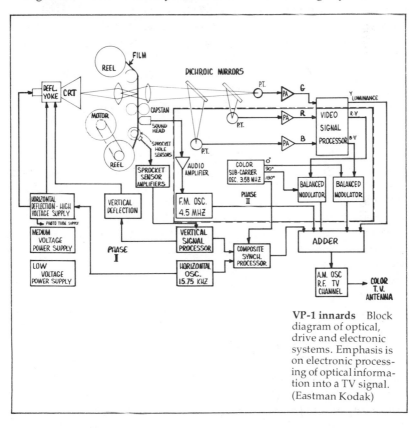

VP-1 innards Block diagram of optical, drive and electronic systems. Emphasis is on electronic processing of optical information into a TV signal. (Eastman Kodak)

PROJECT

287

TV screen for the first time, was, as a friend puts it, a giggle. Sharpness, color, contrast and image steadiness were super duper. I couldn't kick, except that sunlight on objects, or sparkling water, just didn't have the brilliance and beauty of optical projection. That's the essential lessening of pictorial quality I felt, given that I was looking at a little TV screen, and had adjusted my standards to TV rather than optical projection quality.

There was absolutely no discernible difference in image or sound quality at 18 or 24 fps. None at all. Will TV stations using super 8 and VP-1 continue the 24 fps standard hung over from 16mm?

Getting down to cases a bit, let me say that well-exposed Kodachrome looked fine grained, very sharp and had good color. The image was as good as the best closed-circuit TV I have seen. Underexposed Kodachrome had increased granularity, but the exposure was automatically corrected. The VP-1 has contrast and brilliance correction circuitry. The improvement in image quality was a spectacular success. But I don't know how day-for-night or other special techniques might look. Day-for-night is underexposed daylight footage, usually tinted blue, or shot without the 85 filter. The videoplayer might overcorrect and destroy the effect. You see, the VP-1 also has color correction circuits, and I must report skin tones were acceptable, even in fact, often improved. This was especially true of Ektachrome 160 and G shot under mixed illumination or fluorescence.

One interesting point: various color films retained their characteristic quality. Fujichrome looked like Fujichrome, Ektachrome 40 looked like Ektachrome 40 and so on. Black and white was handled very well. The tonality was neutral, that is, the grey scale was without discernible coloration. Sharpness, gradation and granularity were first rate from fast, medium or slow speed film. This was as good as the best black and white I have ever seen on TV. The image was absolutely rich.

I think that Ektachrome G, or a film similarly sensitized, may well turn out to be the best bet for use in conjunction with the videoplayer. E/G (page 24) is supposed to be used without any filtration under all kinds of light. Although it works well with fluorescent lights, its results are so-so outdoors (bluish), but I would expect the videoplayer's color correction circuit would help produce acceptable color all of the time.

The only time there was any unsteadiness was after some tape splices (I didn't have any cement splices to try). Most tape splices passed through okay, but some caused image flutter. I think the cause of the troubles is the narrow clear hairline at the splice. The photoelectric perf sensor must confuse this hairline with the leading edge of a perf. I would think that some kind of memory circuit could be added to correct for this tape splice unsteadiness.

The sound was good, the limitation naturally being those junky speakers and amplifiers they use in TV sets.

What's wrong with the VP-1? For one thing, while there is a rapid reverse for rewinding or repeating a filmed segment, there is no rapid forward. Rapid forward would help in finding desired portions of a film. The reverse feature, by the way, is keyed automatically at the end of the film if the tail leader is anchored to the feed reel.

Another trouble, which actually may have little to do with the videoplayers, is that the image is too heavily cropped by the usual TV receiver. Part of this has to do with the curved outlines of TV screens, part to plain sloppy TV practice. I hate to lose any part of my composition, not only for esthetic reasons, but also because the super 8 frame is so small, it's a shame to waste any of it.

The VP-1 is hardly portable. It's too heavy and bulky, and needs to be wheeled around like a big TV set. Moreover, the Eastman rep admitted that the machine was relatively touchy and needed care in carrying to various locations. Image steadiness is the likely casualty from less than careful handling in transport.

The VP-1 ran a little more noisily than a tape recorder. A cathode ray tube requires high voltage, and high-voltage electronics requires cooling, and cooling requires a fan and a fan produces noise. Maybe we will have a solid state videoplayer someday. It would be smaller, lighter and quieter, and who knows, maybe less expensive.

Opening a page of my dream book, the videoplayer is a natural for image and even sound level cues via the balance stripe. Anything that you can do with the control knobs of a TV set, you should be able to do with a videoplayer designed to respond to digitized information stored on the magnetic balance stripe. That would include color and exposure correction, fades (or dissolves with two machines run in sync) and even sound level control, which is important for single system.

Image and sound cues once user selected would become an integral part of the film for electronic projection, and the same balance stripe cues could be used to control conventional motion picture printing machines.

PRODUCTS & SERVICES

Music	Processing
Accessories	Animation
Sound	Underwater Equipment
Lab	Optical Printing
Lighting	Cameras
Print Sales and Rentals	Film
Projectors	Editing Equipment

a

 Acme-Lite Mfg. Co.
4646 W. Fulton St.
Chicago, IL 60644

 Advent Corporation
195 Albany St.
Cambridge, MA 02139

AKG Products
See Philips

 Allied Impex Corp.
168 Glen Cove Rd.
Carle Place, NY 11514

 Alpha Cine Labs
1001 Lenora St.
Seattle, WA 98121

**American Hydrophoto
Industries, Inc.**
7251 Overseas Hwy.
Marathon, FL 33050

 Ampex Corp
401 Broadway
Redwood City
CA 94063

Aqua-Craft Inc.
5258 Anna St.
San Diego, CA 92110

Argus Inc.
2080 Lunt Ave.
Elk Grove Village, IL
60007

 Arkay Corp.
228 S. First St.
Milwaukee, WI 53204

 Arriflex Co.
P.O. Box 1050
Woodside, NY 11377

 Emil Ascher, Inc.
745 Fifth Avenue
New York, NY 10022

b

 **Baia Photo-Optical
Corp.**
9353 Lee Rd.
Jackson, MI 49201

 Bauer
AIC Photo Inc.
168 Glen Cove Rd.
Carle Place, NY 11515

Beaulieu
See Hervic Corp.

 Bebell Inc.
Motion Picture Lab
Division
416 W. 45th St.
New York, NY 10036

Bell & Howell Co.
2201 Howard St.
Evanston, IL 60202

 **Berkey ColorTran,
Inc.**
1015 Chestnut St.
Burbank, CA 91502

**Berkey Marketing
Companies, Inc.**
25-15 50th St.
Woodside, NY 11377

BI-CEA
P. O. Box 2131
Canoga Park, CA 91306

**Birns & Sawyer Cine
Equipment**
1026 N. Highland Ave.
Los Angeles, CA 90038

 Blackhawk Films
74 Eastin Phelan Bldg.
Davenport, IA 52808

Bolex
See Braun

**Braun North America
(Nizo)**
55 Cambridge Parkway
Cambridge, MA 02142

Byron Motion Pictures
65 K St. N.E.
Washington, D.C.
20002

C

**Calvin
Communications**
215 W. Pershing
Kansas City, MO 64108

 Canon USA, Inc.
10 Nevada Dr.
Lake Success, NY
11040

**Canyon Cinema
Cooperative**
Industrial Center Bldg.
Sausalito, CA 94965

 **Capitol Production
Music**
Capitol Records, Inc.
1750 Vine Street
Hollywood, CA 90028

Capro
See EPOI

Castle Films
221 Park Ave. S
New York, NY 10003

**Century Precision
Optics**
10661 Burbank Blvd.
N. Hollywood, CA
91601

**Cine-Chrome Labs,
Inc.**
4075 Transport St.
Palo Alto, CA 94303

Cine Magnetics
650 Halstead Ave.
Mamaroneck, NY
10543

**Cinema Products
Corp.**
2037 Granville Ave.
Los Angeles, CA 90025

 **Cine-Service Vintage
Films, Inc.**
585 Pond St.
Bridgeport, CT 06606

**George W. Colburn
Laboratory, Inc.**
164 N. Wacker Dr.
Chicago, IL 60606

 Commercial and Home Movie Service, Inc.
614-616 Washington St.
Allentown, PA 18102

 Consolidated Film Industries
959 North Seward St.
Hollywood, CA 90038

Copal
See Harry Gocho Ent., Inc.

 Criterion Film Lab, Inc.
415 W. 55th St.
New York, NY 10019

 Crown International
1718 Mishawaka Rd.
Elkhart, IN 46514

d

 Da-Lite Screen Co., Inc.
Road 15 North
Box 269
Warsaw, IN 46580

 Digital Film Equipment
1205 West Drew
Houston, TX 77006

 Leo Diner Films Inc.
332-350 Golden Gate Ave.
San Francisco, CA 94102

 DoKorder, Inc.
11264 Playa Ct.
Culver City, CA 90230

 Dolby Laboratories, Inc.
1133 Ave. of the Americas
New York, NY 10036

e

 Eastman Kodak Co.
343 State St.
Rochester, NY 14650

Eclair Corp.
62 W. 45th St.
New York, NY 10036

Ediquip Corp.
905 N. Cole
Hollywood, CA 90038

The Ednalite Corp.
Photographic Div.
210 N. Water St.
Peekskill NY 10566

Edwal Scientific Products Corp.
12120 S. Peoria St.
Chicago, IL 60643

EFX Unlimited Inc.
321 W. 44th St.
New York, NY 10036

Electro-Voice, Inc.
600 Cecil St.
Buchanan, MI 49107

Elmo Mfg. Corp.
32-10 57th St.
Woodside, NY 11377

EPOI International Ltd.
623 Stewart Ave.
Garden City, NY 11530

ESO-S Pictures, Inc.
47th and Holly
Kansas City, MO 64112

Eumig (U.S.A.) Inc.
Lake Success
Business Park
225 Community Drive
Great Neck, NY 11020

f

Fairchild Industrial Products
75 Hall Drive
Commack L.I., NY 11725

292

 Filmkraft Services
6850 Lexington Ave.
Suite 217
Hollywood, CA 90038

Film Life
Film Life Bldg.
141 Moonachie Rd.
Moonachie, NJ 07074

**Film-makers'
Cooperative**
175 Lexington Ave.
New York, NY 10016

Fotomat Corp.
7590 Fay Ave.
La Jolla, CA 92037

 **Fuji Photo Film
U.S.A., Inc.**
350 Fifth Ave.
New York, NY 10001

g

 GAF Corp.
140 W. 51st St.
New York, NY 10020

**Harry Gocho
Ent./Sekonic Div.**
56-01 Queens Blvd.
Woodside, NY 11377

Gossen Div.
Berkey Marketing
Companies, Inc.
25-15 50th St.
Woodside, NY 11377

GTE Sylvania Inc.
One Stamford Forum
Stamford, CT 06904

GTE Sylvania
Lighting Div.
100 Endicott St.
Danvers, MA 01923

 **Guillotine Splicer
Corp.**
45 Urban Ave.
Westbury, NY 11590

h

 Hanimex (U.S.A.) Inc.
7020 N. Lawndale Ave.
Chicago, IL 60645

Harrison & Harrison
6363 Santa Monica
Blvd.
Hollywood, CA 90038

Karl Heitz, Inc.
979 Third Ave
New York, NY 10022

Hervic Corp.
14225 Ventura Blvd.
Sherman Oaks, CA
91403

Heurtier
See Hervic Corp.

 Hollywood Cine Labs
1207 N. Western Ave.
Hollywood, CA 90029

 Hollywood Film Co.
956 N. Seward St.
Hollywood, CA 90038

**Hollywood Valley
Film Lab Inc.**
2704 W. Olive Ave.
Burbank, CA 91505

**Honeywell
Photographic Products**
5501 S. Broadway
P. O. Box 1010
Littleton, CO 80120

i, j

**Ikelite Underwater
Systems**
3303 N. Illinois St.
Indianapolis, IN 46208

Inner Space Systems
102 W. Nelson St.
Deerfield, WI 53531

**J-K Camera
Engineering**
5101 San Leandro St.
Oakland, CA 94601

k

 Kalart Victor Corp.
Hultinius St.
Plainville, CT 06062

 KEM Electronic Mechanic Corp.
225 Park Ave. S.
New York, NY 10003

 Keystone Division
Berkey Marketing
Companies, Inc.
25-15 50th St.
Woodside, NY 11377

 Kin-O-Lux, Inc.
17 W. 45th St.
New York, NY 10036

 Kling Photo Co.
25-20
Brooklyn-Queens
Exp. W.
Woodside, NY 11377

 K-Mart Division
S. S. Kresge Co.
3100 W. Big Beaver
Troy, MI 48084

l

 La Grange, Inc.
1139 N. Highland Ave.
Hollywood, CA 90038

 L/C Distributors
P. O. Box 575
Garden Grove, CA
92642

 E. Leitz, Inc.
Link Drive
Rockleigh, NJ 07647

Lowel-Light Mfg., Inc.
421 W. 54th St.
New York, NY 10019

m

 Magna Sync/Moviola Co
5539 Riverton Avenue
North Hollywood, CA
91601

 Micro Record Corp.
487-38A South Ave.
Beacon, NY 12508

 Miller Professional Equipment
6500 Santa Monica
Blvd.
Hollywood, CA 90038

 Minolta Corp.
200 Park Ave. S.
New York, NY 10003

 MKM Industries, Inc.
5500 Touhy Avenue
Skokie, IL 60076

 Morse Controls
Division of North
American Rockwell
21 Clinton St.
Hudson, OH 44236

Moser Development Co.
See Filmkraft

 Motion Picture Labs, Inc.
781 S. Main St.
Memphis, TN 38101

 Movielab, Inc.
Movielab Building
619 West 54th St.
New York, NY 10019

MRC
71 W. 23rd St.
New York, NY 10010

Musi Cues Corporation
117 West 46th Street
New York, NY 10036

Musifex, Inc.
45 West 45th Street
New York, NY 10036

n

 Nagra Magnetic Recorders, Inc.
565 5th Ave.
New York, NY 10017

 Newsfilm Laboratory Inc.
516 N. Larchmont Blvd.
Hollywood, CA 90004

Nikon Inc.
See EPOI

Nizo
See Braun

 Norelco/Philips
100 E 42nd St.
New York, NY 10017

o

 Oceanic Products
844 Castro St.
San Leandro, CA 94577

 Optasound Corp.
116 John St.
New York, NY 10038

Ox Products
180 East Prospect Ave.
Mamaroneck, NY 10543

Oxberry
516 Timpson Pl.
Bronx, NY 10455

p,q

Paillard Inc. (Bolex)
See Braun

W. A. Palmer Films
611 Howard St.
San Francisco, CA 94105

Pathé—
See Karl Heitz

 Ponder & Best, Inc.
1630 Stewart St.
Santa Monica, CA 90406

 Prinz Corp.
813 N. Franklin St.
Chicago, IL 60610

 PSC Technology Inc.
1200 Grand Central Ave.
Glendale, CA 91201

 Quick-Set Inc.
3650 Woodhead
Northbrook, IL 60062

r

 R. G. Motion Picture Lab
1511 Jericho Tpke.
New Hyde Park, NY 11040

 Raven Screen Corp.
124 E. 124th St.
New York, NY 10035

 Rollei of America, Inc.
100 Lehigh Drive
Fairfield, NJ 07006

 Rosco Labs, Inc.
36 Bush Ave.
Port Chester, NY 10573

s

 Sankyo Seiki (America) Inc.
149 Fifth Ave.
New York, NY 10010

 Sea Research & Development, Inc.
P. O. Box 589
Bartow, FL 33830

 Sears Roebuck and Co.
Sears Tower
Chicago, IL

 Sennheiser Electronic Corp
10 W. 37th St.
New York, NY 10018

 Shure Brothers Inc.
222 Hartrey Ave.
Evanston, IL 60204

Silma—
See Hervic

 SIRI Music Inc.
One Towne Road
Boxford, MA 01921

 Slide Strip Lab Inc.
432 W. 45th St.
New York, NY 10036

 Smith-Victor Corp.
Lake and Colfax Sts.
Griffith, IN 46319

 SMPTE
Society of Motion
Picture & Television
Engineers
862 Scarsdale Ave.
Scarsdale, NY 10583

 Sony Corp.
9 W. 5th St.
New York, NY 10009
also see Superscope

 S.O.S. Photo-Cine-Optics, Inc.
40 Kero Rd.
Carlstadt, NJ 07072 and
6331 Hollywood Blvd.
Hollywood, CA 90028

 Spiratone, Inc.
135-06 Northern Blvd.
Flushing, NY 11354

 Sports Film Labs, Inc.
361 W. Broadway
South Boston, MA
02127

 Strand-Century Lighting
20 Bushes Ln.
Elmwood Park, NJ
08217

 Super8 Sound
95 Harvey Street
Cambridge, MA 02140

 Super 8 Systems, Inc.
4016 Golf Rd.
Skokie, IL 60076

 Super-8 Research Associates
11669 North Shore Dr.
Reston, VA 22090

 Superior Bulk Film Co.
450 N. Wells St.
Chicago, IL 60610

 Superscope Inc.
8150 Vineland Ave.
Sun Valley, CA 91352

t

 Tandberg of America
Labriola Ct.
Armonk, NY 10504

 TEAC Corp.
7733 Telegraph Rd.
Montebello, CA 90640

 Technicolor, Inc.
Consumer Products
Div.
6311 Romaine St.
Hollywood, CA 90038

 Testrite Instrument Co., Inc.
135 Monroe St.
Newark, NJ 07105

 3M Company
3M Center
St. Paul, MN 55101

 Thunderbird Films
P. O. Box 4081
Los Angeles, CA 90054

Tiffen Optical Co.
71 Jane St.
Roslyn Heights, NY
11577

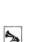 **Tri-Pix Film Service**
49 W. 45th St.
New York, NY 10036

u, v

Uher of America Inc.
621 S. Hindry Ave.
Inglewood, CA 90301

 D.P. Upton Co.
P.O. Box 5052
Tucson, AZ 85703

 Western Cine Service, Inc.
312 S. Pearl St.
Denver, CO 80209

Valley Projection
2227 West Olive Ave.
Burbank, CA 91506

 Wide Range Electronics Corp.
2119 Schuetz Rd.
St. Louis, MO 63141

Thomas J. Valentino, Inc.
150 West 46th Street
New York, NY 10036

Wilcam Photo Research, Inc.
3619 Yolanda Ave.
Northridge, CA 91324

W

Montgomery Ward Co.
619 West Chicago Ave.
Chicago, IL 60607

Y

 Yashica Inc.
50-17 Queens Blvd.
Woodside, NY 11377

PERIODICALS

American Cinematographer
ASC Holding Corp.
1782 North Orange Drive
Hollywood, CA 90028
monthly
$9 yearly

For filmmakers who have arrived. Area of concentration is 16mm and 35mm theatrical productions, but some super 8 too.

Movie Maker
Fountain Press
46-47 Chancery Lane
London, W.C. 2
England
monthly
$10 yearly

The British scene is different from ours. Lots of filmmaking clubs and an absorbing interest in double system shooting. Gabby.

Popular Photography Buying Guide
Ziff-Davis
One Park Ave.
New York, NY 10017
$1.50

A roundup of cameras and projectors.

Filmmakers Newsletter
Sun Craft International, Inc.
41 Union Square West
New York, NY 10003
monthly
$7 yearly

For filmmakers on the make. Area of concentration is 16mm and 35mm commercial productions, but some super 8 too.

Journal of the SMPTE
Society of Motion Picture and Television
Engineers, Inc.
862 Scarsdale Ave.
Scarsdale, NY 10583
monthly
$35 yearly for non-members

For the technically minded. Breakthroughs appear here first.

Super-8 Filmaker
PMS Publishing Co. Inc.
3161 Fillmore St.
San Francisco, CA 94123
bi-monthly
$7 yearly

Your best single source of current information.

INDEX

300

SUPER 8 FILMOGRAPHY

Children of the Golden West
59 minutes

Revelation of the Foundation
68 minutes

Adirondack Holiday
17 minutes

Nadine's Song
12 minutes

Father's Day
9 minutes

The Story of a Man
11 minutes

Hilltop Nursery
24 minutes

ACKNOWLEDGEMENTS

I would like to thank the following people for their help with the preparation of the manuscript, and for information, illustrations, and the loan of products for testing and evaluation. Without their help my task would have been greatly compounded: Paul C. Allen (Eastman Kodak), James Blue (Rice University), Corinne Cantrill (Cocteau quote), James L. Chung (Fuji Photo Film), D. F. Cuitillo (Guillotine Splicer Corp.), Gregory Conniff (Inner Space Systems), Roy Diner (Leo Diner Films), Bob Doyle (Super8 Sound), Timothy B. Huber (Braun North America), Bill Hunter (W. A. Palmer Films), J. Robert Jones (Eastman Kodak), Ricky Leacock (MIT), Diane Lipton (lots of love and typing too), Julie Mamolen (Super8 Sound), Robert Mayer (Bell & Howell), Al Mecklanberg (Super8 Sound), Skip Millor, Jr. (Eastman Kodak), Hans Napfel (Fairchild Industrial Products), Cathy Neiman (typing), Rosemary Nightingale (typing), Frank Schiavi (Brooks Camera), Wendy Schwartz (pasteup), Joe Semmelmayer (Eastman Kodak), Hy Shaffer (Hamton Engineering Associates), Cliff Skinner (Skinner Studios), Robb Smith (GAF Corp.), Fred Spira (Spiratone Inc.), Walter Soul (Filmkraft Services), Christy Stewart (Hervic Corp), Michael D. Sullivan (Eastman Kodak), Jeffrey Thielen (Eumig U.S.A.), Bob White (Inner Space Systems), Ernst Wildi (Paillard) and Fred Zickerman (Elmo Mfg. Co.). Production at Swan-Levine House, Grass Valley, Ca.

And to Jean Cocteau who said, "Film will become an art only when its materials are as inexpensive as pencil and paper." Super 8 is as close as we've come to this dream.